BRITISH PHOTOGRAPHY IN THE NINETEENTH CENTURY
The Fine Art Tradition

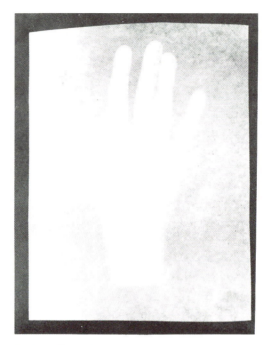

H. F. Talbot, *A Hand*, salted
paper, 1840. Science Museum.

BRITISH PHOTOGRAPHY IN THE NINETEENTH CENTURY
The Fine Art Tradition

edited by
MIKE WEAVER
Oxford University

The right of the
University of Cambridge
to print and sell
all manner of books
was granted by
Henry VIII in 1534.
The University has printed
and published continuously
since 1584.

CAMBRIDGE UNIVERSITY PRESS

Cambridge
New York Port Chester Melbourne Sydney

Published by the Press Syndicate of the University of Cambridge
The Pitt Building, Trumpington Street, Cambridge CB2 1RP
32 East 57th Street, New York, NY 10022, USA
10 Stamford Road, Oakleigh, Melbourne 3166, Australia

First published 1989

Printed in the United States of America

Library of Congress Cataloging-in-Publication Data
British photography in the nineteenth century : the fine art tradition
/ edited by Mike Weaver.
p. cm.
Bibliography: p.
Includes index.
ISBN 0-521-34119-1
1. Photography – Great Britain – History – 19th century.
2. Photographers – Great Britain – Biography. I. Weaver, Mike.
TR57.B75 1989
770'.941–dc19 88–23357
 CIP

British Library Cataloguing in Publication Data
British photography in the nineteenth century :
the fine art tradition.
1. British photography, 1800–1895 – Critical
studies
I. Weaver, Mike, 1937–
770'.941

ISBN 0-521-34119-1 hard covers

FOR ROBERT LASSAM
FRIEND TO US ALL

A fine art appeals only to the finer part of our nature. All the lower arts minister only to the material or animal part of our economy. Does the photographic landscape, with its marvelous delicacy of detail and play of light and shade – does the really graceful and masterly portrait of the genuine artist, with its soul-speaking reality, appeal to our animal appetites or our material sense of comfort? To what does it speak? What feelings does it awaken? What thoughts does it excite? Are they not of a higher order? If it does not do any of these things, what does it do? To use the most threadbare of newspaper phrases – "we pause for a reply".

Stephen Thompson, 1861

CONTENTS

ILLUSTRATIONS

PREFACE

When Alvin Langdon Coburn came from New York to London in 1900 he did so because Britain had long been the seat of photographic culture. If America was to have Stieglitz and *Camera Work*, Stryker and the Farm Security Administration, Steichen and the Museum of Modern Art, and Moholy-Nagy and the Chicago Bauhaus to support its photographic enterprise in the twentieth century, in the nineteenth century Britain had already mustered Fenton and the Photographic Society, Emerson and the New English Art Club, Davison and the Camera Club, and Evans and the Linked Ring.

This book broaches from a historical and critical point of view a scholarly account of certain British photographers, born in the nineteenth century, whose work transcended literal fact to arrive at a degree of expressive meaning. In the early 1970's, just when photography exhibitions began to proliferate and when monographic research might have commenced, the structuralist movement in criticism ushered in the decanonization of the individual artist, and the post-modernist movement in art re-introduced the hybridization of media. Photography as a separate medium with a relatively independent branch of criticism was prematurely blighted by these linked phenomena. Now that the public function of photography has been taken over by film and television, and its artistic use has been diverted towards performance and conceptual art, the poetic treatment of actuality via pure photography has been temporarily eclipsed.

Meanwhile we have witnessed the publication of several new histories and encyclopedias of photography, not based on original research but, on the contrary, perpetuating old fallacies. The time has come for fresh investigation of the field, national school by national school, period by period, until a map has been drawn which will, perhaps, permit the extraordinary presumption of a world history of photography.

It will be quickly seen that much is missing from this book: Bridges, Delamotte, Sedgfield, Frith, Bedford, Bourne and Hollyer are absent from our account – to name but a few. Future years may see the emergence of a new generation of enthusiastic scholar-critics willing to collate old and new materials, and so

provide the prolegomena for a better history of British photography in the nineteenth century than we have had thus far.

Oxford Mike Weaver

CONTRIBUTORS

WILLIAM BUCHANAN is Head of the School of Fine Art, Glasgow School of Art.

ROLLIN BUCKMAN is Professor of Visual Communication, San Jose State University.

BRIAN COE was formerly Curator of the Kodak Museum, Harrow, and is now at the Museum of the Moving Image.

VIRGINIA DODIER received her MA from the Courtauld Institute, University of London, and is an independent researcher.

ANNE KELSEY HAMMOND received her BFA in Graphic Design from the University of Hawaii, and is an independent researcher.

ELLEN HANDY is Curatorial Assistant, Metropolitan Museum of Art, New York.

MARGARET F. HARKER is Emeritus Professor of Photography of the Polytechnic of Central London, and a Past President of the Royal Photographic Society.

DAVID HARRIS is Assistant Curator of Photographs, Centre Canadien d'Architecture/Canadian Center for Architecture.

MARK HAWORTH-BOOTH is Curator of Photographs, Victoria and Albert Museum, London.

IAN JEFFREY was formerly Principal Lecturer in the History of Art, Goldsmiths' College, University of London, and is an independent writer.

DUNCAN MACMILLAN is Curator of the Talbot Rice Centre, University of Edinburgh.

DOUG NICKEL is a doctoral student in Art History, Princeton University.

MELINDA BOYD PARSONS is Assistant Professor of Art History, Memphis State University.

FIONA PEARSON is Research Assistant, Scottish National Gallery of Modern Art, Edinburgh.

MICHELE PENHALL is a doctoral student in Art History, University of New Mexico, Albuquerque.

STEPHANIE SPENCER is Assistant Professor of Art History, North Carolina State University, Raleigh.

SARA STEVENSON is Curator of Photography, Scottish National Portrait Gallery, Edinburgh.

CHRISTOPHER TITTERINGTON is Assistant Curator of Photographs, Victoria and Albert Museum, London.

MIKE WEAVER is a former Chairman of the Photography Advisory Group of the Arts Council of Great Britain, and Reader in American Literature, Oxford University.

1. THE CAMERA AND OTHER DRAWING MACHINES

Doug Nickel

When the process of photography was brought to a practicable state in the late 1830's, its announcement elicited much attention in the popular and scientific press. Curiously, though, not all of this attention was positive. Some critics viewed photography as a scientific hoax, others imagined it to be some manner of sacrilegious blasphemy; many feared that the profession of painting was put in danger of obsolescence. When the suggestion was made that photography might somehow fit into the established hierarchy of pictorial media then in place in European culture, the pitch of the criticism increased. In 1872, John Ruskin wrote of photographs that "for geographical and geological purposes they are worth anything; for art purposes, worth – a good deal less than zero",[1] an opinion shared, evidently, by a number of Ruskin's contemporaries. The artistically minded photographer found himself working in the face of considerable official opposition. One such photographer, writing in 1852, lamented that "perhaps no science or art that has been revealed to mankind, has had to encounter a greater amount of opposition and prejudice than the science of photography".[2] This prejudice was not simply a reaction to a new and threatening medium, however. Among its sources were attitudes associated with the very tools of the process, attitudes which predated the invention of photography.

One of the many perceived deficiencies of the new medium was its essentially mechanical nature – the camera was a machine, it was thought, and its products the result of a chemical process largely removed from the creative, manual activities of the true artist. Popular estimation of older methods of picture-making – drawing and painting, for example – seemed to increase upon the announcement of such mass-production techniques as photography and lithography. A drawing or painting was unique, made by hand, each as individual as its creator. The photographer, on the other hand, was thought to be ruled by his or her apparatus; as Lady Elizabeth Eastlake maintained, the camera could but "give evidence of facts, as minutely and

[1] J. Ruskin, *The Works of John Ruskin*, London 1890, 4:142.
[2] H. Vines, *A Brief Sketch of the Rise and Progress of Photography, with Particular Reference to the Practice of Daguerreotype*, Bristol 1852, 32.

as impartially as, to our shame, only an unreasoning machine can give".[3] But the unreasoning machine, it was thought, could not produce art.

In many respects, this line of argument – which has, to an extent, survived to our day – can be shown to be untenable. Most obviously, Victorian critics failed to appreciate the new set of creative decisions necessitated by the medium of photography: decisions about such pictorial issues as framing, cropping and camera placement; these choices had their counterparts in the traditional arts but were made uncomfortably central to the new picture-making process. Commentators also overlooked photography's craft aspect – the considerable amount of manual skill needed to produce a usable negative or an aesthetically pleasing print. Far from being the product of a machine, the photograph routinely entailed an appreciable amount of hand manipulation on the part of its maker.

Likewise, it is fallacious to ascribe a kind of purity to the traditional, handmade arts: artists have always been ready to take advantage of whatever mechanical innovation might expedite their task. The long-established and widespread use of certain optical devices employed as drawing aids is a case in point. These devices, designed to increase the speed and accuracy of the draughtsman, ranged in complexity from the very simple to the elaborate. The invention of photography was but a new application of one such optical device.

The first artist who, standing before his easel, held up a thumb or pencil in order to measure his subject invented, in effect, the drawing machine. The principle is simple: given a fixed distance (the length of one's arm), an object of known length (thumb or pencil) can be used as a standard measure in determining the relative sizes of objects arrayed in space. Moreover, by aligning the vertical pencil so that it is visually adjacent to his subject, the draughtsman can more accurately follow the intricacies of a complex outline.

A variety of mechanical devices were constructed upon just this principle. A simple frame supporting weighted, positionable strings (Fig. 1) gave the artist not one but several vertical reference lines with which to measure, for example, the features of a sculpted bust.[4] An elaboration of this apparatus – a glass pane or a frame fitted with a grid of both vertical and horizontal threads, or with a piece of translucent gauze – was being employed by the time of the Renaissance: Leon Battista Alberti describes its use in his 1435 treatise *Della pittura*, and in 1488 Leonardo da Vinci sketched such a device in operation. By dividing a complicated scene into several easily rendered sections, and by varying the scale of the drawn grid, any amount of

[3] [E. Eastlake], "Photography", *Quarterly Review* 101, April 1857.
[4] A. Bosse, *Traité des Pratiques Géométrales et Perspectives*, Paris 1665.

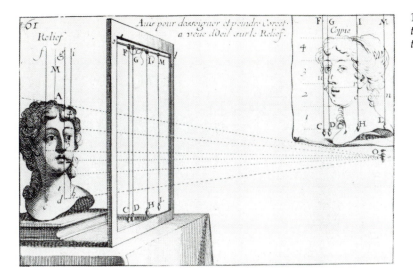

1. A. Bosse, *Traité des Pratiques Géométrales et Perspectives*, Paris 1665.

proportional reduction is possible. Albrecht Dürer, who designed five different drawing aids of this sort, improved the accuracy of his machines by incorporating a fixed sight for the artist's eye, reducing to a minimum errors introduced through movements of the user's head.

Dürer's *Underweysung der Messung* (*Manual of Measurement*) (1525) makes explicit precisely for whom these machines were best suited: "Solichs ist gut all dennen die yemand wollen ab Conterfeten und die irer sach nit gewiss sind" (Such is good for all who wish to make a representation, but who cannot trust their own skill).[5] The drawing machine addresses a problem basic to post-Renaissance art: the transcription of three-dimensional visual reality onto the two-dimensional surface of a picture, such that the spatial relationships in the representation correspond to those experienced by the human eye. Artists will normally plot these perspectival relationships mathematically, before beginning their work, but the procedure entails complicated calculations and usually requires a significant amount of specialized training. The drawing machine replaced the arithmetical with the optical, so that those "who cannot trust their own skill" – amateurs, in other words – could participate in the creation of perspectively correct views.

As amateur participation in the visual arts increased in the seventeenth and eighteenth centuries, so did the use of these drawing machines. Those not pursuing art as a profession, and therefore not privileged to receive lengthy academic and practical training in artistic technique, could nonetheless purchase manuals explaining the laws of perspective, and it is in the

[5]A. Dürer, *Underweysung der Messung* . . . , Nuremburg 1525.

context of these books that one often finds the drawing machine described as an alternative to learning mathematical perspectival rules. Jean Dubreuil, for example, in his *Perspective Practical* (1698) illustrates a drawing machine "for to exercise the Perspective, without knowing it" (Fig. 2). Such machines, explains the author, replace the tools of those perspectival systems based on geometry:

> This shall serve for those that love Painting, and take pleasure to use it; without being willing to take the pains to open the Compass, nor to take the Rule for to draw a line; for in this order, we shall not need neither the one nor the other. And nevertheless we may make very fair Perspectives, either of Buildings, of Gardens, or Landskips.[6]

In the late eighteenth century, amateur draughtsmanship became an activity in which the well-bred lady or gentleman was expected to participate, and the drawing machine became lightweight and portable, easily transported to picturesque sites in the countryside (Fig. 3). The gridded frame was not the only instrument available to the untutored, however. Among other devices, an ambitious sketcher of the period could choose from several optical aids, including the popular "Claude glass." This was nothing more than a small, slightly convex mirror; backed with dark paint rather than the usual silver, it reflected an image diminished in brightness and contrast. Viewed with this device, a scene would appear translated into a narrower, more subdued

[6] J. Dubreuil, *Perspective Practical, or, A Plain and Easie Method of True and Lively Representing all Things to the Eye at a Distance, by the Exact Rules of Art*, London 1698, 120.

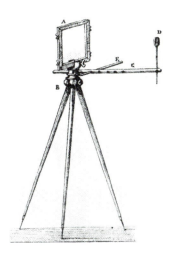

3. Eighteenth-century drawing tripod. Reproduced from *Malerei und Photographie im Dialog*, Zurich 1977.

range of tones – the same tonal range so admired at the time in the works of the seventeenth-century landscape painter Claude Lorrain.

One manifestation of the vogue for sketching among the upper classes was the publication of a number of topographical guide-books, intended to deliver readers to the most promising spots for drawing or scenic contemplation. William Gilpin, the author of many popular works in this genre, was one of those who helped popularize the Claude glass, as did Thomas West in *A Guide to the Lakes in Cumberland, Westmorland, and Lancashire* (1784):

> The landscape mirror will also furnish much amusement, in this tour. Where the objects are great and near, it removes them to a due distance, and shews them in the soft colours of nature, and in the most regular perspective the eye can perceive, or science demonstrate.
>
> The mirror is of the greatest use in sunshine; and the person using it ought always to turn his back to the object that he views. It should be suspended by the upper part of the case, and the landscape will then be seen in the glass, by holding it a little to the right or left (as the position of the parts to be viewed require) and the face screened from the sun. A glass of four inches, or four inches and a half diameter is a proper size.[7]

Travellers often carried the Claude glass simply for the pleasure its reflected images could give; but, as a Thomas Gainsborough drawing of about 1750 indicates,[8] this device also served the draughtsman in the field. By reducing the contrast between light

[7]T. West, *A Guide to the Lakes in Cumberland, Westmorland, and Lancashire*, London 1784, 12.
[8]See Leslie Parris, *Landscape in Britain c. 1750–1850*, London 1973, 124.

and dark, the Claude glass produced an image that was more easily described by the limited tonal capabilities of drawing or watercolour materials. In addition, its mirror reflection could serve much the same function as the gridded glass of the drawing machine: unbounded nature was reduced to a small, flat, readily transcribable optical image.

Unfortunately, the quality of results obtained with the Claude glass was still directly proportional to the draughtsmanly skills of its user. In 1807, William Hyde Wollaston announced his invention of the camera lucida, a drawing aid specifically designed for those lacking artistic training. This instrument consisted of a glass prism fixed by a rigid support over a drawing surface. When viewed from above, the prism reflected an image of whatever subject lay before it. By training one eye on the prism and the other on the blank paper beneath, the draughtsman would experience the illusion of his subject seemingly projected on the paper's surface. A drawing was obtained by simply tracing the outlines of this virtual image with a sharp-pointed pencil.[9] Inexpensive and easily transportable, the camera lucida became a popular tool for travellers wishing to set down quick sketches of interesting topography.

One such traveller was Captain Basil Hall. In the years 1827 and 1828, Hall journeyed up and down the East Coast of the United States, seeking out appropriate material for treatment with his camera lucida. Upon publication of the results in 1830, the author reflected upon the utility, and limitations, of the device:

> This instrument ought, perhaps, to be more generally used by travellers than it now is; for it enables a person of ordinary diligence to make correct outlines of many foreign scenes, to which he might not have leisure, or adequate skill, to do justice in the common way. . . . Artists accustomed to draw in the ordinary way are sometimes teased with the rigid accuracy and the confined limits to which the Camera Lucida subjects them; while persons altogether ignorant of the subject are disappointed to find, that for the first day or two they advance but little. Both parties complain, and not without some reason, that they cannot see the pencil distinctly, – or that they lose sight of the object they are drawing, just when they wish most to see it. . . . But they may rest assured, that a little perseverance will put all these difficulties to flight, after which, the wonderful economy of time and trouble will far more than overpay the short labour of instruction.[10]

As Captain Hall suggests, the camera lucida was not an instrument all that easily mastered. Somewhat more manage-

[9] See Helmut and Alison Gernsheim, *The History of Photography from the Camera Obscura to the Beginning of the Modern Era*, London 1969, pl. 14.

[10] B. Hall, *Forty Etchings from Sketches Made with the Camera Lucida, in North America, in 1827 and 1828*, London 1830, i.

4. Diderot, *Encyclopédie*, c. 1765.

able, though less convenient, was its technological forebear, the camera obscura. Known in principle since the tenth century, this device consisted – as its Latin name implies – of a darkened room equipped with a small aperture on one wall. Light coming through this aperture would cause an image of whatever lay before it to be projected, upside down and backwards, on the interior wall opposite. Sometime before the fifteenth century it was realized that by fitting the aperture with a lens, the projected image could be made brighter and sharper, and by the eighteenth century there was a variety of camera obscura types in use. One took the form of a sedan chair – this portable room employed a mirror which reflected light down through a lens mounted in the roof, and projected its image upon a table-like screen within (Fig. 4 left). More convenient still was the tent-type camera (Fig. 4 right), which could be folded up and carried from place to place.[11] The box-type camera (Fig. 5) was likewise portable, and employed a ground-glass screen to make its projected image visible – this was the type of instrument in which the first photographs would be made.

The camera obscura was put to a variety of uses – for solar observations, as a popular spectacle, and, of course, as an aid to painters and draughtsmen. As such, its usefulness was manifold. In 1763, the Italian art connoisseur Francesco Algarotti enthusiastically urged students to study the camera's images:

> Let the young painter, therefore, begin as early as possible to study these divine pictures, and study them all the days of his life, for he never will be able sufficiently to contemplate them. In short, Painters should make the same use of the Camera Obscura, which Naturalists and Astronomers make of the Microscope and Telescope, for all these instruments equally contribute to make known, and represent Nature.[12]

[11]D. Diderot, *Encyclopédie*, Paris 1751–65, plates vol. 3, under "Dessein", pl. 4.
[12]F. Algarotti, *An Essay on Painting Written in Italian by Count Algarotti*, London 1764, 65–66.

5. M. J. Brisson, *Dictionnaire raisonné de physique*, Paris 1781.

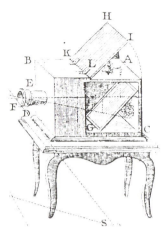

Algarotti, like a number of authors, recommends that the camera obscura be used as a study aid, that its representation of lights and darks should serve as a model of fidelity to nature. Artists realized quite early, however, that the camera could be used more directly in the production of pictures: by placing a translucent paper in the device's plane of focus, one could easily trace the outlines of the projected image. R. Boyle, in *The Art of Drawing and Painting in Water-Colours* (1731), compares the direct use of the camera obscura with that of the drawing frame, praising the former's convenience but warning of the greater expense incurred because of its lens arrangement.[13]

Optical drawing aids, by their nature, introduced certain distortions into the visual representations produced through their use. Because their appearance depended so directly upon the quality of the lenses employed, drawings made with the camera obscura often betrayed the primitive optics in use in the eighteenth century. More problematic, however, was the very process of using a camera to produce art. Free-hand drawings are customarily constructed by the gradual addition of one line to another; the image is formed by a gradual process of selection and correction, until the picture corresponds to the mental image held by the artist. An optical drawing aid, on the other hand, delivers its image preformed, already constructed; the final result, to a large extent, is predetermined. The optical image resists selectivity and control – at least, control in the traditional sense. Laurence Sterne, in *The Life and Opinions of Tristram Shandy*, criticizes those who "will make a drawing of you in the *Camera*; – because, *there* you are sure to be represented in some of your

[13]R. Boyle, *The Art of Drawing and Painting in Water-Colours*, London 1731, 7–9.

most ridiculous attitudes". Sir Joshua Reynolds makes this observation:

> If we suppose a view of nature represented with all the truth of the *camera obscura*, and the same scene represented by a great Artist, how little and mean will the one appear in comparison of the other, where no superiority is supposed from the choice of the subject. The scene shall be the same, the difference only will be in the manner in which it is presented to the eye. With what additional superiority then will the same Artist appear when he has the power of selecting his materials, as well as elevating his style.[14]

In the year 1800, the French landscape painter Pierre-Henri Valenciennes summarized the professional art teacher's attitude towards optical devices used directly in the production of pictures:

> Several artists have conceived of some very ingenious instruments with which to view and copy nature in its true perspective; but despite their convenience ... we believe that it would be detrimental to get used to them. One would no longer be able to observe nature without having recourse to the instrument. ... In general, teachers do not permit their students to employ this method, and with good reason, seeing the consequences which result from this bad habit.[15]

In October 1833, an English gentleman named William Henry Fox Talbot was on his honeymoon in Italy, near Lake Como. As befitted a person of his station, he was attempting to make landscape sketches; as would be expected from someone as lacking in practical training as he was, Talbot tried to employ an optical drawing aid. He found, however, that even the camera lucida could not help the completely untutored and untalented: "After various fruitless attempts, I laid aside the instrument and came to the conclusion, that its use required a previous knowledge of drawing, which unfortunately I did not possess".[16]

Talbot's miserable experience with the camera lucida led him to meditate upon the principle of the camera obscura, and it was then that he conceived of replacing his "faithless pencil" with light-sensitive paper – and photography was born. But it was born into an artistic environment hostile to amateurs, intolerant of mechanical short cuts, disdainful of the merely imitative and suspicious of mass-production techniques. Early critics of the medium did not censure the pictures – they were thought to be miraculous – but rather the camera, and these criticisms paralleled those of the prephotographic era. Photog-

[14]J. Reynolds, "Discourse XIII", *Discourses on Art* [1797], ed. Robert R. Wark, New Haven and London 1975, 237.

[15]Trans. from P-H. Valenciennes, *Eléments de Perspective Pratique à l'Usage des Artistes*, Paris 1800, 207.

[16]H. F. Talbot, *The Pencil of Nature*, London 1844–46, n.p.

raphy became the victim of its own tools, and the negative attitudes towards the process that used these tools – attitudes already in place in 1839 – proved to be but dark clouds on the horizon, foretelling storms of criticism yet to come.

2. HENRY FOX TALBOT:
Conversation Pieces

Mike Weaver

In 1936, Sacheverell Sitwell published *Conversation Pieces, a Survey of English Domestic Portraits and Their Painters.* Sitwell's book is notably sensitive to the British traditions of painting of the eighteenth and nineteenth centuries in which landscape, the sporting picture and the conversation piece "are undecided as to their respective properties and take on the habiliments of each other".[1] He begins with the silhouette, itself a kind of negative–positive photogenic drawing, and includes two photographs, one by Hill and Adamson, and one by Talbot: "Octavius Hill and Fox-Talbot are to be classed, definitely, as artists".[2]

Talbot's good relations with Daguerre's licence-holder in London, Antoine Claudet, took him on more than one occasion to Claudet's studio, where they collaborated on *The Chess Players*[3] and *Persons Conversing over a Glass of Wine* (B72). A silhouette conversation piece in the Victoria and Albert Museum, *A Birthday Party*, shows a lady offering a gentleman a pineapple, her daughter dutifully taking second place with a bunch of flowers.[4] Talbot's *A Fruit-Piece*[5] is, as it were, a detail from such a scene, appearing to us as a still life. The rocking-horse picture by Talbot (B167) really requires three or four children playing on it, as in a conversation piece by Octavius Oakley,[6] and the harp picture on its own (B134) requires Horatia to play it (B161) in order to take its rightful place among musical family groups like those by John Zoffany.[7] The several versions of *A Breakfast Service* look like still lifes in the Dutch tradition and would require the family presence to make them conversation pieces. But the tea-table group of several figures which Talbot made compares very well with eighteenth-century paintings of the same subject.[8] *Two*

[1]S. Sitwell, *Conversation Pieces*, London 1936, 3.
[2]Ibid., 7.
[3]Gail Buckland, *Fox Talbot and the Invention of Photography*, Boston and London 1980, 72. This remains the most comprehensive catalogue of Talbot's pictures. Hereafter, references in the text appear as, for example, B72 = Buckland, p. 72.)
[4]Sitwell, *Conversation Pieces*, 4.
[5]R. Lassam, *Fox Talbot*, Tisbury 1979, [pl. 6].
[6]Sitwell, *Conversation Pieces*, pl. 112.
[7]Ibid., pl. 51.
[8]A. Jammes, *William H. Fox Talbot*, New York 1973, pl. 28; Sitwell, *Conversation Pieces*, pl. 11.

1. H. F. Talbot, *Family Group in the Gardens*, salted paper, c. 1844. Science Museum.

Gentlemen in Conversation[9] has the men positioned far enough away to make conversation difficult, one would think, although it has one of the elements essential to a conversation piece – a country house in the background. *Family Group in the Gardens* (Fig. 1) has a large garden ornament silhouetted on the right which stands for family cohesion. The hierarchy of family intimacy steps back left: mother, child, grandmother, with cousin Kit Talbot on the ha-ha wall – at the immediate family's edge. Gardeners take their place in the background. That Talbot knew he was contributing to the tradition of the conversation piece may be inferred from *The Pencil of Nature*:

> When a group of persons has been artistically arranged, and trained by a little practice to maintain an absolute immobility for a few seconds of time, very delightful pictures are easily

[9]J. Ward and S. Stevenson, *Printed Light*, London 1986, fig. 63.

obtained. I have observed that family groups are especial fa-
vourites: and the same five or six individuals may be combined
in so many varying attitudes, as to give much interest and a
great air of reality to a series of such pictures.[10]

Talbot can be as sophisticated in this arrangement of people as
David Wilkie with *Sir Walter Scott and His Family* (Edinburgh,
Scottish National Portrait Gallery), a group of "peasants" en-
joying themselves. With the exception of an actual shepherd,
the other eight figures (a "miller", "milkmaids", "hunters", and
so on) are in fact the Abbotsford family and friends. The men
could be considered conversation subjects, but ladies as milk-
maids make a fancy subject, between portraiture and genre.
Talbot's *Group of Persons Selling Fruits and Flowers*[11] probably does
not include a single actual fruit- or flower-seller but family mem-
bers and servants: here the class relations of trade are briefly
fictionized.

In early photography, the need to take pictures out-of-
doors in order to obtain maximum sunlight rendered the landed
gentry's activities more suitable for portrayal than those of the
clerical and merchant classes. Talbot was keen to be regarded
as a member of the landed gentry. He was only recently the
occupant of Lacock Abbey, which he took over in 1828. His
father, a Davenport, was in debt until 1819, and took the name
Talbot on inheriting the Talbot estate in Lacock. Henry's three-
year effort to rebuild the south front of the abbey and include
an art gallery represented a considerable attempt to establish
himself as a landed gentleman of taste fit to be included in John
Nash's *Mansions of England in the Olden Time* (1839–49). Nash's
lithograph of the Long Gallery at Haddon Hall (vol. 1, pl. 23) is
comparable with Talbot's attempt to photograph his own south
gallery (B124). His subsequent attitude towards patents may
have resulted from conflicting feelings about his place in society.
He was landed gentleman enough to despise commerce but
anxious enough to reap its benefits. The conversation piece had
long been an ideal kind of representation of the aspirations and
achievements of the rising middle class. Photographs and paint-
ings of the conversation piece variety manifested an air of reality
but also bore witness to property ownership. Carriages evoke
the idea of material property in George Stubbs's paintings of
phaetons with grooms and horses. In Talbot's photographs,
however, the living elements of the picture are missing and we
are left with inanimate objects. Even if in *Footman at Carriage
Door* (B65) Talbot had his servant open the carriage door in the
direction from which his master might enter, it is a metaphysical
rather than social feeling which is created by the image.

[10]H. F. Talbot, *The Pencil of Nature*, London 1844–46, n.p.
[11]Lassam, *Fox Talbot*, [pl. 7].

Talbot's use of carriages, carts, ladders and haystacks has been attributed simply to a descriptive proclivity. Briefly a Whig in Parliament, and by all accounts a good landlord, he portrayed life at Lacock as industrious without idealizing the life of his labourers: his carpenters and bricklayers are real workmen (B36). Occasionally his house servant Nicolaas Henneman simulated a working activity to create a genre picture like *The Woodcutters*,[12] but nobody can accuse Talbot of describing an idyllic picture of village life. The chaos of the woodyard and carpenter's shed, the younger men and boys lounging about, and a lame man with a crutch, suggest an anti-pastoral sentiment. But, without interfering with this realistic aspect of life, the placement of a couple of rough-hewn beams across a doorway (B180), or planks against the tower of the abbey (B82), creates that same strange feeling which attaches itself to various objects set before us, like *The Broom* (B155), *The Ladder* (B86), or *The Wheel* (B128). These objects attain a quiddity beyond material possession, and take Talbot's images into a realm where others had not gone before – at least, not in photography. When the much prized literal quality of a picture begins to prompt such a sense of otherness, the social expression of leisure and prosperity gives way to an immaterial sense of haunting existence. Most *cartes de visite* and most cabinet photographs included props, columns and curtains, which possessed no such special quality: there the people were all-important.

In Talbot's work things often replaced people in significance. *A Scene in a Library* (B85), a shelf of books without the figures present to make it a conversation piece, on close inspection turns out to be a self-portrait. The books carefully represent Talbot's interest in Egypt, philology, botany and general science – in a good print you can still read off the titles. Books were, indeed, Talbot's mute masters. Behind such a picture is a tradition of still lifes of books which found its high point in the trompe l'oeil painting of Giuseppe Maria Crespi (1665–1747).[13] Still lifes of small sculptures or figurines, shelves of silver and porcelain, come from the same tradition. In Talbot's pictures the objects are arranged carefully and symmetrically, beyond the utilitarian needs of record against robbery. A shelf of figurines in plaster which Talbot photographed might be a detail from a conversation piece by Zoffany with a mantel-shelf of bronze figures.[14] Sitwell wrote, "It was in the exact resemblance of painted mantelpiece, or object of silver or porcelain, that value and merit received their guarantee. The accessories of Zoffany were as valuable as his heads or clothes".[15] But for Talbot the

[12]H.J.P. Arnold, *William Henry Fox Talbot*, London 1977, fig. 97.
[13]*Stilleben in Europa*, Westfälisches Landesmuseum, Munster 1979, 454.
[14]Sitwell, *Conversation Pieces*, pl. 47.
[15]Ibid., 8.

accessories, the etceteras, appear to have been the most valuable of all, and not always materially. *The Bust of Patroclus* (B81), the kind of object one would expect to find in a connoisseur's cabinet, which Talbot photographed from several angles under different lights, introduces a *vanitas* theme, which returns it to a still life in the tradition of Jan de Heem (1606–84).[16]

Within Talbot's work we witness a major linguistic shift from the verb of the conversation piece, in which some kind of social relationship is being enacted, to the noun of the still life, a group of named objects meaningful in themselves. With this shift comes the change from social to psychological modes of perception. The strangeness of this solitary group of objects is often described as surrealist, but it was not invented in photography by Eugène Atget so much as by Talbot with his *Milliner's Shop Window* (B80). This dissociation of objects from their full context came partly from the tradition of still life, and partly from the ontology of photography: the sense of being is highlighted in a metaphysical way.

The relation between words and things, names and objects, is as fundamental to Talbot's *English Etymologies* as it is to his photography. His etymology of "thing" is the key to this:

> So very abstract a term as a *thing* must have caused some difficulty to our early ancestors to determine what they should call it.
>
> They made choice of term derived from the verb "to *think*."
>
> Any*thing* is any*think* – whatever it is possible to think of. . . . I think it probable that the word *Thing* (Germ. *Ding*) may have originally meant a word: i.e. any thing *we may chance to speak of*, and that it may have been identical with the old Latin *dingua* (for *lingua*) mentioned by some writers.[17]

From this it is clear that Talbot was neither a nominalist nor a realist but, as might be expected, took his lead from eighteenth-century associationism. Both names and objects caused the mind to think – to form associations. But Sir John Herschel could not agree that the etymological examination of the everyday language in which certain facts are expressed was a valid method of inquiry:

> Were language a true picture of Nature, a perfect *daguerreotype* of all her forms, this proceeding might be pardonable. Half the labour of the modern inductive philosopher is to construct a language which shall be such. But common language is a mass of metaphor, grounded not on philosophical resemblances, but on loose, fanciful, and often most mistaken analogies. From studying such language as the representative of Nature, no

[16] *Stilleben in Europa*, 455.
[17] H. F. Talbot, *English Etymologies*, London 1847, 13. (As this work is well indexed, no further text citations are given.)

pure and fundamental classification of facts, such as legitimate
Induction requires, can result; but, on the contrary, the greater
the acuteness and the broader the induction the wider will be
the departure from sound philosophy.[18]

But the scientist's view does not seem to have inhibited the artist
in Talbot. Because he was a natural philosopher, the objects in
the world had an objective existence for Talbot, but as a my-
thologist and etymologist, he was charmed and fascinated by
words. His etymology of symbol illustrates this:

> Now it is easy to see that the word *Sinnbild* is derived from
> *Sinn* (sense, meaning) and *Bild* (a figure). But, notwithstanding
> that, I think it probable that it is the same word as *Symbol* –
> only in a German dress. In short, that one of those words was
> derived from the other.

Whether there is any foundation in such an etymology seems
very doubtful, but Talbot had no difficulty in associating actual
things with their ideal representation. The perception of sensory
objects and the naming of them were coterminous: the boundary
line between realism and nominalism was still a shared one. The
globe was the single most important geometrical shape for Tal-
bot. According to him, it meant anything amassed into a heap:
"So the Latins say *globus* armatorum, a small body of soldiers;
globus conjurationis, a *knot* of conspirators". Hill and Adamson
employed such a globe or ball in their great conversation piece
of the Chalmers family (see Chap. 4, Fig. 3), where it is a figure
for the family as a cluster of people, the focus of whose concerted
efforts is represented by the still-life group of books adjacent
to it.

Just as the tree or globe is synecdochic of the family, so
the hand stands for the whole body (see Frontispiece). According
to Diodorus Siculus, the right hand with fingers extended meant
study, employment and application. According to Horapollo, it
indicated a constructive nature ("For a hand does all the build-
ing").[19] But in the Christian tradition it meant nothing less than
the Hand of God, as represented in the Codex Aureus of Saint
Emmeram (Munich, Bayerische Staatsbibliothek), accompanied
by the phrase "In Principio erat Verbum". William Warburton
pointed out that hieroglyphic writing was different from sym-
bolic writing in that the hieroglyph revealed whereas the symbol
concealed.[20] For Talbot the hand appears to have been both
human and godlike at the same time. It was the type of the
creative impulse formed in the very image of God:

[18][Sir J. Herschel], "Whewell on Inductive Sciences", *Quarterly Review* 135, June
 1841, 190.

[19]*The Hieroglyphics of Horapollo*, trans. G. Boas, New York 1950, 116, 112.

[20]W. Warburton, *The Divine Legation of Moses Demonstrated*, London 1737–41, vol.
 2, book 4, sec. 4.

> This is a most curious fact, namely, that the ancients should have seen or imagined so great a similarity between the ideas of *straightness*, and *the right hand*, as to induce them to call them by the same names and to almost identify them. But this is not all, for they have combined with these two ideas, a third, viz. that of a *King*, so closely that they can hardly be separated.
>
> I have endeavoured to consider whether there is any natural or necessary connexion between such very different things.
>
> I find no resemblance between the ideas of *straightness* and *the right hand*. But the idea of *royal power* is connected with both, and therefore serves to unite all three together. The notion of *power* is strongly connected with *the right hand*, which for that reason, is called in Anglo-Saxon, *the stronger hand, swithre hand*.

Conversely, acting itself as an intermediate idea, the right hand connects the idea of regulation (keeping things straight) and the notion of power (the exertion involved in doing so): "A *rule*, *regula*, the instrument by which a workman obtains a straight line, and verifies it, is closely related to the verb *regere*, and to *rex*, a king".

Essentially universalist, Talbot's approach followed William Blake's idea that although accidental nature varies, substance does not change.[21] As a pan-Babylonian or Assyriologist with definite solar inclinations, Talbot belonged to the speculative mythological school which included Jacob Bryant. The kind of collation of texts which he pursued in his essays on biblical, classical and antiquarian subjects was similar to that of Bryant's in *A New System, or, an Analysis of Ancient Mythology* (1774; 1807). The title of Talbot's *Hermes* (1839) was probably taken from James Harris's *Hermes: A Philosophical Inquiry Concerning Universal Grammar* (1751), republished in 1816. Such works owed more to a patristic tradition of exegesis than it did to the scientific ideology of Bacon or Locke. When Talbot went on holiday in August 1834, along with his Homer, Virgil, Sophocles and Horace, he took William Parr Greswell's new book, *A popular view of the correspondences between the Mosaic Ritual and the facts and doctrines of the Christian religion*, as well as five volumes by the Scottish philosopher David Hume, author of *Dialogues Concerning Natural Religion*. In the same year, when he was adapting Chevalier's camera lucida to his telescope, he was also reading John Davison's *Discourses on Prophecy* (1824), Alexander Keith's *Evidence of the Truth of the Christian Religion Derived from the Literal Fulfilment of Prophecy* (1832), and John Keble's sermon *Primitive Tradition Recognised in Holy Scripture*.[22] These interests

[21]*The Poetry and Prose of William Blake*, ed. D. V. Erdman, New York 1965, 523.
[22]See Talbot's notebook for 1834, "Memoranda", Photography Department, J. Paul Getty Museum, Los Angeles.

2. H. F. Talbot, *The Broom*, salted paper, c. 1842–43. Science Museum.

informed his ideas about Genesis – his new arguments that classical authors knew the Bible, and alluded to it.[23] In photographing an urn depicting the Medusa (B127) he was indirectly pursuing one of Bryant's topics. Thomas Blackwell's comment on mythology as "a labyrinth thro' whose Windings no one thread can conduct us" was exactly how Talbot described etymology.[24]

In *The Open Door* (B74) the objects represented are clearly emblematic: the broom sweeps the threshold clean, the bridle checks the passions, and the lantern is the attribute of the Light of the World. That the door opens upon a dim, glimmering, latticed light is in marked contrast to the closed door of *The Broom* (Fig. 2) and *Constance and Her Daughters* (Fig. 3). The associational key to these garden pictures is in Richard Bentley's vignette for the frontispiece of Thomas Gray's *Elegy in an English Country Churchyard* (1753). Bentley's picture consists of a Gothic arch on one side of which is a niche with heraldic decorations, and on the other, the spoils of harvest (wheat sheaf, bag of grain, basket and barrel), surmounted by a garland of gardening tools (rake, shovel, axe and pitchfork). Through the archway a man indicates an epitaph on a headstone while another leans forward to read it, not noticing that his own shadow falls upon

[23]H. F. Talbot, *The Antiquity of the Book of Genesis*, London 1839.
[24]T. Blackwell, *Letters Concerning Mythology*, London 1748, 232; cf. *English Etymologies*, vii.

3. H. F. Talbot, *Constance and Her Daughters*, salted paper, 19 April 1842. Science Museum.

the grave. The garden tools represent the harvest both of life and death. In Talbot's pictures garden tools are usually grouped in a more mundane way: *Shed at Lacock* (B88) lines them up in a row with a ladder; *Pullen by the Haystack* (B69) shows them with a wheelbarrow. But in *The Broom*, juxtaposed with the closed door they evoke the melancholic reflection on life which is so characteristic of Georgian Gothic. The connection between the door and the grim reaper is also felt in *Constance and Her Daughters*: no matter how young and vigorous Talbot's children are now, the time they have to sit upon the garden seat of life is limited. Another picture of the children with a maid (B136) shows them with a little cart (the toy carriage found in conversation pieces), filled with garden rakings. Like other containers in Talbot's pictures – pannier and net,[25] basket and rake (B154) – they are concealed emblems of the grave (Talbot's own etymology of "coffin" is "a great case of wicker, any kind of box or case", related to pannier or breadbasket). Bosch's *The Haywain* (Madrid, The Prado Museum) is a large-scale version of this theme that "all life is hay": it is both a cart-ladder picture and a ladder-haystack picture. Talbot's *The Haystack* (B156) is a ladder-haystack picture. His associations with "hay" are suggestive: "Germ. *Heu*: related to the verb *Hauen*, to *hew* or cut – means *cut grass*". The hay knife in the rick and the ladder with its perfectly straight shadow are not as the workman left them but as Talbot has designed them. The combination of objects (knife,

[25]Arnold, *Fox Talbot*, fig. 46.

ladder and hewn hay) has as much in common with the structure of Dürer's *Melencolia* as with nature. The carved beauty of the whole rick is an analogue for both the utility and the futility of man's aspirations.

For Talbot, etymology and mythology were the hiero-glyphic expression of nature transfigured by man's imagination. Hieroglyphics did not represent scientific truth or exact reason-ing of a historical or physical kind but produced a concatenation of concepts in a way Talbot considered especially important: "No words are so expressive, none so rich and powerful, as those which have *two origins*, and present them to the mind *in union*". Such words, such myths, were a dialectical and typological form of expression, acting as a bridge between one world and the next. Talbot expressed this as *Bridge, with ladders small*, a picture dated August 24, 1840 (B138). At Bath Abbey, which his cousin W.T.H. Fox-Strangways said he wished Talbot would photo-graph, there are Jacob's ladders running up both sides of the west front.

Dürer's *Melencolia* is one type of Talbot's ladder pictures. He was, of course, familiar with Dürer's work (he made a *Copy of the Portrait of Albert Dürer* from a print). Talbot's *Man with a Crutch* (Fig. 4) replaces Dürer's winged figure with a lame man. The contiguity of grindstone with ladder is common to both images; Dürer's polyhedron is analogous to Talbot's stone:

The sticks, crossed over each other in the foreground of Talbot's picture, and the shaped and unshaped timbers, are part of the iconography of the Flagellation and Crucifixion. *The Gamekeeper* (Fig. 5) uses the same location, but this time the grindstone is masked by the figure, although a smaller one is visible on the ground. This time the ladder is not present. In the two pictures,

4. H. F. Talbot, *Man with a Crutch*, salted paper, c. 1844. Science Museum.

the crutch and the gun are, respectively, instruments of the men's livelihoods (Talbot's etymology: "old English *liflade*, signifying *the life a person leads*, from the verb to *lead*"). The tone of the two pictures is different mainly on account of these badges of employment.

Another type of *The Ladder* (B86) is found in the subject called the "Mass of Saint Gregory".[26] It is structured in terms of one figure above, and two men looking up to him from below. In Talbot's picture, the man at the top and the one at the bottom make connection, literally, by both touching the ladder. These two look like workmen. The third man, dressed in a frockcoat and wearing dress shoes, can be seen either as the master in a conversation piece or the donor in a sacred scene. Others, perhaps, might recognize the vine (of eternity – Jesus the Saviour) as the true counterpart of the ladder: this would make the picture

[26]A copy of Dürer's version was specially engraved for *Divers Works of Early Masters of Christian Decoration*, ed. J. Weale, London 1846, 1:17.

Mike Weaver

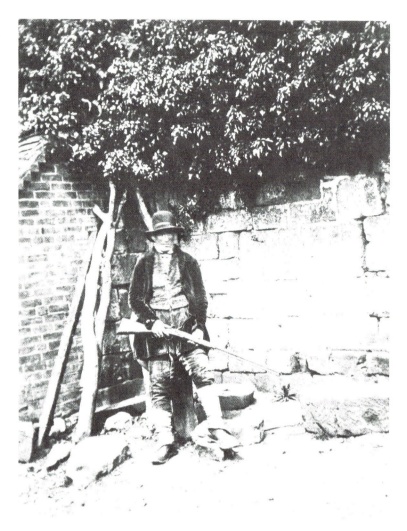

a vine-and-ladder paradigm. But it is also one of a ladder and two doors: there is a broad way on ground level by which we may enter in, and a narrower and higher way above. There is no sign of anything material being moved: for the moment, this is not just a granary. The same location was used for a carriage-and-ladder picture (B87). This, too, can be accommodated to the conversation piece – to a Stubbs phaeton or a victoria synec-dochic of the absent master. But the ladder–wheel relation and the ladder–shafts relation create a paratactic effect which goes beyond the social meaning. At the typological level, Ezekiel's dream of the chariot is evoked (in 1828, Talbot was having Raphael's famous painting of the subject copied). But at the meta-physical level the carriage, like any empty vessel, is a memento mori. It evokes the idea of cart burial in which the body of the carriage suggests the coffin. To a pictorialist at the end of the

century an old cart would evoke an evening-of-life sentiment, and in the tradition of the urban picturesque it might signify something more. Talbot's London and Paris pictures are indebted to Thomas Shotter Boys' topographical studies of the same cities. Boys had a great success with a lithographic series *London as it is* (1842), and his watercolour *Boulevard des Italiens* (London, British Museum) is very close in composition to the calotypes by Talbot except that whereas Boys introduced human activity at street level, Talbot's pictures, taken from the first floor of his hotel, are devoid of people but full of *fiacres*. Nathaniel Hawthorne wrote on the cab in *The House of the Seven Gables*: "A cab; an omnibus, with its populous interior, dropping here and there a passenger, and picking up another, and thus typifying that vast rolling vehicle, the world, the end of whose journey is everywhere and nowhere". Edward Steichen and Alvin Langdon Coburn were to use such images to Symbolist purpose at the turn of the century.

Talbot's etymology of *perspective* is especially instructive because he attempted to disentangle a confusion which had existed since the seventeenth century:

> A *perspective*, i.e. a telescope, is properly enough named from *perspicere*, to look through.
> But the science of Perspective is not correctly named; it ought to be Prospective, being the art of delineating a prospect or view, and so it is called in Italian, la "Prospettiva", which shows the error we have fallen into.

He was much less interested in representing objects with regard to their position, their distance and their shadow projection than in an art of picture making. In preferring prospective to perspective he preferred illusion to cognition, just as in selecting metonymy as his method of composition he elevated metaphysics over literal record. His desire to observe things accurately was modified by his wish to arrange them artistically. As with Virgil and Wordsworth, for him an air of reality did not preclude a poetic effect. Constable wrote that he wished to give "one brief moment caught from fleeting time a lasting and sober existence"[27] – to turn it into a capital moment. Even as he invented the medium, Talbot wanted to do no less.

[27] J. Constable, *Various Subjects of Landscape*, London 1832, introduction.

3. "BORN LIKE MINERVA": D. O. Hill and the Origins of Photography

Duncan Macmillan

When D. O. Hill and Robert Adamson joined in partnership in 1843 the history of photography was just four years old, yet the work they produced, even at the beginning of their brief collaboration, has such assurance that some of their calotypes remain among the most memorable images in the whole history of photography. It is as though with them the art was born like Minerva, fully armed, flying to the highest peak of its achievement on the day of its birth. In the partnership aesthetic leadership is generally accorded to Hill, who was a mature and well-established artist.[1] Adamson, much younger, was trained in photography by John Adamson, his brother, a chemist, and by Sir David Brewster, scientist and correspondent of Henry Fox Talbot. Hill was introduced to Adamson by Brewster in 1843 with a view to his using photography as an accessory in preparing his projected painting to commemorate the Disruption in the Church of Scotland and the creation of the Free Church, though the picture was not finished till 1864. To understand how the partnership achieved such results so quickly the usual approach to the history of photography has to be reversed. Instead of its being looked at as a new beginning with only the most shadowy antecedents in the visual arts, it has to be seen as fitting into a well-established thought process and as fulfilling ambitions that had been close to the heart of Scottish painting for two generations or more.

Photography was the child of the marriage of optics and chemistry. Painting certainly played no part in its conception and subsequently painters tended to distance themselves from it in a rather bashful way, reinforcing the sense that it was in its origins a purely scientific business untouched by any considerations that might be called aesthetic. Brewster's interest in photography, however, stemmed from his interest in optics and that in turn stemmed from the interest in perception that was at the centre of Scottish philosophy. It was an interest, therefore, that Brewster shared not only with such scientists among his contemporaries as Sir Charles Bell, but also with such painters as Sir Henry Raeburn and Alexander Nasmyth. It was David

[1]Sara Stevenson, *D. O. Hill and Robert Adamson*, National Galleries of Scotland, Edinburgh 1981, 16.

Hume, the philosopher, who had established the framework of this discussion. ''To hate, to love, to think, to feel, to see; all this is nothing but to perceive'', he wrote.[2] The whole range of experience from the physical to the metaphysical has only one point of origin, or as he himself puts it inimitably:

> Let us fix our attention out of ourselves as much as possible:
> Let us chase our imagination to the heavens, or to the utmost
> limits of the universe; we never really advance a step beyond
> ourselves, nor can conceive any kind of existence, but those
> perceptions, which have appeared in that narrow compass.
> This is the universe of the imagination, nor have we any ideas
> but what is there produced.[3]

The painter Allan Ramsay was a close friend of Hume's (Fig. 1). It was a friendship of equals for not only was Ramsay the outstanding portrait painter of his time – and portrait painting is, after all, a branch of the study of human nature professed by Hume – he was also a man of great intellectual gifts. So stern a judge as Dr. Johnson said of him, ''You will not find a man in whose conversation there is more instruction, more information, and more elegance than in Ramsay's''.[4]

Ramsay described his own aesthetic position in *A Dialogue on Taste* (1754), but he summarized it most vividly in a remark made in another essay to refute a proposal of Joseph Addison's. Addison suggested that the ''exact'' in painting may be subordinated where appropriate to the ''agreeable''. Ramsay replied: ''The agreeable cannot be separated from the exact; a posture in painting must be a just resemblance of what is graceful in nature, before it can be esteemed to be graceful''.[5] In other words, absolute fidelity to his perceptions was the basis of his art. Light was his vehicle and drawing his instrument, but as his painting evolved what is remarkable is the way in which he managed to describe the very tentativeness and uncertainty of perception itself, the recognition of which was the basis of Hume's own scepticism. In his portraits of Rousseau and of Hume himself, the figures seem scarcely more than suggested by the surrounding darkness into which they may at any moment again disappear. In such pictures Ramsay is visibly an admirer of Rembrandt, and like him he manages to fix the mystery of our awareness of the spiritual in the material; or, as Rembrandt encapsulates it in his constant study of himself, their baffling indivisibility. The impossibility of describing the spirit except in

[2]David Hume, *A Treatise of Human Nature*, 1739, ed. L. A. Selby-Bigge, Oxford 1888, 67.

[3]Ibid.

[4]James Boswell, Journal for 1778, quoted in Alastair Smart, *The Life and Art of Allan Ramsay*, London 1952, 164.

[5]Allan Ramsay, *On Ridicule*, in *The Investigator*, London 1762, quoted in Duncan Macmillan, *Painting in Scotland: The Golden Age*, Oxford, 1986, 24.

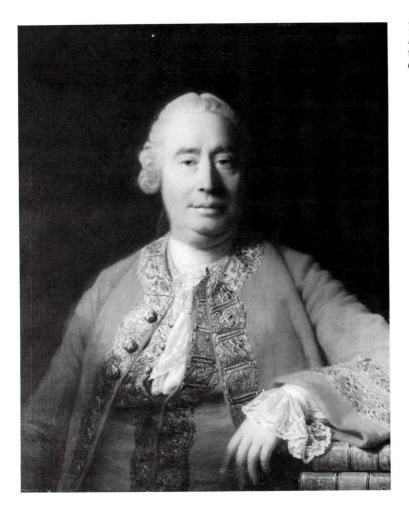

1. Allan Ramsay, *David Hume*, oil/canvas, 1766. Scottish National Portrait Gallery.

terms of the flesh was Hume's dilemma, too, though he saw it the other way round.

The purpose of describing Ramsay's achievement here is to demonstrate first of all that the preoccupation with perception, which was the precondition of the interest Sir David Brewster took in experiments which eventually led to the discovery of the photographic process, was also reflected in painting. It also makes clear that an art based on the most faithful study of perception, on the "exact," in Ramsay's own word, does not lead necessarily to the kind of image that is misleadingly called "photographic" with Ramsay any more than it had done with Rembrandt. Far from being inimical to the imagination, such an approach gives to the imagination its central role as the only power that enables us to understand the world around us, and the people in that world above all.[6]

[6]Hume, *Treatise*, 194.

Ramsay enters this story in another more immediate way. Among his various pupils and assistants the most distinguished was Alexander Nasmyth, the landscape painter. Nasmyth in turn taught D. O. Hill and remained a good friend of Hill's till his death at a great age in 1840. The fact that Nasmyth became a landscape painter has obscured the importance of the link between him and his master. In this discussion, however, it has a vital place. Ramsay passed on to Nasmyth the habit of drawing and its use as a vehicle for the precise analysis of perception in preparation for painting. This became the central tenet of Nasmyth's teaching.[7] A painting had to be built on a clear understanding of what was actually seen. In other words, Ramsay's habit of exactitude was passed on through Nasmyth into the nineteenth century where, learned from Nasmyth, it is immediately recognizable as the origin of Sir David Wilkie's use of drawing. Hill himself was no great draughtsman, but it was for precisely this purpose that he originally intended to employ the calotype process. His calotypes are therefore the direct heir to Ramsay's drawings and the equivalent to Wilkie's.

At another level, too, the link between Ramsay and Nasmyth may have a bearing on Hill. Ramsay's status as an intellectual depended on more than a capacity to impress Dr. Johnson. He had an untiring intellectual curiosity and a belief that however far the painter's mind might range in pursuit of that curiosity it was a proper extension of his dedication as a painter to truth. Nasmyth inherited this. It led him into all sorts of diverse paths, especially into science. Nasmyth's son, James, the engineer, remembered his father's engagement in long scientific discussions with Brewster and other leading members of the scientific community.[8] Hill was therefore predisposed by such a background to regard the latest advance in optical science as having a natural and immediate bearing on his painting.

In the generation after Hume, Thomas Reid was the dominant influence on Scottish thought. For him perception was, if possible, even more important than it had been for Hume. It was Reid who first argued that the answer to the mystery of perception must ultimately be physiological. This moved the whole debate into the realm of science and provided the starting point for the research of Sir Charles Bell which eventually established the true nature and function of the nervous system, as well as for Brewster's preoccupation with optics.[9] But Reid's published ideas also had a direct bearing on painting. For Hume, the key problem in our knowledge of the world about us was summarized thus: "Our reason neither does, nor is it possible that it ever should, upon any supposition, give us assurance of

[7]Duncan Macmillan, *Painting in Scotland*, 140–1.
[8]Ibid., 145.
[9]Ibid., 156.

the continued and distinct existence of body".[10] Reid countered Hume's scepticism by arguing that instead of being reflected via the dim and insubstantial intermediary of ideas, the external world impinges directly on the mind. These external stimuli are themselves entirely incoherent, but are understood intuitively, just as we understand language. In the eyes of Dugald Stewart, Reid's pupil and principal interpreter, himself a close friend of Raeburn and Nasmyth, this was the core of Reid's achievement as a philosopher. According to Stewart, all philosophers until Reid, from Plato to Locke, had persisted in the fallacy of supposing "that we do not perceive external objects immediately and that the immediate objects of perception are only certain shadows of external objects".[11]

It is at this point that the physiological argument enters the discussion, but it is also at this point that both Reid and Stewart turn to the example of painting to explain the process of perception. In doing so they startlingly reverse the traditional view of the painter's role, which had always been in some sense conceptual, to do with the translation and transmission of ideas. Instead the painter was now to become neutral, to record the raw material of perception. The signs he sets down bear no more resemblance to the qualities of matter than the words of a language have to the things they denote. The principal problem that faces the painter is in fact that of freeing himself from preconceived ideas of the significance of things in order to be able to transcribe their actual appearance: "If he could fix the visible appearance of objects without confounding it with the things signified by that appearance it would be as easy for him to paint from life as it would be to paint from a copy".[12]

Reid's proposition, endorsed by Stewart, represents a crucial step in the history of modern art with repercussions into the twentieth century. For the first time it is argued that a painting has no inherent order, only that which the spectator sees in it. The premises of painting converge with those of photography, and the painter is put in precisely the position of the camera, though his task is not to translate a simple, objective reality any more than it is the task of the camera. Reid was under no illusion about that. The signs by which we understand the world and which it is the painter's business to record are fragmentary, transient and incomplete.

Reid's ideas are directly apparent in Raeburn's painting. Using natural light as Ramsay did, but even more boldly, and in his own way just as faithful to the "exact", Raeburn creates

[10]Hume, *Treatise*, 193.

[11]Dugald Stewart, *Elements of the Human Mind*, London 1792–1827, 3 vols., 1:88, quoted in Macmillan, *Painting in Scotland*, 80.

[12]Thomas Reid, *Inquiry into the Human Mind*, in *The Works of Thomas Reid*, ed. Sir William Hamilton, 6th ed., Edinburgh 1863, 2 vols., 1:133–7, quoted in Macmillan, *Painting in Scotland*, 80.

2. Sir Henry Raeburn, *General Francis Dundas and His Wife* (detail), oil/canvas, c. 1812. Private collection. Photograph by Joe Rock.

his images out of broad patches of light and shade, not blended together to give the illusion of continuity of surface, but put down side by side without compromise. Where nothing is visible he transcribes nothing, even if this means leaving such a vital feature of portraiture as an eye, or even the whole side of a face, without articulation (Fig. 2). Instead of an additive image, built up out of separate observations of details, he creates an image which approximates very closely how we actually do perceive people, gleaning intuitively what we need to know without conscious analysis and from what is often a very swift and imprecise impression. Here the analogies with Hill are obvious. The very imperfections of the calotype process, dependent on natural

3. William Dyce, *John Small and His Son*, oil/canvas, c. 1834. University of Edinburgh. Photograph by Joe Rock.

light, and with such breadth, simplification and depth of tone, were ideal for this kind of image. This breadth and lack of defined detail would therefore have appeared to Hill not as limitations but as desirable virtues, Raeburn's example being still very much alive though the painter himself had died in 1823. In fact, one of the most striking prefigurations of a photographic style in portraiture, very much in the manner of Raeburn, was painted by Hill's friend William Dyce, sometime in the 1830's (Fig. 3). It is his portrait of John Small, librarian of Edinburgh University, with his son, also called John Small, and also, as it happened, subsequently librarian in the same institution. Compare this with the portrait of Thomas Chalmers and his son by Hill (Fig. 4).

Raeburn was also a genial man and a great conversationalist. These were gifts to put his sitters at ease which Hill shared and which were a vital element in creating such natural and

4. D. O. Hill and R. Adam-
son, *Rev. Dr. Thomas Chal-
mers and His Grandson*, c.
1845, salted paper. Glasgow
University Library.

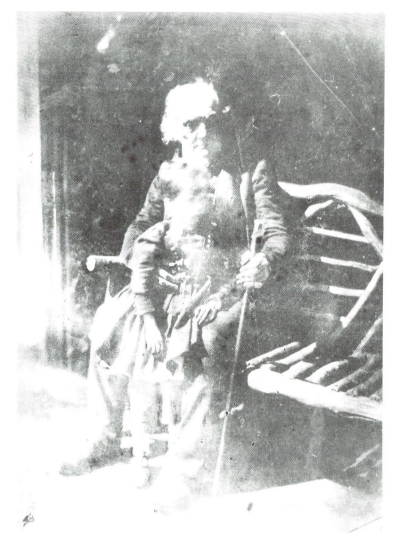

sociable portraiture. Contemporaries immediately recognized
the affinity with Raeburn in Hill and Adamson's calotypes, as
they also recognized their affinity with Rembrandt, whom Rae-
burn, Ramsay and Wilkie all admired and from whom this tra-
dition of empirical portraiture really descends.

Raeburn died twenty years before the Hill–Adamson part-
nership was formed. It was Sir David Wilkie who had become
the dominant influence on Scottish art in the interim, and it was
Wilkie who was uppermost in Hill's mind when he embarked
upon his Disruption picture. Although Wilkie had died two
years too soon to witness the Disruption, his art was very much
involved in the historical process that led up to it. He is best
known, of course, as a genre painter. Himself the son of a min-

ister, he first met the Rev. Thomas Chalmers, eventually leader of the seceders, in 1817, since when he had pursued the ambition of creating a new religious art worthy of the Protestant tradition as he and Chalmers saw it.[13] In two major paintings of the life of John Knox, one of which was left unfinished at his death, Wilkie sought to describe moments in the early history of the Reformed Church in a way which had a contemporary bearing on the quality of religious belief, the importance of the individual conscience and the ideal of church democracy. These were believed to have been central to the "primitive" kirk and were the central issue again in the Disruption in 1843. Hill's painting was to celebrate their triumphant reaffirmation in the dramatic moment of the creation of the new Free Church. Naturally, he turned to Wilkie for inspiration. His first sketches for the picture show that Wilkie's Knox compositions were uppermost in his mind and that through reference to them, Chalmers was to be represented as the true heir to the tradition of Knox.[14] Compare, for example, the calotype of Chalmers preaching with Wilkie's figure of Knox (Figs. 5 and 6).

There was, however, another aspect of Wilkie's art that had a bearing on Hill's project. When Wilkie turned to paint a subject set in the past, as he did first in 1818 with *The Penny Wedding*, to be followed in 1819 by the beginning of his first Knox picture, inspired partly by Sir Walter Scott and partly by his own conviction that truth should always be the painter's first objective, he introduced a new ideal of authenticity in the approach to the representation of history, one that subsequently enjoyed enormous popularity in the rest of the nineteenth century. He undertook research into costume, architecture and physiognomy in pursuit of a convincing account of the real appearance of an historical event. The same search for authenticity took him, at the end of his life, to the Holy Land to find a new authentic vocabulary for biblical painting. The decision to travel there was inspired by the success of David Roberts's paintings of the region. Roberts was a mutual friend of Wilkie and Hill, and Hill and Adamson refer to his *Views in the Holy Land* in their own prospectus for their never completed series of volumes of calotypes, of which the first two were to be Scottish genre studies. The calotypes of Newhaven fisherfolk are the largest single group made especially for this project, and they are identical in character to the kind of studies of costume and type that Wilkie made travelling in the Highlands of Scotland and in Ireland, as well as in the Holy Land.

Although the calotypes of Highland soldiers can be connected with a painting, the Newhaven studies, it seems, cannot. They were intended as studies for their own sake. The portraits

[13]Macmillan, *Painting in Scotland*, 175–80.
[14]Stevenson, *Hill and Adamson*, pl. 5, 7.

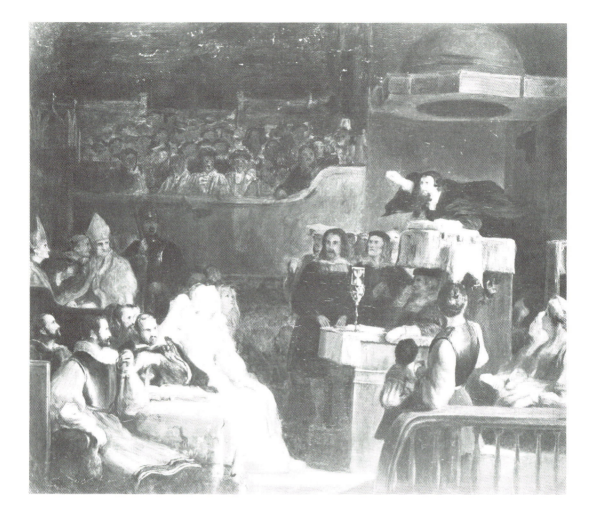

5. Sir David Wilkie, *The Preaching of John Knox Before the Lords of Congregation*, sketch, before 1822. National Gallery of Scotland.

of churchmen, however, although they eventually went beyond the need of Hill's picture in number, were at the start intended as studies specifically for the projected painting which began the whole enterprise. Here Hill did not need to approach history obliquely and by way of hypothesis as Wilkie did. He could claim authenticity as a witness of an event which took place in Edinburgh and in which many of the protagonists were known to him personally. His status as a witness gave him a different kind of problem to any which Wilkie faced, and the practical problem of the quantity of evidence available to him was compounded by the question of principle on which the Disruption hinged. The core of the controversy was the question of patronage. The seceders stood for the historic right of a presbytery to choose its minister and not to have him imposed by a patron. What was held to be at stake was the democratic and anti-hierarchical basis of the Presbyterian church. Hill therefore could

6. D. O. Hill and R. Adamson, *Rev. Dr. Thomas Chalmers Preaching*, 1845, salted paper. Scottish National Portrait Gallery.

not use the conventional language of history painting, which is naturally hierarchical and which would suggest opposing dramatically a small group of identifiable leaders to the large undifferentiated mass of the rest of the Assembly. Such a representation would have been quite contrary to the spirit of the whole event. Instead of the obvious dramatic solution, therefore, Hill was faced from the start by the need to incorporate into his picture, for reasons of principle, an unusually high number of portraits. Jacques-Louis David faced a similar problem, also for ideological reasons, in his representation of another moment of democratic crisis, *The Oath of the Tennis Court* in 1789. In the end the problem of creating an image which celebrated a dramatic event, yet was built up of a large number of portraits all stressed

equally, defeated David, or at least the picture was never fin-
ished, and when he faced the problem of painting contemporary
history again in *The Coronation of Napoleon* (1805–7), the problem
was very different. He could and did adopt a hierarchical so-
lution to record an unambiguously hierarchical event.

Hill may have been aware of David's problem. Certainly
there seems to be a reference to David's picture in his own and
in its final form. Gathering a large number of likenesses was the
first part of the problem that he and David shared. Brewster's
suggestion that he use photography to do it must have appeared
to be the ideal solution. Ironically, it was perhaps access to such
a huge number of portraits that defeated Hill. As he first pro-
posed the picture, it included only certain groups of portraits
and so a limited number. As completed, it contained more than
four hundred. The result is a monotonous evenness of effect
which deprives the picture of any sense of drama. Instead, it
looks for all the world like one of those enormous group pho-
tographs in which pranksters run from one end of the group to
the other in advance of the panoramic camera in order to appear
at both ends.

At the outset, photography clearly fitted Hill's need.
Brought up in the tradition of Ramsay and Raeburn, he could
adapt the new medium to the purposes of portraiture effort-
lessly. Its aesthetic seemed familiar and he could approach it
without having to overcome any artistic prejudice. It seemed an
ally, not a rival. It functioned, especially the calotype with its
strong natural lighting and its simplification, just as Raeburn
had painted, and in exact accord with Reid's view of perception.
It was a neutral recorder of uncoordinated patterns of light. High
resolution was unnecessary because it is not a feature of our
ordinary social vision. Hill could draw on a long tradition, which
in fact stretched back to Rembrandt, not in order to make the
new art imitate the old but to pursue an old end by new means,
and he knew from the start that the apparent objectivity of pho-
tography was an illusion. Like all perception it could record only
a relative impression of the fragmentary and insubstantial ma-
terial – the narrow compass on which the universe of the imag-
ination must be built.

4. DAVID OCTAVIUS HILL AND ROBERT ADAMSON

Sara Stevenson

The photographic partnership of David Octavius Hill and Robert Adamson was an experiment in art which has no parallel in photographic history. The four years of their association from 1843 to 1847 attracted the interest and the co-operation of contemporary artists in Scotland and in England: "certain artists here . . . ," reported Lord Cockburn in 1847, "hold that this is the Paradise of Calotype".[1]

The bulk of Hill and Adamson's studio output was portrait photography. "Face-painting" was the most reliable business for the painters of the day, and "face-photography" would have been Robert Adamson's main purpose in setting out. Calculated from the Scottish National Portrait Gallery's collection, more than half of a probable three thousand photographs taken between May 1843 and mid-1847 were single portraits of men; when the portraits of women and groups are added, they make three-quarters of the total.[2]

The curiosity here is that David Octavius Hill, a landscape and occasionally a genre painter, involved himself closely in an enterprise devoted substantially to portraiture. He first approached Robert Adamson to try photography as a means of "sketching" hundreds of Free Church ministers for a great historical painting. The earliest photographs taken by Hill and Adamson together are "sketches" of a casual kind – figures posed without regard to the general structure of the photograph, with unconsidered backgrounds and supports in full view. This kind of photograph was confined to the first few weeks of their association and did not reappear during the partnership, although one of their expressed intentions was providing photographs for "the execution of large pictures".[3]

The original "large" picture was Hill's painting to celebrate the formation of the Free Church of Scotland and the calotypes include hundreds of portraits of ministers like the Rev. William Govan (Fig. 1). The portrait of Mr. Govan was a study for the

[1]Lord Cockburn, letter to William Empson, editor of the *North British Review*, 22 November 1847, National Library of Scotland.

[2]The numbers of calotypes in this collection are 1,300 men, 300 women, 352 groups, 76 Newhaven and military, 205 landscapes and 23 reproductions of paintings and sculpture.

[3]Sir David Brewster, letter to W. H. Fox Talbot, 3 July 1843, Talbot collection, Science Museum, London.

Sara Stevenson

1. D. O. Hill and R. Adamson, *Rev. William Govan*, c. 1845, salted paper. Scottish National Portrait Gallery.

picture, but it was also a formal and strongly constructed portrait in its own right, which is all the more surprising since William Govan, a missionary in South Africa, was a minor figure in the painting. By 8 July 1843, there were already enough portraits of this kind to add to Hill's public exhibition of painted sketches, a "projected Series of Portraits of Clergymen and Laymen of the Free Protesting Church of Scotland" taken with the calotype.[1]

As a measure of Hill's enthusiasm in discovering the calotype process, it should be said that his Free Church painting was in the opinion of himself and several other influential people destined to be one of the great historical pictures. Only a couple of weeks after starting the painting, he was distracted by pho-

[1]Advertisement in *The Witness*, 8 July 1843.

tography. Worse than that, because he enjoyed calotype portraiture, he took far too many photographs. He was still advertising for sitters in 1846, when he had originally planned to finish the painting. A newspaper notice explained that the painting would not be ready for a while yet: " . . . a circumstance which the doubling of the scale of the picture, and the insertion of twice or three times the number of portraits . . . are sufficient to apologise for".[5] "The fat Martyrs of the Free Kirk", remarked Elizabeth Rigby offensively, "[are] as yet seemingly their favourite subjects".[6] The painting took more than twenty years to finish and there can be no doubt that the problem of organizing more than four hundred individual calotype portraits into a coherent composition was immense. Hill's great painting would have been far better without the help of photography.

The possibility that Hill was interested in calotype portraiture as a money-making scheme can be dismissed out of hand. By 1845, he had lost several hundred pounds (a considerable sum in the 1840's) and wrote, "I think the art may be nobly applied – much may be made of it as a means of cheap likeness making – but this my soul loathes, and if I do not succeed in doing something by it worthy of being mentioned by Artists with honor – I will very likely soon have done with it".[7] In the same letter, he discussed marketing a volume of one hundred calotypes as "a sort of Liber Studiorum in its way", following Turner's example in publishing etchings from varied landscapes with a similar educational exercise in experimental photography.

Hill and Adamson's reputation rests substantially on the success of their portraits. The means by which they achieved this success and which of the two men was mainly responsible has been subject to much discussion. The idea has grown up, expressed most forcibly by Sir Roy Strong, that Hill was a man trained in pictorial formulas and tied to a hidebound academic tradition:

> . . . the poses were devised by a man whose visual imagination had been formed some twenty years before – in the 1820s. It is in fact accidental that Hill created anything new in his calotypes, for it is impossible to argue that he was anything more than an artist working within a tradition of picture-making created at the close of the eighteenth century and the opening of the nineteenth, a tradition which found its quintessential expression in the establishment in 1829 of what became the Royal Scottish Academy, of which Hill was secretary for almost forty years.[8]

[5]*The Witness*, 27 May 1846.
[6]Untitled and anonymous review (most likely by Elizabeth Rigby, who was later Lady Eastlake), *Quarterly Review*, March 1846, 338.
[7]D. O. Hill, letter to David Roberts, 14 March 1845, in a private collection.
[8]Colin Ford and Roy Strong, *An Early Victorian Album*, New York 1976, 50.

There are indisputable resemblances between the work of the great British portrait painters, especially those working around the end of the eighteenth century, and the calotypes. The interest in light and shadow and in generalization rather than clear line and precise drawing is common to both. The monochrome mezzotints from the work of Joshua Reynolds and Henry Raeburn would have increased the resemblance. The journalist Hugh Miller wrote in 1843, "of all our British artists, the artist whose published work most nearly resembles a set of these drawings [the calotypes] is Sir Joshua Reynolds. We have a folio volume of engravings from his pictures before us, and when, placing side by side with the prints the sketches in brown, we remark the striking similarity that prevails between them, we feel more strongly than at perhaps any former period, that the friend of Johnson and of Burke must have been a consum-mate master of his art".[9] Hugh Miller was not an art critic. He had talked to Hill and the opinions he expressed are probably close to Hill's. The implication of Miller's article is that Hill took pleasure in the calotype process because he recognized in it familiar truths, truths which also emerged from the skill of earlier painters, but not necessarily because it enabled him to imitate those painters.

Among the artists and critics who expressed an opinion on Hill and Adamson's calotypes were the watercolourist John Harden: "as Rembrandt's but improved";[10] William Etty, who saw in them "revivals of Rembrandt, Titian and Spagnoletto";[11] the seascape painter Clarkson Stanfield, who said he "would rather have a set of them than the finest Rembrandts I ever saw";[12] Dr. John Brown, who noticed a resemblance between the Newhaven fishwives and the Parthenon frieze;[13] and Eliz-abeth Rigby, who drew parallels with Reynolds, Rembrandt, Murillo, Teniers, Ostade, De Hooch, Hobbema, Gainsborough, Constable and Turner.[14] Charles Eastlake, David Roberts, George Harvey, Sir William Allan, approved of the calotypes; Anna Jameson was ready to "take them up strong".[15] This is an impressive roll call of the contemporary art world, sophisticated in a way that Hugh Miller might not have been, and unlikely to applaud mere imitation. Elizabeth Rigby unconsciously echoed Miller's approach in an aside suggesting a comparison between the calotypes and "what we had not sufficiently prized

[9]Hugh Miller, "The Calotype", *The Witness*, 12 July 1843.
[10]Quoted by Daphne Foskett, *John Harden of Brathay Hall*, Kendal 1974, 52.
[11]D. O. Hill, letter to David Roberts, 25 February 1845, private collection.
[12]Clarkson Stanfield, letter to D. O. Hill, quoted in Ford and Strong, *An Early Victorian Album*, 39.
[13]Dr. John Brown, untitled review of the Royal Scottish Academy's exhibition, *The Witness*, 22 April 1846.
[14]*Quarterly Review*, March 1846.
[15]Charles Heath Wilson, letter to D. O. Hill, April 1845, in the Royal Scottish Academy.

before, a Constable". If Hill and Adamson's calotypes persuaded the eminently cynical Elizabeth Rigby of the virtue of Constable's paintings, and William Etty to think of two centuries of Italian, Dutch and Spanish painting, we are obliged to take the calotypes seriously as something more than the products of a fixed academic mind.

The resemblance between the calotypes and the large-scale work of earlier painters is all the more surprising because the calotypes were generally small – a standard size of 8 by 6 inches. It was easier for photography to imitate smaller, domestic works of art. Hill and Adamson's contemporaries, men like Henry Collen or Antoine Claudet, thought of the calotype as a species of watercolour and the daguerreotype as a kind of miniature. The dispossessed miniaturists found new employment painting photographs.

Hill's success with portrait photography lay not in imitating the pose or composition of paintings or even in borrowing accessories – the swags of drapery or piles of books which do appear in the calotypes – but in imitating the effect. The distinction may be understood more clearly if we cast forward to the late 1850's and 1860's when the rise of the commercial studios saw the rise of a support industry providing papier-mâché columns and balustrades, elaborate drapes and landscape backdrops, all intended to turn every photograph into a Titian. The sitters, tightly clamped into position among all this distracting finery, are "sugar dolls" in cardboard settings.[16] Hill and Adamson's portraits maintain strength and individuality. The strength of the photographs comes from the use of space and focus. The twentieth-century sculptor James Pittendrigh MacGillivray analysed the photographs as follows:

> One of the most notable things about his [Hill's] manner of filling the field was that he designed right up to the limit as a sculptor would do in designing and modelling a bas relief. He left no space to let, and he never seems to have relied on cutting or trimming for adjustment. The result is an obvious largeness of quality in the picture – such an effect as has caused Mr. Annan [James Craig Annan] to remark that Hill must have possessed in a great measure the power of seeing grandly, and that his compositions are of a noble order. In this connection, I have in one respect always admired his courage – he always insisted on getting the head of his subject high in the field. Time and again if you will look you will find in his whole plate size half lengths, that the head of his subject is within half an inch of the top of the plate. This gives to the subject somehow an effect of heroic size and great dignity.[17]

[16]Anonymous review, *The Edinburgh News*, 27 December 1857, which preferred Hill and Adamson's work to the "stereoscopic sugar dolls or the agonising attitudes of recent and more 'perfect' photographs".

[17]James Pittendrigh MacGillivray, "The Art of Photography", *The Photographic Journal*, 1930, 10.

The highly organized use of picture space, seen in portraits like that of William Govan, make it clear that Hill was composing photographs in the camera rather than just organizing them in a general way in front of the camera. The use of the whole surface, rather than the centre of the paper, is of further interest because it exploited a weakness of photography. Contemporary camera lenses were not particularly good. The focus was at its best in the centre of the image and fell rapidly off towards the edge. Photographic logic would suggest putting the head of the sitter in the position of best focus. In practice, as can be seen in Govan's portrait, Hill generally ignored the centre of the calotype, as a point of little interest. Hill's pleasure in the process lay in its breadth, the coarseness inevitable in a photograph using fibrous paper for both negative and positive. By sacrificing the central focus and taking Govan's head and hands into the unfocused area, he achieved a unified effect, strengthened, in this case, by the deliberate darkness of three of the corners and the generalized scribble of shadow coming down from the fourth corner.

In 1905, James Craig Annan expressed a puzzled admiration for the calotypes which is in direct opposition to Roy Strong's idea of pictorial formalism:

> Such productions are evolved as unconsciously and as directly from nature as are the trees and flowers, and constitute a pure product; but soon there come imitators who, incompletely comprehending the work of the master, produce something resembling it in its most obvious features but lacking the subtler qualities, with the result that in course of time the pure art disappears and certain conventions and mannerisms are accepted in its place. . . . To present day pictorial photographers it is extremely interesting and almost humiliating to observe that on the very threshold of the photographic era there was one doing with no apparent effort what they would fain accomplish with eager strivings.[18]

This gilded view of the innocent dawn of photography presents the alternative idea that the calotypes were easy not because Hill was copying the work of the painters but because it was a new art with no precedents to confuse the photographers. Hill himself made it clear that taking these "natural" photographs was no easy matter: " . . . the arrangement of the picture is as much an effort of the artist as if he was in reality going to paint it".[19] A natural result in photography was based on careful and educated calculation. The idea of nature was built into the business of art. Nature was the primary source and a necessary check

[18]James Craig Annan, "David Octavius Hill, R.S.A. 1802–1870", *Camera Work*, July 1905, 17.

[19]D. O. Hill, letter to David Roberts, 12 March 1845, quoted in full in J. Ward and S. Stevenson, *Printed Light*, Edinburgh 1986, 36–8.

on the progress of a painting no less than a photograph. The purpose of art in relation to nature was to draw out or suggest the ideal. The necessary qualities in the artist were perception, sympathy and imagination.

One of the arguments around the Hill–Adamson partnership centres on the sympathetic and imaginative character of the calotypes. For nearly a hundred years after Hill's death in 1870, most of the credit was given to Hill. The bias has now turned the other way and Adamson is increasingly regarded as the sensitive, original mind of the partnership: " . . . always the most shadowy figure, but, one would deduce, the man who possessed that ultra-sensitivity to character missing from the more prosaic Hill",[20] giving Adamson an individual talent capable of boldness, intimacy, artistic conception and modernity.[21]

The problem in resolving the question is a simple one: we have little direct evidence for Adamson's character. The only words he is known to have written are the annotations on the calotypes. In discussing the technical difficulties of photography, Hill quoted him as saying, "Adamson thinks he knows some things others do not"[22] – a careful concealment of his methods. The direct opinions of him were expressed by Hill and Hill's friend, the engineer James Nasmyth, who said he was, respectively, "the most successful manipulator the art has yet seen [with a] steady industry and knowledge of chemistry", and "that authentic and worthy person Mr. Adamson. He is of rare merit and most praiseworthy perseverance".[23] We can add that he was young and that he was unhealthy. We know for certain that the astonishing technical excellence of the calotypes was his responsibility.

There are two ways of expanding on Adamson's character, which are equally dubious. The first is to assume that we can tell his character from the photographs of him. The second is to deny Hill's deeper nature and give it to Adamson because it is to be found in the calotypes. The important concern here is not whether Adamson was a man of unusual sensitivity – there is no evidence either way – but that we should not be trapped by loose thinking into denying that Hill was such a man. Dr. John Brown's description of Hill is echoed by other writers: "Though little known as a delineator of human character, he has many of the mental qualities proper to his department: he can throw himself out of himself and be another; he has humour, which implies not merely character in its owner, but a power of seeing

[20]Ford and Strong, *An Early Victorian Album*, 50.
[21]R. Brettell, R. Flukinger, N. Keeler and S. Mallett Kilgore, *Paper and Light. The Calotype in France and Great Britain 1839–1870*, Boston 1984, 97.
[22]D. O. Hill, letter to David Roberts, 12 March 1845.
[23]James Nasmyth, letter to D. O. Hill, 30 April 1845, Royal Observatory, Edinburgh.

2. D. O. Hill and R. Adamson, *Newhaven Fishwives*, c. 1845, salted paper. Scottish National Portrait Gallery.

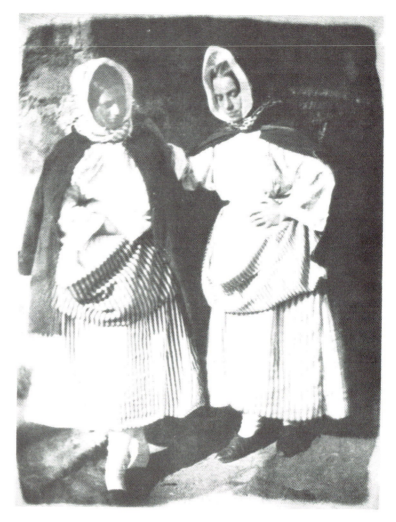

into the character of others; and he has that thorough human-heartedness and love of his kind that makes him lay out his affections on them whenever he sees them".[24]

Hill's sensitivity and sociability is seen most obviously in the portraits. It applies with particular force to the Newhaven photographs, where an interest in "artistic studies" might suggest Hill would calotype the fishwives as lay figures for their picturesque costume. In fact, the Newhaven photographs include some of the most beautiful and powerful portraits to be found among the calotypes (Fig. 2). Sensitivity can be seen in the sense that the pose and grouping of the calotypes have an apparent naturalness or architectural strength which grows out of the way people behaved in life. The Newhaven calotypes are

[24]Dr. John Brown, review in *Witness.*

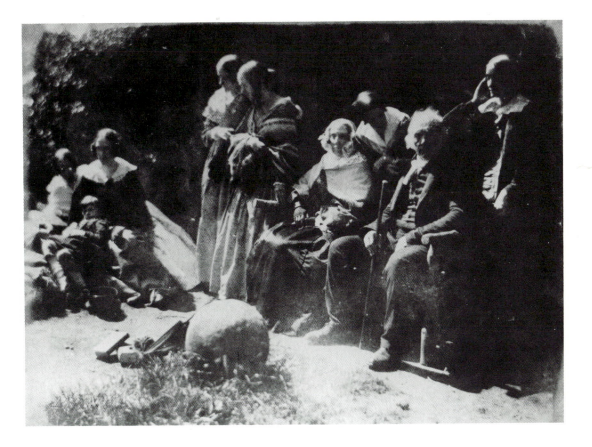

particularly remarkable for this. The sociability was equally use-
ful. Hill's ability to make photography entertaining ensured the
success of the photographic sessions at Bonaly Towers and Mer-
chiston Castle School. That Hill's fellow artists should take a
sympathetic professional interest in the calotypes is understand-
able. That he should persuade the leader of the Free Church to
sit for one of his most experimental photographs (Fig. 3) with
a similar tolerant interest is impressive.

One of the practical talents which Hill brought to the part-
nership was the ability to think in monochrome and, more im-
portantly, in terms of mass and shape. In Hill's library was a
book by John Burnet, *Practical Hints on Light and Shade in
Painting*.[25] This work described and illustrated the work of paint-
ers in an abstract manner, as patterns and blocks of light and
shade. It is a useful guide to the way contemporary Scottish
painters would consider a subject reduced to the basic compo-
nents of its composition and light. Burnet was one of the Scottish
circle which included Hill's teachers, Andrew Wilson and Alex-

3. D. O. Hill and R. Adam-
son, *Rev. Dr. Thomas Chal-
mers and His Family at
Merchiston Castle*, salted pa-
per, 1844. Scottish National
Portrait Gallery.

[25]John Burnet, *Practical Hints on Light and Shade in Painting*, London 1826.

ander Nasmyth. His account of discussions between painters, although put into different mouths, would presumably be characteristic of the kinds of conversation on art that Hill would have joined. He quoted Sir Thomas Lawrence, talking to the Scots landscape painter John Knox as follows:

> "Nothing ennobles a work or takes it out of the common everyday look, so much as shadow; it swallows up a thousand trifling objects, and wraps the whole in a portion of that which contributes towards sublimity . . ."
>
> "True," observed Knox; "my friend Wilkie [David Wilkie] makes use of similar remarks, and talks of objects taking agreeable shapes, and the beautiful forms that a discoloured wall often suggests; but the public cannot appreciate that mode of reasoning, and they smile when an artist talks of good and bad shapes, or of large masses of obscurity."[26]

This quotation is particularly interesting in the context of the portrait photographs. The Rev. William Govan is posed before a background roughly divided into a blank dark rectangle and a light wall smudged with shadow – the light wall introduces a sense of space to the composition and presents the minister with a strong profile; the smudges eliminate the suggestion of counterchange which would make the portrait sit uneasily against its background, and bring the eye back to the sitter himself. The group of the Rev. Thomas Chalmers and his family is an exaggerated experiment with a strong, raking light which renders the portraits almost unrecognizable. This is one of the few successful portrait photographs taken with their bigger camera (which proved difficult to use), and it should be noted that the calotype was physically bigger than usual – 9 by 12 inches – so the composition is more open, relying less on the need to create an impression of scale.

The Fishergate photograph (Fig. 4), taken in St. Andrews, is designed around the central figure and her shadow. Photographed at midday, it would have been much blander. The angled light defined the composition in shapes of light and dark. The central figure in her elegant, balanced walk wears a dark dress over a pale underdress showing at the back to indicate the position of her right leg; the dress and her shadow are defined by the pale road and the white cap on her head is brought out by placing a darker figure behind her against the wall. The supporting figures are placed light on dark and dark on light against the geometric pattern of rectangles and angles in the buildings. Light and dark balance each other in the shapes of the houses, steps and windows, even to the light cloth hanging from the

[26]John Burnet, *The Progress of a Painter in the Nineteenth Century; containing conversations and remarks upon art*, London 1854, 164.

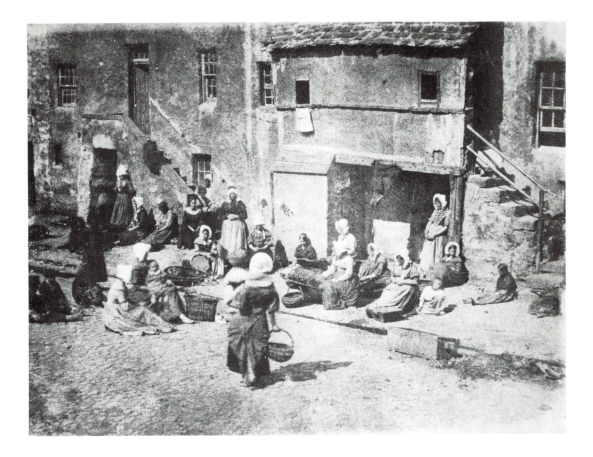

black window opening in the centre.[27] The interest in the abstract geometry of the old buildings provides a valuable comparison with the masterwork of Thomas Annan, who was a great admirer of Hill, *The Old Closes and Streets of Glasgow*, taken between 1868 and 1871.

The organization of photographs in shapes of shadow and light was balanced by an even more interesting organization of photographs with the effects of light itself. In practical terms, photography is the reaction of chemicals to light. But a reaction to light is not the same as a resemblance to light. Unlike the daguerreotype with its mirrored surface which reflected light clearly, the calotype was printed on a dull-surfaced paper. The problem of making an opaque surface represent light had been much discussed by artists earlier on in the century and was solved most notably by J.M.W. Turner. The direct relationship between the watercolour painters and the calotypists was the

4. D. O. Hill and R. Adamson, *Fishergate, St. Andrews*, c. 1845, salted paper. Scottish National Portrait Gallery.

[27]See Graham Smith, "Hill and Adamson at St. Andrews: The Fishergate Calotypes", *The Print Collector's Newsletter*, May–June 1981, 33–7.

Whatman Turkey Mill paper which became fashionable amongst
watercolourists in the 1820s and was recommended for photog-
raphy by George Cundell as giving "pictures of the finest col-
our". Cundell also recommended more generally "a fine satin
post paper, made by R. Turner, Chafford Mill".[28]

With only one or two exceptions in thousands of photo-
graphs, Hill and Adamson were consistent in their affection for
Whatman's Turkey Mill. It had an absorbent surface so that the
chemicals sank in, increasing the density and range of colour
and blurring the definition. The physical depth of the image and
the blurred suggestion of movement gave a liveliness to the
calotype like the shifting light on a landscape or the changing
expression on a face. Hill's admiration for the calotype process
was put in this way: "The rough surface & unequal texture
throughout of the paper is the main cause of the Calotype failing
in details before the process of Dageurrotypes [*sic*] – & this is
the very life of it. They look like the imperfect work of a man –
and not the much diminished perfect work of God ... I think
you will find that the Calotypes like [illegible] pictures, will be
always giving out new lights".[29]

Hill and Adamson's calotypes would justify themselves
with their surface display of texture, light and shape. The rich
appreciation of stripes, folds and patterns, the round hats, bat-
tered hats and top hats in the Newhaven photographs, and the
subtle way the shapes and shadows interrelate are all a source
of immediate satisfaction. The calotypes are, however, based on
the less easily determined characteristics of poetry and the ideal.
The calotypes taken by Hill and Adamson had the virtue of
generalization and suggestion, in contrast to those taken by
other calotypists like Talbot himself or Sir David Brewster, who
were pursuing a clearer image and more accurate detailing. Hill's
pleasure in the "imperfection" of the process, depended on a
philosophical standpoint – echoed among others by John Brown,
who wrote a letter complimenting the painter George Harvey
on a picture more "for the general tone, the religious feeling,
than the cleverness and force of the drawing. I somehow look
at it more as the production of a man than of a mere artist. I
think this is the highest praise that can be given to any pro-
duction of the hands".[30] Generalization in a portrait lost invid-
ious detail and the sense of movement denied the idea of fixed
time. The calotype could in this way give an idea of the whole
person, rather than the way he or she looked with one expres-
sion, in one state of health or with clothes showing a precise
fashion. The calotypes taken in Greyfriars Churchyard are an

[28]George Cundell, quoted in Robert Hunt, *A Manual of Photography*, London and
 Glasgow 1854, 206, 211.
[29]D. O. Hill, letter to Elhanan Bicknell, 17 January 1848, ms. in the George
 Eastman House Collection.
[30]*Letters of John Brown*, edited by his son and D. W. Forrest, London 1909, 129.

5. D. O. Hill and R. Adamson, *The Naismith Tomb, Greyfriars Churchyard with Thomas Duncan and D. O. Hill*, c. 1845, salted paper. Scottish National Portrait Gallery.

important example of the generalized historical effect which could be achieved in a landscape photograph.

The churchyard contained a sequence of seventeenth-century tombs remarkable for their strong, if comparatively primitive, carving. It was a historical monument in itself because it was closely connected with the Covenanters who protested against government interference in the Presbyterian church – a place which had an obvious connection with the newly formed Free Church, struggling against arbitrary authority in the 1840's. The Greyfriars calotypes are consonant with the Renaissance melancholy of the setting, with reclining and pensive figures. The photograph of the Naismith tomb (Fig. 5) with its two artist models, Thomas Duncan and D. O. Hill, tracing the inscription, contains an echo of Poussin's *Et in Arcadia Ego*, the nineteenth century contemplating the lost glories of the seventeenth. The melancholy of the photograph is based on a reference not just

to a painting but also to a painter. The Nasmyth family, Hill's
friend James and his father, Alexander, claimed descent from
the surgeon buried in the tomb. Alexander had died in 1840,
and there can be no doubt that the two painters in the photo-
graph would have thought of him in posing. The inscription
under Duncan's hand, although not readable in the photograph,
was peculiarly apt to the memory of a landscape painter. In an
earlier translation from the Latin, it read:

> Here lyes a Flower, that with the too much haste,
> Of fates cut down, did in her blossom waste;
> What graver Eye, contemplating thy dust
> O happy Nasmyth, after thee, will trust
> The smiles of Nature? Or presume to say,
> This well set morn foresigns a hopeful day?
> O may thy grave, untainted like thy years,
> Grow ever green, bedewed with Sister-tears;
> Who envies not thy good, but grieves to be,
> By lingring life, so long disjoyned from Thee.[31]

The intellectual references to painting and words were re-
inforced by the natural symbols of decay and life – the crumbling
stone and the young ash tree sprouting from the top of the tomb
defeating the two carved symbols of death and time, the skull
and the hour-glass, and acting as living evidence of the
Resurrection.

Similar references can be found in other calotypes. The
interest in making nature into a symbol of inner truth can also
be found in the Chalmers family group. The focal point of this
photograph is as much the large stone ball in the foreground as
it is the main figure, the Rev. Thomas Chalmers. When painting
a posthumous portrait of Chalmers, Hill used another photo-
graph as the basis, but placed such a stone ball at his feet. In
the group, the angled light strikes the ball so that it glows. It
seems probable that Hill thought of the light of Christian religion
illuminating this small stone world at the feet of the great reli-
gious figure of the day. In the same way the clutter of books
beside the stone may be interpreted as the Word of God or as
the writings of the religious teachers illuminated by the same
sunlight. Using the truth of the natural world to reveal deeper
truths was a respectable ploy common to philosophers and art-
ists. The calotypes were also used more simply to present an
ideal actual truth through the deliberate choice of subject matter.
Hill and Adamson's calotypes do not contain portraits of de-
pressed "characters", and if the working classes are presented
as examples, it is as the finest examples of their kind – men like
the deerstalker, Finlay, or Williamson the huntsman.

It is in this light that the Newhaven photographs should
be seen. In the 1840's, the Old Town of Edinburgh was overtaken

[31]Robert Monteith, *A Theater of Mortality*, Edinburgh 1704, 9–10.

by social distress – poverty, drunkenness and disease had gone beyond the help of private charity. By contrast, the fishing community of Newhaven was remarkable because it was independent and self-reliant. The Newhaven fishermen were known for heroism in war and in peace; the fishwives' retort in stormy weather, when the price of fish rose, "Haddies is men's lives the day" (i.e., Haddocks are costing men's lives today), was no less than the truth.[32] From an overview of the Newhaven images which includes the less common prints, like the boats going out and returning,[33] and the unsuccessful images like men in the boats and the catch being brought in,[34] it becomes clear that they were attempting a picture of the whole of Newhaven life. The impossibility of photographing real action did not deter them from trying to fake it because the limitations of photography were creating an untruth. In 1844, Hill and Adamson announced the publication of six volumes of calotypes. The first of these was *The Fishermen and Women of the Firth and Forth.*[35] The Fishergate photographs taken in St. Andrews, and very likely the views of the harbour there, belong, therefore, in the same group as the Newhaven calotypes. They represent the most successful attempt to calotype an active crowd scene and have much of the appearance of a film still. The effort and calculation behind them is astonishing.

The idea of circumventing the limitations of the calotype process to persuade it to tell a greater truth came also into landscape photography. The paradox of the Hill and Adamson partnership is that stated at the beginning of this chapter; the output of the Rock House studio was, substantially, portraits, and the landscapes were only taken in small numbers. There were two reasons for this. The first was that the photographic chemicals were particularly insensitive to green – green trees and fields calotyped as a dark, unattractive mass. Second, it was impossible to photograph the dark land and the light sky together and the sky over a landscape printed out either as a blank white surface or as oddly mottled. Hill's approach to landscape was allied to that of Turner. Like Turner, he painted landscapes in terms of light and aerial perspective – the luminous effects of the air, as much as the solid facts of the land. The calotype was completely unsatisfactory from this point of view, flattening the distance and losing the effect of light outside a short focal range. The

[32]This retort is found in various sources, including James Nasmyth's *Autobiography* and Sir Walter Scott's novel *The Antiquary*. For a discussion of the Newhaven calotypes, see Keith Bell, "An Incalculable Number of Fine Living Pictures: Hill and Adamson's Newhaven Calotypes", *The Photographs of David Octavius Hill and Robert Adamson*, Saskatoon 1987, 13–28.

[33]Examples are in the Clarkson Stanfield album in the Gernsheim Collection, Humanities Research Center, University of Texas at Austin.

[34]Examples are in the Edinburgh Photographic Society's collection, donated to the Scottish National Portrait Gallery in 1987.

[35]Advertisement in *Edinburgh Evening Courant*, 3 August 1844.

6. D. O. Hill and R. Adamson, *The "Fairy Tree" at Colinton*, c. 1845, salted paper. Scottish National Portrait Gallery.

problem of the distant landscape was insoluble. But the calotype's capacity to suggest light in close-up could be used to circumvent the problem of green. This is done in two key photographs taken at Colinton, the *Tree and Fence* and the *Fairy Tree* (Fig. 6). They are, like the photograph of the Chalmers family taken on the same occasion (Colinton Dell runs beside the grounds of Merchiston Castle), an exaggerated exercise in light. Both of the tree photographs are strongly constructed; the shapes of the tree branches and the fence push out to the edges and provide a structure for a background, which is a mass of unidentified blobs and smears of light and dark. The *Fairy Tree* is a particularly subtle photograph. The tree could well be dead. The few identifiable leaves belong to the ivy coiled round it, but the eye accepts the suggestion of sun filtering through spring leaves, which is created by light bouncing off the surface of

plants behind and possibly from water below on the right. The blanked out dark trees in the background present the eye with a tree shape behind the branches and balance the light spots with that effect of variable shadow under the canopy of bright-lit leaves.

The curious idea of lying, or bending the facts, to make an ideal truth is to be found also in Hill's painting.[36] When painting landscapes, he would move parts of the scene about to improve their relationship to each other or to allow the light to fall on the more interesting side of a building. In his great Free Church painting he was anxious to present a whole picture of the Free Church, and not just the moment of the picture's title – *The Signing of the Deed of Demission* – so he included people who had not been present on the day and, more oddly, allowed some of the portraits in the picture to age over the twenty years it took to paint. There can be no doubt that Hill respected the truth of photography, but he was prepared to exploit his and Adamson's understanding of the process to persuade it to tell a greater truth.

The critical problem with Hill and Adamson's calotypes is an elementary one. They are technically and artistically so sophisticated in their construction, so overflowing with ideas, that it is difficult to generalize about them without oversimplifying. "The subject", said Hugh Miller, discussing the calotype in 1843, "is so suggestive of thought at the present stage, that it would be no easy matter to exhaust it; and it will, we have no doubt, be still more suggestive of thought by and by".[37] A hundred and forty years after Adamson's death the subject is still suggestive of thought, and we have no doubt will be still more suggestive of thought by and by.

[36]Hill was by no means alone in this idea, which was approved by Joshua Reynolds, John Brown and John Ruskin, among others.
[37]Hugh Miller, "The Calotype".

5. CALVERT RICHARD JONES OF SWANSEA

Rollin Buckman

The reconstruction of the life and contributions to photography of the Rev. Calvert Richard Jones can be accomplished by using four primary sources: most important are the paintings and photographs; second, his correspondence with Henry Fox Talbot; third, Jones' article "On a Binocular Camera", which appeared in the *Journal of the Photographic Society* (1854); and fourth, the obituary dated 9 November 1877 in the Swansea newspaper *The Cambrian*:

> We have this day to announce the death of the Rev. Calvert Richard Jones, which took place at Bath on Wednesday last, the 7th instant. The gentleman whose decease we now record was born about the year 1804,[1] and had therefore arrived at the boundary commonly assigned to human life. He had been ailing about three weeks previous to his decease, during which time he fell from his chair and broke a rib. The injury then sustained was followed by an inflammation of the chest, which was the proximate cause of his death. The deceased gentleman did not follow at least in recent times, his profession as a clergyman, but he owned by inheritance the Herbert Chapel of St. Mary's Church, and also one of its aisles. He was a brother of Captain Jones, R.N., a Knight of the Legion of Honour, and of the late Sergeant Jones, one of the Metropolitan County Court judges, and a half-brother of the late Raleigh Mansel, Esq. A few months ago, he lost his only child by a first marriage, who was the wife of Lt. Col. Grey, a son of the Bishop of Hereford, and a nephew of the last Earl Grey. By this marriage there are several children; but it is believed that the Swansea estates pass for life to Lt. Col. Grey. Mr. Jones was educated at Oriel College, Oxford, and was a contemporary with Mr. Talbot of Margam, when Bishop Coplestone was provost of that College, at which college, on taking his degree, he obtained a first class in Mathematics. But he was an early proficient in photography, and was also a skilful artist, painting in oil colours, and an accomplished musician. He married his second wife Miss Portia Smith, and has left two daughters by this marriage surviving him. He and his family were intimately connected with Swansea, being the owners of large property in the town and extensive mineral estates in the neighbourhood. And the people of Swansea are under a deep debt of gratitude to them in conse-

[1]Birth date 4 December 1802, baptized 15 January 1803; Register of Births and Baptisms, St. Mary's Church, Swansea.

quence of his father having given the ground of our magnifi-
cent market – a splendid property now producing £3,000 per
annum which the corporation now enjoys. The Rev. Calvert
Jones was a magistrate of this County, and a deputy
lieutenant.

When Calvert Jones took his degree in mathematics at Oriel
College, Oxford, he was a classmate of Christopher Rice Mansel
Talbot. It is through this friendship and his association with
John Dillwyn Llewelyn that he became acquainted with Henry
Fox Talbot. After Oxford, Jones took Holy Orders and in 1829
was installed as Rector of Loughor. We know that he spent little
time performing the duties of a clergyman, although he did
perform the marriage ceremony of Christopher Talbot, cousin
of Henry, to Lady Charlotte Butler in 1835 at Cahir House in
Ireland. Indeed, he was a personality of many dimensions, a
clergyman, musician, mathematician, painter and photogra-
pher. His financial independence allowed him to pursue his
diverse interests and to develop his artistic talents.

After his early experiments with photogenic drawing in
1839, Jones showed serious interest in becoming skilled in the
art of the calotype. He wrote to Henry Talbot on 4 June 1841:

> The marble head is equal to one of M. Angelo's drawings and
> the small bit of Lacock wonderfully pictorial and strong, also
> the backyard sunny in the extreme, the foliage I think brighter
> than any one in silver that I have seen.
>
> These specimens have charmed me so much that I am
> very anxious to learn the method before we go. You can best
> tell me whether any oral instruction is very necessary (in many
> such cases it is) if it should be so I would take advantage of
> your kind offer of speaking to me on the subject.[2]

The next evidence of Jones' development as a serious photog-
rapher is in a letter dated 28 July 1845 from Henry Talbot to his
mother, Lady Elizabeth:

> Mr. Calvert Jones is just arrived to unite his photographic ef-
> forts with mine. He says he had a narrow escape just on arriv-
> ing at his journey's end; the luggage on the roof of the railway
> carriage caught fire and immediately a gentleman exclaimed
> Oh! the gunpowder! for he had 4 pounds of powder in his
> portmanteau, fortunately they were near York and the train
> stopped before the fire had communicated to his fatal
> portmanteau.

The following day Talbot wrote to his wife, Constance:

> Mr. Jones does not seem the worse for his fright for he got up
> extremely early this morning and took a long walk thru the
> City, studying the points of view before breakfast. We took 12

[2]The letters from Jones to Talbot, and Talbot to his mother and wife, are in the
Lacock Abbey Collection, Wiltshire.

views of York today – most of them good – crowds of admiring spectators surrounded the camera wherever we planted it.

In December 1845, Jones, his wife, Ann Harriet, and Lady Charlotte and Christopher Talbot sailed for Malta and the Mediterranean on the *Galatea*, one of Talbot's several yachts. From the images sent back to England to be printed at the Henry Talbot printing establishment at Reading, we know that the company travelled from Malta, where Jones photographed the city of Valetta. They photographed architectural antiquities in Pompei and Venice, Santa Lucia in Naples, and the Colosseum in Rome. It is important to note that before the tour ended, Rev. George Bridges, after receiving instruction from Henry Talbot in the use of the calotype, joined Jones's group in Malta, where Jones helped Bridges to refine his technique. There are two salted paper prints of whole plate dimensions (c. 21 cm × 17 cm) attributed to Jones and Bridges and monogrammed "B": *Views of Venice, St. Mark's Square* and *Lions, Venice-Arsenale*, lightly printed and watercoloured.[3] Apparently, Bridges made the calotype and Jones painted over the salt print.

Jones appreciated the beauty of the salted paper, but he also frequently embellished the image with watercolour. In a letter written from Veranda, 20 March 1847, to Talbot he wrote:

> The coloured specimens have gone to London to be mounted; the prices which I consider them well worth are £1 for large views, £2 for large double d° (*ditto*) . . 10s . . for the half size . . . and 6s each for the quarter size. I could not possibly take less, especially for the first or original copies as they require a great deal of trouble, and more than that, much artistical knowledge and tact.

The image of a street in Valetta, Malta (Fig. 1), is attributed solely to Jones and is an example of a salt print watercoloured over. His urban landscapes have the same compositional strengths as his marine landscapes do. He frequently includes human figures to give scale to the architecture. In this watercolour rendering over a salt print he has added figures which the slow exposure of the camera would not have been able to capture with such definition. This is Merchant Street teeming with activity. The white palace near the end of the vista faces the bustling marketplace. The Scots Guard stands in front of the columned building which is today the Public Registry. Another guard in the street dominates the middle foreground, both highly visible in this British colony. The camera placement emphasizes the buildings on the left and only suggests, by way of the protruding awnings, the shops and marketplace. The composition is consistent with Jones' watercolourist style.

The first public exhibition of Jones' work was held at the

[3]Department of Photographs, The J. Paul Getty Museum, Malibu, California.

1. Calvert Richard Jones,
Valetta, Malta, watercoloured
salted paper, 1846. Private
collection.

Glynn Vivian Art Gallery, Swansea, in 1973. Another exhibition
at the same gallery in 1987, included, along with six copies of
his early calotypes, numerous pencil and body colour or wash
drawings, and several watercolour and ink-and-wash paintings.
The show also included two of Jones' oils, although it is evident
that his talent as a painter was realized through the medium of
watercolour rather than oils. His watercolours were not grand
romantic renderings of tall ships undersail in heavy seas but
rather quiet, intimate genre studies of groups of ships and ma-
rine equipment, and dock studies. He preferred to render
grounded hulls and beached boats in Swansea's tidal harbour.

 His watercolours and later his calotypes stem from a style
thoroughly established in England by the late eighteenth century
and derived from seventeenth-century marine artists. In Calvert
Richard Jones we see the influence of the studio of Willem van
de Velde and his son, who dominated marine painting in En-

gland in the seventeenth century; drawing was as much the basis of their art as it was with Jones. He, too, was a superb draughtsman. We cannot be certain where Jones learned composition and draughtsmanship, but there is a Mr. Harding who accompanied Jones in the presentation of his paper to the Photographic Society of London in 1853. This may have been James Duffield Harding, art teacher of John Ruskin and the assoociate of the marine watercolorist George Chambers, who could have contributed to Jones's art education. We do know that Jones introduced the painter James Harris to Chambers and probably paid for his instruction in Chambers's studio.[4]

Jones's work lay somewhere between that of a ship portraitist and that of a marine landscape artist. He was intrigued with looking at a ship in its entirety, not submerged to the waterline, and preferred exposed rigging to rigging covered by sails. Jones's art is much in the style of Bonington's watercolour *Coast Scene with Shipping*.[5] The composition is similar with dominant hulls of grounded boats on the right, balanced on the left by distant boats afloat. The British watercolourists Henry Bright, John Thistle and John Varley are also among those who painted grounded ships in estuaries and harbours. The author of "Reminiscences of Old Swansea" says

> His subjects were invariably shipping, not ships afloat but lying high and dry in harbour or on the beach. Many were taken inside the piers and I have watched the artist sitting there opposite his easel in dangerous proximity to the mud. They always seemed to be what an artist might call conventional drawings, and I do not suppose the waterline of the ship or any part of the hull, or the perspective would be out of drawing, even if judged by the rules of Euclid.[6]

This was a pattern Jones perpetuated when photographing. Indeed, the camera was an extension of his skill as a watercolourist. His salt prints possess the same proximity, point of view and intimacy as do his watercolours. There is a stillness about these ship portraits, yet there is also dynamic stress. Three-quarter views of the transom are those which Jones strongly preferred. The composition of the watercolours parallels that of the calotypes (Figs. 2 and 3). The bulk of the hull is emphasized, and is contrasted with the lighter superstructure. In ship group portraits the composition is asymmetrically balanced without losing the resonance between the foreground and background subjects. In single ship portraits the composition is frequently enhanced by the inclusion of a dinghy tied off the transom or by human

[4]*South Walian*, December 1902, 186.
[5]*Coast Scene with Shipping*, Aberdeen, The Art Gallery and Regional Museum. 5¼ × 7¼ : 133 × 183 mm. Watercolour. Richard Parkes Bonington (1802–37).
[6]Anon., "Reminiscences of Old Swansea", Royal Institution of South Wales Collection, Swansea.

2. Calvert Richard Jones, *Beached Ship*, sketchbook drawing, 1835. National Library of Wales.

3. Calvert Richard Jones, *A Beached Ship in Harbour*, n.d., modern print from cropped waxed negative. Royal Photographic Society.

figures standing in the distance. These additional elements give a sense of scale to the massive hull.

Calvert Jones was an active, innovative figure in the formative years of photography. He was aggressive in the business of selling photographs and advised the use of a thin varnish to preserve salt prints in shop windows. As early as 1841, just two years after he became acquainted with the calotype, Jones produced a whole plate daguerreotype of Margam Castle, South

Wales, one of the homes of Christopher Talbot, with the in-
scription, ''March 9t 1841 9h. 30m. A.M./ In the Camera 26 min.
Sun clear throughout./ Mercury 7 min. rising. 9 falling./ Calvert
R. Jones''.[7] According to letters from Jones to Talbot in December
1845, he met Hippolyte Bayard, the inventor of a direct positive
process, to learn about his system of sensitizing the paper, and
to compare it with the Talbotype.

Jones was the inventor of a ''binocular camera''. Accom-
panied by Harding, on 5 May 1853 he made a presentation to
the Photographic Society of London. An article, ''On a Binocular
Camera'', was published soon after.[8] Jones showed the design
of a camera with two lenses on lens boards contiguous to each
other at an angle:

The purpose of this camera was not – as the word ''binocular''
suggests – to give the illusion of depth but to produce two
contiguous images, thereby creating a greater field of view or
panorama. The article reads in part:

> Having been, ever since the discovery of photography,
> an ardent follower of the beautiful art, I have long been con-
> vinced that the picture comprised in the field of view of an or-
> dinary lens is not extensive enough, does not subtend an angle
> sufficiently large to satisfy our eyes; it is, in fact, analogous to
> what we see when we look out at nature with one eye shut.
>
> To obviate this imperfection, I have been constantly in
> the habit of taking double pictures; i.e. having taken an upright
> view, I move the camera in a small arc till the left-hand side of
> the second view coincides with the right-hand side of the first.
>
> Such views are, I believe, common enough, and I think
> that I can appeal to any person whether these kinds of pictures
> are not, when joined together and mounted, more satisfactory
> to the eye than any single view.
>
> Of course I speak of general compositions, such as land-
> scapes, architectural subjects, &c., and not studies of any par-
> ticular objects, such as figures, groups, or still-life.
>
> However, from the two portions of double pictures being

[7]The daugerreotype (20.5 × 15.4 cm) is now in the National Library of Wales,
 Aberystwyth.
[8]*Journal of the Photographic Society of London*, 1, 1854, 60–1.

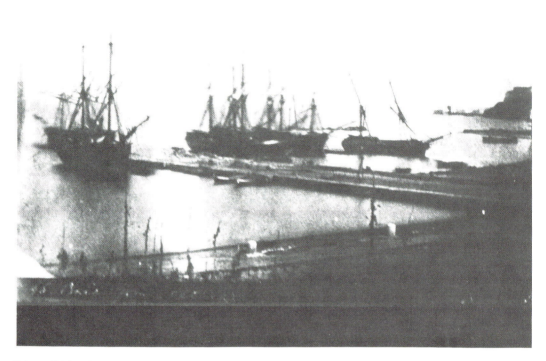

4. Calvert Richard Jones, *Bay of Baia*, 1846, salted paper. Science Museum.

taken on different pieces of paper, and the difficulty of making the edges meet with perfect accuracy, it appears to me a great desideratum that we should be enabled by some means to take the two views on one sheet of paper. . . .

I cannot, however, help thinking that the desired end may possibly be effected by means of a binocular camera; first, taking one view with one lens, and having accurately covered the portion done, by a slide or trap-door, taking the remaining half with the second lens.

I subjoin a sketch of the kind of camera which I would propose to adopt for the above purpose; and throw out the idea to the manufacturers of these instruments, whether it may not be possible to construct the paper-holders with such nicety as to attain the desired accuracy at the junction of the edges.

The size and beauty of the pictures would, I submit, amply repay the outlay of the two lenses required: and I can only add in conclusion, that though I am far from thinking it necessary to have such a camera for all views, I am of the opinion that it would form a very useful appendage for taking a more perfect and satisfactory representation of many compositions in nature which cannot be adequately depicted by a single view.

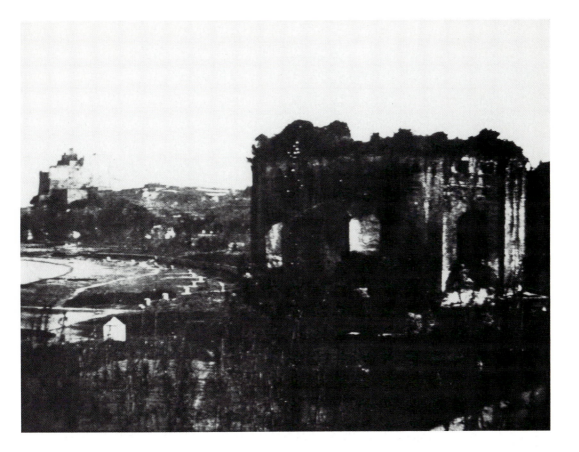

We do not know whether a working model was made, but we do know that Jones was very skilful in joining single prints with excellent registration (Figs. 4 and 5). The panorama of the Bay of Baia illustrates a double view. Jones gives instructions on the bottom edge of the negatives: "x 45 Bay of Baia (joins at 46 at xx)" and on its mate: "46 (joins 45 at xx)". The right view shows the rotunda dominating the composition, which is offset by the fortress on the upper left. Each calotype is a perfectly balanced composition in itself, and the two joined expand the angle of view without destroying the compositional value. Jones wrote to Henry Talbot on 20 March 1847 that he was "extremely anxious to hear how you have got on with your accelerating process as I am very anxious of trying it. I shall begin some double and treble views as soon as the sun comes, which I daily hope." His treble views remain to be discovered, as many prints have been trimmed thereby removing margin instructions.

A comprehensive review of Jones's oeuvre reveals that his genre studies, still-lifes, figure studies and views of antiquities

5. Calvert Richard Jones, *Bay of Baia*, 1846, salted paper. Science Museum.

are surpassed by his urban landscapes and his marine studies.[9] It is on these images that Calvert Richard Jones's contribution as a photographer–artist during the first two decades of photography should probably be based.

[9]For an important recent addition to Jones's oeuvre, see Sotheby's (London), catalogue for the sale of 14 April 1989, 38–67.

6. JOHN DILLWYN LLEWELYN: Instantaneity and Transience

Christopher Titterington

In England the discovery and colonization of photography belongs to an intellectual community that seems to coalesce most naturally around the Royal Society. It was here that Henry Fox Talbot announced details of his photogenic drawing in January 1839, and it was in the *Philosophical Transactions*, the principle journal of the society, that the main papers on photography were published before the appearance of the photographic journals. For serious gentleman amateurs like John Dillwyn Llewelyn, membership gave access to a wide area of knowledge and a diverse culture of scientists, theologians and men of the ancient professions – individuals with polymathic concerns, particularly an inclincation for Natural Philosophy and its attendant metaphysical implications.

Llewelyn, it seems, participated fully in this community. During the 1840's and 1850's, in London and on his Welsh estates, he was consorting with the leading figures in the fields of geology, electricity, botany, astronomy, and his own special discipline, chemistry. Within this group his comprehensive interests are certainly not exceptional. Talbot, to whom he was related by marriage, displays equally wide preoccupations, yet the breadth of knowledge and the particular mix and direction of his enquiries does situate Llewelyn's photographic practice and give access to his basic intellectual orientation. It helps explain not only the main thrust of his photochemical research, but also his polyvalent responses to its results, in particular to the achieved quality of instantaneity in the portraits and landscapes he made in 1853 and 1854.[1]

On the simplest level the impulse towards instantaneous exposure is often understood to have been practical. On this account pragmatism is assumed to have provided the decisive motive for technical change. In portraiture the length of time needed to register a calotype image was uncomfortable if not unbearable, and under these conditions sitters often inadvertently caused images to blur through movement. The process

[1]The album compiled by Bessie Dillwyn, Llewelyn's sister-in-law and daughter of the geologist Sir Henry de la Beche, consisting of family portraits, views of Penllegare (Llewelyn's estate), botanical studies and archaeological and geological illustrations, is in the Victoria and Albert Museum, London.

was thus unreliable and, in terms both of material waste and of the photographer's time, commercially unsound. With landscape the problem again was loss of resolution of image detail, moving foliage failing to register with any precision and water seeming to smear. This difficulty was compounded further by shifting conditions of illumination, for under broken, changeful cloud cover the longer exposures tended to cancel the shadow "relief" that was productive of the most clearly readable image.

Another account assumes a crude teleology at work. It tends to present developments in this area simply as the realization of a self-propelled technological potential, while failing to notice important aspects of contemporary thought that may properly be considered to prepare and condition the impulse within the photographic group. In particular, it misses the significance of equivalent demands and restraints upon representation acting in other disciplines. What we need to know in order to understand this phenomenon is precisely how the new medium was perceived to fail in its description of the objects and scenes it represented.

At base such questions concern the privileged paradigms by which man and material nature were understood in the culture at mid-century. A degree of perspective that hints at possible answers may be had when we notice analogous formulations in the sciences, in literature and in painting. It is in this last discipline that the most helpful analogies emerge. Clearly, the notion of simultaneity had been active here in the interest of enhanced realism since the earlier part of the Renaissance. Without necessarily receiving conscious doctrinal expression, by the end of the fifteenth century the principle had almost exclusively confined the representation of events to the single moment. In contrast to the permissive allowance of prospective and retrospective events within the one image that may be found in painting of a century earlier, more often than not narrative now came to be suspended at a determinate point. The principle receives what is probably its first formulation as a general rule somewhat later. In 1712, Lord Shaftesbury asserted:

> 'Tis evident that every Master . . . when he has made his choice of the determinate . . . Point of Time, according to which he wou'd represent his History, is afterwards debar'd from taking advantage from any Action than what is immediately present, and belonging to that single Instant he describes.[2]

By the last quarter of the eighteenth century this demand for temporal coherence was allied to a new concern for exactitude to the specific material form of the subject, and it was this basic

[2] *The Characteristicks of Men*, London, 1773 ed., 3:353 (first edition in French, 1712).

alliance that forms the received code of practice available to Llewelyn in 1850.

Portraiture was at this time concerned with the discovery and presentation, in the phraseology of the early part of the century, of the "leading passion" of a soul. In this the external features were considered, in accordance with the theory of physiognomic expression, to be the clue to the content of the personality as it is manifested in the fleeting, fluid succession of mood and inclination. Particularly since the late eighteenth century, mental characteristics had been recognized to be more authentic and valid when discovered in the momentary expression, and partly as a result of this doctrine a cult of spontaneity in painting had emerged that simultaneously placed emphasis on the sincerity of artistic contact and on the authenticity of the sitter's emotional composition. This is the basis of the rising aesthetic of the sketch in the last quarter of the eighteenth century and of the emphasis on virtuoso execution in the 1830's and 1840's. Conditioning and allowing this cult of sketching is the profoundly anti-rationalist belief in the primacy of the imagination, with its emphasis on immediacy and intuition as the key human faculty. It is within these ideas that Llewelyn's disposition towards instantaneous portrait exposures should be located. For by this system of values the static and necessarily serene daguerreotype or calotype must have connected with neoclassical Winkelmannian concepts of considered repose and merely potential emotion, and in so doing, within a culture that placed emphasis on the insights of intuition, must have struck a note profoundly out of key with the prevailing doctrine that authentic and genuinely apprehended emotion was available not in the fixity of a held pose but in the momentary expression.

In landscape painting the concept of instantaneity was also already in operation, immanent within the empiricist doctrine that the artist should depict a specific place at a specific time. Ultimately this is founded upon the eighteenth-century sensationalist philosophy that placed confidence and final trust in the senses to supply us with valid information about the world – in strict opposition to idealist doctrines of a transcendent reality of which the phenomenal world accessible to the senses is but a shadow. In landscape this doctrinal structure is expressed most clearly in the concept of "effect"; the particular conditions in operation over a certain area were signified beyond the obvious storm, rain-shower, or time-of-day *topoi* by a diversity of nuanced and often hardly differentiated illumination. Intellectually, in unifying the composition such effects demonstrated the artist's apprehension of a profound order within nature's apparent diversity. But in aesthetic terms this chiaroscuro was perceived as especially beautiful in its production of a broad variety in the pictorial construction. And this was crucial for

Llewelyn. From the first decade of the century, the accepted standard in leading circles was one of well-observed detail united with an ordering perception of the broader masses of illumination. It is for just this combination that the newly sensitive collodion was praised in the 1850's and 1860's. Instantaneity may thus have been sought both for specificity and, because the longer exposures cancelled out the broad shadow masses cast by moving cloud, desired in order to comply with the dominant aesthetic of "variety".[3]

In landscape painting specificity of "effect" often carried with it the implication that it was loosely scientific. Here pictures were considered, beyond their intrinsic beauty, as documents of little understood processes operating in the atmosphere, and like texts, as repositories of information. An instantaneous landscape photograph would clearly have value within this structure of thought, but in the hands of photography instantaneity could have a more rigorous empirical use. This was quickly realized by Talbot. In 1851 he demonstrated before the Royal Institution that photography had the ability to arrest motion if the exposure was of sufficiently short duration. His problem was that the sensitizing agents then in use were relatively inert. In this case the solution was to increase the power of the light source by producing a bright flash in closing an electric circuit. This illuminated a spinning sheet of printed paper allowing the photographic disclosure of a form moving too rapidly for the unaided human eye.

By 1853, Llewelyn believed that his own photochemical research had yielded results which would allow him to use momentary exposures in natural daylight. There begins at this time a sequence of instantaneous pictures made along the sea-shore at Caswell Bay and Three Cliffs Bay on the Gower peninsula in South Wales. The most successful of these were exhibited first at the Photographic Exhibition in London in 1854, and later at the Paris International Exhibition the following year. Here *A Wave Breaking at Three Cliffs Bay, The Juno Blowing Off Steam at Tenby, Clouds over St. Catherine's, Tenby* and *A Ship in Full Sail off Caswell* were shown in one frame under the title *Motion* (Figs. 1, 2, 3, and 4 respectively). For this he was awarded the silver medal of honour alongside Claudet and Fenton, who also got silver, and Talbot, who was awarded gold.

Clearly there is an element of demonstration in this series – indeed, an important technical feat had been performed. Yet this perhaps is not the full account. It seems possible that *A Wave Breaking* (see Fig. 1) can be considered, in a way analogous to Talbot's 1851 demonstration, as an empirical study of form.

[3]See, for instance, Uvedale Price, *Essays on the Picturesque*, London 1794–98, 1810 ed., 2:21.

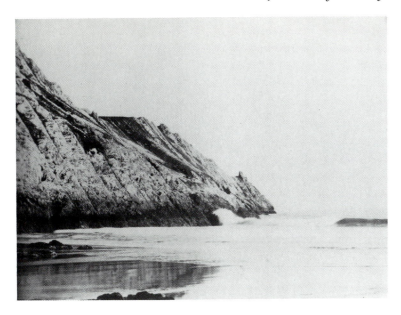

1. J. D. Llewelyn, *A Wave Breaking at Three Cliffs Bay*, albumen, 1854. Family collection.

Certainly, as a subject waves have a special and central relevance in science at this date. Llewelyn's life almost spans that period between the corpuscular models of Newton and Einstein when the undulatory theory of light was at its most powerful. It should follow from his interest in optics, and also from the sensational nature of this discovery which overturned the Newtonian orthodoxy, successfully explaining all known optical phenomena, that he can hardly have been unaware of the importance of the newly prominent wave theory. The relevance of his awareness becomes apparent when we consider that in order for light to propagate through a vacuum, it was thought a medium known as "the ether" was required and that the transmission of waves through this elastic substance was felt, moreover, to resemble wave motion in fluids. Thus, if Llewelyn's interest was indeed scientific, then his choice of this subject in the 1850's seems natural and obvious enough.

There is an element of this kind of empiricism in the aesthetic prescriptions of the realist movement in painting at this time. Certainly one need look no further than Ruskin for confirmation, and as an amateur this may have been the extent of Llewelyn's reading in aesthetics. In *Modern Painters*, Ruskin writes of his conviction that Van de Velde's depictions of waves were fundamentally false, and of his disappointment "that I cannot catch a wave nor daguerreotype it, and so there is no coming to pure demonstration".[4] Concerning the "Truth of

[4]London 1843, 1:349.

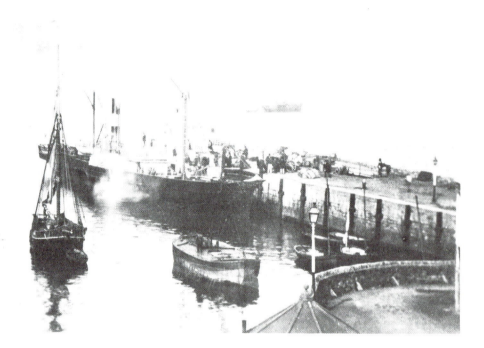

2. J. D. Llewelyn, *The Juno Blowing Off Steam at Tenby*, albumen, 1854. Courtesy of the Board of Trustees of the Victoria and Albert Museum.

Clouds" he believes "it is totally impossible to study the form of clouds from nature with any care and accuracy, as a change in the subject takes place between every touch of the following pencil, and the parts of an outline sketched at different instants cannot harmonize, nature never having intended them to come together". It is from within this discourse that the *Illustrated London News* suggests when reviewing Llewelyn's *A Wave Breaking*, that the picture will be of "immense use to the artist".[5] Here the implication is that the photograph has the standing of a sketch. Indeed, in offering photographs as works of art, photographers were siding with those in the culture who had elevated the sketch to the highest aesthetic status. Yet when compared to the rigorously scientific wave diagrams produced by the 1849 British Association Committee on Waves, or even

[5]April 14, 1855.

3. J. D. Llewelyn, *Clouds over St. Catherine's, Tenby*, albumen, c. 1854. Family collection.

4. J. D. Llewelyn, *A Ship in Full Sail off Caswell*, albumen, c. 1854. Family collection.

the sketches made by his relation Sir Henry de la Beche for his publication on the mechanical action of water in the erosion process, the differences are readily apparent.[6] On the evidence of the relatively removed point from which the subject is viewed, it is apparent that Llewelyn is not concerned to disclose strictly empirical information about wave or cloud form. There is no attempt to emulate the concentrated descriptive vision charac-

[6]Sir Henry de la Beche, *The Geological Observer*, London 1851, 1853, chap. 4.

teristic of drawing in the natural sciences. His purpose, it seems more likely, has to do with a poetic and broadly philosophical recognition of the phenomenal world as a flux. Wordsworth, writing in *The Friend*, identifies the poetry of this precisely, translating Giordano Bruno's "ex visibilium aeterno immenso et innumerabili effectu" as "the perpetual, immense and innumerable goings-on of the visible world". It amounts perhaps to a statement not simply that the world changes, but that what is real is basically a state of process. This observation was fundamental to Heraclitian cosmology and to Newtonian physics, but its sufficiency as an acceptable account of reality in the pictorial culture surfaces only with aesthetic doctrines influenced by eighteenth-century empiricism. Most importantly, it occurs in the high Picturesque as codified by Uvedale Price in 1794, but by the 1850's its depiction in these instantaneous photographs may also be attributed in some measure to evolutionist historicism within the natural sciences.

Significantly, for this "age of transition,"[7] Llewelyn's moral and emotional position on the point seems to have been contradictory, unstable and deeply ambivalent. The evidence is that although he took full part in the mid-century scientific optimism, nevertheless he was prey to doubts impelled by the wider theological implications of the new geology, doubts the more perplexing during this period of resurgent evangelical fundamentalism. Indeed, it is evident from his poems and photographs that his thinking was a complex, fluctuating mix of optimism and uncertainty; a belief on the one hand in reason and progress, and on the other an apprehensive misgiving concerning the old theology. Crucially, his thinking centres on ideas of human transience; ideas that lie deeper in the individual consciousness than particular creed or even religious belief. It is his fractured, polarized position on transience that informs and conditions his use of instantaneity.

As may be expected, when ascendant, his optimism feeds from his practical scientific pursuits; the optimism of his electrical experiments with Wheatstone and his chemical researches with Maskelyne and Claudet.[8] Instantaneity in this sphere fixes the world-flux and becomes a weapon of anti-transience – a quality that captures the fleeting. Talbot describes his own discovery in just these terms: "The most transitory of things a shadow, the

[7]Sir Henry Holland, "The Progress and Spirit of Physical Science", *Edinburgh Review* 108 (1858), 71.

[8]See Richard Morris, "John Dillwyn Llewelyn", *History of Photography* 1, 3 (1977), 222–3. The results of his work with Maskelyne were published by the British Association for the Advancement of Science in the *Report of the Committee, consisting of Messrs Maskelyne, Hadow, Hardwick and Llewelyn, on the present State of our Knowledge regarding the Photographic Image*, 1859, 103–16, Science Museum Library, London.

proverbial emblem of all that is fleeting and momentary . . . may be fixed for ever in the position which it seemed only destined for a single instant to occupy".[9] The power of photography to fix the momentary was in fact doubly potent, for not only is the shadow or the changing material object captured, but the images produced in the camera obscura and mirrored Claude glass were traditional emblems of the transitory because they were formerly unable to be retained. The eighteenth-century cult of transience at the core of the Picturesque has, in addition to the ruin, such mirror or camera images as central to its iconography. Gilpin is representative in his use of the mirror: "Forms and colours fleet before us; and if the transient glance of a good composition should unite with them, we should give anything to fix and appropriate the scene".[10] In view of this tradition it is perhaps not coincidence that the daguerreotype, the "mirror with a memory," should imitate in its casing the pocket Claude glass. Llewelyn's participation in these ideas is evident in his poetry, notably in the poem to his wife Emma:

> See how the Chemist's art can give
> These fleeting shadows power to live,
> Can every transient form engage
> And chain them on his magic page.
> Thus on the sheet before you now
> You see your darling's cloudless brow.
> With beating heart you fondly trace
> Each well loved feature of the face.[11]

In this mode instantaneous photography alleviates the sadness of a fugitive and ephemeral reality and translates in some way these objects and scenes into things that endure. This emotional tenor must to some extent colour our reading of the *Motion* series of 1855. Yet the note of optimism sounded in a letter dated 6 July 1854, concerning his submission to the Paris exhibition, displays a consciousness of an older, more despondent attitude at its close: "I am looking forward ere long to a campaign on the sea coast. For this I am making experiments daily and providing all the advantages I can procure, both chemical and optical and manipulatory for the purpose of attacking the 'restless waves' ".[12] If one looks at the use of the wave and sea-shore in the imagery of contemporary poetry, one sees these things used

[9]William Henry Fox Talbot, *Some Account of the Art of Photogenic Drawing*, 1839, reprinted in Beaumont Newhall, *Photography: Essays and Images*, London 1980, 25.

[10]Quoted in E. W. Manwaring, *Italian Landscape in Eighteenth-Century England*, New York 1925, 186.

[11]Quoted in Richard Morris, *John Dillwyn Llewelyn 1810–1882*, Welsh Arts Council 1980, 30. I owe thanks to Richard Morris for information given in conversation and in family papers.

[12]Ibid.

as emblems of metaphysical doubt, and this begins to suggest
his wider uncertainties. If there is an ambivalence beyond a type
of fashionable melancholy in these 1855 Paris pictures, that same
ambivalence is found in Tennyson. In Tennyson's poem *In Me-
moriam* the "poet of science" develops the wave image to amplify
his own loss of faith:

> I heard a voice "believe no more"
> And heard an ever-breaking shore
> That tumbled in the Godless deep;[13]

Tennyson had been created poet laureate in 1850 and was hugely
famous for *In Memoriam*, but the pervasiveness of the image can
be gauged from "The Sea and the Soul", a poem of 1860 by an
amateur, Viscount de Montgomery.[14] Here a similar connection
between psychic unrest and the ocean is made, and the viscount
significantly couples the "troubled soul" with the "restless
waves". But perhaps the saddest image of the sea-shore at this
date is given by Matthew Arnold in "Dover Beach":

> Listen! you hear the grating roar
> Of pebbles which the waves draw back, and fling,
> At their return, up the high strand,
> Begin and cease, and then again begin,
> With tremulous cadence slow, and bring
> The eternal note of sadness in.

Here it brings into Arnold's mind the loss of all certitude, and
especially of religious faith in the survival of the soul after death.
Llewelyn seems to participate in this sadness in *Caswell Bay –
Waves Breaking* (Fig. 5), also known in another print as *The Restless
Waves*.[15] The evidence of a sombre watercolour that he painted
for his son in about 1850 (Fig. 6), and which is virtually identical
in its composition and depiction of a woman looking from a
beach out to sea, confirms the conclusion that *Caswell Bay* is
constructed to comply with a preconceived matrix of ideas while
also verifying the general melancholic tenor. The picture illus-
trates a scene from *Ostreme*, an historical novel set in the reign
of Edward II (1307–27) that Llewelyn wrote for his children.[16] It
shows the witch Elspeth: " . . . old Elspeth . . . usually remained
within the walls of her hut and was seldom seen abroad by day.
But now as Walter and Kate approached her dwelling they were
somewhat suprised to observe her standing at the edge of the
raging sea." Later she chants a prophecy of the King's future,
beginning:

[13]124, London 1852.
[14]In *Hours of Sunshine and Shade*, London 1860, 53.
[15]Victoria and Albert Museum, London (Ph. 145–1984).
[16]Mss. in family collection.

5. J. D. Llewelyn, *Caswell Bay–Waves Breaking*, albumen, 1853. Courtesy of the Board of Trustees of the Victoria and Albert Museum.

It is for me to read the fate
That mortals have in store
Whether predicted in the voice
Of the wild tempest's roar
Or in the gentle rippling waves
That sob along the shore.

This poetic context goes some way towards explaining Llewelyn's emotional reasons for taking waves as his subject-matter, but in the light of his geological work we can be yet more specific.

Geology in the first half of the nineteenth century was the vanguard science, the solvent in which long-held scientific and metaphysical certainties were finally dissolved, and was therefore the natural metaphor of poetic doubt. As workers in an historical rather than a classificatory discipline, geologists were presenting hard empirical evidence that put the Mosaic teachings on Creation and the Deluge into question. Cosmogonist or early geological evidence had formerly been one of the main supports of the theological argument from design that had to some extent supplanted revelation as the chief evidence for the existence of God. In the new scheme however, the rocks themselves, formerly the very emblems of steadfast belief, were now

6. J. D. Llewelyn, illustration for *Ostreme*, watercolour. Family collection.

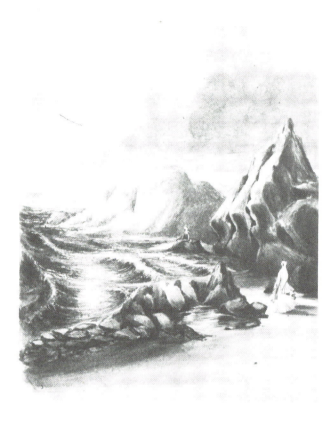

seen to be as mutable and as transient as man himself. Thus for Tennyson:

> The hills are shadows and they flow
> From form to form, and nothing stands;
> They melt like mist, the solid lands
> Like clouds they shape themselves and go.[17]

Furthermore, by 1850 the long-established cult of transience could itself find a new piquancy in Clausius' discovery, set out in what came to be known as the "second law of thermodynamics", not only that the world was a remorselessly mutating flux, but also that this changeful state was slowly but surely "running down". In that year the German mathematician and physicist had proposed the concept of entropy, and had stated that in what is possibly the most fundamental of all natural laws, the total entropy or energy unavailable for work in a given system never decreases, so that the physical processes we observe in nature tend thus to increase its disorder, bringing it finally to chaos.

[17] In *Memoriam*, 123.

That Llewelyn was expert in current geological thinking is surely not in doubt. Sir Henry de la Beche, a leading British geologist and founder of the Geological Museum, was his brother's father-in-law and a constant guest at Penllegare during his surveys of the county. Before his death in 1855, de la Beche was again present in order to be near his daughter. In addition, Llewelyn is known to have made extensive and systematic photographic records of rock types in Cornwall and in South Wales, possibly in conjunction with de la Beche's work in these areas. But if geology can be said to have contributed to a loss of religious faith, in redescribing nature as indifferent to mankind, it was also a cause of neurosis and melancholy. For Protestant fundamentalists after 1830 the belief which held that nature had been created for man's utility was threatened, and the new geological knowledge caused profound disturbance to those of Llewelyn's generation, schooled as they were in the Hartleian benevolism of Wordsworth and Coleridge where nature was seen as man's moral instructor.

Llewelyn, in *Caswell Bay* (see Fig. 5), has his wife stand before the heavy surf. She looks intently at the ebb and flow of water seeming to recognize the flux of all material things. What we have here is not a wise passivity before a benevolent nature, or a declaration of the benign organic unity of man and providential creation as proposed in the Picturesque aesthetic of Price. Llewelyn's insight concerns the ephemerality of the individual, her reduction in earthly status to that of a potential fossil, and related to this, the extinction of the species and the individual soul. Within the new geological nature the single life is left to chance in the flow of natural forces acting upon it.

Llewelyn's campaign along the beach would have been conducted from Caswell cottage, the family retreat at the bay, and it is from this place of retirement that he may have had the leisure to reflect upon the wider metaphysical implications of the place. It was here that de la Beche had shown, in his *Memoirs of the Survey of Great Britain* (1851), that by the mechanical action of water "a series of palaeozoic strata, not less than 10,000 feet in thickness has been stripped off considerable areas".[18] And this bears strongly on the cult of transience. Here in the associations of local rock formations were ages of far greater duration than any abbey ruin or edifice of human construction. In terms of space occupied, man had long recognized his insignificance, but anthropocentrism could still cling to the biblical certainty that the creation of the world was synchronous with man's own origin. Now the evidence of the fossil record told not of immutable forms of flora and fauna created for human comfort or

[18]Quoted in a review of Charles Lyle's *Principles of Geology*, London, 8th ed., 1850, *Quarterly Review* 89 (1851), 413–14.

ethical advancement, but of species that had lived and been extinguished long before man's apparently late appearance. Evidence such as this provoked what may be termed "the temporal sublime" – an infinity not simply of dimension but also of time. In this scheme a single human lifetime could no longer be perceived as a "sixtieth part" of the time elapsed since the Creation, but must now be considered almost as an instant.[19] Such an instant may be presented in *Caswell Bay*. What we see here perhaps is Llewelyn's attempt to set forth his emotional response and deepest thoughts concerning his culture, its discoveries and their widest implications. If his poem to his wife, Emma, displays verbs of photographic power – "fix", "chain", "capture" – and speaks of man's dominion over nature, here Llewelyn seems to join with Tennyson and Arnold in doubting that power. In a letter to Elizabeth Rachel Chapman, Tennyson puts forward his reservations on the Comtist positivism that sees man's eventual destiny as immortality: " . . . according to astronomical and geological probabilities this great goddess Humanity in a certain number of ages will breathe her last gasp".[20] It is a form of scientific pessimism, and Llewelyn, in basic agreement, seems simply to acknowledge or submit to transience. Instantaneity in this mode becomes a poetic device by which the flux may be described the more poignantly.

[19]Quoted in Stephen Toulmin, "The Discovery of Time," in *The Philosophy of Geohistory* 1785–1970, ed. C. C. Albritton, Jr., 1975, 20.
[20]Hallam Lord Tennyson, *Tennyson, a Memoir*, London 1906, 696.

7. BENJAMIN BRECKNELL TURNER:
Photographic Views from Nature

Mark Haworth-Booth

Benjamin Brecknell Turner was born in the Haymarket, London, on 12 May 1815, and at the age of sixteen joined the family business, Brecknell & Turner, tallow-chandlers. There is, according to Turner's great-grandson the late Professor Giles Robertson, "a reference somewhere in Surtees to a dining table shining with Brecknell Turners, which were the best quality candles".[1] B. B. Turner managed the business, whose premises (a factory and shop) were at 31–32 the Haymarket, from 1841 when his father died until his own death in 1894. The business, which also made saddle soap, must have been on a substantial scale: Turner's brother, Robert Samuel Turner, "a rather Proustian character, who was a celebrated bibliophile and lived in Albany, was joint owner of the business but a sleeping partner".[2] B. B. Turner married Agnes Chamberlain of the Worcester china family in 1847. In her memoir of B. B. Turner, Muriel Arber writes that Agnes Chamberlain's father, Henry, "gave up his share in the Chamberlain china factory, and in 1837 bought Bredicot Court, a farm with about 400 acres, a few miles from Worcester. Here he took up farming. . . . When he bought Bredicot, the land was in a very bad state and the house was almost ruinous, but it was gradually improved and became the beloved home of the family".[3] According to the family memoirs gathered together by Miss Arber, "B. B. T. took up photography in 1849 with a licence from Fox Talbot". Some photographs by Turner survive, dated 1849.[4] However, his obituarist John Spiller claimed that Turner was "a friend of Fox Talbot" and contributed "some of the illustrations to the now famous original publication known as *The Pencil of Nature*".[5]

[1] Letter from Giles Robertson to M. Haworth-Booth, 28 July 1977, files of Photograph Section, Department of Designs, Prints and Drawings, Victoria and Albert Museum. I am most grateful to the late Professor Robertson and to others of Turner's descendants, most notably Miss Muriel Arber and Mrs. John Carswell; and also to Pamela Roberts, Brian Coe, George Carter and John Hannavy.

[2] Ibid.

[3] "Benjamin Brecknell Turner (1815–1894), notes by his great-grand-daughter Muriel Agnes Arber", 1985. Miss Arber has kindly allowed me to quote from her memoir, a typescript of which is in the files of the Photograph Section, Victoria and Albert Museum.

[4] Private collection. A group is on loan to the Photograph Section, Victoria and Albert Museum.

[5] *The Photographic Journal*, 26 February 1895, 159.

Spiller added that "a copy of this work and the lens used in 1849 [*sic*] – one specially made by Andrew Ross – was exhibited in the Loan Collection of Scientific Apparatus, 1877, and afterwards presented to the South Kensington Museum". Certainly the Science Museum in South Kensington preserves a landscape lens made by Andrew Ross, given to its ancestor the South Kensington Museum in 1876. The lens has a traditional association with Talbot's *Pencil of Nature*, dating presumably from the time of the donation. There is no record of a gift to the Museum of a *Pencil of Nature* by Turner, but he did present a copy to the Photographic Society of London in 1859." It would be unwise to rule out Spiller's claim, but at present it would be equally unwise to accept, without further confirmation, his statement that B. B. Turner contributed illustrations to *The Pencil of Nature*. However, Spiller is a valuable eye-witness. He recorded that among Turner's most intimate and respected friends were his cousin Professor George Fownes, F.R.S., whom he consulted occasionally on chemistry, and Robert Murray, an instrument-maker of high repute, who made Turner's first camera. Other especial associates mentioned by Spiller were "Mr Fox Talbot's coadjutors and original licensees, Messrs Henneman and Malone, of Regent Street". Henneman and Malone's premises were only a few minutes stroll from Turner's own, and possibly his knowledge of wax, and of business, may have been of considerable interest to the photographers. What is more likely than that a licensee of Talbot's calotype process would avail himself of discussion with Talbot's own operatives while he learned to master calotype technique?

B. B. Turner's earliest surviving works, presumably from 1849, are about the size of Talbot's calotypes, roughly the size of ordinary writing paper (about 7 1/2 × 5 1/2 inches), and of such subjects as Bredicot church – where Turner and Agnes Chamberlain were married – a village street with an inn, seamen by boats, and a venerable blasted oak. Turner photographed his wife and sister-in-law looking out of a lattice window at Bredicot and – in a small but ambitiously composed roundel – seven members of the Chamberlain family posed under trees. The work indicates good technical skills but represents only a beginning. In 1850, Turner began a *Photographic Scrap Book*.

The *Scrap Book* contains press-cuttings concerning important communications in the development of photographic materials: about, for example, Blanquart-Evrard's improvements in preparing paper for negatives and positives; Archer's suggestions for improving the manipulation of collodion materials; J. E. Mayall on "Glazing the Positive Proof" (a refinement which he

"See H. Kraus, Jr., and L. Schaaf's facsimile edition, *The Pencil of Nature*, New York 1989, for a full discussion.
Private collection.

promised "brings out the detail, and gives a finish to the drawing hitherto unattainable); "Scientific Gossip" – about gutta-percha – from the Photographic Club, which was said to be "exciting much interest among artists: At the last meeting at Mr Fry's house – Sir Charles Eastlake, Mr Harding, Mr Roberts, Mr Mulready, Mr Lane, Mr Prescott Knight, Mr George Cruikshank, and several other artists and men of science, were present". A cutting dated 27 November 1851, an article by Talbot himself, is titled "On the Production of Instantaneous Photographic Images" and describes his experiments held at the Royal Institution in June that year.

Another extensive item is a description of a patent taken out by Talbot and Thomas Malone for a variety of technical improvements in photography. The *Scrap Book* indicates its owner's desire to inform himself of the most recent technical possibilities of the medium.

A quantum leap occurred in photography in the period 1851–52. Roger Fenton attributed it directly to the Great Exhibition of 1851. The results of this new activity were gathered together at the Society of Arts exhibition, Recent Specimens of Photography, in December 1852. Turner exhibited six works, all taken earlier in that year,[8] and all fulfilling Fenton's characterization – in his introduction to the catalogue – of English photography as superior to the French in the field of the paper negative (as opposed to glass) and of excelling in depictions of such subjects as "the peaceful village; the unassuming church, among its tombstones and trees; the gnarled oak, standing alone in the forest; intricate mazes of tangled wood . . . the still lake, so still that you must drop a stone into its surface before you can tell which is the real village on its margin, and which the reflection". Fenton wrote admiringly of work by "English draughtsmen on paper", meaning the calotype negative as used by Turner or the waxed paper negative invented by Le Gray which was also popular. "Nothing", Fenton believed, "can surpass in delicate beauty or in grandeur some of the specimens exhibited". Fortunately we can study prints likely to be close to the ones Turner exhibited in 1852. He assembled a very grand album of sixty of his photographs, the one now in the Victoria and Albert Museum.[9]

Turner's album opens with a photograph of a living tree enclosed by the new engineering of 1851. The album closes with a photograph of an oak tree outside an ancient parish church (*The Church Oak, Hawkhurst, Kent*). Late in the anthology we find a photograph from the same village in which the church is shown

[8] Turner exhibited no. 175 *The Church Oak*, no. 179 *Old Farm House, Worcestershire*, no. 182 *Lyndale, North Devon*, no. 187 *Old Farm House, Worcestershire*, no. 190 *Scotch Firs*, no. 193 *A Photographic Truth*.

[9] See M. Haworth-Booth, "The Picturesque Eye: Benjamin Brecknell Turner's Album", *The Victoria and Albert Museum Album 1*, London 1982, 135–9.

1. B. B. Turner, *A Photo-graphic Truth*, albumen (from calotype negative), 1852. Courtesy of the Board of Trustees of the Victoria and Albert Museum.

exactly reflected in the sheet of water before it (Fig. 1). The photograph, *Hawkhurst Church* in the album, is the composition Turner exhibited in the Society of Arts exhibition in 1852 as *A Photographic Truth*. He used the latter title when he inscribed the envelope in which he kept the negative, now at the Royal Photographic Society. Perhaps Fenton was at least half thinking of this image when he made the remarks quoted above about the real village and its reflection. Of course, many photographs of the time played with this illusion – but are there any which treat the illusion so boldly, which fill the whole frame with it and which make it so inescapable, like a syllogism which demands a response? Hence, presumably, Turner's equally bold title, *A Photographic Truth*, which refers perhaps to the way in which reality becomes, in photography, its own matrix. His photo-graph of the church is as natural and true as the reflection of the church we see in the water (which also enters the photo-graph, in its turn, as natural and true).[10] I have suggested else-

[10]See Robert Hunt: "To select a group of photographs as examples, the very excellent pictures of Mr. B. B. Turner's may be chosen. Beautiful as these are in many respects, it will be found that the lights upon the trunks of

where that photographers at this early date appear to have in-
herited a Wordsworthian poetics in which the mind is opened,
like a sensitive plate, to the impressions of benign nature – which
then faithfully transcribes itself.[11] Critics during the 1850's si-
multaneously praised the wonders of the new medium of pho-
tography (comparable to electric telegraphy) – and found that it
revealed itself most clearly in photographs uncannily like (in
their descriptions) B. B. Turner's, "the little cottage home of
England", and "that old oak . . . a familiar friend loved by our
grandsires".[12]

"Album" does not seem the right word, with its associa-
tions of privacy, of keepsakes and miscellanea, for this spectac-
ular work. Turner placed his photographs, probably at the end
of 1854 or the beginning of 1855, in a specially created volume
– of elephant-folio proportions, bound in green pigskin, lettered
in gold with gilt printers' ornamental flowers stamped in the
binding, a handsomely printed title page bearing his name and:

PHOTOGRAPHIC VIEWS FROM NATURE *Taken in* 1852, 1853, *and*
1854/ON PAPER BY MR FOX TALBOT'S PROCESS

Then follows a contents list of the titles of the sixty photographs.
It is not so much an *album* as an *anthology* assembled for consid-
ered public scrutiny – and one of the monuments of its medium
and period. It opens (let us assume that the lay-out *is* significant)
with two views of the Crystal Palace in Hyde Park, 1852 (i.e.,
after the exhibits of the Great Exhibition of 1851 had been re-
moved, but before the dismantling of the structure and its re-
building in Sydenham). The first view conveys the spaciousness
of the building, and its airy construction. Turner's viewpoint
features the "transept", showing the barrel vault of cast iron
and glass above the gallery, and within the transept, one of the
elm trees which Paxton elegantly enclosed in his design. The
elm, fully grown, stands decoratively within the scheme like an
orchid in a hot-house.[13] The second view shows the "nave" but
more particularly the construction of trusses Paxton evolved for
the roof structure. The associations are not with the Crystal
Palace as "cathedral" – or indeed palace – but as factory. It is
the only photograph of those known to survive from the Hyde
Park site which presents the building as a brilliant, tensile ge-
ometry. Those are Turner's first two shots, as it were, in his

the trees, and those spread over the various surfaces of *green* sward, *brown*
paths, and *blue* water, are not such as we see in nature. The 'Photographic
Truth' is not nature's truth, – the watery mirror brightly reflecting solar
light never gave to the eye such an image". "The Photographic Exhibi-
tion", *Journal of the Society of Arts* 1 (7 January 1853), 78–9.

[11]See *The Golden Age of British Photography, 1839–1900*, ed. M. Haworth-Booth,
New York 1984, 17–18, 49.

[12]*The Photographic News*, 20 May 1859, 124. This article, quoting from the *National
Review* for April 1859, contains a marvellous description of the visual
qualities of a collodion-on-glass negative of a rural subject.

[13]These two views are illustrated in M. Haworth-Booth, "The Picturesque Eye."

anthology. He shows us nature enclosed in the new industrial construction (a mixture of light, air, iron and glass) for itself and because, in his image at least, it is radically new.

From here on, Turner demonstrates what the new technology of photography can do. He conducts experiments of many kinds, shows off the instrument, produces a *Pencil of Nature* for the 1850s. He is, after all, photographing many of his subjects either for the first time or at a height of ambition not previously attempted. The prints in the album are *large* – approximately 10 1/2 × 15 1/4 inches – and they sit impressively within a much larger sheet. The whole album is 17 1/2 × 23 1/2 inches. The prints are exhibited on the page in a way that resembles a print in or on a modern mount.

The next two prints are from famous "Picturesque" places in North Devon. At Lynmouth, Turner photographed the river valley as it cuts beside the new Italianate holiday villas. The photograph demonstrates, in accentuated form, the natural drawing of aerial perspective for which photography was prized from its earliest days. Mistiness settles beyond the houses – a subtle and naturalistic effect of atmosphere. At Lyndale, nearby, Turner focuses diagonally downwards on the river, creating a close-up.[14] It may or may not be the first landscape "close-up": but it is among the first of monumental scale, of consequence. The imposing rocks here – are they boulders in a river or pebbles in a stream? The photograph, by interrupting a continuous landscape and showing only this detail, proposes such questions of scale, interpretation. As in all photographs of rivers at the time the water is, of course, transmuted into a veil wrapped loosely around the forms of the rocks. The image is a good instance, perhaps, of a purely *photographic* effect here used to a good aesthetic effect.

As we look through the pages of the album we can sense how Turner was trying out features of the process. The obvious way to test a new medium is to address the traditional problems of the graphic arts and see what solutions can be achieved using the new technique. Thus, it is hardly surprising to find Turner focusing his camera on subject-matter at the heart of the existing pictorial canon. Such subjects account for the bulk of the album: the cathedral buildings at Peterborough and Worcester, Tudor and Jacobean houses and inns at Earl's Croome, Worcestershire, and Ludlow, Salop.; Norman castles at Ludlow, Arundel and Hurstmonceaux; and the ruined abbeys of Rievaulx and Whitby. Given the opening photographs, however, it is hard for a modern viewer of the album to look at (say) the views of the abbey at Whitby without inadvertently comparing its structure with that of the Crystal Palace. Whitby Abbey is presented by Turner six times, beginning with a proud silhouette redolent of the building's antiquity and historical associations, moving pro-

[14]Illustrated, ibid.

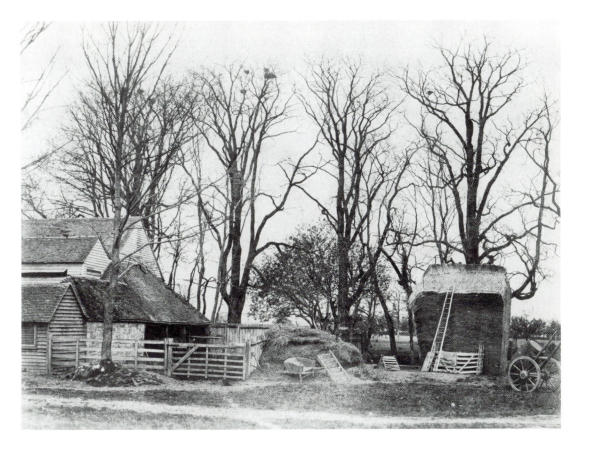

gressively closer to the masonry until its dynamics become clear and the elegant strength of the piers and columns becomes the main point of the photograph. The close-up details of the abbey are essentially, however, masses of stone – utterly different from the light-filled structure recorded in the nave of the Crystal Palace. One may also feel that Turner became, after the epoch of the Crystal Palace, far more aware of the culture of stone, brick and wood because the new materials displayed at and by the Crystal Palace underlined the traditional nature of the earlier materials.

Perhaps such subjects as farmyards and their implements, canonical subjects for generations of painters, sustain their interest after 1851 not only because they were part of a canon – and therefore provided a gauge to measure the new possibilities of photography as draughtsmanship – but because they began to look so certainly of the past: like historical subject-matter. One entertains such a thought, at any rate, when looking at Turner's *Farmyard, Elfords, Hawkhurst* (Fig. 2), in which he displays wooden outhouses, wooden barns, wooden fences, wooden gates, a wooden wheelbarrow, forks with wooden handles, wooden steps, a wooden sawing horse, wooden ladders,

2. B. B. Turner, *Farmyard, Elfords, Hawkhurst*, albumen (from calotype negative), 1852–54. Courtesy of the Board of Trustees of the Victoria and Albert Museum.

wooden hurdles, wooden (mainly) wheels and a wooden barrel
– the picture completed by elms with a rookery, hedgerows and
a copse. On the other hand, such a picture is also a picture of
an English autumn day, and perhaps primarily so. The most
obvious part of the iconography is the one least discussed – the
effects of weather, of atmosphere, those qualities which most
anticipate the future direction of painting. *Kempsey Mill*, simi-
larly, is a photograph of summer, notably of the way sunlight
is absorbed and reflected by the volume of the mill in the centre
of the photograph. The anthology, then, is an exploration of
conditions of light and of the seasons. Autumnal, or winter,
scenes preponderate in the album. Sometimes the focus is very
shallow – almost like P. H. Emerson's differential focusing of
the 1880's. In Turner's *Pepperharrow Park, Surrey* an oak is placed
almost centrally, and beyond it everything is soft, hazy, out of
focus. There are experiments and variations throughout the
work. Some of these involve the tone and colour of the prints.

In his Society of Arts exhibition catalogue introduction
Roger Fenton noted that the printing of photographs was still
an arduous and highly skilled, interpretive, process:

> According to the method generally employed, and which
> seems at present to give the best results, negative pictures can
> be copied [i.e., printed] with sufficient rapidity only on days of
> strong sushine; and in order to produce rich tone and agree-
> able colour, each proof requires careful watching during the af-
> terward process of fixing. To say nothing of the risk of injury
> to which the negative picture is exposed by careless manipula-
> tion, it is impossible at present to trust the re-production of the
> positive proof to less skillful hands than those employed in the
> creative branches of the art.

Turner used the new, glossy albumen-coated papers which, as
Fenton also noted, took a "sharper negative impression" than
the old uncoated papers. Turner's album exhibits a wonderful
range of print colours. The airy views of the Crystal Palace in-
terior are a pale, creamy shade. In other prints chocolate tones
could be classed now as "milk", now as "bitter". Warm tones
are characteristic of sun-printing, as opposed to printing by
chemical development, which give a neutral, grey tone, but in
Turner's prints this general warmth may become a pronounced
reddish-purple, a colour thought at the time to be a feature of
English photographic papers, which were sized with gelatine,
as opposed to the orange-red considered characteristic of starch-
sized French and German papers.[15] However, nuances of tint
were possible by many other means (aside from accident) – in-
cluding, for example, by varying the ratio of old and new hypo,

[15]Davanne and Girard, "The Philosophy of Positive Printing", *The Photographic
Art Journal*, April 1858, 42–3.

and as part of the toning process employing gold chloride.[16] Turner's prints have many different shades of colour – pink, blue, orange, green for example, or mere suspicions of these hues.

It would be wrong to suggest Turner was a faultless technician: very good, even inspired, but some prints reveal fogged negatives, or those blurs which suggest that either the negative was slightly wrinkled at the time of exposure or negative and print were not exactly flat in contact during printing. Like everyone else who used the early papers, he had to put up with the flaws caused by fragments of metal (from old metal buttons) which were part of the rag content of the paper and found their way into the surface of the sheets sold to photographers. They resemble tiny explosions. One or two prints have small processing stains, another is thoroughly mottled by impurities. The standard, however, taken over sixty prints, is high. The prints are the size of exhibition watercolours. The finest examples are resonant in tone, like the looming cottages with their red-purple cast suggesting the colour of their ancient brickwork. Fortresses like Ludlow Castle are displayed in deep brown-black, suggesting the onset of a thrilling twilight. Deepest blacks make trees and their twigs stand out sharply against the empty skies beyond but, equally, the tone may not be at all thumping or grand but simply give the impression of pleasant, even sunlight in summer or autumn, a light in which trees or farmyards can be seen clearly in every detail and appear harmonious, replete.

Turner won a bronze medal for the excellence of his photographs at the Universal Exposition in Paris in 1855 and exhibited his calotypes with great success up to and including the International Exhibition of 1862 in London. There are many appreciative critical remarks concerning his work to be found in the art and photographic periodicals of those years. This is perhaps the finest critical paragraph, establishing just why Turner continued with Talbot's calotype process after others had turned to collodion on glass or waxed paper for their negatives. The article is by "Theta", perhaps the best photographic critic (aside from Lady Eastlake) writing in England in the 1850's, and it directly compares the aesthetic merits of "Paper v. Collodion":

> In pictures larger than 12 × 10, or, at all events, not less than this size, the texture of the paper [negative] gives a boldness and artistic effect, in comparison with which a *large collodion* picture is dead and that to a degree. . . . Not that it can be so stated as to every kind of picture. To be in the highest degree successful with paper the picture should be more what may be called a "study" than a "panorama" – something requiring texture and massive boldness. Bedford's exquisite pictures seem to

[16]See the vivid description of Le Gray's prints in Eugenia Parry Janis, *The Photography of Gustave Le Gray*, Chicago and London 1987, 32.

be chosen with reference to the process he works [collodion on glass]; sharpness, minuteness, and position are all irreproachable. Turner's calotypes are, however, no less beautiful – his old oaks and cottages are far bolder than anything from collodion; broad shadows, which give a massive look to the trunks and architecture, and a stereoscopic effect which few, very few, collodion subjects have. The difference seems to me to be, that the collodion subjects are intended to be kept in portfolio, and the large paper productions are far more fit to be framed on the walls.[17]

Turner was a founder member of the Photographic Society of London in 1853 and later a vice-president. He was also a founder of the Photographic Club. According to Spiller's obituary, Turner was chiefly responsible for producing the club's album of portraits – in which all its members appear. This volume is titled *Rules of the Photographic Society Club.*[18] Its production coincides with the date of Turner's interest in portrait photography. Spiller mentions that Turner built a "studio and dark room for experimental photography and portraiture early in the year 1855". It was on top of the premises in the Haymarket. We should not infer that the glass-house was used for a commercial operation. A photograph survives which is clearly from the glass-house. It shows his wife seated in a studio casually furnished to resemble a drawing-room. Many other portraits were taken by Turner, probably in this room. Among these is his portrait of the distinguished photographer Robert Howlett, the only image of Howlett (who died prematurely in 1858) at present known. There are other portraits of fellow photographers, family (Fig. 3) and friends.

Turner also served as treasurer and honorary secretary to the Photographic Exchange Club, and appears to have masterminded a handsome volume of photographs by members, *The Photographic Album for the Year 1857*. This was intended for private distribution, among the club's members. A letter from Francis Bedford to Turner is preserved at the Royal Photographic Society. It concerns the selection of a suitable quotation to accompany the photograph by Bedford in the 1857 album. Bedford wrote that his brother had been composing something but that Turner's choice (lines from Scott) was a better solution. The club also produced *The Photographic Album for the Year 1855*. Turner accompanied his own photograph in this volume, a view of Bredicot Court, with a quotation from "Geoffrey Crayon", pseudonym of the American writer Washington Irving: "England does not abound in grand and sublime prospects, but rather in

[17] *The Photographic News*, 19 August 1859, 279.
[18] See Grace Seiberling and Carolyn Bloore, *Amateurs, Photography and the Mid-Victorian Imagination*, Chicago and London 1986, 151–3.

3. B. B. Turner, *B. B. Turner Jr.*, albumen (from glass negative), c. 1855. Private collection.

little home-scenes of rural repose and sheltered quiet. Every antique farm-house and moss grown cottage is a picture."[19] Turner may not have endorsed the whole chapter on "Rural Life in England" from which he chose the quotation, but reading Irving's enthusiastic appreciation is to be reminded of the moral qualities legible in such photographs. The paragraph following the quotation tells us: "The great charm, however, of English scenery is the moral feeling that seems to pervade it. It is associated in the mind with ideas of order, of quiet, of sober, well-established principles, of hoary usage and reverend custom".

The chief – if not the only – focus of Turner's feeling for English landscape scenery was his wife's native Bredicot. "At Bredicot", Agnes Arber has written,

[19] *The Sketch Book of Geoffrey Crayon, Gent.*, Artist's Edition, London 1865, 100.

he took photographs of the house, the farmyard, and the pump, the handle of which was said to have knocked out the front teeth of several of the family. He also photographed Bredicot village, which was very small; his wife recorded that it consisted of one other rough farmhouse, called Mantells, and a half a dozen miserable cottages. Agnes Chamberlain spent much of her time looking after the villagers in every way, and in all difficulties they turned to her for help. In Bartholomew's Gazeteer of 1887, the population is given as 67.

Muriel Arber also quotes this reminiscence by the photographer's daughter Mary:

In those early days the "camera" was a huge square box, I should think about 30 inches square, it was lifted on to a little platform with wheels, and pulled along like a bath-chair from the front. The legs, strong and heavy, folded in half and had to be carried, and there was a little folding tent and all the apparatus for changing plates, and I have an idea that developing was sometimes, if not always, done at the spot.

Possibly Turner part-prepared his calotype negatives at the location of the photograph, inserting the negative into the camera moist[20] – or possibly his daughter's reminiscence refers to his brief experiment with the collodion process. The albums of 1855 and 1857 include technical information provided by Turner. Of his 1855 photograph of Bredicot Court he writes: "Taken by Fox Talbot's process in April, 10 a.m. in clear sunshine; Exposure 30 minutes; developed with Fox Talbot's Gallo-nitrate wash. Lens by A. Ross; focal length twenty inches; diameter four inches; Diaphragm half an inch." A smaller calotype by Hugh Diamond in this volume required an exposure of only six minutes. Turner's larger negatives and general preference for sharp focus in every plane required the longer exposure time.

In the club's 1857 album Turner contributed a view of Bonchurch in the Isle of Wight. This time Turner's technical notes indicate – what is evident from the print – his use of the collodion-on-glass negative: "Taken on Collodion, June 1856, 1 p.m.; weather hot and bright; Exposure two minutes; developed with Pyrogallic acid". The lens was as before. Turner noted that his photograph was "Printed by the ordinary method [e.g., by sunlight] and toned with gold". The photograph was accompanied by lines of blank verse by H. Kirke White on the characteristic theme, frequently met with in these volumes, of the play of fancy in scenes of rural retreat. The play of light and shade among the forms of the church and the surrounding foliage, in which are to be found three figures (perhaps Turner, his wife and mother-in-law, might be thought to echo the sentiment of

[20]On the physical procedures of the calotype process during the 1850's, see *The Photographic News*, 1 October 1858; 19 November 1858, 127.

the verse. However, Turner's work with collodion was hard and wiry (and technically imperfect) compared to his mastery with the calotype negative. A critic asked, "Why has Mr. B. B. Turner sent us ineffective collodion in lieu of his charming calotype?"[21] He returned to calotype until taking up the gelatine dry plate late in his career.[22]

Turner's paper negatives, preserved at Bath, reveal considerable handwork. He blanked out skies with black ink and wash and rubbed graphite. Pencil drawing was used to variegate foliage detail. There are a number of variant negatives, showing that Turner made as many as four negatives of a favourite subject (*Kempsey Mill*), and two closely related ones (differing slightly in the density of tone as well as in viewpoint) of *At Compton, Surrey*, his almost stereoscopic farmyard scene (Fig. 4).

The grand albums from 1855 and 1857 at the Royal Photographic Society bear Turner's own book-plate. They were given to the society either by Turner himself or by his family after his death. His support of the society from its earliest days is well documented from the pages of the society's journals but also by the way in which he photographed his eldest son and namesake (see Fig. 3). B. B. Turner Jr. was photographed about 1855 reading a volume, which rests on a second volume. Close inspection reveals these books to be the first and second volumes of the *Journal of the Photographic Society of London*.

After Turner's death 245 paper negatives[23] were given to the Royal Photographic Society in a wooden box. Inside the lid is inscribed the information that the box contains "paper negatives mostly 15″ × 12″ made by B. B. Turner for Murray & Heath about 1850–60." It seems likely that the negatives were made by Turner himself for his own purposes (and perhaps these negatives, all of a large size, date from 1852 onwards) but that the London firm of Murray & Heath sold Turner's prints. The firm's prospectus states, (in the *Photographic Scrap Book*) "It is . . . intended to found a DEPARTMENT for the SALE OF PHOTOGRAPHIC PICTURES, selections being made from the best and most interesting specimens". It is most unlikely that the firm ever issued a catalogue of the prints they stocked.

[21]*Journal of the Photographic Society*, 21 February 1857, 215.
[22]*The Photographic Journal*, 10 October 1881, lists among the society's exhibits no. 181 *Burnham Beeches* ("Carbon Enlargements from Gelatine Negatives"), and no. 208 *Rivage Dinant on the Rhine* (same technical details): Turner also made and exhibited carbon prints from calotype negatives.
[23]There are no stereoscopic negatives, although Turner is said by Spiller (*The Photographic Journal*, 26 February 1895, 59) to have taken some for use with Wheatstone's stereoscope. Those in the Wheatstone Collection at King's College London cannot be attributed to Turner. See, however, Rainer Michael Mason et al., *Pygmalion Photographe: La sculpture devant la camera 1844–1936*, Cabinet des Estampes, Musée d'Art et d'Histoire, Geneva 1985, no. 31, "Buste de Dionysus", for a paper negative by Turner which may be half of a Wheatstone stereo pair.

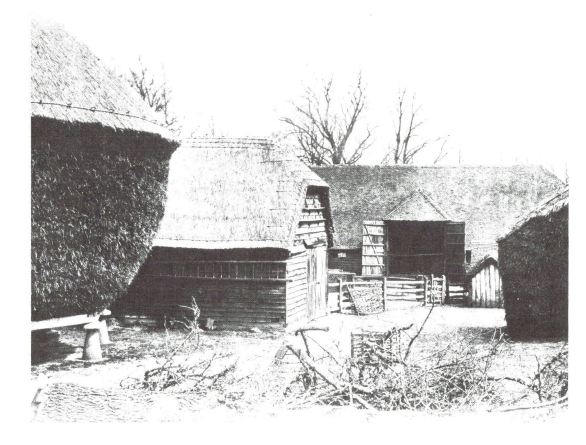

4. B. B. Turner, *At Compton, Surrey*, albumen (from calotype negative), 1852–54. Courtesy of the Board of Trustees of the Victoria and Albert Museum.

Murray and Heath played a role in promoting fine photographic prints, both as retailers, and as lenders to (for example) the Art Treasures Exhibition held in Manchester in 1857. They lent the famous *River Scene, France* by Camille Silvy to the major exhibition arranged by the Photographic Society of Scotland in 1858. Silvy's masterpiece, and perhaps the Le Gray photographs lent to the Manchester exhibition, may have been acquired from Murray & Heath by the connoisseur C. H. Townshend, who bequeathed his collections to the South Kensington Museum in 1869. Thus, those famous photographs, so prized as part of the Victoria and Albert Museum photograph collection today, may have been seen for the first time in Britain through the entrepreneurial skills, and in the Piccadilly or Jermyn Street premises, of Murray & Heath. It seems likely that the inscription in the box lid at Bath is correct, to the extent that the firm sold (rather than commissioned) photographs by Turner.

A descendant of Robert Murray, founder of the firm with Vernon Heath, preserves a collodion positive photograph of

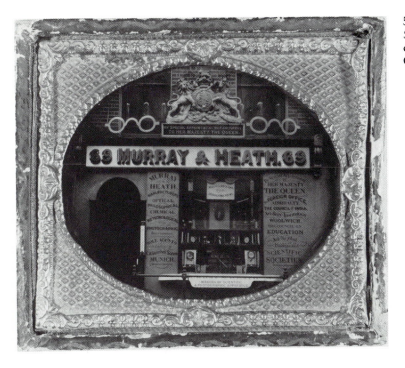

5. Anon., *Murray & Heath's Shop*, Jermyn Street, London, collodion positive, n.d. George Carter Collection.

their shop in Jermyn Street (Fig. 5). It is illuminating to consider that Turner's works were sold in the context of optical and philosophical instruments. At the centre of the shop display is what appears to be a portrait of Sir Isaac Newton. Murray, and in due course his son Robert C. Murray, were clearly ardent public expositors of the scientific principles and practical applications from which they made a living. The younger Murray followed his father as a demonstrator of new instruments at the Royal Institution ("on one or two occasions to the late Prince consort and his two Royal sons Edward and Alfred") and described himself in an autobiographical fragment as "a constant attender at the old Polytechnic, the Royal School of Mines and the South Kensington Museum, then being ambitious to do the utmost in teaching and imparting the knowledge gained in Science and Photography besides the commercial working party".

At the end of the glittering decade of high ambition for the art of photography in Britain and France, Murray & Heath were responsible for a display of "philosophical instruments" at the the famous Photographic Soirée held at the Mansion House in the City of London. The soirée, held on 18 April 1859, included a display of photographs, by Turner among others. Murray & Heath showed dissolving stereo views and "a very elegant little model, showing practically the application of electromagnetic motive power" (according to an unsourced press-cutting). A

writer for *The Photographic News* (21 April 1859) described a scene in which we can imagine B. B. Turner and his wife, and no doubt the younger Murray as demonstrator. The report gives some idea of how splendid it may have been, on occasion, to be associated with the serious art of photography in the 1850's and how photographs were part of an ethos of rational, but surely inspiring, entertainment:

> The company, on arriving at the Mansion House, were introduced to the Lord Mayor, the Lady Mayoress, and the President of the Blackheath Photographic Society (Mr. Glaisher, F.R.S.), after which each individual was at liberty to wander about the Egyptian Hall and adjoining apartments, and admire the numerous beautiful photographs suspended along the walls, and the no less interesting pictures in the stereoscope. The hall was most brilliantly lighted, and the animation imparted to the general aspect of the company by the presence of ladies in gay dresses, which, owing to the present fashion, were seen to great advantage, made it one of the prettiest sights imaginable. Add to this the charm of music at short intervals and an abundant supply of delicacies for the restoration of those whom enthusiastic admiration of Delarue's wonderful stereogram of the moon, Glaisher's photographs of snow crystals, Williams's portraits, and other pictures, had somewhat exhausted, and it will easily be understood that the whole affair was as well conducted and agreeable as possible.

Turner began his posthumous career early. In 1898 his son, H. Fownes Turner, lent eight works to the gigantic photography exhibition held by the Royal Photographic Society at the Crystal Palace. With a pleasing circularity, the exhibits included *The Church Oak, Hawkhurst, Whitby Abbey, Photographic Truth* and *Interior of the 1851 Exhibition.*

Perhaps it was not long afterwards that his negatives were presented to the Royal Photographic Society by the family – not all, though. Some are now in the University of Texas, Austin. In a major exhibition of international photography held at the Musée des Arts Decoratifs, Paris, in 1965, André Jammes showed an important group of prints and negatives by Turner, mainly from his own collection, and described Turner as "un des plus grands calotypistes anglais". On 6 June 1980, *Photographic Truth* and other photographs by Turner came to auction at Christie's in South Kensington, and major works by him were offered at successive sales on 30 October 1981, 26 March 1981, 18 June 1981, 29 October 1981. By direct bidding, or subsequently through international dealers in fine photography, the major museums and private collections in Europe and the United States acquired major examples of a major English calotype artist.

8. PHOTOGRAPHY AND TOPOGRAPHY: Tintern Abbey

David Harris

In this volume the Publisher has availed himself of the accuracy of Photography to present to the reader the precise aspect of the places which, at the same time, are commended to his notice by the pen. It appears to us a decided advance in the department of Topography, thus to unite it to Photography. The reader is no longer left to suppose himself at the mercy of the imaginations, the caprices, or the deficiencies of artists, but to have before him the genuine presentment of the object under consideration. We trust that this idea of our Publisher will be pursued to the extent of which it is capable; and that hereafter we shall have works of topography and travel, illustrated by the photographer with all the yet-to-be improvements of the art, so that we shall be able to feel, when reading of new scenes and lands, that we are not amused with pleasant fictions, but presented with realities. With this sentiment, we submit the present work to the public as a step in the right direction, and as an evidence on the part of the publisher of a desire to assist in authenticating literature by the splendid achievements of modern art.

These words are taken from the preface to William and Mary Howitt's book *Ruined Abbeys and Castles of Great Britain*.[1] In 1862, the use of photographs (rather than a combination of steel and wood engravings) as illustrations for an arm-chair travel book was still rare enough to warrant such a statement. However, the ideas themselves and even their formulation were by no means unique but rather were typical of the period. Such passages provide us with insights into the mid-nineteenth-century mind, how writers understood photography and promoted its use.

The large body of nineteenth-century writing on photography, which includes both critical and scholarly work, as well as more popular accounts, such as the Howitts's preface, reveals the gradual process whereby photography fundamentally altered our knowledge of the visual world. In the case of topographical representation, photographs provided more accurate and reliable information but did not initially alter the nature of the tourist's experience. Rather than eliciting a new response,

[1] William and Mary Howitt, *Ruined Abbeys and Castles of Great Britain. The Photographic Illustrations by Bedford, Sedgfield, Wilson, Fenton, and Others*, London 1862; second vol. 1864. See Gwen Schmaltz, "Ruined Abbeys – And the Howitts", *Northlight* 7(1977), 46–53.

photography perpetuated the established interpretations of such romantic sites as Tintern Abbey.[2]

The use of the first-person plural gives the Howitts's preface its authoritative and confident tone. Rather than forming a cohesive argument, the writers rely upon a series of rhetorical declarations to articulate their understanding of the nature and impact of photography in the 1860's. A number of assertions are made: photography is the ideal medium for the recording and preserving of visual information; all previous forms are flawed and unreliable; photographs are not merely another form of conventional representation but equivalent to the subject itself. For the Howitts, photography represented the triumph of truth over falsity, presenting us with "realities", while topographical prints and drawings were relegated to the position of "pleasant fictions". In common with other contemporary accounts, the Howitts's position was based on the technical capabilities of the camera, and what the photographic process seemed to guarantee in the resulting image. In their preface, two related concepts are advanced. The first of these states that the method of image production determined the truthfulness or falsity of information in the final work. The mechanical operations of the camera, in which the photographer's hand played a minimal role, ensured that the resulting photograph was completely faithful to the original subject. In contrast, a hand-drawn image was a subjective interpretation which was inherently unreliable. Although the passage is ambiguous at this point, credit for the photograph is accorded to the machine, and the photographer is clearly cast into a subordinate role. This idea is frequently found in the early accounts of photography. In a letter written to the editor of the *Literary Gazette* on 2 February 1839, William Henry Fox Talbot used this argument to explain the characteristics of photography:

> From all these prior [drawing devices], the present invention differs totally in this respect (which may be explained in a single sentence), viz. that, by means of this contrivance, it is not the artist who makes the picture, but the picture which makes ITSELF. All that the artist does is to dispose the apparatus before the object whose image he requires; he then leaves it for a certain time, greater or less, according to the circumstances. At the end of the time, he returns, takes out his picture, and finds it finished.[3]

The conclusion of such a line of reasoning is that what is mechanically produced must be truthful, and that therefore all photographs are reliable representations. By implication, all

[2] A parallel argument is found in Ray McKenzie, "The Cradle and Grave of Empires: Robert MacPherson and the Photography of Nineteenth Century Rome", *Photographic Collector* 4(1983), 215–32.

[3] Cited in G. Buckland, *Fox Talbot and the Invention of Photography*, Boston and London 1980, 43.

drawings are false or at best limited in their ability to provide accurate information.

The second concept equated the physical operation of the camera with that of the human eye.[4] Although the argument is not fully developed, the conclusion is that photographs represent truth since they present what the photographer saw, and by implication what the viewer would see if he visited, in the case of topographical photography, the site. As the photograph becomes the equivalent of the scene, so the viewing of the photograph becomes equated with the direct experience of the place. Sir David Brewster wrote:

> The homefaring man, whom fate or duty chains to his birthplace, or imprisons in his fatherland, will, without the fatigues and dangers of travel, scan the beauties and wonders of the globe, not in the fantastic or deceitful images of a hurried pencil, but in the very pictures which would have been painted on his own retina, were he magically transported to the scene.[5]

The Howitts also subscribed to a widely held belief that the photograph provided an unmediated record of its subject. Neither the pictorial conventions nor the optical and chemical properties of the medium could affect the quality and character of the visual information found in the photograph. Although the Howitts refer vaguely to future improvements of the photographic process, the sense is that these can only result in a more authoritative image or record.

In many ways, the Howitts's arguments are retrospective in nature. It was only with photography that one could address the problem of topographical representation in such a way. Before its invention, one had no means of assessing the information found in a picture, what was inherent in the objects themselves and what had been added by the artist. The Howitts's phrase "at the mercy of the imaginations, the caprices, or the deficiencies of artists" perfectly conveys a state of uncertainty and mistrust. Short of a personal acquaintance with the subject, there was no means of judging a drawing's accuracy. In the Howitts's minds, photography provided the equivalent of such knowledge.

It is not difficult to cite examples of hand-drawn images in which resemblance to Tintern Abbey is so slight as to justify fully the Howitts's apprehensions. William Gilpin's drawings of Tintern Abbey which appeared as aquatint engravings in his *Observations on the River Wye* of 1782 provide a forceful example.[6] The assumption that these illustrations represent Tintern Abbey is based upon their place in the text. The architecture has been

[4]See H. F. Talbot, *The Pencil of Nature*, London 1844, commentary on pl. 3.
[5]Sir D. Brewster, "Photography", *North British Review* 7(1847), 502.
[6]Reproduced together with the original watercolours in Carl Barbier, *William Gilpin, His Drawings, Teachings, and Theory of the Picturesque*, Oxford 1963, pl. 9.

generalized into a gothic ruin and set within an idealized Italianate landscape. From the evidence of both written accounts and visual documentation, small and dilapidated cottages surrounded the Abbey on the north and west sides and a thick forest enveloped it to the south, east and north until the 1830's.

Gilpin justified his alterations to the appearance of Tintern Abbey and its surrounding topography in a well-known letter to William Mason in 1784:

> I did all I could to make people believe that they were *general ideas* or *illustrations*, or any thing, but what they would have them be, exact portraits; which I had neither the time to make, nor opportunity, nor perhaps ability; for I am so attached to my picturesque rules, that if nature gets wrong, I cannot help putting her right.[7]

Gilpin's motives are clearly mixed: he describes the purpose of the illustrations as presenting his "general ideas", indicating that he imposed his theories of picturesque beauty wilfully over the existing topography. At the same time, he modestly deprecated his abilities, admitting that he had neither the skill nor the time to produce accurate representations even if he had wanted to do so.

Admittedly, Gilpin's prints are extreme examples, but as the quoted letter indicates, it is not a simple matter to differentiate between information and interpretation in hand-drawn images. With such images, it is impossible to separate what Tintern Abbey looked like from what it represented in cultural terms. Gilpin's work epitomized the dilemma facing a reader seeking reliable information from topographical prints. A representation such as Louis Haghe's lithograph *Interior of Tintern Abbey, Monmouthshire (Looking East)*, published in 1841 (Fig. 1), appears to be far more accurate and reliable than Gilpin's prints. However, when placed next to Roger Fenton's *Interior, Tintern Abbey* (Fig. 2), the superiority of the photographic information in presenting the "precise aspect of the place" is revealed through such specifics as the fall of light on the Abbey's floor and columns, the texture of the stone and the genus of vegetation. Photography seemed to provide the means of separating aspects of interpretation from description, at least as the problem was understood by nineteenth-century writers. Largely because of its mechanical nature, photography provided the reader with description only. Modest though it is, the Howitts' preface is symptomatic of an almost naïve faith in the objectivity of the photographic process.

If, as they claimed, photography marked a turning point in the nature and hence the history of topographical representation, one would expect this sensibility to inform the entire text.

[7] Cited in Barbier, ibid., 72.

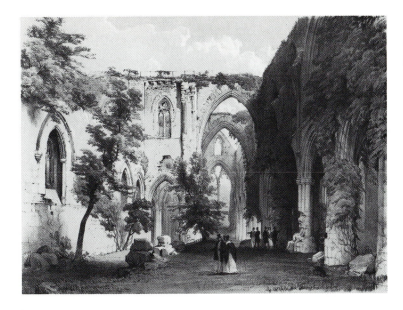

1. Louis Haghe, *Interior of Tintern Abbey, Monmouthshire (Looking East)*, tinted lithograph, from *Views of Tintern Abbey and Chepstow*, Bristol 1841. Yale Center for British Art.

However, except in the use of photographs as illustrations, the book is virtually indistinguishable from others produced during the same period. Since the photographs are mentioned only in the preface, one would assume that the text was conceived of and written independently of the photographs, and followed the conventions of British topographical writing. Indeed, to understand how photographs fitted into the traditions of topographical books, one must define the separate purposes of the text and illustrations, and further their relationship to one another.

A nineteenth-century reader would have approached the illustrations of Tintern Abbey with a set of literary and historical ideas in mind. From about 1770, British tourists began to explore South Wales, and, by 1805 an image involving the related ideas of nature, architecture and history had been formed around the experience of visiting Tintern Abbey.[8] Information about the history and architecture of the Cistercian monastery with an aesthetic appreciation of the ruins as an integral part of the landscape were woven into a narrative of a visit to the Abbey. The accounts dwelt on such aspects of the ruin as its relative isolation and solitude in the sheltered valley of the Wye River, the effects of time and nature upon the building (as seen in the weathered stone and encrustations of ivy and moss) and the historical associations of the retiring Cistercian monastic order:

> Approaching this sublime and sequestered spot, the enthusiastic lover of simplicity in art and nature, the admirer of the pic-

[8]See J. E. Vaughan, *The English Guide Book c. 1770–1870*, Newton Abbot 1974.

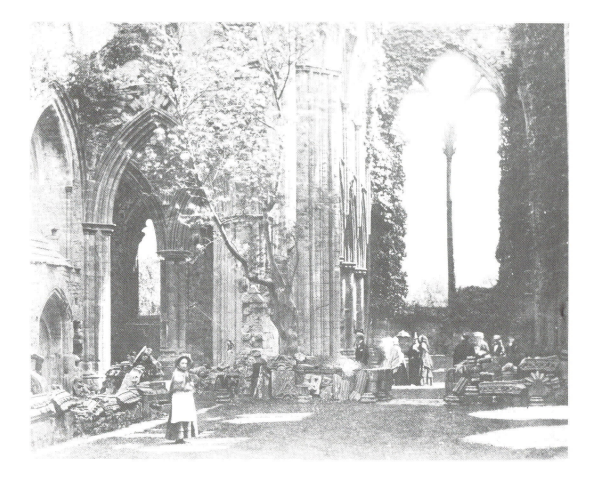

2. Roger Fenton, *Interior, Tintern Abbey*, albumen, c. 1857. Centre Canadien d'Architecture/Canadian Centre for Architecture, Montréal.

turesque and beautiful, the antiquary, and the moralist will feel the effect, as it were, of enchantment, and become lost almost in a pleasing melancholy. The sleepy hills, the hanging woods, the rolling stream, the nodding ruin, the surviving monument of fallen grandeur and beauty in decay; the constructed space, the stillness and retirement, all conspire to impress the mind with awe, and for a moment withdraw it from its raw pursuit of wealth and power, and abstract it from the world.[9]

After 1800 little new research was undertaken and the subsequent guide-books increasingly relied upon previous ones for their information and emotional response. The established themes of the refreshment found in nature, the mortality and vanity of earthly pursuits, and a yearning for the past were repeated and reworked in a heightened emotional tone.

These books combined the separate roles of guide with interpreter and, in their accounts of visiting the Abbey, moved easily and naturally from topographical description to reflection

[9]Samuel Ireland, *Picturesque Views on the River Wye*, London 1797, 132–3.

and, increasingly in the nineteenth century, to moralizing. The reader was encouraged to approach the Abbey with a set of literary and historical ideas in mind and to use the occasion of a visit (even if only from an arm-chair) to engage in historical, poetical and ethical reflection. Within this literary tradition, the emphasis changed with the political and religious convictions of the writer, but the essential approach remained constant: the Abbey was valued not for what it was in itself – a thirteenth-century ecclesiastical ruin – but for what it could evoke in the mind of the reader. For example, William Beattie, in *The Castles and Abbeys of England*, stressed the political and religious significance of medieval ruins as representing the visible links with the past where many of the present freedoms and traditions had originated.[10]

The plates which accompanied the text in such guide-books acted as vehicles for reflection, combining topographical information with an interpretation. Indeed they were meant to recall and simulate the associated experiences of visiting the Abbey as described in the writing. In this way, the prints were intended to engage the viewer on both a visual and an emotional level: they illlustrated the experience of visiting the Abbey rather than merely describing it.

Following upon this tradition, photographs of Tintern Abbey made the immediate visual experience of the ruin more vivid. This is what the phrase "to have before him the genuine presentment of the objects under consideration" implied. Photography was asked to authenticate an experience but not alter it. A new medium, even one as potentially radical as photography, could not force a new interpretation upon its viewers nor change their visual habits all at once. Not until the photographic process – the way in which information is recorded – was understood more fully could such a transformation occur.

At the heart of the Howitts' text, there exists a fundamental ambiguity. As a preface, it describes an attitude towards photography that is not evident in the rest of the book, nor is it reflective of the experience or expectations of the contemporary tourist in examining topographical illustrations. As a document, it does typify the nineteenth century's desire for a system of visual representation that would be both unbiased and truthful.

[10]W. Beattie, *The Castles and Abbeys of England*, London and New York 1844–45, 1:2.

9. ROGER FENTON:
Landscape and Still Life

Mike Weaver

Roger Fenton was born in 1819 into a middle-class, land-owning family in Lancashire, a county which, partly because of its proximity to Ireland, had been a stronghold of the Catholic faith for centuries. An ancestor, Roger Fenton (1565–1616), had been one of the authors of the Revised Version of the Bible, and preacher to the readers of Gray's Inn, which his descendant, a lawyer, was more familiar with as one of the Inns of Court. Fenton, the Anglican divine, although he wrote a treatise against the hegemony of Rome, was noted for his respect for Catholics.[1] A Catholic school, Stonyhurst, was founded in 1794 near Blackburn, when the Roman Catholic Relief Act permitted the school to be established. Roger Fenton was baptized as a Congregationalist and married in an Anglican church, but even as a member of the Free Church he would have still recognized the Catholic tradition in the Independent liturgy. He was on extremely good terms with his Catholic neighbours at Stonyhurst when he presented the school with a handsome collection of his work in 1859.

Roger Fenton, the lawyer, began his career in the Faculty of Arts and Laws at University College London in 1836, just a few years after religious tests were abolished at Oxford and Cambridge. He won prizes for Greek, Latin, English and Philosophy of the Mind before graduating with the degree of bachelor of arts in 1840. Although UCL represented a broad church with Whig connections, it was still against the exaltation of reason over faith. Charles Cameron, Julia Margaret's husband, had been elected by his Utilitarian supporters to the first Chair of Moral and Political Philosophy at London University, only to be rejected by Council because he was not in holy orders. When Fenton was at UCL, the religious controversy over the Oxford or Tractarian movement was at its height. The pervasiveness of religious feeling in the period allowed him to submit a photograph reproducing a relief showing Mary receiving Elizabeth's child, John the Baptist at his birth, as his contribution to *The Photographic Album for the Year 1857*, and to offer an "Ecce Homo" from a drawing as an entry to the International Exhibition of 1862. As a member of the Arundel Society, his interest in the reproduction of great Christian works of art cannot be wholly

[1]*Dictionary of National Biography* 6 (1908), 1191.

explained by his highly profitable career as official reproductive photographer to the British Museum. Like others of his time, he was subject to its peculiarly religious temper.

The gentlemen of the early photographic clubs and societies saw themselves as part of a national clerisy in which physical science was still pursued in the context of other kinds of knowledge, including religion: the motto of the other great London University college, King's, was *Sancte et sapienter*. Nor did the industrial aims of the Society of Arts, from which the Photographic Society of London sprang, lead to the proscription of religion. Although Fenton would have considered photography a physical science, one of the main tenets of which was to prove the independence of the real world, he believed that an accurate record in no way precluded reflection of the mental state of the observer:". . . . everything that is ideal . . . is translated to us materially. Every disposition of mind has its bodily expression".[2] If topography was a mundane representation of places in which man's activities were set, landscape could represent man's psychological feelings about those places for spiritual and moral ends.

One of the photographers who exhibited with Fenton at the International Exhibition of 1862 was James Mudd, a Mancunian. Whereas Fenton won a medal "for great excellence in fruit and flower pieces, and good general photography", Mudd got his "for very excellent landscapes".[3] In a book of hints on composition, Mudd expressed the common idea that the Deity had stamped the face of nature, no matter how lightly, with an impression of His moral truth – with what John Ruskin called "a language of types".[4] Mudd wrote:

> Now, although nature may be said to be always beautiful, yet there are certain groupings of objects in relation to each other – certain agreeable outlines and combinations of forms – which, however difficult to explain in words, are seen at once, and recognised as picturesque.[5]

The existence of a picturesque quality thus depended upon the grouping of objects. One difficulty for the photographer was "to determine the order in which objects shall be associated". This is where Mudd's hints on composition were useful. Objects should be well spaced, not placed too close together, or piled on top of each other – this would flatten the picture plane, and was undesirable. A series of lines parallel to the bottom of the

[2]R. Fenton, "Introductory Remarks", *A Catalogue of an Exhibition of Recent Specimens of Photography*, Society of Arts, London, December 1852, 6.

[3]International Exhibition of 1862, *Catalogue of the Photographs Exhibited in Class XIV*, London 1862, 14.

[4]J. Ruskin, *The Complete Works*, ed. E. T. Cook and A. Wedderburn, London 1904, 11:41.

[5]J. Mudd, *The Collodio-Albumen Process*, London 1866, 42.

picture would also flatten the image, and needed to be broken up by foreground details. Albertian perspective was important to photographers who took J. D. Harding as their guide. The rise of stereoscopic photography in the late 1850's was not due simply to commercial opportunity but reflected anxiety about the loss of traditional perspective in photography. There was always the danger that overcrowded and overlapping elements in a picture would lead to perceptual confusion and obscure the main subject of a picture. A proper order of associating objects or elements in a picture allowed the imagination to work properly. Correct combination of elements underpinned the proper reading of a language of such combinations or types. Mudd's phrase "however difficult to explain in words" suggests that the point was not to be so much descriptive as "picturesque" in one's treatment of the natural scene.

When Arthur Hallam reviewed Tennyson's early poetry,[6] he also used the word "picturesque" positively to suggest emotion could be conveyed sensationally by objects in the external world, as well as bestowed associatively upon them by the viewer. Today, "picturesque" and "pictorial" have overtones of sentimentality and empty imitation of the past, but it was not always so. John Ruskin's solution was to distinguish between what he called the "surface" and the noble picturesque. Mere superficiality of painterly effect was set off against the profundity of an image which would arouse significant trains of thought.[7] In the early part of the century, when Ruskin was still an Evangelical, and when Wordsworth's reference in *The Prelude* to types and symbols of eternity found in landscape was still fresh in people's minds, the idea of nature revealed by religion, and of religion embodied in nature, had not yet faded. Indeed, the Tractarians carried immanence in landscape deep into the last half of the century. John Keble's *The Christian Year* (1827) was immensely popular, and his *Tract for the Times* on biblical typology maintained the traditional analogy between natural and moral things, which were considered to reflect mutually upon each other.[8] Keble combined a Wordsworthian pantheism with a more specifically typological sense of God's immanence in the landscape. Thomas Gray had written, "not a precipice, not a torrent, not a cliff, but is pregnant with religion and poetry",[9] and Ruskin reaffirmed, "the earth, in its purity, sets forth His eternity and his TRUTH".[10] Both were referring to the Epistle to

[6] *The Writings of Arthur Hallam*, ed. T.H.V. Motter, New York 1943, 192.
[7] Ruskin, *Works*, 6 : chap.1.
[8] [J. Keble], "On the Mysticism Attributed to the Early Fathers of the Church", *Tracts for the Times* 89, London 1841.
[9] *The Correspondence of Thomas Gray*, ed. P. Toynbee and L. Whibley, Oxford 1935, 1:138.
[10] Ruskin, *Works*, 11:41.

the Romans (1:20), "For the invisible things of Him from the creation of the world are clearly seen, being understood by the things that are made".

To transform nature from scenery into landscape art requires a code by which various aspects of the natural scene are accommodated to current ideology. Today the set of ideas is social, but in Fenton's time biblical references still conditioned the idea of what was beautiful in nature. A shady valley, a rocky river-bed, or an upland bridge carried a set of associations ultimately related to certain Christian doctrines. Mudd's "certain groupings" of objects in the landscape were recognized by the artist as figures of eternity. They had a *pictural* value which combined both forms and ideas into a language of types. It was a code that had been evolved through a thousand years of Christian art, reflecting the accumulated feeling of ages, always different in terms of changing pictural styles, but constant to the pictural meaning of the doctrines which had engendered its types.

It is possible to list some of these motifs or types, together with their variations or subtypes, and to indicate some doctrinal references. In accordance with the dualistic nature of Christianity the type can be treated both *in malo* and *in bono* – in a bad or malign sense as well as in a good or benign sense. Each type is, therefore, binomial:[11]

The Tree:	stump, intertwining trees, three trees (Sacrifice/Redemption)
The Rock:	boulder, stone, mountain (Vengeance/Foundation)
The Cliff:	cave, sandy bank, crag (Entombment/Virginal Conception)
The Arch:	vault, clearing (Hell/Heaven)
The Stairway:	ladder, pathway, road (Descent into Hell/Ascension)
The Mill:	granary, threshing-floor (Judgment/Resurrection)
The Waterfall:	well, pool, sluice (Deluge/Salvation)
The Bridge:	aqueduct, canal-lock (Flight/Conversion)
The Sanctuary:	church, castle, cottage, vehicle (Destruction/Forgiveness)
The Cloud:	banner, sail, linen (Divine Wrath/Ministry)

[11]This provisional list is the result of a continuing collaboration between myself, Anne Hammond and Chris Titterington.

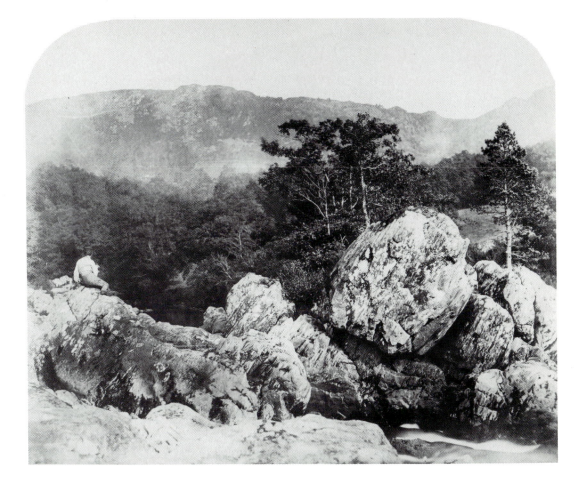

Fenton's *Bowder Stone, Borrowdale*[12] shows a curious geological feature with a pagan legend undoubtedly attached to it, but J. M. W. Turner's *Desert of Sinai*,[13] featuring a similar boulder, carries with it associations of the Holy Land: such boulders are both big enough to found churches, and to destroy whole houses – as can be seen in Turner's *Fall of an Avalanche in the Grisons* (London, Tate Gallery). *Junction of the Lledr and the Conway* (Fig. 1) shows such a rock apparently sprouting trees above a stream. This associates it with the baptismal boulder as well as with the stone rolled away at the Entombment. The figure in the picture viewing the landscape contemplates not just the junction of two rivers but the relation of joy to sorrow. Fenton's

1. Roger Fenton, *Junction of the Lledr and Conway*, albumen, 1857. Royal Photographic Society.

[12]Valerie Lloyd, *Roger Fenton*, London 1988, [94]. (Hereafter, references in the text will appear as, for example, RF94 = *Roger Fenton*, p. 94.)

[13]T. H. Horne and W. E. Finden, *The Biblical Keepsake*, 1835, n.p. John Brett's *Val d'Aosta* (1859) uses foreground rocks in a similar way (see frontispiece to Ruskin's *Works*, 14).

2. J. S. Cotman, *Hell Cauld-ron, called Shady Pool on the Greta*, watercolour, [1808]. National Galleries of Scotland.

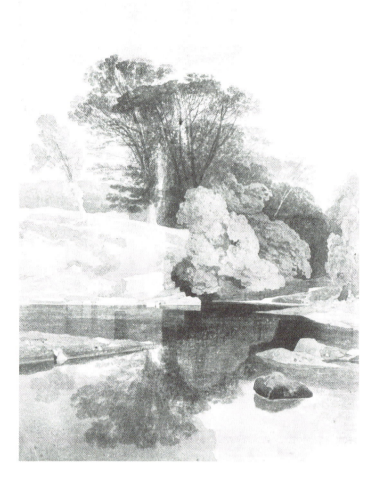

Double Bridge of the Machno (RF90) combines the Cliff with the Tree, but the tree is so dominant that it also suggests the Arch and the Bridge. The Machno's ruined bridge has been overgrown by the tree. In the context of the river, the pools are types of the Waterfall, and the dark mystery of the crag with a tree grow-ing out of it refers us simultaneously to resurrection and con-ception. The dappled effect of whited and moss-covered rocks transforms a scene of sensuous particularity into an abstract thought. John Sell Cotman's *Hell Cauldron, called Shady Pool on the Greta* (Fig. 2) has a title which conveys first the bad sense and then the good sense of the scene. Cotman makes it one of perpetual joy and summer, comparable with Fenton's *Junction of the Lledr and the Conway* (see Fig. 1). The watercolours of Cot-man and the photographs of Fenton share the same language of types.

The Vehicle (boat, cart, wheelbarrow) is a part of the type of the Sanctuary – every castle and church needs one to be

complete. Fenton's *Church of St. Vasili, Moscow*,[14] for instance, shows a cart centred in the foreground. A view across the River Dnieper of the Monastery of the Caves, *Kievo-Pecherskaya Lavra* (RF33), and another across the harbour of *Lincoln Cathedral* (H47), show boats on the bank and in the water. At Kiev two boats rhyme with two towered buildings on the bluff. At Lincoln the boat, blurred by the length of the exposure, completes the idea that it is a temporary tabernacle whereas the cathedral is the True one. This is, indeed, how John Constable relates a cart drawn by three horses across a river to the cathedral in *Salisbury Cathedral from the Meadows* (London, Tate Gallery, oil-sketch), and in *Dedham Vale* (Edinburgh, National Gallery of Scotland), where a tent, a boat, a bridge, and a church all correspond vertically in the picture plane. When Fenton went to the Crimea he did not leave this kind of metonymical construction behind. In *The Ordnance Wharf, Balaclava* (H17) he made a three-masted naval ship the Sanctuary, and subordinated to it a shed and cart on shore. What was normally the moveable element in the type – the boat – is here firmly established. As a political use of the typology in wartime, it suggests that wherever the Royal Navy drops anchor, there the British monarchy, uniting church and state, defends the faith.

Etymologically, the nave of a church has long been associated with a ship (Latin, *navis*), and may also relate to the hub of a wheel (Anglo-Saxon, *nafu*). One theory of Gothic architecture, however, attributes the origins of the nave to an avenue or grove of trees. In *Chapter House and Cathedral, Salisbury, from the Bishop's Garden* (RF140), what makes the views typological is the great living Tree centred in the frame: now a tree is in the position of the vehicle. This substitution of elements within a typical relationship is what makes the language infinitely variable and richly creative. In an untitled landscape by Fenton of a boat placed in relation to a large tree on a far bank (Fig. 3), the shadow of the tree is reflected in the water next to the skiff. The tree–vehicle relation seems weighted in favour of the boat until we notice that the tree's significance is inflected by the line of washing near it on the far shore – the subject of the drying grounds, originating in the preparation of the linen at the Nativity, and in the linen clothes at the Tomb. The effect of the washing-line is to modify significantly our feeling about Fenton's landscape. The boat seems suddenly very empty. If the cathedral–tree pictures are in a major key, the skiff–tree image is in a minor one.

Fenton's *Kew Ait*[15] shows a large boat laid up on a forest

[14]J. Hannavy, *Roger Fenton of Crimble Hall*, London 1975, pl. 4. (Hereafter, references in the text will appear as, for example, H4 = Hannavy, pl. 4.)

[15]*Nature and the Victorian Imagination*, ed. U. C. Knoepflmacher and G. B. Tennyson, Berkeley 1977, 3.

3. Roger Fenton, *Tree and Skiff*, albumen, n.d. Royal Photographic Society.

floor, with a man seated in the stern sheets. An ait is literally an island, figuratively a refuge, and figurally a tabernacle. With a tree growing from it, such a boat is an emblem, found in genealogies of sacred history, of the Ark which survived the Deluge, and which supports the family tree of Christianity. Centred in Fenton's picture is a wreath of growing foliage. Together with the inscription on the stern this suggests the grave. A painterly precedent available to Fenton was Constable's *Leaping Horse* (London, Royal Academy of Arts), the left side of which shows a tree–boat–sail combination.

On the Beach, Hythe (RF107) is a lateral reversal of a great watercolour by Cotman, *Seashore with Boats* (London, Tate Gallery), in which Fenton's Napoleonic roundtower substitutes for Cotman's headland (the Sanctuary). Cotman's sail on a ship at sea, the hull of which is blocked from view by the empty boat on shore, is related to his cloud forms (the Cloud), whereas Fenton's sail is draped over a boat. Fenton's figures are most

suggestive, but, regrettably, he could not manage clouds here: these he had to confine to a few cloud–land pictures in the manner of Constable – and of Alfred Stieglitz.

View in the Slopes, Windsor[16] employs a symbolism of elevation, but there are two ways of ascent. One allows a direct glimpse of the castle through a clearing in the trees (the Sanctuary via the Arch), whereas the other is more gradual, via a pathway leading to a bridge and up the Slopes. The great tree standing between these two approaches is the counterpart of Fenton's tree in relation to a cathedral – the clearing–castle combination is a perfect emblematic homage by the camera to the Crown. *Raglan Castle, the Watergate* (H28) also shows two ways to a sanctuary: one beyond a drop-gate to a bank with two trees; the other through an arch and up a stairway to the top of an ivy-clad tower. *Helmsley Castle, the Fosse* (H51) compresses the elements of the Raglan picture into a narrower compass, and adds the seated figure of a woman in the arched doorway.

Numerous pictures by Fenton relate women to arches, which refer typically to Mary, mother of Jesus, and the Gate of Heaven. *Raglan Castle, the Porch* (H29) shows a woman before an arched gate and a gardener with his wheelbarrow and scythe. Residually referring to the scene of the Magdalene in the garden with Christ, the woman looks troubled: an uncertain relationship exists between her and the man, as in a genre piece. In another Arch picture, *A Vista, Furness Abbey* (H34), a girl also under an arched doorway looks down upon a flight of steps which, although bathed in a pool of light, promises her shadow a rougher footing ahead. Behind her, two youths are watching intently. It is a picture which deserves comparison with Peter de Wint's watercolour *The Devil's Hole, Lincoln* (Edinburgh, National Gallery of Scotland), in which a young girl drawing water at a pool is also watched by two boys. The feeling it evokes is of such biblical type-scenes as Rebekah, or Rachel, or Zuleika, at the well, with just a hint of Susannah and the Elders. *A Small Chapel in Tintern Abbey*[17] depicts a young peasant girl sitting on the ledge of an arched window. Her dress shows real wear – she is not "ragged" in Carroll's or Rejlander's genre fashion. The nettles by her side and the chipped crock in her lap hint at a loss of innocence before time, but we are most certainly not yet in the erotic world of William Bouguereau's *Broken Pitcher* (San Francisco, De Young Museum). With neat hair and handsome face the girl looks modestly away: there is still hope for her in terms of Wordsworth's ecclesiastical sonnet, "Baptism":

> Dear be the Church, that, watching o'er the needs
> Of Infancy, provides a timely shower

[16]F. Dimond and R. Taylor, *Crown and Camera*, Harmondsworth 1987, 56.
[17]Ibid., 126.

Whose virtue changes to a christian Flower,
A Growth from sinful Nature's bed of weeds!

One of Fenton's favourite subjects was fishing. It is hard
to imagine that, like P. H. Emerson after him, he was not a
devotee of *The Compleat Angler* by Izaak Walton. *The Keeper's
Rest, Ribbleside* (H31) shows a group of gentlemen and their ser-
vants professing angling, as amateurs of a photographic society
might have professed photography. In Walton's book, Piscator,
leader of the fishing expedition, asks whether man's happiness
is to be found in the contemplative or the active life, and claims
that angling covers both. Fenton would have felt the same about
photography in "representing in the most efficient possible man-
ner the *artistic* side and the *practical* side of the art". Walton
praises the early Christians as quiet men who lived in a time
before lawyers. The best of them were fishermen: " . . . it was
our Saviour's will, that these four Fishermen should have a
priority of nomination in the Catalogue of his twelve Apostles,
(*Mat.* 10) as namely first St. Peter, St. Andrew, St. James and
St. John, and then the rest in their order".[18] Venator, Piscator's
convert to fishing, confirms his faith in the following profession:

> As a pious man advised his friend, *That to beget* Mortification *he
> should frequent* Churches; *and view* Monuments, *and* Charnel-
> houses, *and then and there consider, how many dead bones time had
> pil'd up at the gates of death.* So when I would beget content, and
> increase confidence in the Power, and Wisdom, and Provi-
> dence of Almighty God, I will walk the *Meadows* by some glid-
> ing stream and there contemplate the *Lillies* that take no care.[19]

The college boy who contemplates the river in Fenton's *Paradise,
a view near Stonyhurst* (H43) is fulfilling early in his life Venator's
more recent vocation. When Fenton wrote about the penchant
of his countrymen for such subjects as "the unassuming church,
among its tombstones and trees", and "the quiet stream, with
its water-lilies and rustic bridge",[20] he was expressing Venator's
new credo.

Another characteristic Waltonian scene in Fenton's work
is *Pool in the Ribble* (H32), where trees over a pool form "a sweet
Arbour, which nature herself has woven with her own fine fin-
gers",[21] and where a blind wood is pierced by a tree-mullioned
clearing like a church window. The angler proffers his net as if
it were a kind of tracery as much for catching souls as fish.
Fenton wrote: "Every disposition of mind has its bodily expres-
sion. As one mental phase succeeds another, so do their material
formulas; if the first is rapid so is the second fleeting and hard

[18]Izaak Walton, *The Compleat Angler*, ed. J. Bevan, Oxford 1983, 201.
[19]Ibid., 371.
[20]Fenton, "Introductory Remarks", 6.
[21]Walton, *Compleat Angler*, 366.

to define".[22] To combine such objects in such a way as to strike a responsive feeling in the viewer was the true goal of the photographic artist, no matter how material or mechanical his medium.

The first few years of the *Journal of the Photographic Society*, when Fenton was secretary and editor, show just how practical he was. His manipulation of the institution of photography led to criticism that he and the other professionals were using the society for their own commercial ends. The private gentlemen were independent scientists in the tradition of the other societies of the day, like the Microscopical Society (founded 1839), the Chemical Society (1841), the Ethnological Society (1843), the Hakluyt Society (1846) and the Palaeontographical Society (1847). The first use that commercial photographers like Fenton made of the Photographic Society was to see it founded in the first place. Induced by amateurs, Talbot gave his blessing to the new society in the name of intellectual freedom. But before long it was obvious to the amateurs that membership of Council by the professionals was influencing the society in ways they had not anticipated. The journal anonymously announced the possibility of someone going to photograph the war in the Crimea[23] – and then Fenton went himself. Within two years of the society's founding, Fenton was a fully professional photographer at the British Museum.

Fenton served the establishment precisely at the point when the national need to compete with France and Germany in the field of arts, manufactures, and commerce was greatest. The Great Exhibition (1851), L'Exposition Universelle (1855) and the International Exhibition (1862) were, above all, manifestations of industrial competition between growing empires. When Fenton organized the exhibition at the Society of Arts ("for the encouragement of Arts, Manufactures and Commerce"), the first seventy-two items were photographs exhibited by the Royal Commissioners of the Great Exhibition. Photography's primary role, it seemed, was to reproduce statues, chandeliers, porcelain, musical instruments, clocks, ivory caskets, embroidered saddle cloths, fire grates and camel guns. Photography was serving the industrialization of the applied arts, and helping to create a taste for them.

The reorganization of art schools in this period, and the establishment of a *Journal of Design* (1849–52), were intended to encourage production of textiles, embroidery, pottery, metalwork, stained glass, and of every kind of ornamental article. In 1850, Fenton helped Ford Madox Brown and others found the North London School of Drawing and Modelling to further these

[22]Fenton, "Introductory Remarks", 5.
[23]*Journal of the Photographic Society* 1, 15 (21 March 1854), 176.

aims.[24] *The First Report of the Department of Practical Art* (1852) induced the Treasury to provide funds to acquire contemporary works for the express purpose of creating a permanent collection at Marborough House in order to improve public taste in design.

Francis Bedford was the finest single illustrator of what was called "practical, ornamental and decorative art" in the period 1851–57. Digby Wyatt's *Industrial Arts of the Nineteenth Century at the Great Exhibition* (1851), and Owen Jones' *Grammar of Ornament* (1856), were illustrated by lithographs made by Bedford and his assistants. But items in J. C. Robinson's *Treasury of Ornamental Art* (1857), and J. B. Waring's *Art Treasures of the United Kingdom* (1858), were first photographed, and then lithographed by Bedford: photography guaranteed the accuracy of the copies. The avowed aim of such works was to provide a "museographic" survey of objects of vertu at Marlborough House in Robinson's case, and in Waring's, an account of the contents of the Manchester Art Treasures Exhibition (1857), where the central hall had been filled from end to end with ornamental art.

Bedford, when not making landscapes, specialized in the photographic reproduction of ornamental art at Marlborough House. The Royal Photographic Collection at Windsor has an album of works of applied art which he compiled in 1854,[25] some of which were used for the lithography of Robinson's *Treasury*. At the British Museum, Fenton concentrated on statuary, reliefs, inscribed tablets, drawings and paintings. C. Thurston Thompson, Fenton's rival at the South Kensington Museum, made photographs of decorative furniture exhibited at Gore House (1853), of works at the Exposition Universelle (1855), of Raphael's drawings in the Louvre, and of plants for the Royal Horticultural Society (1863). Such was the desire to raise standards of art among the public that the Art Union of London in 1858–59 selected two volumes from existing work by Fenton, Frith, Cundall and Howlett, Caldesi and Montecchi, and Thompson, and distributed them free.[26]

Relations between the artist and the art-workman were tense in this period. High art was asked to confer its grace upon ornamental design and industrial art to bestow its strength on fine art. It was hoped that differences between the useful and the fine arts were not irreconcilable. The nautilus shell, an example of "the perfect compatibility of the highest utility with the greatest beauty, and with the greatest simplicity of material",[27] had, after all, been mounted as cups and depicted in still-life painting since the seventeenth century. Flowers also com-

[24]Lloyd, *Roger Fenton*, 2–3.
[25]*Crown and Camera*, 52.
[26]L. S. King, *The Industrialization of Taste*, Ann Arbor 1985, 169–71.
[27]G. Wilson, *The Relation of Ornament to Industrial Art*, Edinburgh 1857, 28.

bined utility, beauty and simplicity. They were not just sensual temptations to pleasure but evidence of the truth of natural theology. They could be used allusively as well as decoratively, symbolically as well as playfully. One analyst wrote:

> We may term those styles symbolic in which the ordinary elements have been chosen for the sake of their significations, as symbols of something not necessarily implied, and irrespective of their effect as works of art, or arrangements of forms and colours. Those that are composed solely from principles of symmetry of form and harmony of colour, and exclusively for their effect on our *perception of the beautiful*, without any further extraneous or ulterior aim, may be termed aesthetic.[28]

Clearly, a response to the religious temper of the age would affect relations between the symbolic and aesthetic in a given work of ornamental art. In the period of the Gothic Revival religious symbolism might be said to have divided the field of ornament with aesthetic design. In D. O. Hill's painting *The Signing of the Deed of Demission*, the arrangement of pewter communion plate, books and newspapers, symbolizes the Free Church. But in Bedford's arrangements of cups, plate and china, sometimes with the addition of fruit and with a background of drapery, the effect is intended to be purely aesthetic. It was probably Bedford who gave Fenton the idea of combining in his still lifes objects of vertu with fruits and flowers. The Manchester Art Treasures exhibition had begun to synthesize the sensibility of the artist with that of the art-workman in the national interest. It was a patriotic duty to unite arts and manufactures in the interests of the commercial community. Certainly it was an attitude which attracted royal patronage.

On exhibition at Manchester in 1857 in the fine arts section were fruit pieces by George Lance and William Henry Hunt. Lance seems to have confined himself to fruit, without the addition of ornaments. But Hunt, on the other hand, has left us a watercolour, *Fruit and Tankard* (Manchester, the Whitworth Gallery), which includes a tankard, like one Bedford photographed and lithographed, together with a glass chalice, fruit and drapery. Among Hunt's effects at his death were this tankard and a set of Fenton's Crimean photographs.[29] If Fenton took from Bedford the idea of displaying *objets de luxe*, he was reminded by Hunt of a late-eighteenth-century tradition of still-life painting in the Netherlands – Jan van Os's use of *fruits de luxe*. But "Bird's Nest" Hunt did not usually paint ostentatious still lifes, the epitome of bourgeois aspiration. He took a half-plebeian interest in the natural beauty of peaches, grapes, apples and wild flowers, rather than in Fenton's and van Os's exotic

[28]Ralph N. Wornum, *Analysis of Ornament*, London 1856, 5.
[29]John Witt, *William Henry Hunt (1790–1864)*, London 1982, 242–3.

pineapples, pomegranates and cultivated flowers. Chinamania, the Gothic Revival and a certain neoclassicism mark a taste ultimately different from Hunt's. Fenton's interest in the exotic extended to his Nubian and Turkish figure subjects, which he derived from John Frederick Lewis's celebrated Orientalist paintings.

The fruits and flowers of Fenton's still lifes are combined with the art objects to suggest that the pictures are both symbolic and aesthetic. No doubt some of the pictures are, in the modern sense of ornamental, purely decorative. But two or three of the most beautiful are also emblematic. It would be wrong to describe any of them as devotional, yet the typological way of thinking at the heart of the Anglo-Catholic interpretation of Scripture and nature, the warrant of Scripture for the mystical view of things natural, is still present even if concealed by aesthetic reserve. If the church was generally thought of by Tractarians as the Vineyard of the Lord, we are entitled to speculate whether the cultivated fruits and flowers of Fenton's great Victorian kitchen-garden and glass-house are not symbolic as well as decorative:

> Now considering to what an extent nature (so to speak,) delights in pairs, and groupings, and relations; how "one thing;" as the son of Sirach observes, is every where "set against another;" how impossible it is to find an object single and uncombined with all others, or to limit the extent of the associations and connexions, which manifest themselves one after another, when we set about tracing any one of the works of creation, through all its influences and aspects on the rest; it ought not perhaps to seem over strange, if the symbolical and mystical use of any one thing were thought to imply the possibility at least of a similar use and bearing in all things.[30]

Some objects are warranted as symbolic by Scripture, like the lily and the grapes. Some are guaranteed by a tradition of nature poetry, like the rose and the peach. Others, like cups and chalices, are sanctioned by church ritual: the lamb, the dove, the ox and the goat; the palm, the cedar and the hyssop; colours like white, purple and scarlet; materials like wool, cotton and silk; metals, precious stones and ivory –

> the use of any such thing in the divinely ordained ritual would give a new and heavenly significance to any mention of it which might occur in Isaiah and the Psalms, and both together would set it apart for ever, in the judgment of affectionate and imaginative minds, as a natural symbol or sacrament of something out of sight.[31]

[30] [Keble], *Tracts for the Times* 89, 169–70.
[31] Ibid., 184.

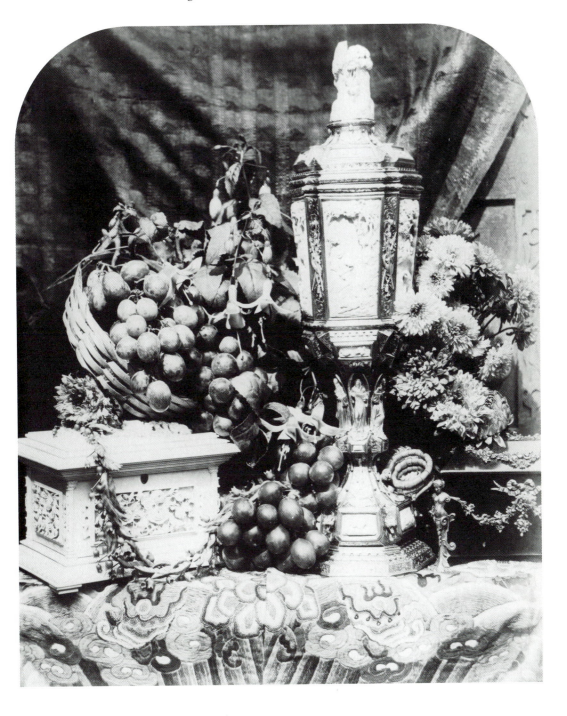

In this context, *Still Life with St. Hubert Cup and Chinese Curiosities* (Fig. 4) sets the cup against the casket, the flowers against the grapes, with the fuchsias and the second casket adding new variables. The Gothic carving exposed by the drape is set against the Chinese silk covering the table. The odour of Chinese chry-

4. Roger Fenton, *Still Life with St. Hubert Cup and Chinese Curiosities*, albumen 1860. Royal Photographic Society.

santhemums is compared to the grace of a European saint like Saint Hubert: certain plants were linked in mediaeval times with saints' days. The language of flowers and fruits conveyed such associations to a Victorian viewer of Fenton's still lifes, who probably responded to them either as religious musings or as fashionable fantasies, or both.

The dominant tone of Fenton's still lifes is Bacchic. He used a Parian-ware ewer decorated with grapes, probably by Minton, and a silver-gilt tankard with a carved ivory surround depicting Bacchic scenes and surmounted by a cover with two *amorini*, possibly Flemish and influenced by Rubens. Two more somewhat Anglicized *amorini* appear as separate figures: one dedicated to Ceres, supported by a wheat sheaf and brandishing ears of corn; the other devoted to Saint Michael or Saint George, a miniature English Red Cross knight. The figurines incorporate in an emblematic way the significance of the vine and the grapes of sacrifice, and the sheaf and the growing corn of resurrection. They attend Bacchus and Cupid, who like other pagan saints, were moralized in the typological manner as foreshadowers of Christ.

Fenton's tableau *The Seasons* (H10) showed Prince Alfred in a role ingenuously described as "Autumn", in which he was seated on a wine-cask, wearing a leopard skin, with grapes in his hair, and holding aloft a silver cup – the very personification of Bacchus. That Queen Victoria disapproved of this series of pictures suggests that she knew perfectly well what Fenton was doing. The one person in the tableau who did not portray a season was Princess Helena, who dominated the whole group as the Queen of Heaven, with a large cross in her hand. Under her Christianizing influence, Prince Arthur and the Princess Royal ("Summer") became a Madonna and child, the Prince of Wales ("Winter") a somewhat unlikely Joseph, and the Bacchic Prince Alfred the very type of John the Baptist, in the manner of the painting by Leonardo da Vinci, *Bacchus* (Paris, the Louvre), known before 1695 as "Saint Jean-Baptiste dans le désert".

In *Parian Vase, Grapes, and Silver Cup* (Fig. 5), the Ceres figure in such close proximity to a grape-decorated ewer typifies a relation between bread and wine that the adjacent vine-decorated chalice – the grapes reflected in its polished silver – has no trouble accommodating to church ritual. The chalice is the Christian version of the pagan ewer. Fruit emblems which are traditionally associated with Christ – the strawberry, the cherry, and the fig – are placed in nice contiguity to the Ceres figurine and the vessels, a sprig of lilac bears its own message in the language of flowers, and a combination of Regency stripe and Scottish plaid guarantees the Britishness of the whole.

In *Ivory Cup and Fruit* (RF170) Fenton shows how essentially the same motifs can be used to convey a quite different message.

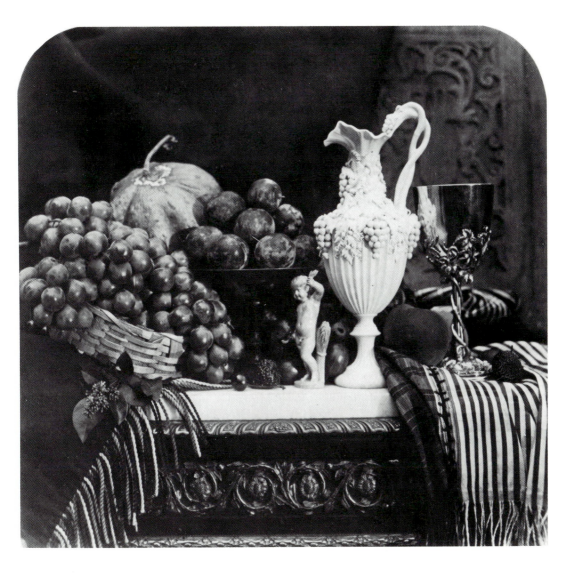

The sensual joys of the grape lead to the emptiness of the over-turned tankard. The melon, noblest product of the Victorian kitchen-garden, is visibly perishing. The *putto* on the cover of the overturned cup finds his buttocks wittily juxtaposed with two peaches. The crown of the pineapple – part palm, part thorn – acts as a *vanitas* symbol for the whole composition. This is in the satirical mode which Bacchic–Christian typology often takes. In Rochester's Anacreontic poem "Upon his Drinking a Bowl," we find the typology of future joys refers not to divine love but to human pleasure:

5. Roger Fenton, *Parian Vase, Grapes, and Silver Cup*, albumen, 1860. Royal Photographic Society.

> . . . carve thereon a spreading *Vine*,
> Then add Two lovely *Boys*;
> Their limbs in Amorous folds intwine,
> The *Type* of future joys.[32]

In *Still Life with Mirror and Chalice*,[33] a wicked-looking thorn protrudes between lilies of faith, replacing the half-opened rose of love which appears in other pictures. In *Proserpina*, Ruskin would call the thorn "the type of distress *caused by crime*, changing the soft and breathing leaf into inflexible and wounding stubbornness".[34] The Ceres figurine holds up his ears of wheat, but Demeter has brought forth tares as well as corn, cockles as well as barley. He who would reach for a grape should beware of the Wicked One who lurks beneath the petals. He who would look into the ornate mirror, and touch lace as intricate as lilies, should know that both are easily torn illusions.

Fenton's work is a kind of grammar of landscape and of ornament based on a wealth of art knowledge. But in using principles laid down by past works of art he imitated their structure rather than their appearance. Faced with the age-old problem of expressing the ideal by means of the real, he had the benefit of a medium with characteristics which allowed him "the power of ready and accurate observation". But "the image floating before his sight"[35] was as much one lodged in the mind as found in nature. He succeeded in making landscapes rather than views, still lifes rather than displays, because he was able to draw upon a typology that was both Christian and imperial at the same time. He was, indeed, the photographer laureate of the High Victorian age.

[32]*The Poems of John Wilmot, Earl of Rochester*, ed. K. Walker, Oxford and New York 1984, 37–8.
[33]*Selections from the Art Museum, Princeton University*, Princeton 1986, 168.
[34]Ruskin, *Works*, 25:294–5.
[35]Fenton, "Introductory Remarks", 6.

10. O. G. REJLANDER: Art Studies

Stephanie Spencer

Oscar Gustave Rejlander, affectionately called "the father of art photography" by his peers, played a seminal role in establishing photography as an artistic medium in the middle decades of the nineteenth century in England. Through his writing and, more importantly, through his photographs, he tried to demonstrate that photography could be art if photographers absorbed and applied lessons learned from the great masters of the fine arts. In his opinion it was the thought that counted; photography was simply one medium among many through which an artist could "render thought visible".[1]

Born in Sweden in 1813, Rejlander trained as an artist in Rome during the 1830's. He studied anatomy, antiquities and the Old Masters, and supported himself by painting portraits, copying Old Master paintings and making lithographs.[2] While in Rome he met and married an Englishwoman and moved with her probably to Lincoln, where his presence is documented in 1841. In 1846 he moved to Wolverhampton for reasons still not entirely clear. At this point, Rejlander considered himself a painter, listing his profession as such in 1847, 1849 and 1851, and exhibiting a now lost oil in the Royal Academy exhibition in 1848.[3] Rejlander was initially less than impressed by photography. He described some daguerreotypes he saw in 1851 as eminently forgettable and another group of photographs, probably calotypes, as "reddish landscapes".[4] By 1852, however, he began to appreciate the usefulness of photography as an aid to artists and from there it was a short step to taking photography lessons himself. He learned the wet collodion process in 1853 and exhibited his results for the first time in 1855. From then until a month before his death in January 1875, he exhibited regularly in British and international exhibitions, winning a total of nine medals.

In 1862, Rejlander moved to London, working first in Mal-

[1] O. G. Rejlander, "What Photography Can Do In Art", *Yearbook of Photography and Photographic News Almanac*, 1867, 50.

[2] "The Late O. G. Rejlander", *British Journal of Photography* 23 (29 January 1875), 55.

[3] O. G. Rejlander, "An Apology for Art Photography", *Photographic News* 7 (20 February 1863), 89.

[4] Ibid., 88–9.

den Road and in 1869 moving to the more fashionable Victoria
Street. By this time, Rejlander was almost exclusively a photog-
rapher, although he never entirely gave up drawing and paint-
ing. His choice of medium was based not on artistic merit but
rather on financial considerations and speed. As he said, pho-
tography in art was like steam in navigation – you got to your
destination so much faster.[5]

Although Rejlander was relatively prolific and generally
respected by critics and his peers, he was not a financial success.
As one of his obituarists stated, "Mr. Rejlander did not possess
the useful, if vulgar, faculty of making money".[6] Several factors
were involved. First of all, Rejlander's technical skills were de-
cidedly below the norm; many of his photographs have blots,
scratches and dust specks. Rejlander cared about technique, pe-
riodically soliciting advice from his colleagues, but he cared more
about content and form. Since most critics demanded, and could
get, technical excellence, Rejlander's carelessness worked
against him. Second, Rejlander seems to have chosen subjects
to please himself rather than a potential market. A case in point
is his art studies, which he valued highly and which critics con-
demned as fragments. Last, Rejlander was effected by external
factors beyond his control. During the late 1860's the British
economy as a whole experienced the worst decline in forty years,
and the photography trade in particular experienced financial
difficulties due to oversupply and decreased demand.[7] Rejlander
was also affected by the controversy over whether photography
was art. This debate was particularly vehement during the
1860's, and as one of the most visible proponents of "photog-
raphy as art", he was an obvious target. Rejlander's reputation
fell to its lowest point at exactly the moment the controversy
was most heated and rose again in the late '60s and early '70s
as definitions of art photography gradually became more flexi-
ble. His actual photographs were consistent throughout; how-
ever, larger theoretical issues significantly coloured opinion
about them.

Rejlander photographed in all the traditional subject cat-
egories with the exception of still life and with the addition of
what he called studies. In other words, he made history or "high
art" photographs, portraits, landscapes and genre pictures. Of
all these subjects, his favourites were his studies. Although he
made art studies throughout his career, he particularly empha-
sized them in the last decade of his life. Their importance to him
is suggested by the fact that he persisted in making and exhib-
iting them despite negative criticism.

These studies illustrate Rejlander's conception of what

[5]H. Baden Pritchard, *About Photography and Photographers*, New York 1973, 42.
[6]Edgar Yoxall Jones, *Father of Art Photography: O. G. Rejlander 1813–1875*, Green-
 wich, Conn., 1973, 40.
[7]"Annals of Photography for 1867", *Yearbook of Photography*, 1868, 19.

photography was and what it might achieve. Fundamentally, he believed that "it is the mind of the artist, and not the nature of his materials, which makes his production a work of art."[8] To improve the photographer's mind, Rejlander advocated the study of art of the past, which he considered as important a part of a photographer's education as that of any other artist. He exhorted, "Let it be seen that we have understood the teachings, and produce, by our means, works that look like art"[9] He also retained throughout his life the belief that photography could be a handmaid to art, helping painters become "better artists and more careful draughtsmen".[10] In this regard, he extolled and exploited the "honesty" (realism) of photography.[11] As for the art-versus-science debate, Rejlander affirmed the notion that photography was neither one nor the other but rather a combination of both.

These theories resulted in studies that verified the poses of individual figures in Old Master works of art, replicated the overall style and mood of particular artists and investigated expression, pose in the nude and draped model and anatomical details such as hands and feet. Some of these were works of art in their own right; the majority were intended as aids to artists and notes for his own future compositions.

Iphigenia or *Evening Sun* (Fig. 1) exemplifies Rejlander's adaptation of art of the past as well as his goals in posing and lighting the draped model. The pose is quite close to that of the Venus de Milo with the addition, of course, of arms, more drapery and expression. At the same time, this slightly exaggerated *contrapposto* pose could be found in numerous paintings from the Renaissance. This multiplicity of potential sources is typical. With the exception of the few studies designed to test the veracity of the Old Masters, Rejlander usually analyzed the general effect of works of art he admired with the ultimate goal of producing a photographic equivalent. Since he rarely copied directly, specific sources usually cannot be found. In studies of the draped model, Rejlander was particularly concerned that there be a clear relationship between figure and fabric. Since painters and sculptors would not tolerate drapery that obscured form, photographers should not either. His solution was to adopt the classical device of wet drapery. Unfortunately for his models, he did this quite literally. He dampened thin fabric and stained it with coffee "to lessen the colour contrast of flesh and drapery".[12] Folds thereby composed better and lights and shades combined more readily to yield "an effect far more picturesquely

[8]Rejlander, "What Photography Can Do in Art", 50.

[9]Ibid.

[10]O. G. Rejlander, "Something for Photographers to Undertake", *Yearbook*, 1870, 46.

[11]Rejlander, "Apology", 89.

[12]A. H. Wall, "Rejlander's Photographic Art Studies – Their Teachings and Suggestions", *Photographic News* 29 (31 December 1886), 862.

1. O. G. Rejlander, *Iphigenia* or *Evening Sun*, albumen, 1860. Gernsheim Collection, Harry Ransom Humanities Research Center, University of Texas at Austin.

simple and classical".[13] Rejlander was careful to include a suggestion of emotion in most of his figure studies. As he said, perhaps a bit defensively, "I dislike a mere nude, if it . . . conveys no idea".[14] Here, the gesture and hint of facial expression evoke a mood and, combined with the titles, suggest possible subjects for which this figure might be used. The titles may also indicate that this study was exhibited as an independent work.

Rejlander made many studies of human expression. He believed expression was critically important in transmitting an idea or advancing a narrative; that it was therefore an essential component of a work of art. Unlike his peers, Rejlander also believed that photography was actually better than painting at catching fleeting feelings, emotions and passions.[15] Here was a

[13]Ibid., 836.
[14]Rejlander, "Apology", 89.
[15]Rejlander, "Stray Thoughts", 65.

clear case where the science of photography contributed a degree of speed and accuracy that could aid the artistic aspirations of photographers and artists alike. In fact, Rejlander drew both from art and science in this kind of study. Heads of expression by artists such as Le Brun and Greuze provided an artistic precedent, while physiognomic studies by Lavater and contemporary British scientists added a scientific dimension. The revival of interest in physiognomy in the early and mid-nineteenth century and the application of the more rigorous, empirical methods of modern science to the study of mind and character as revealed through facial features may indeed have stimulated Rejlander's interest in expression. In many cases, his photographs correspond remarkably closely to descriptions in physiognomic texts. Although it cannot be proved that Rejlander was familiar with all the literature on the subject, he most certainly knew Darwin's work. He was, in fact, commissioned by Darwin to make approximately eighteen to twenty illustrations for *The Expression of the Emotions in Man and Animals* (1872). Darwin was trying to identify universal emotions and isolate the muscles responsible for creating these expressions. In *Grief* (Fig. 2), Rejlander illustrates Darwin's contention that oblique eyebrows, caused by contractions of the muscles around the eye, and the depression of the corners of the mouth were universally recognizable signs of this condition. According to Rejlander, the child did burst out crying shortly after the photographing session was over.[16] Even though this photograph was designed to illustrate a scientific principle, it is nonetheless artistically composed, demonstrating once again that Rejlander did not see art and science as antithetical.

Genre photographs constitute the largest single subject category of Rejlander's work. They were invariably popular with reviewers, and formed the foundation upon which his reputation rested. Critics were more inclined to approve of photographic genre scenes because they perceived a greater congruence between subject and medium than existed in "high art" allegories done in photography – what they termed "Dutch realism versus Italian idealism." Rejlander's genre pictures were of two types: low-life subjects such as drinkers and the urban labouring poor, and middle-class themes revolving around domesticity and women and children. He typically chose scenes which were amusing in themselves or which could be used to illuminate the foibles of human nature through a humorous interpretation. His photographs were usually narrative, either explicitly or implicitly, and he often took the opportunity to comment on contemporary issues such as morality, poverty and class structure.

Contrary to what one might expect, Rejlander drew his ideas from personal observation, not his imagination. He himself

[16]Charles Darwin, *The Expression of the Emotions in Man and Animals*, New York 1873, 182–3.

2. O. G. Rejlander, *Grief*, al-
bumen, n.d. Gernsheim Col-
lection, Harry Ransom
Humanities Research Cen-
ter, University of Texas at
Austin.

stated that this was his practice and his friends told anecdotes
about the lengths to which he was willing to go to obtain the
original model or even the original clothing in an incident he
had observed.[17] Obviously, however, Rejlander re-created these
incidents in the studio, thereby retaining total artistic control.
To a degree, he also relied on traditional paintings as models
for composition. What prototype he studied varied according to
the subject of his photograph. For low-life genre, he looked at
Dutch genre painting, Hogarth and Murillo. For middle-class
subjects, he used contemporary British painting, primarily in
terms of subject-matter, not style. As was true in his studies,
Rejlander rarely copied but rather considered the general effect.

 Guard Your Complexion (Fig. 3) is a representative example
of Rejlander's genre work. According to Rejlander's friend, the

[17]Rejlander, "Stray Thoughts", *Yearbook*, 1872, 81; H. Baden Pritchard, *About
 Photography*, 163.

3. O. G. Rejlander, *Guard Your Complexion*, albumen, n.d. Gernsheim Collection, Harry Ransom Humanities Research Center, University of Texas at Austin.

critic A. H. Wall, Rejlander saw a group of children mimicking fashionable women by protecting themselves with rag and stick "parasols" and chanting "take care of your complexion".[18] One little boy, unable to find a "parasol", buried his face in another's dress. Wall said Rejlander befriended the children, took them to his studio, put them at ease, encouraged them to reenact the game and took the photograph when they were no longer paying attention to him.[19] While this charming anecdote contains a kernel of truth, there are some obvious flaws. All the children appear to be girls, they carry large leaves instead of sticks and rags, the picture is well composed, and the children stood still long enough to be photographed without blurring. The incident and perhaps even some of the models may be derived from real life, but the composition, pose and lighting were controlled by Rejlander to make his photograph conform to the standards governing the traditional fine arts. The photograph contains a comment on the silliness of vanity, but Rejlander softens his message through a humorous interpretation and the use of children as vehicles for the moral.

Although Rejlander is best known in the twentieth century for his "high art" allegories, he actually made very few of these photographs. Most date from the first five years of his career

[18]A. H. Wall, "An Hour with Rejlander", *Photographic News* 4 (26 October 1860), 303.
[19]Ibid.

when he was still experimenting with the type of subject that would best suit him and his public. Fairly quickly he decided that he could more successfully moralize through genre subjects and demonstrate his artistic abilities through his studies. Although they are atypical, Rejlander's allegories are nonetheless useful in identifying his initial ideas about what subjects and interpretations were suitable for photography. Most discussions centre around the large (16" × 31"), complex *Two Ways of Life*. This was Rejlander's most ambitious work to date, designed as a competition piece for the Art Treasures exhibition in Manchester in 1857. Critical comments before the exhibition were uniformly positive, reviews during the exhibition were just as uniformly negative. The two major points of distress were the temerity of his attempting to rival painting and the impropriety of the all too realist nudes. The notoriety surrounding the photograph made Rejlander's reputation.

Technically, Rejlander used the controversial method of combination printing. In this case, thirty negatives were required, each one printed separately onto the final piece of paper. Most artists and art critics and some photographers objected to this technique on the grounds that it violated the inherent truthfulness of photography. Rejlander felt he was simply composing as any artist did. The iconography is equally complex. The basic theme – the choice between good and evil – is stated in three central figures and the ramifications of each choice is explored through the remaining twenty-five men and women. Many of these figures can be traced to a specific source in art of the past; this unusual parallelism can be found only in Rejlander's earliest work.

Rejlander never again attempted a composition of this intricacy. The technique was too time-consuming and expensive and the result was not uniformly well received. Subsequent allegories, such as *The Young Oak Within the Old Oak's Arms* (Fig. 4), were compositionally simpler yet retained the ability to instruct, ennoble and purify that was an unstated prerequisite of a good history picture. This subject was probably inspired by the perceived threat of a French invasion around 1860, which led in turn to the formation of Volunteer Companies in England. Rejlander joined one of these corps.[20] The photograph demonstrates England's strength, continuity with its past and ability to endure. The oak tree, mentioned in the Doomsday Book according to Wall, symbolizes history and strength.[21] There is life in the old tree yet, as indicated by the young tree growing out of it. The oak is also haunted by the "Lady of the Oak" who blesses the passing on of tradition enacted by the human char-

[20]Jones, *Father of Art Photography*, 39.
[21]Wall, "An Hour with Rejlander", 303.

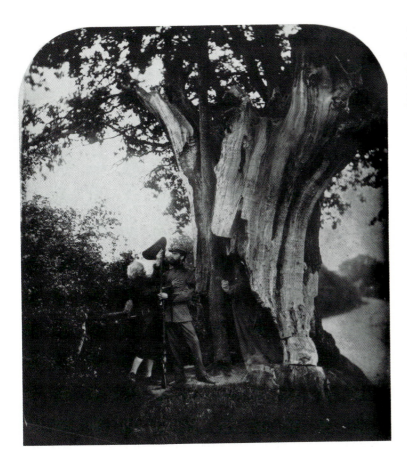

4. O. G. Rejlander, *The Young Oak Within the Old Oak's Arms*, albumen, 1860. Gernsheim Collection, Harry Ransom Humanities Research Center, University of Texas at Austin.

acters. The theme is obviously and unabashedly nationalistic. As these two examples suggest, Rejlander originally believed that photography was capable of rendering lofty ideals visible. Few critics agreed. Most believed that the literalism of photography jarred with imaginative subject-matter. Rejlander came to accept the majority opinion and by 1860 turned his attention to other kinds of subjects.

Portraiture was the professional photographer's mainstay. But Rejlander's philosophy reflected current thinking about artistic, expressive portraiture. His first concern was for the basic compositional shape; he believed that no amount of interesting detail would make up for an unbalanced outline. Lighting was important to create three-dimensionality and emphasize characteristic facial features. Rejlander was also one of the few photographers to vary lighting and tonal effect to correspond with the physical appearance and personality of different individuals. As one might expect, expression through both pose and facial features was of paramount importance. As he commented, expression is the result "not of a desire to look pleasant, but of

5. O. G. Rejlander, *Lord El-
cho and His Son*, albumen,
1860. Fotografiska Museet,
Stockholm.

pleasurable feelings."[22] To achieve this end, Rejlander would often assume the expression he wanted to inspire in his sitter.[23] In posing, he manipulated furniture and props rather than the sitter and directed the client's attention to various parts of the room to attain an easy, characteristic posture. The result was "not petrified specimens of humanity [but] real portraits of real people, with their individuality stamped upon them in action, pose and expression".[24]

While Rejlander's portraits are characterized by a wide range of composition, tonal value and pose, *Lord Elcho and His Son* (Fig. 5) is representative of the care he took in creating an expressive image. The composition is typically simple – a major and minor diagonal offset by the curves of the chair and upholstery. His backgrounds were usually of a single tone to help focus attention on the sitter. The poses here diverge from the preferred serpentine, three-quarter view. The profile view was felt to be aloof and the frontal somewhat confrontational. Rejlander probably chose these poses to illustrate individual character as well as the difference between youth and maturity. The gestures link the two figures both compositionally and emotionally. The major ways in which Rejlander differed from standard practice are also illustrated in this photograph – the closeness of the sitters to the camera and the impression of casual intimacy. While this photograph speaks of the importance of family and the perpetuation of an aristocratic line, it is not the typical stiff and formal presentation of a lord and his son.

Rejlander's photographs and his theory of art photography had both immediate and extended influence. During his lifetime, his photographs stimulated the development of two trends – genre photography, which became a significant theme by 1865, and pictorial studies, which, in modified form, developed into the Pictorialist movement at the turn of the century. Later photographers profited more from his belief in the validity of imagination in photography, the right of the photographer to alter the appearance of reality, and the necessity of applying artistic principles.

[22]Wall, "Rejlander's Photographic Art Studies", 565.
[23]Ibid.
[24]Ibid.

11. HENRY PEACH ROBINSON: The Grammar of Art

Margaret F. Harker

Henry Peach Robinson expressed his intention very clearly in 1886 in the preface to his book *Picture Making by Photography* when he said:

> My aim is to induce photographers to think for themselves as artists and to learn to express their artistic thoughts in the grammar of art.... The materials used by photographers differ only in degree from those employed by the painter and sculptor.[1]

He had demonstrated this concept nearly thirty years in advance when he exhibited his composite photograph *Fading Away*,[2] which showed a girl dying of consumption in the Grand Manner, with sorrowing relatives at her bedside. A distressing scene to Victorian eyes, too well accustomed to such sights in real life, the photograph was compared with *The Dead Lady*, a massive oil painting by Sir Joseph Noel Paton by a contemporary critic writing in the *Edinburgh Weekly Herald*.[3] By this comment and other favourable notices Robinson had immediately, at the outset of his life as a photographer, scored a point in favour of the recognition of photography as an art.

In the art world of the nineteenth century, photography was regarded as a means of visual documentation and as such a servant of Fine Art, initially providing artists with aides-mémoires for the construction of their paintings and subsequently with reproductions of these works. Robinson fought a battle all his life to lift photography out of this subordinate role. He saw no alternative at that time to the acceptance of the traditions established in painting and their application to photography. Photography as an independent art was unthinkable then. However, the idea was promoted by P. H. Emerson soon after the publication of *Picture Making by Photography*. A newcomer on the photography scene who denounced Robinson and the position he had occupied for so long, Emerson tried to free

[1] H. P. Robinson, *Picture Making in Photography*, London 1884.
[2] Illustrated in M. F. Harker, *Henry Peach Robinson: Master of Photographic Art*, Oxford 1988, pl. 47. (Hereafter, references in the text appear as, for example, H47 = Harker, plate 47.)
[3] Review of the exhibition of the Photographic Society of Scotland in the *Edinburgh Weekly Herald*, 1 January 1859.

photography from artistic principles, but failed to do so and in a pique declared that photography was a non-art. It was well into the twentieth century before photographers began to shake off the principles which governed painting.

Henry Peach Robinson's youthful ambition to become an artist was frustrated by his father's fear that he would be unable to make a living by the practice of painting and apprenticed him to a printer-bookseller in Ludlow when he was fourteen years old. Although he worked hard and the hours were long he still found time to draw and paint. He read as much as he could: classical literature and poetry, and about art. (Later he was required to leave one employer who complained that Henry read the books in his bookshop instead of persuading his customers to buy them.)

Robinson became a staunch adherent of the Picturesque movement in art. He was well read in the works of John Ruskin, who sent him to Nature for everything, and John Burnet, who advised that Nature was but the foundation of Art. He synthesized these two somewhat alien philosophies. After several years of applying artistic principles to his own photographic work, which he exhibited with considerable success, in 1869 he published his theory of photographic art, *Pictorial Effect in Photography*. His influence was profound and his advice followed and perpetuated well into the twentieth century by many leading exponents of pictorial photography. Robinson had learned a great deal about artistic principles by studying the works of great painters displayed in the National Gallery in the 1850's and 1860's. He urged the readers of *Pictorial Effect in Photography* to study these works in terms of picture construction, light and shade, emphasis, focus and perspective rendition. Victorians were very conscious of narrative – they liked their pictures to tell a story. This could be achieved in photography by the application of the principles to which Robinson directed his readers, and which he applied to his own work. Art was a means whereby artist and viewer alike could be uplifted and escape from the disturbing and changing ways of the world emergent during Victorian times. The world described by Dickens was horrific and sordid, and worse, it could be bereft of hope. Those educated to an appreciation of art wanted to escape into a land of dreams presented as reality through a combination of fact and fiction. In the presentation of the dream as reality Robinson was conscious of the power of photography and he found it stimulating. The ability of the medium to record, minutely, every facet of a real object in front of the camera was undeniable. This had both advantages and disadvantages for the purposes of artistic expression.

Robinson stated that he saw nothing wrong in mixing the real with the ideal (or artificial) in a photograph to improve the

narrative element and therefore the artistry.[4] After the success of *Fading Away*, and *A Holiday in the Wood* (H38), his second major composite photograph, he attempted an interpretation of *The Lady of Shalott* (H52) by Alfred Tennyson.[5] He felt confident that photography could be used to interpret the themes popular with painters of this period, even historical events and romantic legendary tragedies. He was particularly interested in the association between visual and verbal expression, and several of his major compositions depend on this relationship. J. M. W. Turner, for whose genius as a painter Robinson had the greatest respect, was inspired by the poetry of Lord Byron to paint *Childe Harold's Pilgrimage: Italy*, and exhibit the painting with the lines from Canto 4 by Byron alongside.[6]

Robinson met members of the Pre-Raphaelite Brotherhood at the house of the sculptor Alexander Munro. He saw the relevance between the accurate and closely refined rendition of detail in their paintings and the supposed realism of a scene transmitted to paper by light and the lens in a camera. He was particularly impressed by Sir John Everett Millais's painting of *Ophelia* and frequently visited the National Gallery, where it was on permanent exhibition, to admire it, "never weary of its wondrous beauty".

The Lady of Shalott was by no means an easy subject to express in a photograph in the nineteenth century. As was his usual practice, the idea for illustrating Tennyson's poem of that name was formed in his mind, made into a pencil sketch, and annotated for the purpose of taking the required photographs. Robinson decided to concentrate on the first two lines of the verse:

> And at the closing of the day
> She loosed the chains, and down she lay;
> The broad stream bore her far away,
> The Lady of Shalott.

In so doing, he had commited himself to a theme fraught with difficulties. The rocking movement of the boat would make a blurred image inevitable with the length of exposure time required by the wet collodion process in 1861, and the background would be out of focus at the wide-open aperture necessary for the setting of the lens. Undeterred, Robinson set about his self-imposed task by making a negative of his model lying in a punt in the outdoor studio of his back garden in Leamington. He then photographed a suitable stretch of river in the nearby Warwick-

[4]H. P. Robinson, *Pictorial Effect in Photography*, London 1869, 109.

[5]The photograph, *The Lady of Shalott*, was exhibited in 1861 at the British Association's exhibition, London.

[6]Robinson used this painting by J. M. W. Turner to illustrate the chapter "Light and Shade" in *Picture Making by Photography*.

shire country-side. By masking out the unwanted portions on both negatives and making sure they would print in register, he was able to print them, one at a time, onto the same sheet of paper. It sounds simple enough but required considerable skill at all stages to ensure the correct juxtaposition of the images and accuracy in the determination of proportion and perspective to create the natural effect he desired.

Another limitation Robinson encountered when photographing *The Lady of Shalott* was in the choice of a suitable boat. It had to be shallow in depth to permit a camera angle which would reveal the lady "Lying robed in snowy white that loosely flowed to left and right". The punt, however, was not a boat that Tennyson had in mind when he wrote the poem, as it lacks a prow round about which the lady wrote "the lady of Shalott". Robinson overcame this problem by inscribing it on the side of the punt. His sense of fun would have led him to describe these tactics as photographic licence. The Robinson photograph comes somewhere between the J. W. Waterhouse painting of the same name and Millais's *Ophelia* in concept, illustration and picture construction. The selection of ambience by each artist was similar, willowy banks beside the clear running water of a shallow stream with reeds beneath the surface providing a solution in each instance.

Henry Peach Robinson's next major picture was *Bringing Home the May* (H58). After some critical notices which deprecated the use of photography to portray legendary figures, he decided to photograph a popular country pastime in which he had participated in his youth. Executed the following year to *The Lady of Shalott*, it exhibits the same Pre-Raphaelite tendencies. In theme, picture construction, rendition of detail and tableaux-esque qualities it is comparable with a monochromatic version of Millais's *Spring (Apple Blossoms)*. The rites of spring provided the narrative in each case, the subjects are contained in frieze-like formats and the grouping of the girls and young women participants are not dissimilar. *Bringing Home the May* was Robinson's most ambitious project, being constructed from nine separate negatives organized at the printing stage onto one sheet of paper to present a unified picture.

The idea of Beauty as a supreme value in art was synonymous with the Picturesque movement as a whole and remained dominant for most of the nineteenth century. To Robinson it was a sine qua non. He promoted the notion that to record "unprincipled nature" with a camera would seldom lead to an aesthetically pleasing photograph. The contemplation of natural beauty is subjective and involves the physical if unconscious act of visual selection. For instance, we can retain an image of the sinuous curves of a river and the surrounding landscape but erase the view spoiling electric pylons from our memory. With

this in mind Robinson advanced the concept that artistic truth could differ from factual truth. By associating together, in one picture, parts that had their being in different locations at different times, he constructed an idealized form of truth to create the mood, incident or narrative he wished to bring to reality. He maintained that all his composite photographs were real in content, although idealized in form, as photography inevitably records real objects which exist in time and space. It does not record, in the conventional sense, pictures which exist only in the mind.

Henry Peach Robinson's most popular composite photograph *When the Day's Work is Done* (H79) was based on a photograph of an elderly crossing-sweeper who went to his studio in Tunbridge Wells to have a *carte de visite* made. Robinson visualized his studio transformed into a cottage interior with an elderly lady seated at a table sewing beside the old man who was reading. One of his early pictures, a painting, was based on a similar theme, *The English Farmer's Fireside*. Robinson's intention was to show the dignity of old age, however simple the circumstances, in an ordered household after a hard-working but God-fearing life. Although he was only forty-seven when this photograph was completed, the pattern of his domestic life was well established and his children were in their teens. It is likely that his vision of the future was built into this picture. It was easy to project his wife, Selina, and himself into the forms of the elderly couple portrayed. The roles are the same: Selina sewing, Henry reading. Some years later the image was realized, as one of his grandchildren recalled on seeing her grandparents either side of their hearth in the twilight of their years. It was no cottage but a respectable Victorian villa, but essentially the dream came true.

A less personal interpretation is that the Victorian imagination, especially among middle-class townsfolk, was fuelled by those writers who idealized the less demanding status of agricultural communities and the virtues of the simple life led by cottagers. It was an extension of the Picturesque idyll. Robinson constructed his picture from five negatives taken over a period of time but based on a carefully designed plan to ensure accuracy of scale, proportion and dimension so that the separate images would fit together perfectly when printed, one at a time, onto one sheet of paper.

Henry Peach Robinson loved children. They were his favourite sitters and a whole wall of the gallery in his Tunbridge Wells studio was devoted to his child portraits. He prided himself on capturing their fleeting expressions.[7] He could enter the child mind easily and recalled his own experiences: the delights

[7] *Picture Making by Photography*, 52.

1. H. P. Robinson, *Sleep*, al-
bumen, 1867. Royal Photo-
graphic Society.

of exploring the country-side by day and the terrors of sleeping
alone at night, above all the trusting nature and vulnerability of
children. His imagination was stirred by a verse from the poem
by Matthew Arnold: *Tristram and Iseult* (1852), which begins with
the lines

> But they sleep in shelter'd rest,
> Like helpless birds in the warm nest . . .

It expressed his feelings of love and fear for his own children.
He visualized the drama of the poem in his composite photo-
graph, *Sleep* (Fig. 1), which was exhibited in 1867. It has a mysti-
cal, dreamlike quality and considerable aesthetic appeal. He was
a master of the skill of handling light and interpreted the mood
of the poem and his own feelings by means of the concentration
of dark and light tones in this photograph. He conveys an
impression of safety by the proximity of the children to the
moonlit casement and the restless sea beyond (representing light
and life by day), and a feeling of menace by their positions in
relation to the surrounding space and the threatening figuration
of the wall tapestry (representing darkness and the fears of
imprisonment).

In the 1880's Robinson embarked upon a series of photo-

graphs in a very different genre from his major compositions. His subjects were figures in landscape. They were straight photographs in the sense that they were taken straight from nature and the prints made from single negatives, with the exception of those scenes where it was necessary to associate a sky with the landscape.

One of the features which distinguishes these photographs from those taken by his contemporaries is the use he made of body language. Robinson interpreted popular pastimes and rural activities through pose, gesture and facial expression. This compelled him to use members of his family and friends, rather than the labourers themselves, to represent the agricultural community. He tried labourers on more than one occasion, but the photographs were not successful because the country girls seemed incapable of acting out his instructions and one was so scared of "the evil eye of the camera" that she ran off.[8] Another possible explanation for Robinson's lack of perseverance with farm girls was the popular middle-class pastime, practised in France as well as Britain during that period, of "playing at being

2. H. P. Robinson, *Dawn and Sunset*, albumen, 1885. Royal Photographic Society.

[8]Ibid.

a rustic''. In consequence he had no difficulty at all in securing the services of satisfactory models. Clothes and other accoutrements were obtained from the local folk for a fee.

Robinson photographed figures in landscape while on holidays in the Mold–Ruthin area of North Wales and made them up into three albums, one for each of the participating families: Gossage, Tate and Robinson. He also exhibited the best photographs individually. There is considerable variety in these photographs of country activities and although the groups were stage-managed, natural qualities were brought to life by variations in pose, gesture and expression.

Robinson's photographs are based on the expression of Victorian values: sentiment, courtesy, rewards for hard work, order and repose. As the nineteenth-century idea of beauty is irrelevant in the present-day conception of art, and twentieth-century values are at variance with those cited above, Robinson's work is not easy to understand and appreciate. There is a serenity inherent in his photographs which distinguishes them from those of other photographers. A particularly good example of this is *Dawn and Sunset* (Fig. 2), where the cycle of life, represented in the forms of the elderly man, his daughter and her baby, is treated as a rhythmic, harmonious whole with contentment as the underlying theme.

12. CLEMENTINA, VISCOUNTESS HAWARDEN: Studies from Life

Virginia Dodier

In a career spanning about seven years, Lady Hawarden produced approximately 850 photographs.[1] Her work centred on her family. Through photography Lady Hawarden documented, directed and participated in family activities, and her photographs reveal the rapport and cooperation between photographer and models, mother and children.

Lady Hawarden exhibited her photographs as *Photographic Studies* and *Studies from Life*. The term "studies" indicates that Lady Hawarden followed an artistic tradition in which form is valued over content and which relies not on narrative but on observation and reflection. By adapting this tradition to photography Lady Hawarden was able to suggest as well as record, evoke as well as document, hint as well as tell. "She worked honestly, in a good, comprehensible style. She aimed at elegant and, if possible, idealised truth".[2]

Lady Hawarden was born Clementina Elphinstone Fleeming on 1 June 1822 at Cumbernauld House, near Glasgow, Scotland. Her father, Admiral Charles Elphinstone Fleeming (son of the eleventh Lord Elphinstone), was a Whig member of the Reform Parliament and ended his naval career as governor of Greenwich Hospital. Her mother, Catalina Paulina Alessandro, was Spanish, of Italian descent. She married the admiral in 1816, when he was commander-in-chief at Gibraltar.[3] The admiral's brother, Mountstuart Elphinstone, was a highly respected Indian colonial administrator and had served as governor of Bombay. The family was well connected politically and socially: Clementina's father and uncle were part of the Holland House set and her cousins included the Adams of Blair Adam, the Erskines of Cardross, the Anstruther-Thomsons of Charleton and the Keiths of Tulliallan.

Clementina and her sisters were educated in music, art, literature and languages. She later photographed her daughters

[1] Seven hundred and seventy-five Hawarden photographs were given to the Victoria and Albert Museum in the late 1930's or early 1940's by Lady Hawarden's granddaughter, Lady Clementina Tottenham. They were removed from albums by cutting or tearing, hence their missing corners.

[2] O. G. R[ejlander], "In Memoriam", *The British Journal of Photography* 12 (1865), 38.

[3] Family papers held by Lady Polwarth, Harden, Hawick, Roxburghshire. See R. B. Cunninghame Graham, "The Admiral", *Hope*, London 1910, 216–30.

1. Anon., *Clementina Lady Hawarden, née Clementina Elphinstone Fleeming*, oil/canvas, c. 1838. Mrs. Jean Clementina Keyte.

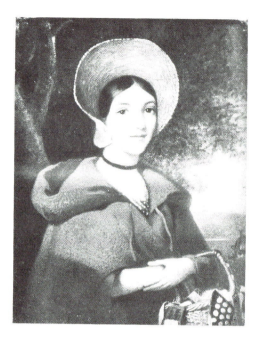

reading, painting with watercolours, and doing needlework, as she had done. A portrait showing Clementina at about age sixteen (Fig. 1) dressed as a gypsy suggests that she enjoyed wearing fancy dress, a popular pastime which she later shared with her daughters, as can be seen in her photographs. Clementina's taste for costume portraits and tableaux may have been nurtured by publications such as *Heath's Book of Beauty* and *Finden's Byron Beauties*, from which engravings were clipped and pasted into her mother's scrapbook from the 1830's onward.[4]

In 1841, after her father's death, Clementina and her family were taken to Italy by Mountstuart Elphinstone as a method of coping with their reduced finances. The girls' education was the chief consideration and tutors could be hired less expensively abroad. In Rome, where it was hoped that they would settle for a couple of years, Elphinstone introduced his charges to the sights and spectacles of the city as well as to Roman society and artistic and intellectual circles. But the family soon returned to London, despite their relatives' misgivings:"... the risk will be their getting into bad society in London, as I fear they will not get in to what they ought to do from their connections and their beauty will be a snare".[5]

Such fears proved unfounded, for in 1845 Clementina mar-

[4]Lady Polwarth collection.
[5]D. Erskine, letter to M. Elphinstone, 6 September 1842. India Office Library, Mountstuart Elphinstone Collection (hereafter IOL, Mountstuart Elphinstone Coll.).

ried Cornwallis Maude, then a captain in the Life Guards. It was
a love match. His parents did not approve and initially would
not receive her, possibly because Clementina was half Catholic,
from a Whig family; the Maude family were Protestant and Con-
servative. By her marriage Clementina was assured a future
place in the "Upper Ten Thousand". The Maudes lived in Lon-
don, moving frequently to accommodate their growing family –
eight of their ten children survived infancy. Though she some-
times suffered from illness after childbirth, Clementina was a
"great baby lover".[6] Her "devotion to her children seemed
enough to spoil a whole generation, but her good sense and
regard to duty has kept all right", in the opinion of her uncle,
who added that he "never saw nicer children or better brought
up".[7] Clementina's pride in her children is palpable in her pho-
tographs; in a few instances she celebrated motherhood with
Madonna and child tableaux.

In 1856 her husband succeeded to his title, which brought
with it Dundrum, an estate near Cashel, County Tipperary, Ire-
land.[8] In 1857 the family moved from London to Dundrum,
where Lady Hawarden began photographing in late 1857 or early
1858,[9] after her husband's inheritance had provided her with
the money, time and work space then necessary for photog-
raphy.[10] She may have received instruction in wet collodion
negative–albumen print technique (which she appears to have
used exclusively), or she may have consulted photographic
books and journals. She soon established her working methods,
including photographing in series. She apparently began with
a stereoscopic camera, but was soon using various formats.[11]

Situated in the most fertile part of Tipperary, Dundrum
offered picturesque vistas which had been produced by design
as much as by nature. In the late eighteenth century its old-style
formal gardens were altered to "one very noble lawn . . . scat-
tered negligently over with trees" and the river cleared "so that
it flows . . . in a winding course through the grounds".[12] Lady
Hawarden's photographs emphasize the Romantic qualities of

[6]A. E. Bontine (sister), to M. Elphinstone, 20 May 1856. IOL, Mountstuart El-
phinstone Coll.
[7]M. Elphinstone, to A. E. Bontine, 5 August 1854. National Library of Scotland.
[8]Dundrum comprised 15,272 acres at a gross annual value in 1883 of £8,781.
[9]On a visit to Dundrum her stepfather "assisted Clemmy with her Photography,
to which she seems as much devoted as ever, and has really done some
very pretty landscapes". C. P. Katon (mother), to M. Elphinstone, 30
December 1858. IOL, Mountstuart Elphinstone Coll.
[10]A relative "heard from Clemy [that the Hawardens] expected to be now very
comfortably off". A. E. Bontine, to M. Elphinstone, 17 November 1856.
IOL, Mountstuart Elphinstone Coll.
[11]Because of the cut or torn edges of the V & A Hawarden collection, it is difficult
to ascertain the exact format sizes. It appears the largest format was
approximately 9½" x 11", which she began using by about 1860.
[12]A. Young, *Arthur Young's Tour in Ireland (1776–1779)*, ed. A. W. Hutton, London
1892, 1:392.

149

2. Lady Hawarden, *Isabella,*
at Dundrum, albumen, c.
1857–64. Courtesy of the
Board of Trustees of the Vic-
toria and Albert Museum.

the rolling pastures dotted with cows, the river overhung with
trees, the threatening cliffs of the quarry. There is no hint of the
resentment and unrest of the local population.[13]

Often in Lady Hawarden's landscapes her husband and
children act as figures in the landscape, as in the photograph
(Fig. 2) in which her daughter Isabella Grace appears on the
estate drive. Perhaps, with her skirt pinned up for ease of move-
ment, Isabella Grace is returning home from a walk in the coun-
try. The unnatural shape of her belling petticoat and its solid
shadow, cast by an unseen sun, seem to immobilize her. Behind
her are the gates and before her a plinth marking a fork in the
road: one way is to the stables, the other to the house, all hidden
behind a natural screen. The road leads, the marker points, but
– though the leaves have stirred – the heavy atmosphere of high
summer absorbs all action for the moment.

[13]See W. Nolan and T. G. McGrath, eds., *Tipperary: History and Society*, Dublin
 1985. For reproductions of Hawarden photographs of Dundrum, see
 Clementina Lady Hawarden, ed. G. Ovenden, London 1974, 16–21.

Another artist who worked at Dundrum was Sir Francis Seymour Haden, the etcher and surgeon, who was James McNeill Whistler's brother-in-law. Some of Haden's most renowned prints – those on which his reputation rests – are Dundrum landscapes which correspond with Lady Hawarden's photographs of the same scenes. Haden's association with the Hawardens, probably initiated by his acting as Lady Hawarden's obstetrician, dates from about 1860, about the time he began plein-air landscape etching. Lady Hawarden and Haden may have worked alongside each other, or even collaborated, on several occasions. Besides sharing landscape subjects and motifs with Lady Hawarden, Haden also borrowed directly (in at least two instances) from her photographs of her daughters to produce genre scenes, rare in his oeuvre. He did so without publicly acknowledging his source, perhaps because he wished to consolidate his position as chief proponent of the British etching revival. To reveal that he had occasionally worked from photographs could have affected Haden's standing as an artist-etcher.[14]

In 1859 the Hawardens moved to a newly built house at 5 Princes Gardens, South Kensington, in London, though they returned to Dundrum regularly. The development of the area coincided with the establishment of the South Kensington Museum (now the Victoria and Albert Museum), a stone's throw from Princes Gardens. The Museum and the planned 1862 International Exhibition may have attracted the Hawardens to the area.[15] Haden was a member of the South Kensington circle through his friendship with the museum's first director, Henry Cole, with whom the Hawardens also became acquainted. Through Cole, the Hawardens joined the extensive network of influential people in South Kensington, then the centre of the British alliance of science and art.

In the Princes Gardens house – the site of her best-known work – the first floor was entirely given over to Lady Hawarden's photography. Light flooded these rooms, for on either end of the house were the open spaces of Princes Gate gardens to the north and Princes Gardens to the south. At first, Lady Hawarden used tables, chairs, mirrors, rugs and drapes – the professional portrait photographer's studio props, borrowed in turn from the portrait painter – and produced stereoscopic photographs which owe much to fashionable *cartes de visite*.[16]

Soon conventional props and poses gave way to suggestion

[14]See V. Dodier, "Haden, Photography and Salmon Fishing", *Print Quarterly* 3, 1(March 1986), 34–50.

[15]For a reproduction of a Hawarden photograph showing the 1862 Exhibition building, see *The Survey of London: The Museums Area of South Kensington and Westminster*, ed. F.H.W. Sheppard, London 1975, vol. 38, pl. 32a.

[16]See G. Ovenden, *Clementina Lady Hawarden*, 104, 108, reproduced as half-stereos.

3. Lady Hawarden, *Clementina and Florence*, 5 Princes Gardens, albumen, c. 1859–61. Courtesy of the Board of Trustees of the Victoria and Albert Museum.

of action and exploration of the improvised studio space. In the photograph of her daughters Clementina and Florence Elizabeth (Fig. 3) Lady Hawarden used a stereoscopic camera for its relative instantaneity and depth of field to suggest the distance between interior and exterior. French windows resembling a cage separate the girls from the overcast sky and the rain-puddled terrace. As if to mark this nearly invisible division Florence Elizabeth holds back the net curtain, through which the substantial houses in the background can be glimpsed dissolving. Her action presents her sister to the spectator; her upright figure counterpoints Clementina's languid form. Their informally staged tableau recalls scenes of pastoral dalliance played not in a drawing room but *sur l'herbe*.

Moved to the foreground, the terrace is the stage in the photograph of the children with the dog (Fig. 4). Grouped in a pyramidal composition, they are linked as in a conversation piece, communicating with each other by touch and with the spectator through the little girl's gaze. Isabella Grace, well-groomed but not too fastidious to put the dog on her lap, and Elphinstone Agnes, as solemn as the bronze owl she hugs, form the base. Between them Clementina, almost disguised behind her tilted hat, lifted hand and embracing cloak, rises to the apex. Her somewhat theatrical gestures seem to gently mock her sis-

4. Lady Hawarden, *Isabella, Clementina, and Elphinstone,* 5 Princes Gardens, albumen, c. 1862–64. Courtesy of the Board of Trustees of the Victoria and Albert Museum.

ters' deportment. With one hand she grasps the dog's paw, much as she clasps her sisters' hands in other photographs; with the other hand she perhaps suppresses a giggle.

From about 1862, Lady Hawarden, working primarily in her home studio, concentrated on photographing her daughters in costume tableaux, perhaps as an extension of their participation in amateur theatricals and tableaux vivants. Some of these photographs show the girls gesturing rhetorically while holding what appear to be scripts. Other photographs bring to mind – in mood, setting and composition – Whistler's and Albert Moore's Aesthetic paintings of the late 1860's.

Lady Hawarden manipulated mirrors and shifted screens to break the confines of the studio, as in the photograph of her daughter Clementina (Fig. 5). The Orientalist divan on which she lies lifts Clementina onto the plane of dreams, while the world recedes. She is nearly insubstantiated by light. The mirror – a "psyche" – isolates one hand in the classic gesture of contemplation; the other holds a fruit basket, symbol of sensuality. Perched on the table's edge, beside another, blank mirror, is a jug whose shape echoes the contours of the female body and whose situation recalls the traditional predicament of feminine virtue.

The love shared by Lady Hawarden and her daughters, her identification with them and self-expression through them, are clear in the costume tableaux. By pairing the girls, or twinning them with their own reflections in the mirror, in some

148 *Virginia Dodier*

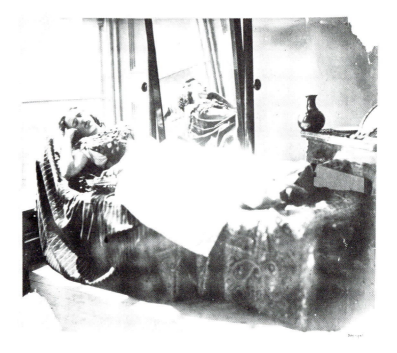

photographs, Lady Hawarden was perhaps exploring the notion of self-contemplation and the possibility of recognizing aspects of oneself in another. Whether or not the participants were aware of it, these images reverberate with romantic, even sexual, feeling. In other photographs Lady Hawarden and her daughters seem to be playing with ideas about courtship, Clementina usually taking the part of the importuning male lover (Fig. 6).[17] Such are their powers of persuasion, it is no matter that this eighteenth-century tableau is set not on a mossy rock in a wooded glade but on a rolled-up mattress on a bare wooden floor. The elegant line of Clementina's legs, revealed by Cherubino-like knee-breeches, thrusts her towards Isabella Grace. Foiled by her crossed arms, the lover does not enfold the beloved. Rather, in a gesture epitomizing the scene's pervasive delicacy, Clementina merely fingers the brim of Isabella Grace's hat. A shadow hangs over the pair, though it serves to draw them closer.

The ambiguities of such photographs, combined with Lady Hawarden's creative use of costume, have led to latter-day suggestions that she was influenced by the Pre-Raphaelites. However, Lady Hawarden's contemporaries did not include her work in this ever-expanding category: "There was nothing of mysticism nor Flemish pre-Raffaelistic conceit about her work".[18] As

[17]See *The Golden Age of British Photography*, ed. M. Haworth-Booth, Millerton, N.Y. 1984, 123.
[18]O.G. R[ejlander], ibid.

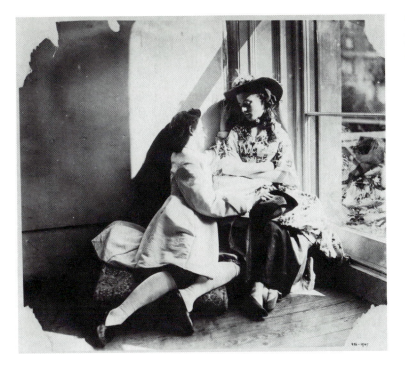

6. Lady Hawarden, *Clementina and Isabella*, 5 Princes Gardens, albumen, c. 1864. Courtesy of the Board of Trustees of the Victoria and Albert Museum.

far as is known, she was not associated with any member of the Pre-Raphaelite group, nor did she quote from or reproduce any of their works.

Lady Hawarden may have been influenced by other photographers, including O. G. Rejlander, Charles Thurston Thompson and Colonel A. H. P. Stuart Wortley, acting as teachers or mentors. Rejlander wrote an appreciative obituary for Lady Hawarden, and the Hawardens had a copy of his *After Raphael's Sistine Madonna*. Thurston Thompson, official photographer of the South Kensington Museum, taught photography there. Lady Hawarden may have been one of his students.[19] Stuart Wortley, noted for his technical expertise, knew the Hawardens. Lady Hawarden's technique, which allowed short exposures without sacrificing breadth of tone, possibly owed much to Stuart Wortley's research.[20]

Lady Hawarden first showed her photographs at the 1863 Photographic Society of London exhibition. She was awarded a silver medal for "the best contribution by an amateur", and was elected to the society.[21] She exhibited for a second, and final,

[19]From 1856, Thurston Thompson taught photography to the Sappers garrisoned at the South Kensington Museum. See J. Physick, *Photography and the South Kensington Museum*, London 1975, 3.

[20]See S. Wortley, "On Instantaneous Photography", *The British Journal of Photography* 10 (1863), 70.

[21]*The British Journal of Photography* 10 (1863), 69, 79.

time at the society's 1864 show, where she won a silver medal for the "best group or groups, or composition or compositions, each from a single negative".[22] One visitor to the 1864 exhibition, Lewis Carroll, wrote in his diary: "I did *not* admire Mrs. Cameron's large heads, taken out of focus. The best of the life ones were Lady Hawarden's". The next day Carroll found Lady Hawarden at a fête to raise money for the Female School of Art, selling her photographs and taking portraits in an outdoor studio with Thurston Thompson. Carroll complimented Lady Hawarden by bringing her two of his favourite child-models to be photographed, and by buying five of her photographs.[23]

By the summer of 1864, Lady Hawarden had won the acceptance of her contemporaries and had been awarded their highest accolades. She was prepared for a brilliant career. Possibly she was planning to participate in the United Association of Photography, a venture set up by Stuart Wortley and backed by her husband.[24] Any such plans were cut short when she died of pneumonia, aged forty-two, on 19 January 1865, leaving her bereft family the caretakers of her work and reputation.

[22]*Journal of the Photographic Society* 9 (1864), 69.
[23]*The Diaries of Lewis Carroll*, ed. R.L. Green, 1:217–18. The photographs Lady Hawarden took of Irene and Mary MacDonald for Carroll have not been located. Those he bought from her he placed in his album "Professional and Other Photographs". Gernsheim Collection, Humanities Research Center, University of Texas at Austin.
[24]Hawarden was a vice-president and major shareholder of the UAP; see *The Photographic News* 8 (1864), 348, and advertisement in the same issue (15 July 1864).

13. JULIA MARGARET CAMERON:
The Stamp of Divinity

Mike Weaver

In 1886 a "Lady Amateur" wrote that Mrs. Cameron's intentions were to revolutionize photography and to make money.[1] She concluded that she had done the first but failed at the latter. It is not difficult to agree that she achieved the first intention if by "revolution" is meant that she raised photography to a high art by adapting its mechanical means to moral and spiritual ends. But Mrs. Cameron's very intention to make money must have been a surprise to those who thought she, too, was a lady amateur.

Julia Margaret Cameron was born in 1815, the daughter of a senior civil servant in the East India Company, James Pattle. Her mother received her education in France, and was the daughter of Antoine de l'Etang, who was an assistant supervisor of one of the East India Company's stud-farms. In 1838, Julia Margaret married Charles Hay Cameron in Calcutta. It was a good match. Mr. Cameron had been a law commissioner in Ceylon, 1830–35, and before that had reported on the operation of the poor-law in England. He assisted Thomas Babington Macaulay on the Indian penal code, and when Macaulay left India he nominated Mr. Cameron for his post on the Council of India.

Mr. Cameron was a Benthamite radical and one of the world's losers. Macaulay noted his devotion to the memory of a great-grandfather who was hanged and quartered for his part in the Scottish Rebellion of 1745. When Julia was compiling her photographic album for Lord Overstone in 1864, Charles was erecting a monument to the Jacobite martyr. Macaulay wrote:

> How old [James] Mill would have shuddered to see his favourite disciple grubbing among the Stuart papers for materials which might furnish a vindication of a Jacobite who was hanged before our fathers were born! Alas for the weakness of human nature! Yet I like Cameron all the better for it.[2]

What Macaulay overlooked was that Cameron was also the author of a *Treatise on the Sublime and Beautiful* (1835). He was an Associationist as well as a Utilitarian, a man of sentiment as well as of thought.

The contribution of the Philosophical Radicals to education

[1] Anon., "A Reminiscence of Mrs. Cameron by a Lady Amateur", *Photographic News* 30 (1 January 1886), 2–4.
[2] *The Letters of Thomas Babington Macaulay*, ed. T. Pinney, Cambridge 1974, 4:309.

was enormous. George Grote, the historian of Greece, put Mr. Cameron's name forward for the first chair in moral and political philosophy in London University in 1825, but, although he was recommended by the education committee led by Mill, the university council would not accept that a man not in holy orders could teach morals.[3] What a serious blow this episode in Mr. Cameron's career this must have been has gone unnoticed. It was the first of several set-backs to a career of distinction. That Mr. Cameron was well respected by the members of the Political Economy Club in London is evident from John Stuart Mill's discussion of his health there with Lord Overstone.[4] It transpired that Sir Edward Ryan, co-member with Mr. Cameron of the Calcutta branch of the Society for the Diffusion of Useful Knowledge, had been on a convalescent cruise in the Indian Ocean with him. Ryan, a Member of the Royal Astronomical Society, was a close friend of Sir John Herschel, then at the Cape of Good Hope.

In 1839, Herschel wrote to Mrs. Cameron that the Cape had marked an important moment in both their lives.[5] When she went there in 1838 on her honeymoon with Charles perhaps Ryan provided the introduction to Herschel. In 1841, Herschel's daughter, Caroline, reminded Mrs. Cameron that she had given her an album with some poems in it when she was at the Cape, perhaps the earliest recorded instance of Mrs. Cameron's making such a gift. Caroline went on to say that she had been "making impressions of leaves with the sun, upon paper which Papa has taught me to prepare. I keep them all for my album, and, if Mama allows it, I will send you one". Mama and Papa added their own letters. Lady Herschel said that her husband had been distracted from astronomy by photography and metaphysics: "Perhaps you may know Mr. Fox Talbot two of whose drawings Herschel has sent you. He is one of the most successful – indeed the first Photographer in England, as has just invented a still more perfect and rapid process which he calls Calotype". Herschel, she said, was now making his prints with plant dyes ("the blue is *heart's ease* and the pink is *Stock*"). Herschel himself wrote of the "all but miraculous art of Photography of which I dare say you have seen plenty of the French or Daguerreotype specimens. Your Indian Architecture would afford superb subjects and I never look on these things without longing to be at work on these venerable monuments in which India abounds".[6]

Lady Herschel regarded Mrs. Cameron as someone who

[3] *Dictionary of National Biography*, London 1908, 8:730.
[4] *The Correspondence of Lord Overstone*, ed. D. P. O'Brien, Cambridge 1971, 217.
[5] Sir J. Herschel to J. M. Cameron, 16 June 1839. Los Angeles, The Getty Center for the History of Art and the Humanities, Archives of the History of Art, Cameron Papers (hereafter GCHAH, Cameron Papers).
[6] Caroline, M. B. and Sir J. Herschel to J. M. Cameron, 28 June 1841, GCHAH, Cameron Papers.

relished study of every kind, recommending to her a review by Herschel of Whewell's *History of the Inductive Sciences,*[7] and Sir John also referred to her interest in scientific matters:

> I enclose two specimens of chemical novelties, lately sent me from Basle by their inventor M. Schönbein – the one is *paper* rendered *transparent* and in an extraordinary degree electrical by a peculiar process which extends its application to any vegetable tissue. The other (which seems to be and in fact is a piece of cotton) has the explosive property of gunpowder and is even more powerful (weight for weight) with the additional peculiarity of not losing its power by immersion under water for any length of time. Neither of these processes are yet made public.[8]

The second of these processes shows that Herschel was in touch with Christian Friedrich Schönbein with a view to discovering a transparent material which could carry a film of soluble guncotton. He was anticipating the wet collodion process on which Mrs. Cameron would later found her career.

The giving of albums and commonplace books was Mrs. Cameron's habit before she took up photography. In the 1840's they were intended for poetry, but in 1859 she presented one to the third Marquis of Lansdowne which just included photographs, mostly by Rejlander. Included with portraits of Tennyson and Herschel were portraits of her sons Ewen and Hardinge, and Julia Jackson with May Prinsep, who became two of her favourite models later but were in 1857, when the photograph was made, just eleven and thirteen. There were also photographs of the drawing by G. F. Watts of James Spedding and of a medallion carved by Thomas Woolner of Thomas Carlyle. Both in profile, they were a basic influence of Mrs. Cameron's photographs of the same subjects. In 1861, G. F. Watts enquired of her whether she could help him lure not only Sir Henry Taylor for a painted portrait but also Sir Richard Owen, the naturalist, and Michael Faraday.[9] Her influence with such worthies was based on a knowledge of literature and science which was widely acknowledged.

The album which she gave to her niece Adeline Anne MacTier may be the last she presented before she began to include her own photographs. The date of its inscription by her is 5 October 1863, just two months before she made *Annie, My First Success.*[10] The contents of this album are, again, mostly by Rejlander with one or two by Lewis Carroll. She had seen Carroll operating in 1858 when he made a photograph of her with two of her children.[11] In April 1863, Rejlander was at Freshwater

[7]*Quarterly Review* 135 (June 1841), 177–238.
[8]Sir J. Herschel to J. M. Cameron, 18 August 1846, GCHAH, Cameron Papers.
[9]G. F. Watts to J. M. Cameron, January 1861, Royal Photographic Society, Bath.
[10]See *Whisper of the Muse: The Overstone Album & Other Photographs,* essay by Mike Weaver, Malibu, Calif., 1986, 86.
[11]Ibid., 14.

photographing both the Tennyson and Cameron families, and
it may have been then that she received instruction from him.
The pictures which appear in several albums of her maids draw-
ing water from the well date from this period or earlier. She may
have begun to make family pictures herself as early as 1860
because there is an inscription in the MacTier album in her own
hand: "from Life year 60 printed by me J.M.C."[12] The picture is
of Julia Jackson in profile next to a tree, the prototype of one of
her later Magdalene pictures which began with this picture, and
another of a girl actually called Magdalene Brookfield in the
Overstone album.[13] She had been actively interested in printing,
and perhaps taking, pictures at least three years before she de-
cided to go into business.

Lord Overstone had recommended to Mr. Cameron that
he should stay in Calcutta long enough to build up an adequate
provision for his retirement to England.[14] But the Camerons did
not heed his warning. Within five years of their return in 1848
the family was already in financial difficulty. By 1862, Mr. Cam-
eron was in serious trouble. In 1865, Lord Overstone bailed him
out with a thousand pounds, and a year later he and George
Norman, a founder member of the Political Economy Club, lent
him another thousand pounds and five hundred pounds re-
spectively. At the time when Mrs. Cameron began her career
the family was broke. For a decade Mr. Cameron had been
hoping against hope that he would get a government job. In
1860, Lord Overstone had tried to secure him the post of
governor-general of Ceylon. Mr. Cameron also tried to obtain
the post of colonial governor of Upper Canada, and even of the
Ionian Islands. But he had never held an administrative post.
His undoubted intellectual capacity and his literary ability could
not compensate for that – then as now.

Mrs. Cameron did what women still do when their hus-
bands fail: she went out to work. The idea of her as a wealthy
amateur is nonsense. Furthermore, what connections she had
gained with British men of letters and of science had been earned
by her genuine interest in their work. Her relations with Col-
naghi, the print-seller, from the very beginning of her career
and her arrangements with the Autotype Company, which sold
her carbon prints, suggest what the "Lady Amateur" noted –
that she intended, indeed needed, to make money. She joined
the Photographic Society, and made an immediate impact:

> The nearest approach to art, or rather the most bold and suc-
> cessful application of the principles of fine-art to photography
> will be found in several portraits of literary men and painters,

[12]Both the Marquis of Lansdowne and MacTier albums remain in private
collections.
[13]*Whisper of the Muse*, 95.
[14]*The Correspondence . . .* , 336. Further information about C. H. Cameron comes
from the same work.

and studies from women and children, intended as illustrations of "Faith", "Hope", "Charity", &c, by Miss Julia Cameron.[15]

But she did not make money. Lord Overstone contributed more than six thousand pounds to the family over the next few years, and lent the Cameron sons money for their mortgage on the family estate in Ceylon. So far as Lord Overstone was concerned, his old school friend and co-member of the PEC was in a state of extreme financial distress. The gift of the Overstone album was made in a particularly acute period. On 2 September 1866, Mr. Cameron's son-in-law wrote to Lord Overstone: "My father-in-law for the last two months has been utterly penniless, so that his debts are increased by butchers' Bills, etc."[16] Mrs. Cameron's photographic chemicals must have placed a huge burden on the family. On 28 September 1866, after a further thousand pounds had been forthcoming from Lord Overstone, the son-in-law now wrote: "I have told my mother-in-law that it is positively the last time that any assistance of this kind can be given her and that her future happiness or discomfort & misery rests Entirely with herself". We cannot tell whether this refers to butchers' or chemists' bills.

In November 1867, Mrs. Cameron sent some additional pictures to Lord Overstone:

> I am anxious that you should see to what *point* I have now been able to bring Photography – Our English artists tell me that I can go no farther in excellence, so I suppose I must suppress my ambition & stop – but it is an art full of mystery & beauty & I long to hear your & Harriette's opinion abt. my pictures which you will give me when they have reached you.[17]

She had, indeed, gone far in excellence. By this time she had already made her portraits of Herschel, Carlyle, and Tennyson, carried her studies of the Holy Family to the high points of *The Return 'After Three Days'*,[18] and *Iago – Study of an Italian* (W25), and begun in earnest on her Magdalene series with *Call and I Follow* (W63). It was an astonishing three years work, but she had not finished yet.

Mrs. Cameron's membership of the Arundel Society, the success of the Manchester Art Treasures Exhibition (partly due to the involvement of Lord Overstone as organizer and lender) and G. F. Watts' connection with the emergent National Portrait Gallery made her mindful of the new art historical consciousness. Her own passionate commitment to the Christian faith is

[15]"The London Photographic Exhibition", *Photographic News* 9 (30 June 1865), 309–10.
[16]C. L. Norman to Lord Overstone, 12 September 1866. University of London Library, Overstone Papers (hereafter ULL, Overstone Papers).
[17]J. M. Cameron to Lord Overstone, 5 November 1867, ULL, Overstone Papers.
[18]M. Weaver, *Julia Margaret Cameron 1815–1879*, London and Boston 1984, 34. (Hereafter, references in the text appear as, for example, W34 = Weaver, p. 34.)

now proved beyond dispute by the letters and documents which have surfaced or been acquired by public collections. Anyone who reads the prayer when she first became pregnant in 1838 will see at once, first, what a remarkable aptitude she had for church language; second, what joys and sorrows were promised her in childbirth; and third, how much she loved her husband, and feared for his salvation: "Open to him the veil of Thy sanctuary and engrave upon his soul the blessed truths of Thy gospel so that the Saviour may become to him his only hope & the Saviour's blood seal him with the seal of redemption".[19] As a Utilitarian and a classical scholar, Mr. Cameron held Horace in equal esteem with the Bible. But the accommodation of Christian themes to classical, Shakespearean and contemporary literature was part of the Victorian gift for typological thought. It entered into what has become the most famous single piece of art criticism of the Victorian age – Walter Pater's account of the Mona Lisa:

> All the thought and experience of the world have etched and moulded there, in that which they have of power to refine and make expressive the outward form, the animalism of Greece, the lust of Rome, the reverie of the middle age with its spiritual ambition and imaginative loves, the return of the Pagan world, the sins of the Borgias. She is older than the rocks among which she sits; like the vampire, she has been dead many times, and learned the secrets of the grave; and has been a diver in deep seas, and keeps their fallen day about her; and trafficked for strange webs with Eastern merchants: and, as Leda, was the mother of Helen of Troy, and, as Saint Anne, the mother of Mary.[20]

Mrs. Cameron's invitation to the Lord to "engrave" blessed truths upon her husband's soul, to "seal" him with the "seal" of redemption, refers to the stamp of divinity which, in the mind of Evangelicals and Tractarians alike, guaranteed God's immanence in the world. Pater's references to etching and moulding may be as much aesthetic as typical, but his idea that the Lady Lisa combines Leda and Saint Anne, Helen and Mary, makes this a piece of typological criticism. Pater was a whole generation younger than Mrs. Cameron, and she would have found this particular superimposition of types decadent in the extreme: according to Pater, the Mona Lisa is a femme fatale as world-weary as one by Rossetti. The eroticism in Mrs. Cameron's work in such pictures as *The Kiss of Peace* (W62), *Call and I Follow* (W63), and *The Angel at the Tomb* (W59) is controlled by the great picture of 1869, *The Dream: "Methought I Saw My Late Espoused Saint"*.

The figure in *The Dream* (Fig. 1) began as *The Lady of the Lake* (Fig. 2) from Sir Walter Scott's poem, and *Lady with a Crucifix*

[19]*Whisper of the Muse*, 62.
[20]W. Pater, *The Renaissance* (1873), London 1904, 125.

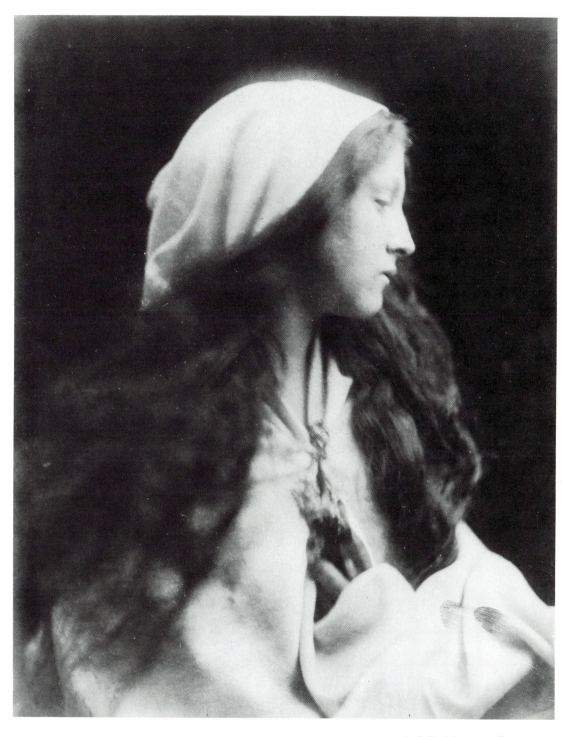

1. Julia Margaret Cameron,
The Dream, albumen, 1869.
Royal Photographic Society.

2. Julia Margaret Cameron, *The Lady of the Lake*, albumen, 1869. Maison de Victor Hugo, Paris.

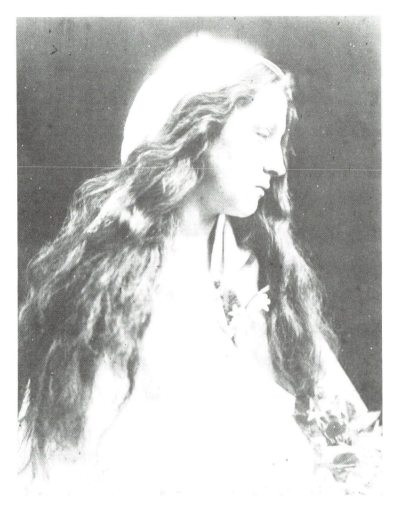

(Fig. 3).[21] The order in which the series was made is not known, but the conflation of the Romantic figure clothed in white samite with a religious figure contemplating the Cross suggests that they are both types of the Magdalene, as painted by G. F. Watts (Fig. 4), whose influence on Cameron it is impossible to overestimate. Yet the hair in *The Dream* is much less dishevelled and unkempt, the head-dress less negligently arranged and the tilt of the head neither disconsolate nor yearning as in these other versions. The reference in the title to Milton's dream of his dead wife shifts the poetic reference from a contemporary, Scott, to a poet who was read in the eighteenth century with almost the same reverence as the Bible. Milton's allusion to his wife as

[21]Mrs. Cameron presented Figs. 3 and 4, and twenty-five other photographs, to Victor Hugo sometime before 1870. See Maison de Victor Hugo, *Hommage de Julia Margaret Cameron à Victor Hugo*, Paris 1980.

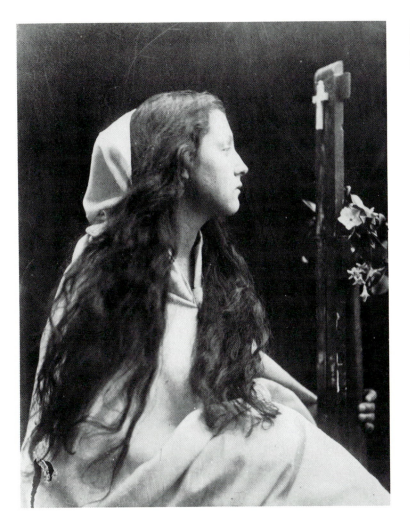

3. Julia Margaret Cameron, *Lady with a Crucifix*, albumen, 1869. Maison de Victor Hugo, Paris.

"espoused" draws on the description of Mary Madonna as espoused wife in the New Testament (Luke 2:5). Milton's poem refers to his dead wife as "wash'd from spot of child-bed taint",[22] a rite of purification known as The Churching of Women. The legendary view of the Magdalene as someone carnally tainted and the doctrinal view of Mary's Immaculate Conception are reconciled in Milton's poem, and in Cameron's picture, in a single person. To Pater's Leda–Saint Anne, Helen–Mary, she added a composite Magdalene–Mary. The fact that the model in Cameron's picture was actually called Mary only shows how transparently photography can close the gap between the literal and the metaphorical: the stamp of divinity is to be found, indeed, in real life.

[22]The full text of Milton's "On His Deceased Wife" (c. 1658) is given in Weaver, *Julia Margaret Cameron*, 61.

4. G. F. Watts, *The Magda-len*, oil/canvas, c. 1866. Na-tional Museums and Galleries on Merseyside.

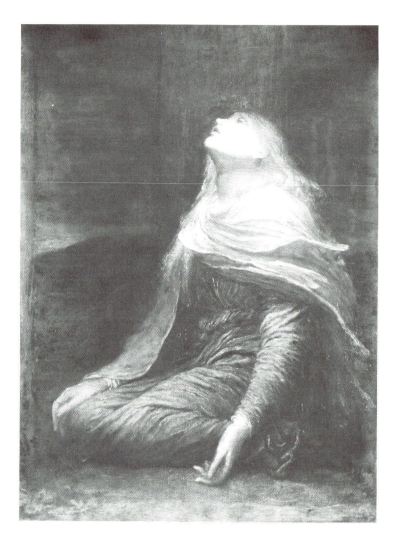

Macaulay, who disliked the company of women at the best of times, found Mrs. Cameron "pert, ugly, absurd".[23] Virginia Woolf, with an anti-Victorian axe to grind, found her "base and noble,"[24] which could be construed as concerned about money and keen on art. Woolf's father, Sir Leslie Stephen, historian of the Utilitarians, called her, on the other hand, "as unselfish and generous as it was possible for a woman to be, and with the temperament, at least, of genius".[25]

Charles Cameron, through the 1850's, wanted to return to Ceylon, or at least to spend a year or so at a time there. But he acknowledged that Julia Margaret's taste for literary society

[23]Cited in *The Letters . . .* , 5: 127, n. 4.
[24]*A Change of Perspective: The Letters of Virginia Woolf*, ed. N. Nicolson, London 1977, 3:280.
[25]*The Life and Letters of Leslie Stephen*, ed. F. W. Maitland, London 1906, 335.

would always prevent her from a long stay.[26] When they finally steamed away on the *S.S. Mirzapore* in October 1875, it was because his dropsy and asthma and her bronchitis, his lack of pecuniary means and her exhaustion, had finally driven them to it. He had his heart's desire, but she, on the other hand, had no wish to die in Ceylon. Her life had been so caught up with that of her sisters and their extensive families that separation hit her very hard. She and her faithful servant and photographic assistant, Ellen, were prostrated with the effort of getting away and nearly suicidal with sea-sickness, while Charles, who had never felt better in his life, slept soundly in the next cabin. At Malta he would not go ashore for fear of reviving memories of the time in 1800 when his father had been governor. But Mrs. Cameron was received by the governor of the day, who showed her his paintings, some of which she pronounced good. Then she spent an hour in St. John's:

> To enter this was like entering a different world beyond the gates of the din & dust & glare, & clamour, & crowd & bustle of this our every day world. No words can describe the beauty of this building. It was not entirely of the cathedral order. No lofty aisles – no dim religious light – no storied windows – but nevertheless all was of the highest order of ecclesiastical art and the quiet & repose soothed the soul. It was such a holy privilege to pray in silence & in secret & to bathe one's soul in quiet comtemplation."[27]

They revisited England briefly in 1878, and died in Ceylon, Julia in 1879 and Charles in 1880. We remember him because of her – the most passionate and most profound of all British photographers.

[26] C. H. Cameron to J. M. Cameron, 8 November 1850, GCHAH, Cameron Papers.
[27] J. M. Cameron to Adeline Vaughan, 14 November 1875, Oxford, Bodleian Library (ms. Eng. Lett. d444:156–164).

14. AESTHETIC ASPECTS OF THE PHOTOMECHANICAL PRINT

Anne Kelsey Hammond

In 1902, when an English-born art critic who had emigrated to America, Charles Caffin, wrote in *Camera Work* about the modern photographic artist's attention to subtleties of tone, he was expressing a preoccupation of British art for more than two hundred years.[1] In England, where Claude Lorrain's rendering of the quality of light was revered, the goal of the pictorial arts was perfect semblance of tonality: "Claude was the inventor of the tonal match – matching opaque pigment to atmospheric tones".[2] Thus the desire to reproduce a natural scale of light and shadow had long preceded the birth of photography. By engraving with the burin, tones could be rendered only by a progression of lines cut in varying widths or in different directions, but only with the introduction of the mezzotint in the seventeenth century did the engraved plate achieve tonality. The expertise of the English in applying this technique to the reproduction of portrait paintings led the French to dub it "la manière anglaise". Aquatint was a tonal extension of etching, used successfully to give the effect of watercolour washes by the English artist Paul Sandby as early as 1775. The lithotint, which also produced the effect of a wash, or gradation of tone, was one of the major graphic developments surrounding the announcement of photography. It was patented in England in 1840 by Hullmandel, the lithographer, in collaboration with the watercolourist J. D. Harding.[3]

Watercolour painting reached its peak of development in late-eighteenth and early-nineteenth-century England. It owed much of its ability to express soft and subtle gradations to the high standard of paper-making in northern Europe. In 1760, the Englishman James Whatman returned from his study of the production methods of Dutch paper makers, and set up his mill in Maidstone, Kent. Whatman's Turkey Mill was the paper Talbot adopted for photography in the spring of 1840. His requirements for a photographic paper base were essentially the same: wet strength, uniform texture and a smooth surface. The calotype achieved its effect of gradation with silver deposits in much

[1]Charles Caffin, "Is Herzog Also Among the Prophets?" *Camera Work* 17 (1907), 22.
[2]Arts Council of Great Britain, *Painting from Nature*, catalogue of an exhibition, introduced by Lawrence Gowing, London 1980, 3.
[3]Michael Twyman, *Lithography 1800–1850*, London 1970, 145.

the same way as the watercolour did with ground pigments –
both gave a gradual change in the density of minute particles,
allowing progressively more (or less) of the paper itself to be
seen.

With a fine-textured paper, larger cameras and improved
sensitizing procedures, Talbot's calotype stood as a serious rival
in 1840 to the clarity of the daguerreotype. There were photo-
graphic scientists like Robert Hunt who valued the daguerreo-
type for its crystal-sharp definition, but also sought to capture
that quality in the paper print. In a letter to Sir John Herschel,
Hunt proposed that the surface of the photographic paper could
be coated with additional silver compounds in order to produce
a paper "as good as the Daguerreotype".[4] The two different
processes of photography were seen from the beginning as aes-
thetic opposites. The paper calotype carried with it the "soft"
aesthetic of diffusion, while the polished metal daguerreotype
gave the "hard" effect of reflection. This polarity generated the
"hard versus soft" debate which found expression in the course
of the nineteenth century, and determined the evolution of pho-
tomechanical printing.

Talbot early realized, as Herschel did in his report to the
Royal Society in 1840, that the most important application of his
invention would be "the exact reproduction of indefinitely mul-
tiplied fac-similes of an original photograph once obtained, by
which alone the publication of originals could be accom-
plished".[5] Unlike the daguerreotype, which was a positive pro-
cess yielding a unique image, the negative calotype could
provide any number of positive prints. This placed it in a crucial
position in the history of the graphic and reproductive arts. In
1843, Talbot and his assistant Nicolaas Henneman established
the first photographic production facility at Reading, where *The
Pencil of Nature* (1844–46), *Sun Pictures in Scotland* (1845) and
Annals of the Artists of Spain (1847) were printed. A further step
in the evolution of the photomechanical print would be to make
perfect facsimiles of continuous-tone photographs which could
be ink printed for permanence, because it was soon obvious that
the photographic print was prone to fading. Attempts were
made in the early 1850's to transform the metal surface of the
daguerreotype itself into a printing plate by etching or electro-
plating, but the results seldom produced an impression com-
parable to the original, particularly in rendition of half-tones.
Talbot also sought a method by which a printing plate might be
engraved photographically. However, his initial investigations
were impeded by the fibrous texture of his paper negative. But

[4]Herschel correspondence, 15 April 1840, quoted by A. Pearson, *Robert Hunt,
 F.R.S.*, Penzance 1976, 21.
[5]Sir John F. W. Herschel, "On the Chemical Action of the Rays of the Solar
 Spectrum on Preparations of Silver . . .", *Philosophical Transactions of the
 Royal Society*, 1840, 2.

with the invention of the glass negative (albumen in 1847, and collodion in 1851) experimentation in the processes of photo-mechanical reproduction gained renewed energy.

In 1852, Talbot made the discovery that potassium bichro-mate produced a hardening effect on organic colloids such as fish glue, albumen or gelatine. Thirteen years before, Mungo Ponton found that paper dipped in bichromate of potassium was coloured brown by the rays of the sun, but that unexposed bichromate would dissolve out of the paper in water.[6] Talbot's idea was to place a layer of bichromated gelatine on a metal plate beneath a photographic positive made transparent by waxing. When exposed to sunlight the gelatine would harden in direct proportion to the density of the photograph. The parts of the gelatine which had been protected from the light remained sol-uble, and were washed away with water, leaving an image in gelatine relief corresponding to the light and dark areas of the positive. This acid-proof gelatine image served as an "etching resist" which allowed the plate to be etched only in the areas where the sun had not reached – that is, the shadows. So that those shadows would be able to hold ink during printing, a textured surface in the etched parts of the plate was needed. Talbot accomplished this by first exposing the plate under the superimposition of a "screen" of two or three layers of muslin or lace (the prototype of the modern half-tone screen), and then exposing it under the photographic transparency. His alternative was to apply an "aquatint ground" of finely powdered resin dust to the surface of the plate; the acid then etched around each grain of resin, creating a grained texture which would sup-port the ink in the intaglio plate. Karl Klíč used exactly this method of aquatint ground, more than twenty-five years later, in his development of the photogravure.

For his new "photoglyphic" printing process Talbot bor-rowed from current advances in printmaking the idea of the steel-faced plate, which could print a greater number of images than copper, and the aquatint ground, and added to them a new chemical formula for etching, ferric chloride, used in baths of varying saturations for maximum control. But his single greatest contribution to photo-engraving was the bichromated-gelatine relief image, the basis of experimentation in photomechanical processes to the end of the century. The photolithograph, the collotype, the photogalvanograph, the photogravure, the Wood-burytype and the pigment (or "carbon") print all relied upon the action of light on a film of gelatine containing bichromates which renders it insoluble, so that washing in warm water re-veals a relief image. Ultimately, all these processes sought a relief image which could print continuous tones, and produce "gra-dation". Gradation in the graphic arts occurs when the medium

[6]*Edinburgh New Philosophical Journal* 27 (1839), 169.

(chalk, watercolour or emulsion of silver salts) creates the effect
of a gradual transition from one tone to the next. The more finely
distributed the points of colour (or silver), the more continuous
the change from tone to tone: watercolour has a smoother tonal
range than chalk, and the collodion negative a smoother tonal
range than the calotype.

Among the members of the Calotype Club (formed in 1847)
were Roger Fenton and Frederick Scott Archer. Soon after Scott
Archer presented his discovery of the collodion process (1850–
51) Fenton adopted it for his own photographic work.[7] The ad-
vantage of the collodion plate was that it had extremely fine
grain and was held by an invisible film to a plate of clear glass:
there was no paper base to distort the full range of tones unique
to the process. In 1853, Fenton was instrumental in the founding
of the Photographic Society of London. One of the society's main
concerns in the early years was that of the photograph's sus-
ceptibility to fading. In the interest of image permanence, Fenton
lent his support to experiments, such as those being conducted
by Talbot, in processes of photo-engraving. In the spring of 1854,
Talbot received an encouraging letter from Fenton: "I hope that
the honour of finally solving this question of fading photographs
will by your researches be won for this country. It would be a
rare good fortune for the same hand to have commenced &
completed the structure of the photographic art".[8] Fenton was
suggesting that if the photograph, in all its unique expression
of tone, could be rendered "imperishable" by printing in ink,
then the goal of the photographic art would be fulfilled, and the
art of photography would be as lasting as the arts of engraving
or painting in oils. The incentive for Talbot's photoglyph was
not just the need for a faster, cheaper way of engraving, but the
survival of the photographic expression itself.

In 1856, Roger Fenton was appointed head of the Photo-
graphic Department of the Photo-Galvanographic Company.
The "photogalvanograph", patented in England by Paul Pretsch
in 1854, consisted of a gutta-percha mould from a chromated-
gelatine relief (swelled by application of water, after exposure
by Talbot's method) which was coated with graphite and then
electrotyped to create a copper printing plate. The company
began its activities with the publication of *Photographic Art Trea-
sures* (December 1856). The first number was illustrated by four
photogalvanographs from photographs by Fenton, and many
other such collaborative efforts were anticipated for future pub-
lications. Unfortunately, by 1858 the company had effectively
collapsed, owing partly to harsh reviews by critics like Thomas
Sutton, who, although he welcomed the process as a blessed

[7]John Hannavy, *Roger Fenton of Crimble Hall*, London 1975, 33.
[8]Lacock Collection, 5 May 1854, quoted by Gail Buckland, *Fox Talbot and the
 Invention of Photography*, London 1980, 113.

alternative to the harsh and over-brilliant surface of albumen prints, found fault with the overwhelming evidence of the retoucher's hand. To call them "photomezzotints", and to claim in the *Photographic Journal* that they had been "absolutely untouched by the graver", could not hide a great deal of hand retouching by Pretsch's copperplate engravers. Pretsch's process was featured in a monumental compilation of reproductive techniques, published in 1860 under the title *The Art Exemplar*.[9] Described as "A Guide to Distinguish one species of Print from Another", it was an A to Z of pictorial reproductive methods, with actual examples bound in, and listed the photogalvanograph as the latest thing in photo-engraving. A companion volume treating the second half of the century would be twice the size but equally invaluable.

In December 1858, John Pouncy presented a method of "carbon" printing to the Photographic Society of London. The response of the presiding chairman, Roger Fenton, perhaps reveals his disappointment with the limited success of most printing methods to reproduce the essential qualities of the photograph. He recommended that although Pouncy should be encouraged in his endeavours, the society would "continue to prefer the silver process, which is most beautiful", because "even carbon prints are not everlasting".[10] Pouncy's process involved the application of a carbon-based ink (mixed with asphaltum and dissolved in benzole) onto a sheet of paper. After exposure, the print was "developed" by immersing it in turpentine, which removed all the asphaltum solution not affected by light. The technique was based upon earlier experiments in the area of photolithography by Lemercier, Lerebours, Barreswil and Davanne of Paris, published in 1852. In effect, Pouncy was producing one-off photolithographic plates on paper.

Pouncy found a staunch supporter for his "carbon" prints in Thomas Sutton, editor of *Photographic Notes*. In 1863, Sutton claimed (in his book *Photography in Printing Ink*) that Pouncy's process was the only one capable of rendering half-tones, and compared his prints to fine engravings. He returned continually to the idea of the artistic importance of the paper base in photography. Even when writing on *The Collodion Processes* (1862), he suggested that the prints should be made not on the customary albumenized paper, but on "paper prepared with a salted alcoholic solution of some gum resin, instead of albumen; the object being to produce prints without a glaze, and resembling engravings".

The "hard versus soft" debate in photography began as "metal versus paper", a question of surface characteristics. On

[9]Harry Sandars (i.e., W. J. Stannard), *The Art Exemplar*, London 1860 (Bodleian Library, Oxford).
[10]Thomas Sutton, *Photography in Printing Ink*, London 1863, 27.

the whole, the more reflective the print surface was, the more it mirrored the object. Precise definition delivered quantitative information (number of leaves on a tree, or fine architectural details) and the relationship of the observer to the thing observed was relatively objective. The more soft and diffused the surface, the more it referred the viewer to his own contemplative associations; its evocative effect provided qualitative information (depth of shadow cast by a tree, or atmospheric perspective of a cathedral interior) which was subjective or interpretive. Edmund Burke, in his treatise on the sublime and beautiful, wrote that "there are reasons in nature why the obscure idea, when properly conveyed, should be more affecting than the clear. It is our ignorance of things that causes all our admiration, and chiefly excites our passions. Knowledge and acquaintance make the most striking causes affect but little".[11] A degree of indistinctness in a work of art often had greater impact than perfect clarity because it stimulated the imagination.

In 1850, the albumen-on-paper process was introduced in France by Blanquart-Evrard. Albumen had been first employed by Niepce de Saint-Victor in 1847 to bind silver salts to the surface of plate-glass, thereby creating a transparency. The albumen print consisted of a very thin sheet of polished paper, coated with a non-absorbent layer of albumen which held the silver image and adhered it to the support. One of the many photographers who valued its clarity and high definition was George Shadbolt, who wrote, "the more the picture is kept on the surface of the paper, the more brilliant is the effect, and the more perfectly is the detail, especially in the half-tones, brought out, and . . . anything like soaking the solutions into the paper produces a flat & unsatisfactory effect".[12] Although the glitter and severity of the albumen high finish was often criticized as vulgar and superficial, there was no denying its ability to render the exact likeness of objects. Not every photographer held the artistic values which promoted the paper effect. Russell Sedgfield objected that "mere artistic effect is often a very secondary consideration in a photograph. There is another, and sometimes much more important requisite, namely, the perfect clearness and legibility of every detail, whether in light or shadow; and here the albumenized paper is without a rival".[13]

George Shadbolt drew the line between what he called the "Modern School" of Photography, and the "Pre-Raphaelite School". As a scientist in the field of microscopy, Shadbolt con-

[11]Edmund Burke, *A Philosophical Inquiry into the Origin of our Ideas of the Sublime and Beautiful*, Dublin 1766, 87.

[12]George Shadbolt, "Some Observations upon Photographic Printing", *The Photographic Journal* 1, 36 (21 November 1855), 256.

[13]W. Russell Sedgfield, "Albumenized Paper", *The Photographic Journal* 2, 38 (21 January 1856), 291.

sidered himself a Pre-Raphaelite.[14] The Pre-Raphaelite Brotherhood (Ford Madox Brown, Rossetti, Holman Hunt and others) painted in a style which placed a high priority on the precise delineation of each flower and blade of grass. Like Shadbolt, their pictures demanded a high concentration of information but, unlike his visual scientific record, their minute details signalled symbolic references in each object in the composition. Ironically, the opposing pictorial school which Shadbolt referred to as "Modern" was in fact quite traditional. Instead of sharp realism, it called for overall tonal coherence or "breadth of effect", the quality to which British artists had aspired, from Claude to Constable and Turner.

In 1861, A. H. Wall initiated a series of articles in *The Photographic News* with the aim of educating the amateur photographer in the principles of art. Of breadth he wrote, "Harmonious gradations at once secure it. Perfection of detail will not banish it, nor does absence of detail produce it."[15] Supporting his claims with testimony from Ruskin, Delaroche, Titian and Sir Joshua Reynolds, Wall suggested that a photograph which exhibited perfect gradation of continuous tone possessed the quality defined as "artistic".

The importance placed on photographic gradation was due partly to the technical characteristics of line and stipple engraving, where the greater the number of points of information within a given area, the more even the tone and the more perfect the gradation. This convention supported the idea that the imperceptible transitions of tone in the photograph were visually blended gradations. Change in tone, even in a double-albumenized glossy print, could appear soft as long as it was gradual. As a writer in *The Photographic Journal* put it, "the presence or absence of half-tone is the principle element of photographic truth".[16] He equated half-tone (or gradation) with "delicacy", and offered the evidence that "Ruskin says that he can find one thing common to all great artists – delicacy". When Robert MacPherson presented examples of his photolithographs (as yet untraced) to a meeting of the Photographic Society of Scotland in 1856, James Ross complained of their rough granularity, and suggested that a smoother, finer-grained, lithographic stone might be used. Although he admired the process, he doubted its successful application "to delicate subjects especially portraits of ladies." This criticism was countered by David Octavius Hill, who "could not concur in the objections

[14]R. W. Buss, "On the Use of Photography to Artists", *The Photographic Journal* 1, 6 (21 June 1853), 77.

[15]A. H. Wall, "The Technology of Art as applied to Photography", *The Photographic News* 5 (2 April 1861), 172.

[16]Jabez Hughes, "About Light, and about Lighting the Sitter . . .", *The Photographic Journal* 10, 159 (15 July 1865), 106.

that had been made to the roughness or stippling in the lighter portions. There could be no greater roughness than that seen in a fine chalk drawing, which was far from objectionable".[17] Hill had practised lithography himself, having produced a series entitled *Sketches of Scenery in Perthshire* (1821), and was well acquainted with other graphic methods: the two-volume publication *Land of Burns* (1840) was illustrated with engraved versions of his paintings. Hill preferred the calotype's warm surface to the "livid" pictures of Daguerre, rejecting the dead and bluish appearance of the metallic daguerreotype. He remarked in a letter: "The rough and unequal texture throughout the paper is the main cause of the calotype failing in details before the Daguerreotype . . . and this is the very life of it. They look like the imperfect work of man and not the much diminished perfect work of God".[18] A decade later, however, popular opinion sided with photographers like Ross and Sedgfield. Even with the preference for paper, the value attached to sharpness in a photograph was rising. William Crookes, in his *Handbook to the Waxed Paper Process in Photography* (1857), claimed that the waxed paper negative had greater sensitivity than the calotype, and could rival collodion in sharpness.[19]

In 1856, the urgent demand for a method of preserving the photographic image from fading prompted the Duc de Luynes, in France, to offer prizes for the production of permanent photographic prints. The chairman of the Paris Photographic Society, H. V. Régnault, prefaced the announcement by explaining that carbon had been decided upon as the optimum substance for permanent printing, because it was found to be resistant to atmospheric pollutants, and because carbon, in the form of lampblack, was the basic ink in which ancient manuscripts and books were printed.[20] There were many awards given for various achievements, including Pouncy's process, but a jury appointed by the Paris Photographic Society determined that Alphonse Louis Poitevin was the discoverer of the principles upon which most of the competing processes were based, and he was given the gold medal.

The cornerstone of Poitevin's inventions was a chromated layer of albumen, gum arabic or gelatine, which was exposed to light under a negative. Dampened with water (absorbed only by the unexposed gelatine) and rolled up with greasy ink (adhering only to the hardened exposed areas), it would make a

[17]"Photolithography", *Photographic Notes* 2, 18 (1 January 1857), 8.

[18]Letter from Hill to E. Bicknell, 17 January 1848, quoted by Colin Ford, *An Early Victorian Album: The Photographic Masterpieces of David Octavius Hill and Robert Adamson*, New York 1976, 30.

[19]William Crookes, *Handbook to the Waxed Paper Process in Photography*, London 1857, 1.

[20]See Josef Maria Eder, *History of Photography*, trans. E. Epstean, New York 1972, 555–6.

positive ink impression of the negative. In Poitevin's patent description (1855), he suggested a variation by which coloured prints could be produced by adding a dye (or pigment) to the gelatine mixture, and washing away the unexposed portions with water. Although the resulting picture was essentially a "carbon print", it was not until 1860 that continuous-tone reproduction by this method was perfected. The imperfect half-tones in Poitevin's pigment process suffered because the surface of the pigmented gelatine formed a water-resistant skin where it was in contact with the negative in any degree of tone, preventing the partially unexposed gelatine beneath from washing away, and producing a high-contrast effect which limited the use of his early process to the reproduction of line drawings. This shortcoming was discovered by the Abbé Laborde in France, and Burnett and Blair in Britain in 1858. Burnett's recommendation was that the exposure should be made through the back of the pigmented paper, but this was not entirely satisfactory because the utmost in smoothness and sharpness could not be achieved through the fibrous body of the paper itself. So, in 1860 in France, Fargier patented a process in which the pigmented gelatine on paper was coated after exposure with collodion. The collodion layer provided an adhesive medium which protected the exposed gelatine when the paper base was loosened by washing. This gelatine–collodion film transferred the photographic image onto a secondary base, which was usually paper. The next step toward a commercially viable "carbon" process was J. W. Swan's patent in 1864 of the carbon transfer.

Swan's original carbon tissue consisted of two layers applied to a sheet of glass: one of collodion and one of bichromated gelatine (mixed with sugar and carbon). When this sandwich was stripped from the glass support after exposure and flipped over, the gelatine layer could be washed from the back, allowing full continuous-tone development of the image. The pigmented gelatine image, in slight relief, was then given an application of adhesive and passed through a copper-plate press to fix it to the paper base. Later improvements by Swan allowed him to transfer the gelatine image from one base to another (in order to reverse the print), using a coating of india rubber solution to pull the gelatine from a temporary paper support and to adhere it onto a secondary one. A solvent, benzene, released the india rubber from the secondary support after it had been transferred yet again.

The lineage of Swan's invention can be traced back to Talbot's experiments with bichromated gelatine (1852), Poitevin's pigmented-gelatine process (1855) and Fargier's application of collodion onto the bichromated-gelatine layer (1860). So heavy was Swan's debt to earlier experimenters' work, in 1867 the Edinburgh Photographic Society concluded that the process was no real improvement on previous carbon processes, particularly

Fargier's.[21] But the commercial potential of the process out-weighed such reservations. Within four years of the process's announcement Swan had sold the rights to Hanfstängl of Munich, Braun of Dornach, T. & R. Annan of Lenzie, near Glasgow, and John Robert Johnson and Ernest Edwards of London.

One of the first artists to employ Swan's carbon process was David Octavius Hill. In 1866, he engaged the professional services of Thomas Annan to assist him in publishing reproductions of his painting of the signing of the deed of demission by the Assembly of the Free Church of Scotland, for which his calotype portraits were ostensibly produced. The original prospectus called for an engraving to be made in mixed mezzotint, but, although it was largely subscribed for, the time required for a high-quality engraving made the plan impractical. Instead, Annan proposed they use the new carbon process, and commissioned Dallmeyer to build him a camera especially for the purpose. The carbon reproductions were regarded by *The Scotsman* (24 May 1866) as "far more valuable than any engraving". Julia Margaret Cameron also had prints made of her photographs in "imperishable carbon", as did Frederick Hollyer and many other prominent photographers.

Although Swan's carbon print found its widest application in reproducing photographic images of works of art, Swan claimed not to be in competition with "printing press processes". Unlike the ink prints of Talbot and Pretsch, the pigmented gelatine which created the carbon relief served as the substance of the finished print, just as salts of silver did in the photograph. Swan himself considered it "an analogue of the silver-printing process",[22] and there was some discussion in the journals, immediately after its announcement, as to whether it might supersede the reproduction of works of art by silver printing altogether. It claimed to be able to reproduce "the very body and soul of an artist's work – his touch and sentiment", and yet was capable of limitless duplication. The art critic Tom Taylor proposed the name "autotype", "to signify the reproduction of the artist's work in monochrome without the action of another hand or eye, the only means used being the natural forces of light or actinism and chemical affinity; and the materials employed being any of the permanent pigments of the artist's palette."[23] Like the lithograph, the autotype was a chemical process and it was polyautographic – capable of multiple reproductions of the artist's original, whether a photograph of a work of art or the photographic image itself. Although the autotype carbon print was "photomanual" rather than photomechanical, it was

[21]"Swan's Carbon Process", *The Photographic Journal* 12, 183 (16 July 1867), 77.

[22]"A New Method of Carbon Printing", *The Photographic Journal* 9, 144 (15 April 1864), 24.

[23]K.J.M. Mitchell, *The Rising Sun: The First Hundred Years of the Autotype Company*, Wantage n.d., 3.

closely related to the printing processes which followed in its wake, such as the collotype and Woodburytype, and fundamental to the photogravure.

Alphonse Poitevin's English patent (1859) for printing in greasy ink from a bichromated-gelatine plate was described as "Improved Photographic Printing". Later called "collotype", it grew from a demand to find a way to reproduce the qualities inherent in a photographic print. In the 1860's the process was perfected by Joseph Albert of Munich, and more than a hundred years later it is still one of just two photomechanical printing processes (the other is photogravure) capable of rendering the continuous tone of the photograph without the imposition of a screen. This ability is primarily due to an effect of "tanning". Areas under the negative which receive the greatest exposure of light are hardened, or tanned like leather, and become resistant to water.[24] The degree of resistance depends entirely on the density of the negative at a given point. When the exposed plate is dampened, the areas which have resisted the absorption of water will take up the greasy ink which is applied, and print it as half-tones of black according to the degree of exposure.

The first English patent for the collotype process was taken out 19 October 1869 by F. R. Window, an agent for the Autotype Company. In 1871, Autotype created a "Mechanical Printing Department" to carry out "photo-collographic printing" under the management of J. R. Sawyer and W. S. Bird. The terms "photo-collograph", "collotype" and "mechanical autotype" became interchangeable, and considerable confusion resulted because the Autotype Company was making reproductions by both carbon and collotype simultaneously, each receiving the identical signature "Autotype".

The art periodical *The Portfolio* (1870–93), carried in its 1871 issue Tom Taylor's glowing recommendation of the Autotype process: "It is impossible to exaggerate the perfection of the reproductions by this process of the drawings of the great masters."[25] Published by Philip Gilbert Hamerton, author of *Etching and Etchers* (1868) and critic of the graphic arts, *The Portfolio* was a pioneering effort in photomechanical reproduction. In its first two years of publication, it led the field with a wide range of high-quality processes, including lithographs, original etchings, original photographs (by Frederick Hollyer and others), Autotype, collotype and Woodburytype.

The Woodburytype was patented in England by Walter Bentley Woodbury in 1866. The process consisted of a gelatine relief, produced exactly like Swan's carbon image, but which, under a hydraulic press, served as the form for a mould of soft

[24]Kent Kirby, *Studio Collotype: Continuous Tone Printing for the Artist, Printmaker & Photographer*, Dalton, Mass. 1988, 49.
[25]T. Taylor, "The Autotype Process", *The Portfolio* 2 (1871), 55.

lead. This impressed lead sheet became an intaglio plate which was coated with a liquid pigmented gelatine "ink" in order to print a coloured gelatine image. The Autotype Company added Woodburytype to its mechanical printing activities in 1880, a logical decision considering that the first step in the process was another Autotype Company product, the carbon print. Woodbury had also taken notice of other printing inventions during the crystallization of his idea, primarily the technique known as "nature printing" (Alois Auer, 1852), by which natural objects such as leaves were impressed into a soft lead sheet, from which a copper printing plate was obtained by electrotype.

Woodbury effectively translated the two-dimensional tonal gradation present in a photograph into a three-dimensional model in gelatine. Where the layer of gelatine was deepest (in those areas which appeared as shadows in the print) the cumulative effect of its colouring was darkest. The varying depth (and colour) of the gelatine relief was in direct proportion to the photographic gradation in the negative. When the editor of *The Photographic Journal* stated (15 September 1865) that "the gelatine and colour so delivered onto the paper in all respects resemble a carbon print", he was quite right. Woodbury's process used a carbon print to create a lead template which would reproduce exact replicas of that first carbon print. But those who remarked how closely the Woodburytype resembled silver prints were right, too, for while its rival, the collotype, had the "soft" graphic qualities of ink on paper, the Woodburytype presented a surface as hard and brilliant as the albumenized prints contemporary with it. In 1874, John Thomson published his four-volume work, *Illustrations of China*, with photographs reproduced by the Autotype Mechanical Printing Process (collotype). Although in his introduction he praised the facility and permanence of collotype, when he and co-author Adolphe Smith produced *Street Life in London* three years later, they chose to print their "permanent photographic illustrations" by Woodburytype. Since both processes were commercially available by 1870, it is tempting to speculate on the reasons for Thomson's preference for one over the other. Did he feel that his treatment of architecture and landscape in *Illustrations of China* warranted printing in ink, whereas the documentary interest of *Street Life* deserved the meticulous detail of the Woodburytype? Or was his choice merely dictated by the limitations of publishing? The collotype process employed for the book-format of *Illustrations of China* allowed reproductions of different sizes on a page to be bound integrally with pages of text. Woodburytypes, however, had to be individually hand-mounted onto separate sheets, but since *Street Life* was first issued in parts the expense of tipping-in was minimal.

Everything that the Woodburytype was, the platinotype was not. As much as Woodbury's gelatine image stood in relief

on its smooth substrate, the image of the platinum print was given by finely divided metal held within the fibres of the paper. The Woodburytype was hard and glossy, the matt-surfaced platinum was soft. While the Woodburytype was a mechanical process, the platinotype was handmade, although it is interesting that the title of the first platinotype patent, "Improvements in Photo-Chemical Printing" (William Willis, Jr., British Patent no. 2011, 5 June 1873), has been mistakenly referred to as "Perfection in Photo-mechanical Printing". In contrast to the albumen print, in which the silver image was held above the fibres of the paper in a binder layer of albumen on the surface, the platinotype image resided within the paper itself. When William Willis founded the Platinotype Company in 1879 he provided a process perfectly suited to the needs of the so-called Naturalistic photographers of the next two decades.

Since the 1850's the question of "diffusion of focus" had concerned serious photographers like Sir William Newton and Antoine Claudet. But ideas about the use of focus differed considerably from the overall breadth produced by atmospheric effects. P. H. Emerson proposed a technique of differential focusing in which one plane of focus was selected by the artist for maximum definition, where the emphasis of certain forms and their relative tonalities expressed the greatest depth of feeling. Naturalistic photography took its name from a school of painting represented largely by members of the New English Art Club who broke away from the Royal Academy, with the aim of reviving painting by a direct observation of nature, based upon scientific principles of light and colour and the way the eye perceives them. Emerson dealt with relationships of tones in the photograph just as his friends worked with relationships of colour in their paintings, for it was tone (or colour) that defined forms, and forms (selected through differential focus) that had the power of the association of the emotions – "truth of sentiment".

In 1866, John Henry Dallmeyer constructed a lens especially to assist the artistic photographer in creating a softer image, since "amongst the most able photographers pictorial qualities in portraiture are regarded as of more importance than microscopic definition on one plane".[26] Thirty years later, his son Thomas Ross Dallmeyer championed the cause of the soft aesthetic when he designed, jointly with the painter J. S. Bergheim, the "Bergheim–Dallmeyer" lens which gave soft definition without sacrificing image structure. The elder Dallmeyer, in his discussion of the 1866 portrait lens, had praised the pin-hole as theoretically the best way for obtaining a subdued but even depth of focus, but rejected it as impractical for the photographer

[26]J. H. Dallmeyer, "On a New Portrait Lens", *The Photographic Journal* 11, 176 (15 December 1866), 160.

because of the feeble image it produced. When a lens was added
in order to increase the light intensity, it brought to the image
its own characteristic faults. But the idea of the pin-hole as the
perfect optical aperture persisted to the end of the century, and
Emerson himself speculated that "were it not for the great length
of time required for exposure, it would be a great question
whether any lens at all need be used in photography".[27] Because
of its soft tonal rendering and lack of perspective distortion, the
pin-hole was chosen by George Davison in 1891 (by which time
more sensitive plates were available) as the perfect lens for im-
pressionistic photography, and the effects it achieved were re-
markably similar to those of the Bergheim–Dallmeyer lens. With
extra rough surfaced platinum papers as his print medium, Dav-
ison carried suppression of the hard edge even further.

Emerson's commitment to the platinotype was complete.
"If the photo-etching process and the platinotype process were
to become lost arts", he wrote in *Naturalistic Photography*, "we
. . . should never take another photograph".[28] Emerson's expe-
rience with photographic processes had begun with the albumen
print, but he soon discarded it because of what he considered
to be an unpleasant glaze. He then experimented with salted
paper, which absorbed the solution of silver salts and presented
a matt finish. Finally, he turned to the platinotype, beginning
with his entries in the Pall Mall exhibition of 1882. One of the
chief characteristics of the platinum process was that, like car-
bon, it was practically imperishable. The fading of silver prints
was a prime motivation in Willis's researches: he sought a pho-
tographic process which would resist the degrading effects of
London's atmospheric pollution. When Emerson published *Life
and Landscape* (1886), he sent off his negatives to the commercial
photographic establishment of Valentine and Sons, and the forty
illustrations were printed in platinum. In *Naturalistic Photogra-
phy*, he placed platinum printing under the heading "Photo-
Mechanical Processes", and, for the purpose of artistic repro-
duction in book illustration, named the platinotype as the only
photographic printing paper worth considering.

When a studio fire in 1904 destroyed F. Holland Day's
prints and negatives, Frederick Evans reproduced a new set of
platinotypes from Day's series of prints "The Seven Last Words
of Christ", which Evans had acquired in the 1890's. Evans had
considerable experience in producing platinotype reproductions
of works of art: besides the ink drawings of Aubrey Beardsley,
Evans printed platinum "re-presentations" of the wood engrav-
ings of Holbein, Blake and Edward Calvert. The word "facsim-
ile", applied to the history of printmaking, meant that the print
taken from a wood engraving was an exact record in ink of the

[27]Peter Henry Emerson, *Naturalistic Photography*, London 1890, 132.
[28]Ibid., 193.

artist's drawing on the block. Until the platinotype, it had been impossible to produce a perfect facsimile of a fine print which gave the feeling of the line, tone and paper surface of the original. Evans' platinum facsimiles were (to use William M. Ivins's word) "non-syntactic" translations. The platinotype took its place in printing history, maintaining its characteristic visual style while superseding the problem of codification by an engraver. Evans shared the idea of the re-presentation with another photographer working exclusively with platinum, Frederick Hollyer. They were not so much concerned with mechanical translation of the original as a sensitive re-creation, whether in Evans's rich black facsimiles of wood-engravings or in Hollyer's full tonal photographs of the paintings of contemporary artists like Burne-Jones. Frederick Hollyer began his career as a reproductive engraver of paintings in mezzotint – the process of engraving which bears the greatest likeness, in its velvety surface and its subtle range of tones, to the platinotype.

The photogravure, introduced into Britain by Karl Klíč in the early 1880's, was the photomechanical realization of the platinotype. So similar were they in tonal expressiveness that Alvin Langdon Coburn wrote, "a photogravure may be so much like a platinum print that it is difficult to tell them apart".[29] The photogravure was a refinement of Talbot's basic photo-etching process in which an aquatint ground of powdered resin was applied to a plate covered with photographically prepared bichromated gelatine. The effect of the resin grains was to break up the etched plate microscopically into an irregular surface of tiny pits, corresponding in depth to the darkness of line or shadow in the original. The end effect was comparable to the mezzotint, in which a toothed "rocker" was impressed in different directions across the surface of a copper plate to create an overall irregular pitted surface, burnished more or less level according to the half-tones and highlights in the picture. Indeed, a hand-pulled photogravure can be easily mistaken for a mezzotint.

In 1862, Baudelaire wrote that "L'Eau-forte est à la Mode", but it took twenty years for the full force of the etching revival to reach England. Searching for ever greater autographic freedom, French etchers like Auguste Delâtre used the technique of "retroussage", coaxing a thin film of ink from the etched intaglio up onto the surface of the plate, which could then be rubbed and wiped for greater expressive effect. This added to the otherwise linear etching a variable midtone. Sir Francis Seymour Haden, brother-in-law to Whistler, was a great admirer of Delâtre's style and supported the etching revival in England by founding the Society of Painter-Etchers and Engravers in 1880. In Whistler's case, this hand-wiping of the plate became as im-

[29]Alvin Langdon Coburn, "Photogravure", *Platinum Print* 1 (October 1913), 1.

portant as etching the lines, and made each impression visibly unique. Whistler, Haden and other artist-etchers found their aesthetic model in the evocative chiaroscuro of Rembrandt, whose prints suggested the emotive power of linear representations in ink. Charles Blanc's *Grammaire des Arts du Dessin* (1874) explained that "chiaro'scuro could express the depths of reverie as well as those of space, and with all the reliefs of the body, all the emotions of the soul".[30] In a superficial sense, the light, airy quality of a high-key print tended to uplift the viewer, while dark, inky shadows gave a feeling of melancholy. The intensity of feeling was, for etchers and photographers alike, as much determined by the proportion of dark ink to light paper as by pictorial content.

Just as the platinotypists achieved the effect of light diffusion with rough-textured papers, the photogravurists followed the etchers' use of Japan tissue as recommended by Philip Gilbert Hamerton in 1868: "When the thinner kinds of Japanese paper are employed, it has another valuable quality, transparency. It is then mounted on Bristol board, by pasting the upper edge only, and the white of the card board shines through it, giving it a kind of luminousness which, according to a law well known to painters, is greater than that of the opaque body from which the light comes".[31] Light striking the surface was reflected back off the white Bristol board mount, and diffused by the gauze-like tissue. James Craig Annan capitalized on this virtue of tissue as a print support to enhance the luminosity of his own photogravures. In 1883, James Craig Annan and his father, Thomas Annan, went to Vienna to learn the art of photogravure from its inventor, Karl Klíč. In 1890, Craig Annan rephotographed and produced photogravures of Hill and Adamson's calotypes. Though a devoted photographer himself, Annan's knowledge of the great etchers of his day, Whistler (with whom he corresponded in 1893), and D. Y. Cameron (whose etchings were exhibited alongside Craig Annan's photographs of north Holland in 1892), attuned him to the potential of the etched plate.

In 1906, Alvin Langdon Coburn began his training in the technique of photogravure at the London County Council School of Photo-Engraving and Lithography, thus following Talbot, Fenton, Emerson and Evans in the British tradition of experimentation with permanent photographic printing. The photogravure was the logical embodiment of Coburn's photographic process – the gum-platinum print. The subtle tonal range of platinum was transmitted by apparently grainless photoetching, and the deep pigmented shadows of gum bichromate by ink. The big difference was that the gum-platinum was limited

[30]Charles Blanc, *Grammaire des Arts du Dessin*, Paris 1870, trans. Kate Newell Doggett as *The Grammar of Painting and Engraving*, New York 1974, 126.
[31]Philip Gilbert Hamerton, *Etching and Etchers*, London 1868, 345.

to a single print, and the photogravure was not. Between 1909 and 1913, in his publications of *New York*, *London* and *Men of Mark*, Coburn created from his own photogravure plates more than 40,000 prints, each of which – the final expression of a single negative – was an "original".

Between 1880 and 1900 the goal of photogravurists shifted from pure reproduction of photographic imagery to the ink-printed photograph as an art and craft in itself. Alfred Stieglitz acquired his first Annan photogravures in 1894, and was so impressed by their artistic qualities that he later suggested that a photogravure could be equally as expressive as a photographic print from the same negative.[32] Annan's gravures will have provided one important stimulus to Stieglitz's decision to adopt photogravure for the production of *Camera Work*, the beauty of which rests firmly upon its supreme examples of photomechanical printing.

[32]Christian A. Peterson, *Camera Work: Process and Image*, Minneapolis 1985, 10.

15. ART AND SCIENCE IN P. H. EMERSON'S NATURALISTIC VISION

Ellen Handy

Remember that your photograph is as true an index of your mind as if you had written out a confession of faith on paper.[1]

P. H. Emerson

P. H. Emerson's brief career (1886–95) in the art of photography was long enough to alter significantly the terms of aesthetic controversy in both British photography and art photography in general. The relation of art and science was a question which lay at the heart of both his aesthetic theory and his practice. Successive attempts to oppose or to synthesize the two resulted in an unevenly dialectical process which favoured sometimes contradiction and sometimes a transcendental fusion. The difficult and idiosyncratic style of Emerson's methods in philosophy and picture-making is identical to his eristic style in ordinary life. A man of intense but brief enthusiasms, he was active in many fields, characteristically entering a new sphere of activity with a challenge to established authority, and with the presentation of a new style, method or principle. He gained notoriety in the photographic community of the 1880's by his combative, highly critical writing and his fierce letters to editors of such publications as *The British Journal of Photography*.

In Emerson's photographs, the relation of science and art was an often uncertain and shifting one. His pictures were concerned with "life" and "landscape". Sometimes "life" was viewed scientifically, as if by natural historian or ethnographer, but sometimes it referred to the artist's own life and experience. Similarly, "landscape" could be the purely aesthetic subject of pictorial composition, or it could be the photographic subject which best demonstrated Emerson's scientific theory of selective focus for naturalistic truth. His struggle to apprehend the connection between life and landscape in East Anglia is directly correlated to his struggles in balancing and completing his literary, scientific and photographic endeavors. The geographical borders of his artistic world were precisely delimited so that the Broadlands of Norfolk and the coast of Suffolk comprised a special place which was both an artistic realm and a scientific pictorial laboratory in which Emerson could work out the contradictions and the conclusions of his theory.

[1]P. H. Emerson, *Naturalistic Photography for Students of the Art*, London 1889, 119.

The best-known instance of conflict and contradiction in Emerson's career is his repudiation in 1890 of his theoretical treatise *Naturalistic Photography for Students of the Art* (1889), and of his photographic works of art.[2] Caught up once again in the tension between art and science, he abjured his theoretical positions concerning the artistic status of photography but still was unwilling to desist from the practice of his art. The sharp and sudden transition from ardent polemicist for the art of photography to apostle of disillusionment is not as inexplicable as it might seem. Everything in Emerson's methods and persona is consistent with this fiercely contrary reversal. Emerson's decision that he could no longer consider photography an art was based on the scientific discoveries of the chemists Hurter and Driffield, who proved that the photographer does not have complete control of his materials (and thus pictorial tonalities) in that fixed ratios exist between photographic exposure and development.[3] In short, photography could no longer be considered an art because it was no longer in perfect harmony with its opposite, science.

The synthesis of strongly opposed elements is always liable to instability, and in both his picture-making and his theorizing, Emerson showed signs of a loss of this balance or synthesis even before he confronted the problem and renounced his cherished artistic vision of photography. In his photographs, purely artistic landscape imagery showed a tendency to diverge from informative and documentary scenes. And in his writing the contradiction was apparent from the first. A characteristic statement from *Naturalistic Photography* is, "All good art has its scientific basis".[4] Yet in the same year, in an address on science and art given to the Camera Club, Emerson insisted that a photographer must choose between the distinct paths of science and art or risk hindering the progress of both, for art is:

> the selection, recording and arrangement of certain facts, with the aim of giving aesthetic pleasure; and it differs from science fundamentally, in that as few facts as are compatible with complete expression are chosen, and these are arranged so as to appeal to the emotional side of man's nature, whereas the scientific facts appeal to his intellectual side.[5]

Only by looking closely at Emerson's photographs can we understand how this divided philosophy and combative person-

[2] P. H. Emerson, "Death of Naturalistic Photography", privately published 1890, also appeared in *The Photographic News* and *The British Journal of Photography*, 23 January 1891, in *Camera*, 1 February 1891 and in the *Photographic Times*, 13 February 1891.

[3] Ferdinand Hurter and Vero Driffield, "Photochemical Investigations and a New Method of Determination of the Sensitiveness of Photographic Plates", *The Journal of the Society of Chemical Industry*, 31 May 1890.

[4] *Naturalistic Photography*, 210.

[5] P. H. Emerson, "Science and Art", *The British Journal of Photography*, 12 August 1889, 252–5, and 19 August 1889, 269–70.

ality can have combined to create moments of harmony and visual balance. There is a pronounced if not entirely consistent stylistic development from his first published photographic book, *Life and Landscape on the Norfolk Broads* (1886) to his last, *Marsh Leaves* (1895). The individual images which make up the photographic portions of the books undergo changes and stylistic evolution as well. But the development of the individual photographs, and that of the books as wholes, is not precisely synchronized. The photographs are but one of the several elements that together make up the books which were the basic units of Emerson's creative expression. Written texts, small supplementary half-tone illustrations in some cases, and general organization and format all influence the final style and content of each book.

Life and Landscape is Emerson's first essay in naturalism. It represents a working-out of his theories in practice and in collaboration with the painter T. F. Goodall. It is the book in which the relation of image and text is the simplest: text and images are equal. Single pictures and small groups of images alternate with brief essays which sometimes describe the subjects of the pictures, occasionally describe the pictures and sometimes discuss art or nature in general. Texts and images are independent of but complementary to each other. The relation between the two could perhaps be described in the same words Emerson used to describe his collaboration with Goodall: "an ideal partnership". Their aim in this book was to produce

> a book of art for lovers of art; and the text, far from being illustrated by the plates, is illustrative of and somewhat complementary to them, sometimes explanatory, and containing interesting incidental information or folklore intended to bring the scene or phase of life treated of more vividly before the reader, and depicting in words, surroundings and effects which cannot be expressed by pictorial art.[6]

Thus, from the beginning we find formulated the idea that certain things can be represented in the medium of words, while others require pictorial imagery. By the time of *Marsh Leaves*, the distinction became so absolute that the text and images seem to ignore each other entirely.

The division of labor between image and text is made very clear in *Life and Landscape*. But it is less certain whether it is the work of the book to produce a subjective artistic vision, or faithfully to depict the life and country-side. The "Life" and "Landscape" of the title imply a world composed of both people and place, inhabitants and environment. In the watery Norfolk Broads, these elements are interdependent to a striking and unusual degree. This volume includes harmonious arrange-

[6]P. H. Emerson and T. F. Goodall, *Life and Landscape on the Norfolk Broads*, London 1886, preface.

ments of topographical features into coherent views, or pure landscapes, as well as landscape views which serve a narrative or illustrative purpose as well.

But a third group of images is predominant in *Life and Landscape*. These are depictions of work, often grouped in sequences illustrating the phases of a task. "Life" in this book is almost entirely a matter of work relieved only by the sailing sport of the annual regatta. The type of work most frequently depicted is harvest. Marsh hay, reeds, schoof stuff (coarse straw) and gladdon (rushes) are cut after their characteristic fashions, and transported. Fishing and hunting is a secondary theme. A snipe-shoot, the preparation of a bow net for fishing, and the eel-catcher's work are shown. A simple existence in which hard work and traditional skills are rewarded by the unique fruits of the land is suggested: not the pastoral mode nor the idyllic, both of which are mentioned by Emerson in book and picture titles, but the georgic. The details of how work is done are depicted, but the social conditions under which it takes place are not. The East Anglian landscape is expressed through precise description of marshland agriculture and fishing, but the anonymous dignity of the cycle of work depicted is a universalized conception. The tone of the texts accompanying the pictures is fairly detached and generally informative rather than expressive.

In striking contrast with this first book, we find that by 1895 the informational burden of Emerson's images disappeared entirely, to be replaced by a symbolic one. The individual sensibility prevailed over the landscape. Emerson's renunciation of art in photography in 1891 did not affect his steady production of photographs, which became markedly more lyrical, precious and concerned with form for its own sake. His texts also altered out of all recognition from the writing of 1886. *Marsh Leaves* is a series of descriptive passages, small tales and observations utterly unlike their visual accompaniment in the frequency of grotesque incident, crude dialogue and cynical observation. Each image and each little text is a self-contained unit. This could not be more different from the integration characteristic of *Life and Landscape*, in which each element is subordinated to the whole. Emerson's naturalistic vision ceased to be a holistic one, and in *Marsh Leaves* he created a series of discrete fragments of experience bound together only by a pervasive refulgence. This links each image to the others, but it cannot prevent the separation of prose from photography. The two sequences unfold simultaneously without genuine parallel or connection. Only a cold, somewhat elegaic mood is common to both. Life has been utterly vanquished by Landscape in these photographs, but struggles to reassert itself in the texts.

Such a comparison indicates that *Life and Landscape* is a more coherently arranged book than its successors. The images are carefully sequenced to allow the unfolding of the comprehensive

picture of life and landscape without relying upon a simplistic organizational pattern based on seasons of the year, times of day or geography. Unpopulated landscape pictures alternate with more elaborately composed tableaux in which two or three or more figures are seen at work, captured in some representative activity. They are almost always seen as strong and competent representatives of general types, not as individuals. The specific work performed takes precedence over the workers in the photographs. Emerson writes of a group of such figures that they are "typical specimens of the Norfolk peasant, – wiry in body, pleasant in manner, intelligent in mind. Their lot, though hard is not unpleasant."[7] Such assessments of local character are asserted throughout *Life and Landscape* with vaying proportions of condescension and admiration. The most striking photograph in *Life and Landscape* is a variant of this type. *Poling the Marsh Hay* (Fig. 1) depicts a young woman and a shadowy second figure carrying harvested marsh hay on a kind of litter fashioned from two poles, across which hay is piled. Her motion arrested, the woman stands bearing the heavy weight of the hay. She is a robust figure rooted to the ground on which her clumsy boots stand, with the high horizon line crossing her sturdy shoulders.

It is the directness and immediacy of contact which makes this picture so extraordinary in Emerson's oeuvre. T. F. Goodall's text, "Marsh Hay," accompanies this picture, omitting any mention of the woman. He provides an informative rather than an interpretive note:

> When dry, the hay is forked up into heaps: these are borne to the nearest dike on two poles, passed underneath in such a manner as to support the load when carried by two men walking between them, one in front and one behind the burden. This picturesque mode of conveyance is adopted because the load has to be carried over ground so soft that cart or barrow would be worse than useless.[8]

No information is given about the frequency with which women did such work; indeed, Goodall seems strangely unaware that the subject of the photograph is a woman. Wanting to see the photograph as a depiction of a "picturesque mode of conveyance", he must elide the sex and formidable individuality of this woman. Giving a general explanation rather than narrating a specific incident, the text explains:

> On a dull November day some poor peasants are bringing home the remnants of their crop, which, left too late, has been caught by the autumnal flood, and lain for weeks soaking in the water. When the water fell, the sodden heaps were moved,

[7]Ibid., 9.
[8]Ibid., 45.

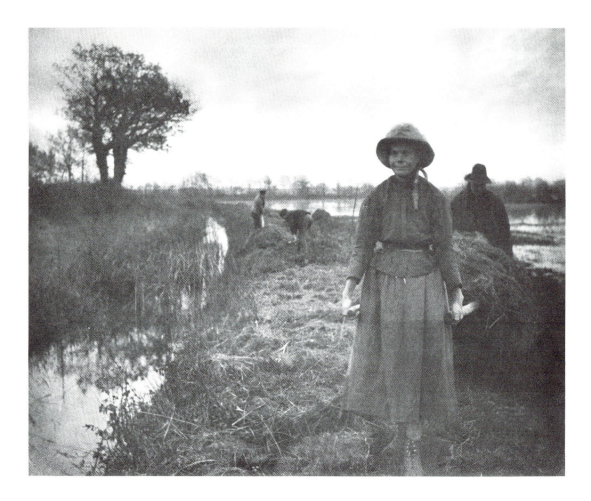

1. P. H. Emerson, *Poling the Marsh Hay*, platinum, 1886, from *Life and Landscape on the Norfolk Broads*. J. Paul Getty Museum.

and placed on the marsh wall to dry, and they are now poling them away to the litter stack.[9]

The photograph is described as depicting both the destructive potential of the seasonal cycle, and a technique for transporting hay. But here, as is seldom the case in Emerson's early work, the subject-matter is a pretext for something else. The heavily overcast sky and general darkness of the print convey a more dramatic atmosphere than the sad sentiment Goodall describes. The compositional structure contributes to this as well by means of the strong but unbalanced, deep diagonal recession not unlike those used repeatedly by Edvard Munch. Throughout *Life and Landscape*, Emerson and Goodall employed carefully ordered compositions in which paths and streams of water mark out a recession to the horizon, dividing the ground plane into triangles

[9]Ibid., 46.

met at the horizon by the flat rectangular block of pale sky above. This composition both exploits the perspectival potential inherent in the camera's monocular view, and takes into consideration the tendency of objects out-of-doors in a flat landscape like that of East Anglia to arrange themselves on the level ground across a large open space bounded only by open sky and distance. One sees objects in the landscape as existing between oneself and the sky. But here, the curve of the tongue of land on which the figures stand points emphatically to the brooding silhouettes of two trees with dark, tangled branches that strike an unexpectedly strong note of pattern.

Yet it is by no means an expressionistic landscape. Rather, it is a tension-charged setting for the woman who carries the marsh hay. She is portrayed in the very act of poling the hay, as is evident in the authentic pull of the load's weight registered in her arm muscles, but she is standing not walking, presumably pausing if not posing before Emerson's camera for the exposure. While her body faces the camera, her eyes look away. She stands as though on a threshold or at a gateway, stopped in her tracks against a heavy sky. The dark figure behind her is like a shadow or a portent.

The power of the photograph is in the force of the personality unexpectedly portrayed. It is a depiction of a stranger, a "peasant" unknown to Emerson, but also of a woman whose individuality could not be submerged in Emerson's usual conventions of figural representation. The heroic but anonymous labouring figures with averted faces more commonly found in Emerson's photographs are derived from French models, most particularly Millet, which uniformly lack the emotional intensity of this photograph. The reverence which Emerson consistently displayed for Millet helps to place him within the English art world of his time. Emerson's evolving theory of naturalism parallels the developing naturalism of the mildly progressive New English Art Club, whose membership included Goodall, H. S. Tuke, Frederick Brown and H. H. La Thangue. Emerson initially met Goodall with La Thangue in 1885, while cruising on the Broads for the first time, and perhaps the painters stimulated his interest in Millet. Emerson's writings indicate that Millet and Jules Bastien-Lepage (whose work was popularized in England by the painter George Clausen) were among the few in the history of art whose work he found sound on naturalistic grounds.

The influence of Millet upon Emerson's depictions of labourers is most evident in *Pictures of East Anglian Life* (1888). His least artistic book in many ways, this is also his strongest statement in defense of the East Anglian peasantry. One of its epigraphs is the section from Goldsmith's poem "The Deserted Village", which ends:

But a bold peasantry, their country's pride,
When once destroyed, can never be supplied.

An encyclopedic work, *Pictures* is crammed with incident, statistics, subsidiary illustrations and occasional polemic. Yet in the preface he wrote, "I have endeavoured in the plates to express sympathetically various phases of peasant and fisherfolk life and landscape which have appealed to me in Nature by their sentimental poetry. In short, I trust the complete work may form a humble contribution to a Natural History of the English peasantry and Fisherfolk". Thus he reduced these labourers to a rough equivalency with the birds, beasts and fishes of the region which he described in a later book.[10] "Sentimental poetry" makes a poor showing on the whole in this volume, which is undecided whether to treat the peasants as local fauna or as noble but oppressed heroes. The rhetoric of the texts favours the latter while the statistics and method of compilation of the entire volume incline toward the former. Essentially it is a conflict between the methods and goals of science and those of art. In addressing his reader, Emerson reveals a great deal about himself while deploring convention:

> Prosperous reader! Have you ever thought of the peasant's position? Have you tried to realize that morning rising while yet it is night, that day of toil followed by the too short night, that endless, hopeless regularity? Have you ever thought what it must be to live in debt, and not have enough to feed the mouths at home, even with bread? Have you seen your children ill as well as starving? . . . Hewers of wood and drawers of water there must always be, but why dull, unloved, and uncared for? Equality there can never be; the stern truth of heredity forbids that *in utero*. An anthropological aristocracy there must always be; the struggle for existence and survival of the fittest declares it. But alas! to-day there is no centre of light, of reason, of Truth in English villages, but only a paralyzing conventionality![11]

Pictures is a large and complex book. It lacks the aesthetic balance and order of *Life and Landscape* but, like it, tries to convey the totality of a way of life. It is crammed with bits of information and opinions which are always threatening to break the divisions of Emerson's somewhat complex organizational scheme. Its text discusses the folklore, agriculture, diet, character and intelligence, superstitions and habits of the "peasantry around Southwold". Its appendices record meteorological data and list bird sightings in the area. The text keeps pace with the images so that their subjects are discussed in chapters that do not discriminate between the actual harvest and photographs of the harvest, for instance. Some of the balance established in *Life and Landscape*

[10] P. H. Emerson, "Preface", *Pictures of East Anglian Life*, London 1888, iii.
[11] Ibid., 135.

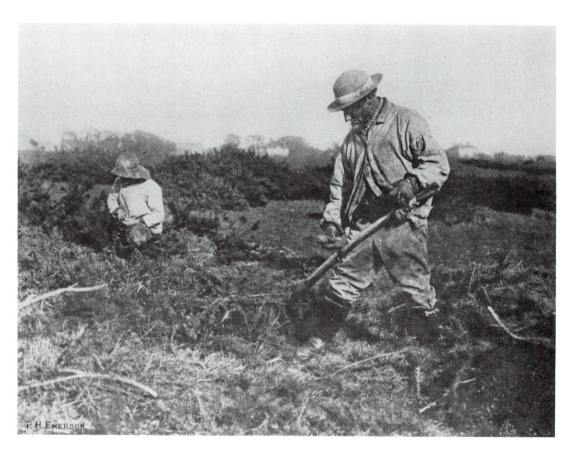

still holds. But the pressures of the encyclopedic approach are too great for total integration or coherence. The text accompanying *Furze Cutting on a Suffolk Common* (Fig. 2) begins by calling the man in the photograph "intelligent" and discussing the work depicted but soon slips into a different mode, despairing of the possibility of full depiction of Nature and then positing ultimate communion of man with nature in death. The photograph itself is not very informative regarding furze cutting, for though the man with the scythe stands in the attitude of work, he is posing and not actually cutting. His concentration upon his work and his shadowed face are typical of the poses of labourers in *Pictures* and in accordance with examples by Millet, but the vigor conveyed through his stance and the creases of his clothes gives more than usual energy to the scene, while the hovering form of the self-absorbed child at the left acts as a balance.

On the whole, *Pictures* is a compendium of information, and a tremendously specific one of limited geographical focus. The book is studded with place names and mentions of the area around Southwold, Suffolk, where Emerson himself lived for a time. While he often strove for simplicity in the compositions

2. P. H. Emerson, *Furze Cutting on a Suffolk Common*, photogravure, 1887, from *Pictures of East Anglian Life*. J. Paul Getty Museum.

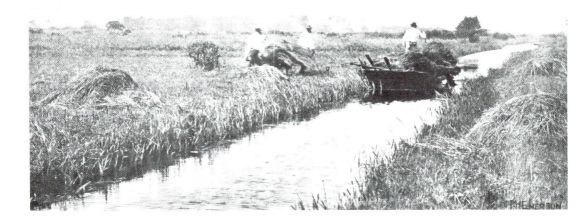

3. P. H. Emerson, *The Sedge Harvest*, autogravure, 1888, from *Idyls of the Norfolk Broads*. J. Paul Getty Museum.

of his images, Emerson's larger projects, such as this book, acknowledge the untidy complexity of the world which cannot be expressed simply. As he argued, science explains the world by making order of it through categorization and description, while art makes order through suppression and selection. A tension arises from this fundamental disharmony of methods of image and text in this volume. The suppression by which art arranges the world in a coherent image can assuage the discomfort of the incoherent experienced reality. It is social reality, not landscape or "Nature," that poses the problem. The reality of the role of the labourer in the landscape necessarily underwent transformation and suppression in the pastoral and georgic images of landscape in nineteenth-century British art. John Barrell's brilliant study, *The Dark Side of the Landscape*, explores this in the work of Constable, painter of East Anglian scenery.[12] Barrell examines the way in which Constable renders agricultural labourers as mere spots of paint, white sleeves in the landscape, in order to preserve a pictorial and ideal harmony in the face of increasingly disharmonious social reality. Something very similar is at work in Emerson's photograph *The Sedge Harvest* (Fig. 3) from his *Idyls of the Norfolk Broads* (1888), which, as its title suggests, frames scenes of the Broads as idylls.

In rendering this landscape idyllic, Emerson put the figures at a great distance, in marked contrast to his practice in *Pictures*, a book whose purpose was so different. Two of the figures are poling the sedge between them while a third stands beside the waiting boat. A broad expanse of water intervenes between viewer and figures. The picture is cropped tightly at the top, making a high horizon which emphasizes the distance of the men. The treatment of the figures resembles Constable's daub-

[12]John Barrell, *The Dark Side of the Landscape: The Rural Poor in English Painting 1750–1840*, Cambridge 1980.

of-paint technique. Much of the scene is in deliberately soft focus, and the two figures at the left were photographed while in motion, slightly blurring the image. Differential focus was the essence of Emerson's aesthetic style, as well as of his scientific naturalism derived from his study of optics and perception. In *Naturalistic Photography*, Emerson pronounced that "The rule in focussing, therefore, should be, focus for the principal object of the picture, but all else must not be sharp; and even that principal object must not be as perfectly sharp as the optical lens will make it".[13] From this it is clear that the figures are not the "principal object" in the landscape. They cannot be so while an idyll is proposed, for the sweat and labour of the harvesters is incompatible with this vision. Emerson's shifting intentions, and his wavering between scientific naturalism and artistic expression, make the already difficult problem of representing the figure in the landscape one which cannot have a single solution. In *Poling the Marsh Hay*, he came closest to finding a balance between the conflicting promptings of Art and Science, which allowed him to represent such a subject without either distance or idealization.

After 1888, Emerson turned away from agricultural subjects and cultivated landscapes. He began to depict depopulated landscapes, and to present them purely as objects for aesthetic contemplation rather than as informative documents. They became transcripts of his communion with a disembodied, inhuman nature as well. He became more interested in the sailing, fishing population of East Anglia as he ceased attempts to depict the agricultural scene. In 1890 he completed *Wild Life on a Tidal Water*, an account of his sojourn in a houseboat on Breydon Water, near Great Yarmouth. The book is illustrated with marine views of the harbour and some scenes of Great Yarmouth, photographs made once again in collaboration with Goodall. As the text veers into diary and meditation, the images retain an objective interest in the subject-matter for its own sake, but the figures are consistently placed at a distance, and never characterized as individuals. *In a Sail Loft* (Fig. 4) depicts two men at an unreachable distance from the camera, at work on the seams of a sail which fills the foreground with marvellously folded, massy billows of canvas. The almost universal flat chalky light of Emerson's early work has given way to a beautiful clear light that falls through small-paned windows and across the canvas, and which is as much the subject of the photograph as anything else.

There is an exact correspondence between Emerson's increasing interest in light and the decreasing frequency of his ethnographic photographs. The people in the landscapes cease to labour, and then virtually disappear, while the texts become chronicles of Emerson's own experiences, adventures and per-

[13]*Naturalistic Photography*, 119.

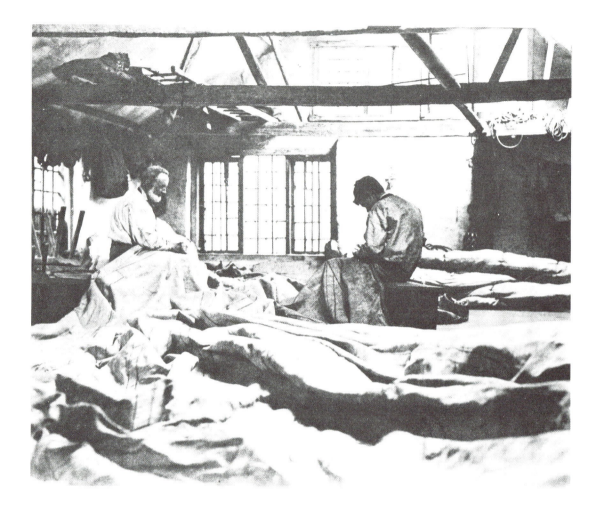

4. P. H. Emerson, *In a Sail Loft*, photo-etching, 1890, from *Wild Life on a Tidal Water*. J. Paul Getty Museum.

ceptions. Increasingly, he uses the landscape as a mirror of his thoughts and emotions. *On English Lagoons* (1893) describes a boat voyage Emerson made on the Broads, and is illustrated with images largely unrelated to the text, like *The Marshes in June* (Fig. 5). Two men stand watching a flock of sheep whose forms are edged by a radiant contour. Men and sheep are immobilized by the light. The light defines a new land, not the prosaic East Anglia of scientific fact but a new territory of experience, a realm bounded by the extent of Emerson's sensations. The men in the photograph are standing on the threshold of a radiant world which Emerson could not depict by his established means as a record of nature seen, but instead had to treat as a landscape *felt*. The figures are no longer illustrative parts of the description of the agricultural landscape, but emotional surrogates for the artist in the landscape. Their experience of the dazzling light on the land is a direct metaphor for Emerson's own experience of the same vision and place. As in the idyll of *The Sedge Harvest*,

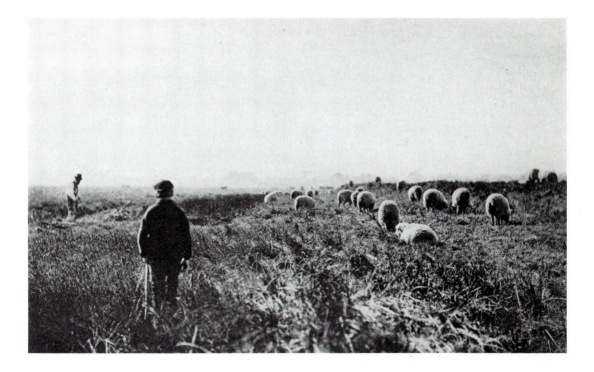

a distance and removal from the subject of the photograph is necessary to achieve the desired effect.

Marsh Leaves (1895), even more than *On English Lagoons*, is a series of images suffused by exquisite light. Morning mist permeates *A Corner of the Farm Yard* (Fig. 6), but the early sunlight causes the fogged atmosphere to glow. The moment is an ephemeral one that might be destroyed by as little as a footstep. Sleepy fowl temporarily appear to be fabulous birds of antiquity, while the farm-yard corner is an exalted realm. The perfected instant of expectant humid light is expressed as a function of place as much as time and atmosphere.The picture was made at the threshold of a magical world; Emerson placed his camera in the gateway to the farm-yard, with the gate pulled wide open, to point inward to the centre of the illuminated fog. The open gateway is an unmistakable invitation into the radiant space, into the artist's otherwise incommunicable experience, into a new world where sensation and emotion take precedence over optical accuracy of vision and information. The softness of the photograph results from the effect rendered rather than natur-alistic theory, and the subject is chosen for its own associations rather than for social, natural-historical or documentary pur-poses. Emerson's exploration of East Anglia led him from a local survey finally into himself, where his subject matter was near to hand, without reference to geography. The life and landscape of *Marsh Leaves* are Emerson's own, not an attempt at objective

5. P. H. Emerson, *The Marshes in June*, copper-plate engraving, 1893, from *On English Lagoons*. J. Paul Getty Museum.

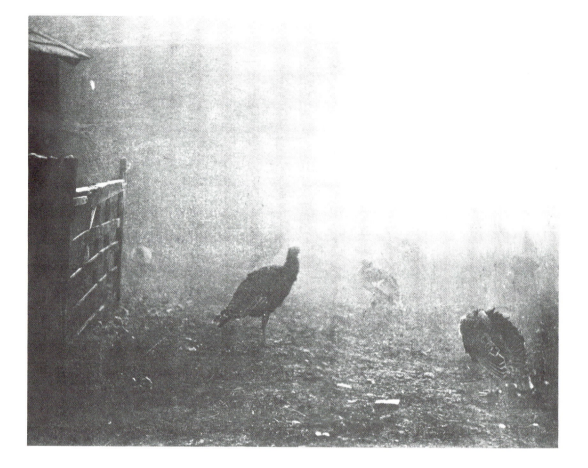

6. P. H. Emerson, *A Corner of the Farm Yard*, photo-etching, 1895, from *Marsh Leaves*. J. Paul Getty Museum.

survey. Although this may sound like an aesthetic or even emotional liberation, a healing or productive resolution of old conflicts, it is not necessarily that. It is no coincidence that most of the now empty, unworked landscapes of *On English Lagoons* and *Marsh Leaves* are winter scenes. A coldness and a beautiful numbness were setting in for Emerson in the 1890's. The artist who nourished himself on controversy may have found a fulfillment in making these pictures, but he also found it impossible to continue beyond them. The old energy, contradiction and complexity dissolved into cold, radiant light. The small precious gravures seem to glow with a light deep within their fabric, but they also seem to suggest a stilling of all life forces in the frozen landscape.

For Emerson, death was not an end but the ultimate communion of man with nature. He wrote, "The nearer we get to Nature the sweeter will be our lives, and never shall we attain the true secret happiness till we identify ourselves as a part of Nature. . . . Matter is indestructible; we perish not, but only are

changed, and live again".[14] Emerson sought union with nature through both art and science, art as the mirror of nature and science as the tool for looking into nature. He first studied science, then taught himself art, with nature ever present as his ideal. His attempts to merge the two in photography took varying forms over the years, and at times his contradictory spirit asserted itself in insistence upon the separation of art and science. Although at last Emerson renounced the great work of his crusade for the recognition of photography as a fine art, and denied the possibility of art in photography, the pictures he continued to make demonstrate both art and science. In time, subjectivity overtook theoretical argument, and as naturalism always had been about the subjectivity of truth, the results were unexpectedly tranquil. Perhaps the truth was that however opposed science and art might be, photography needed them both, and as Emerson wrote:

> ... there lurks still a leaven of Art in Science, and a leaven of Science in Art; but in each case these leavenings are subordinate, and not at the first blush appreciable. For example in Science the facts can be recorded or demonstrated with selection, arrangement, and lucidity – that is, the leaven of Art in Science. Whilst in Art the physical facts of nature must be truthfully rendered – that is the leaven of Science in Art.[15]

[14]*Pictures of East Anglian Life*, 92–3.
[15]"Science and Art", 269.

16. THE CORRESPONDENCE BETWEEN P. H. EMERSON AND J. HAVARD THOMAS

Fiona Pearson

The correspondence between P. H. Emerson and the sculptor James Havard Thomas (1854–1921) of 1887–1919 is the record of an affectionate friendship,[1] which began in the early days of the New English Art Club.[2] Havard Thomas trained at the South Kensington Training Schools (now the Royal College of Art) alongside George Clausen, and made trips to France and Norfolk with H. H. La Thangue and Clausen from 1883, following his further studies in Paris. The three artists worked in the open air recording peasant life.[3] On 27 March 1887, Havard Thomas, by then honorary secretary of the NEAC, wrote to Emerson quoting prices for casts of his *Peasant Woman* sculpture. It was clear that Emerson was already photographing his sculpture and was encouraging both Havard Thomas and T. F. Goodall, his collaborator on *Life and Landscape on the Norfolk Broads* (1886), in the use of photography. Emerson and Havard Thomas, like all the founder members of the NEAC, were opposed to commercialism in the art world and to the closed shop of the Royal Academy. This belief in the suffrage of artists and their right to elect their own selectors united the two men in a comradeship which also explored the pursuit of truth through art itself. Art political problems were discussed during their get-togethers throughout 1887, and higher ideals debated among the Greek and Roman collections of the British Museum.[4]

By January 1888, Emerson was trying his hand at sculpture in his friend's studio and lending his knowledge of classical literature to the sculptor's search for subjects drawn from antiquity. However, Emerson knew his path lay elsewhere, writing in May 1888: "Had I begun sculpture 12 years ago I could

[1] P. H. Emerson's letters are in a private collection, but transcripts are available, as are those of the J. H. Thomas letters, in the Local Studies Department, Norwich Central Library. Thanks to the Havard Thomas family, Kenneth McConkey, Veronica Sekules and Clive Wilkins-Jones for their generosity in making this material available and sharing their expertise.

[2] City Museum and Art Gallery, Birmingham, *The Early Years of the New English Art Club*, exhibition catalogue by Mary Woodall, 1952.

[3] See Tyne and Wear and Bradford museums, *Sir George Clausen, R.A., 1852–1944*, exhibition catalogue by Kenneth McConkey, 1980; Oldham Art Gallery, *A Painter's Harvest. H. H. La Thangue 1859–1929*, exhibition catalogue by Kenneth McConkey, 1980.

[4] P. H. Emerson's *Naturalistic Photography for Students of the Art*, London 1889, refers to antique sculpture, Thomas and posing the model, 40, 94, 244.

... calmly settle down to it – but my comings and goings are uncertain & perhaps I more than most men am destined to be a wanderer''. Emerson's experiments in the depiction of peasant life through photography was of great interest to the NEAC members, whose artistic roots lay in the French tradition of Courbet, Millet and Bastien-Lepage. It is not known which Emerson text the NEAC members discussed, but in an undated letter prior to the summer 1889, Havard Thomas described how about a dozen men had stayed in his studio until eleven one Monday night looking at Emerson's use of tone. ''Goody [Goodall] & Charles both thought that you had clearly defined local colour. Goody suggested that a white sail may either look white or black . . . I was glad to see there was no 'fighting photographer' in their minds[;] they all seemed to wish the book should be quite all right''.

However, such amicable proceedings were soon disrupted by the unhappy influence of another founder member, W.J. Laidlay. In 1889 a break-away group, called ''The London Impressionists'', was formed by Fred Brown, painter, fellow student of Clausen and Thomas in London and Paris. Brown, together with Walter Sickert and Philip Wilson Steer, rejected the Bastien-Lepage ideals of Clausen and La Thangue, and Laidlay sought to use this difference for his own ends. However, Clausen called his bluff when Laidlay attempted to force a wedge between Brown and La Thangue, and he retreated.[5]

The acrimonious emergence of the Impressionists, the resistance of the Royal Academy to reform, and the souring influence of Laidlay led Havard Thomas to smash up what was left in his studio, and ignoring Whistler's advice to stay and fight, he set sail for Italy in October 1889 to pursue his art. Emerson accompanied him to Capri for a short spell at the beginning of his new life in Italy and their adventures were satirized in an unpublished short play by Henry Neville Maugham.[6] Emerson as ''Borrodaile'' appreciatively watches the tarantella dancers and Thomas, who was to marry Sofia Milano in 1891, as ''Macleod'' proclaims proudly that he is married to ''a little Capri girl''. In their subsequent correspondence they addressed each other as ''dear old Bor'' and ''Dear Mac'', Emerson anxiously following his friend's courtship and suggesting subjects that required a nude female.

On a higher plane, their philosophy of art dialogue continued, with Thomas beginning to question the NEAC wish ''to say something'' in their work by asking, ''Is it not the philosophy of painting to *show* something rather.'' Emerson, like the London

[5]See W. J. Laidlay, *The Origin and First Two Years of the New English Art Club*, London 1907, for his side of the story.

[6]See Henry Neville Maugham, *The Blue Lizard*, London c. 1897 (British Library Cup.407.6.39). Proof-sheets of unpublished play dedicated to Norman Douglas by Thomas.

Impressionists, was also falling under the spell of Whistler's arguments for the decorative and the beautiful rather than the narrative approach of the first years of the New English Art Club. He was much taken up in their initial correspondence with photographic techniques which would take his work beyond the mere recording of peasant life and into fine art. Thomas was himself quite familiar with the mechanics of photography and thus able to follow Emerson's thoughts. When the sculptor set sail from England, his baggage had contained four cameras by Meagher, four Dallmeyer lenses, a case of photo appliances, a tripod, a box of photochemicals and a box of photo dry plates. Unhappily, they were all lost when the ship foundered, and Thomas spent the first year with just one small camera. Emerson was working with a new lens, "like the eye", designed by his friend Thomas Dallmeyer. He wrote to Thomas in alternating moods of elation and despair. "It is still as death and I am alone", he wrote, after a row with T. F. Goodall in June 1890. But by the next month Emerson was enthusiastic once more:

> Did I tell you I gave Barber (the poacher) The Idyls[7] & told him he was *Darkel*. He was very pleased & said it was the best thing he ever read. He has told me a lot of good yarns – he is a clever fellow that man – knows all the game laws off by heart. His workman is the *Flea*. I am going poaching with him in November – to see some fish as he says, to see some fun I say. He is dead nuts on Goodall for coming out with the keeper one night – *will never forgive him* thinks he ought to have dropped the oar on to his head. . . . I have made some new observations in the eye question *conclusive* – I have been trying some quite new effects – delicate decorative reed subjects – came beautifully & my boy I have one *splendid* figure subject.

The whole tone of Emerson's letter captures his extraordinary mixture of boyish excitement, quick temper, scientific interest and a striving for aesthetic perfection. In the summer of 1890 Emerson sent a portfolio of plates to James McNeill Whistler and an invitation to tea followed: " . . . he was delighted with the extraordinary photographs full of the most charming effects . . . he insists on my taking his portrait – I'll make a stunner of him too. . . . It is very pleasing to get the great Jimmy's approval . . . Keep it *private*". It was Whistler's use of such terms as "a certain harmony of colour" and "artistic arrangement" in the Ruskin trial of 1878 that had brought the French concept of art for art's sake to the London art scene. In the "Ten O'Clock" lecture, published in 1880, Whistler was even more specific, arguing that art should be not only disassociated from special epochs "but from Nature Herself. . . . That Nature is always right, is an assertion artistically as untrue as it is one whose truth is universally taken for granted". Emerson was overwhelmed

[7]P. H. Emerson, *English Idyls*, London 1889, chap. 13: "Darkel, The Poacher".

by the implications of this anti-naturalistic theory and during the latter half of 1890 he struggled in vain to marry the new theories with his own experiments in tone relations and composition.

The technical problems of naturalistic focusing were explored by Emerson and Dallmeyer on a trip to Norfolk in September 1890. Emerson claimed that "mathematical principles and artistic ditto are different matters. Thus a stopped down lens is *mathematically* true but *not artistically*. For this reason when looking at principal object other things out of that plane *enlarge* & the only way is to throw part out of focus". The discovery of two chemists, Hurter and Driffield, that relations between tones were determined by correct exposure and development when Emerson had held that they could be altered at will, prompted him to write a detailed letter to Thomas on 11 September 1890 begging him to study the tones in the photographs he took in the bright sunshine of Capri: "Tell me how truly your prints tell as compared with Nature. How well the *real values* of the colours, blue, green, red and yellow *tell* . . . I go to Norfolk on Monday and hope to solve this tone problem. . . . It's very complex." Emerson battled on with his tone experiments until 20 December in thirteen inches of snow and temperatures of 14° Fahrenheit, taking "some of the loveliest things ever produced from Camera or any other way".

Emerson's reassessment of his own aesthetic ideals and philosophy of art led him, in the last half of 1890, to deride the work of his old friends in the New English Art Club. La Thangue, Clausen, Brown, the Newlyn School and Goodall were all criticized. Goodall was singled out as one who had taught him much but had since sold out to German "naturism" and abandoned naturalism. Emerson wrote on 31 December that he was in a curious moral state but saw a way ahead. By the end of January 1891 he had decided to withdraw his book *Naturalistic Photography* and to go to the Norfolk Broads for a year: "I am no longer a follower of *any school* – there is so much to say for every side of *art* . . . I don't even think I must be perfectly true to Nature. . . . I don't believe in *pure* photg. as an *art* – photo-etchings – yes!" Despite his claim to not following any school, Emerson added a reminder to "keep always the decorative and beautiful in view".

Thomas, well aware that Emerson was easily swayed and obviously a follower of Whistler, tried to persuade his friend to give up polemics: "They don't run well with art and serve to make one too hypercritical especy of one's own work & so stop the playfulness which I think we both esteem a dear quality". But Emerson was not finished with polemics, nor Goodall, with whom he published *Notes on Perspective Drawing and Vision* (1891). This suggested that photographs were false in outline, and Emerson considered giving up photography altogether as a result of this blow: "I shall turn Naturalist or rather I shall resume Naturalist for such I have ever been."

Now by "Naturalist" he meant "student of natural history". By 27 May 1891 he had decided to abandon photography, however much this was against his natural inclination. Emerson wrote to his friend in a downward spiral of self-doubt:

> Art is a compromise & we must depend freely on sensuous impressions & record them – isn't it so? . . . I have this last year taken some lovely things (in Nature) & the result[s] tho good as photos are poor & mean & small. I wish to God I had never seen a camera.

Thomas wrote to Emerson at his hideaway in Anglesey four months later, trying to pull him away from the argument of art as the registration of nature; he held that masterpieces were dominated by an idea. Emerson replied on 6 December 1891: "As for theory I think Whistler is nearer the mark than anyone. . . . I feel that Nature must be there *au fond* – the Essence of it & resides in Whistler". He then went on to develop this theme in January 1892:

> As to Whistler . . . the "newness" of his theory on art is really his assertion that there is no *newness*. He holds pure and simple that the whole aim & subject of a picture is to seek a *decorative scheme or pattern* either of line or colour & he holds further that Nature sometimes does the thing but *rarely* that is all.

Thus Emerson wrote, in preparation for his paper of 1892, "Photography Not Art",[8] that "all art is *ideal* – that Nature is more beautiful than any art. That photog. is neither art nor nature & beautiful in the same way a flower or nature is". The next three years were then spent on horticulture, natural history and purely literary projects.

During 1892, as Emerson prepared for the publication of *On English Lagoons* (1893), he asked Thomas for a cover design and received a pen and ink sketch (Fig. 1), a roundel of two figures seated in profile against a landscape. It bears a faint inscription: "P. H. E. holding forth to a rather select audience". In 1895 he published his final photographic work, *Marsh Leaves*. The compositions of these, his finest photo-etchings, drew upon Cuyp, Rembrandt, Turner, Whistler and Japanese woodcuts. Each plate united Emerson's interest in the object and the mood by the use of reflections, mist and expansions of foreground, isolating one feature to produce a contemplative, almost abstract quality. This resolution of his artistic aspirations brought Emerson's work to a natural close.

The correspondence with Havard Thomas dried up until 1901. Apart from his plans to publish a book on colour in January 1897, work on the family history, and a history of the English camera, in March 1901, Emerson was preoccupied with the building of his new house ("what thieves builders are") in South-

[8]P. H. Emerson, "Photography Not Art", *The Photographic Quarterly* 19 (1889), 214.

1. J. Havard Thomas, proj-
ected cover for *On English
Lagoons*, pen and ink, 1892.
Dr. Mark Havard Thomas.

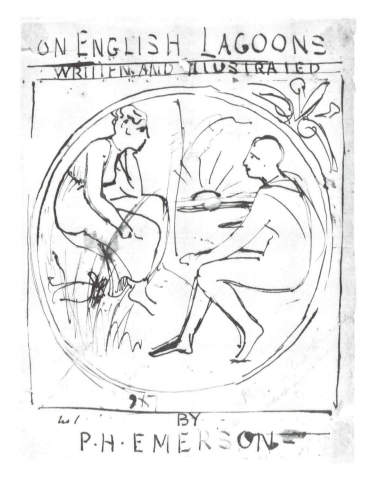

bourne near Bournemouth. Domestic issues then took prece-
dence in the correspondence until April 1905, when Emerson's
eldest daughter, Sybil, having won distinction at the Slade
School of Art, went to study with Havard Thomas on Capri and
live as one of the Thomas family. Unfortunately, the threat of
a cholera epidemic, the children's educational needs and the
sculptor's success in London with *Lycidas* brought the sculptor
and Sybil back to London in December 1905.

Emerson built Sybil a studio at "Foxwold", the new house,
so she could work from home, and Thomas suggested that she
could make a career in commissioned portraits. Thomas rented
the Manse at Bourton from one of his patrons, Sir Cyril Butler,
and it was to Bourton that Emerson went for a sitting for the por-
trait relief on the Emerson medal. This had first been mooted in
1902 as an honour to be bestowed upon the members of the "Fox-
wold" Billiards Club, where Emerson was the leading light. The
production of this medal dominated the correspondence for
some time, broken only by Emerson's expression of grief at the

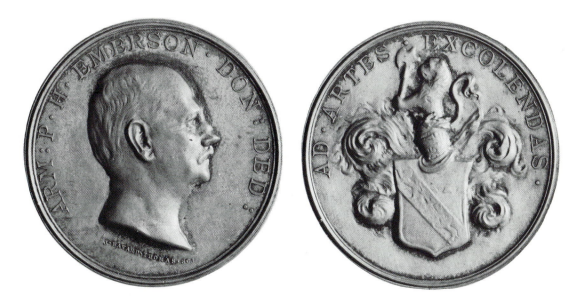

death of Dallmeyer in 1907. By the end of 1908 the Emerson medal had been completed and cast in silver and bronze (Fig. 2). Despite his initial disappointment with the quality of the medal and the work of the die-caster Moore, Emerson sent one of the silver medals to G. F. Hill, the Keeper of Coins and Medals at the British Museum. Its inscription around the profile reads: ARM: P. H. EMERSON • DON: DED: (Given as a gift by P. H. Emerson Esquire) and around the Emerson coat of arms on the reverse: AD • ARTES • EXCOLENDAS (for perfection of the skill/arts).[9]

In September 1911, Thomas wrote to Emerson, "But MPs are to be paid . . . are you still going in for it? Your remarks on Political Economy are interesting". Whatever Emerson's political intentions, they never came to fruition. Polemics interested him, but not their enactment. Thomas's teaching post at the Slade from 1911 until his death brought the element of art dialogue back into their letters. Emerson was keen to know whether a painter could paint what he saw in a stereoscope and Roger Fry's Post-Impressionist exhibition of 1912 prompted him to ask Thomas for a good reproduction of "one of the best" Post-Impressionist works. In January 1913, Emerson read the new Futurist Manifesto and asked Thomas how their paintings rated as decorative schemes, expressing his own reservations about ideas stemming from literature being translated into paint. In 1914, after reading a history of Impressionism, Emerson criticized Clausen and La Thangue for bringing back from Paris the realism of Courbet

2. J. Havard Thomas, *The Emerson Medal*, 1908. Courtesy of the Trustees of the British Museum.

[9]Initiated for the "Foxwold" Billiards Club, with the suggestion that it might be further used as a presentation at Emerson's Cambridge college for literary achievements, fifty-seven medals were given to photographers between 1925 and 1933.

and Millet, when Impressionism was the new thing: "Whistler was the only man of his time who saw clearly what was *happening in his own times.*" Emerson concluded by calling Whistler's "Ten O'Clock" lecture "the biggest Art writing or philosophy ever written".

The last six years of the correspondence was dominated by Emerson's interest in stereoscopic photography, which began in January 1912. Emerson was convinced of its potential use for the artist in studying the model, but Thomas criticized its lack of relief and the loss of lateral vision. In March 1913, Emerson bought an ordinary stereoscopic camera and began taking stereo photos in natural colours. Both men were also entranced by the further realism of the Scala picture show in June 1913, which combined cinematograph, stereoscope and the gramophone. Emerson thought, as he had done following the 1889 Exposition Universelle in Paris, that this was the way forward for photography, image, movement and sound united, and wished that he had been born a hundred years later.

The outbreak of the First World War plunged the lives of the two friends into concern for their children. Anxious letters were exchanged charting the children's movements until the Armistice was signed. In 1919, Emerson moved next door to his "dear old friend" in Chelsea and the correspondence came to an end. Havard Thomas died in 1921 and three years later Emerson dedicated the third edition of *English Idyls* to his memory. For Emerson, the "fighting photographer", Havard Thomas had been his only lifelong friend. The two men had shared a boisterous sense of humour, a love of nature and, to the end, a search for truth through art. The sculptor had perceived Emerson's lyrical qualities in his prose writing and foresaw the inevitable death of naturalistic photography once Emerson took up Whistler's polemics. Therefore the correspondence between Havard Thomas and Emerson presents to modern research the sustained admiration of Emerson for Whistler and Thomas's unique insight that once Emerson had emulated Whistler in *On English Lagoons* and *Marsh Leaves*, he would not be able to find his own way forward into the twentieth century.[10]

[10]For discussion of Emerson and Whistler, see Neil McWilliam and Veronica Sekules, eds., *Life and Landscape: P. H. Emerson*, Sainsbury Center for Visual Arts, University of East Anglia, Norwich 1986, 10, 30–2, 39, 63.

17. EMERSON OVERTURNED:
On English Lagoons and *Marsh Leaves*

Ian Jeffrey

One question involves P. H. Emerson's continuation in photography after a vivid denunciation of the medium and its adherents in 1890, *The Death of Naturalistic Photography*. Another involves Emerson's eventual, and final, withdrawal in 1895. He had, after all, been a great advocate, and shiningly successful in the 1880's. And what sort of pictures followed on his first denunciation? What did he claim to be doing? What, in fact, was he doing, this photographer who seems to have given most of his time to writing? He was a naturalist, and close observer of everything from Man to the weather; and he was a sentimentalist, prone to dream, and cruel, vulgar, irritable, sensitive, living among "naturals" and shifty, often callous, fenmen, his preferred company – men he was inclined to heroize, despite their often arrant ways with nature and with language. There is plenty of evidence – but evidence of what? For a start there is a long diary for the year following the summer of 1890, published in 1893 as *On English Lagoons*. It chronicles a twelvemonth spent on a converted sailing barge, *The Maid of the Mist*, with Jim, a laconic crewman from the region; in support there are fifteen copper-plate engravings from photographs. In 1895 his last major book, *Marsh Leaves*, presented sixty-five short prose pieces and sixteen photo-etchings.

The renunciation of 1890, which Emerson called a "burning of books", is as bizarre an "artist's statement" as history has to offer, for it shows a vehement turning away from a preferred medium. Photography amounted to "the lowest of all arts", and could, he judged, give nothing other than "transcripts more or less literal". He concluded with a vicious onslaught on some contemporaries and fellow workers, and on that evidence ought never to have taken, nor had printed, another picture. But despite his vehemence Emerson was never to be believed; he was never literal, never straightforward – not because of any inherent bad faith on his part, but because he found himself baffled by an intuition.

What was the renunciation meant to achieve? It committed Emerson to nothing, but would have left a careful reader in a quandary, and could, if seriously attended to, have dished photography as a fine art. Emerson maintained that art involved

"the individuality of the artist", and that this was impossible in photography, where interventions which might express individuality were suspect as "dodging". Photography's destiny was to be true to nature, which meant true to appearances, and this automatically disqualified it as art. That argument meant that Emerson, and all the others, needed no longer to take photography seriously. Emerson's formula relieved them, and him, of worries about the status and relative place of photography in a hierarchy of the arts – it scarcely featured. He then went on to renounce theory altogether: "It may be asked then what theories on art I have? I answer at present *none*. What artists I admire? I answer, all good artists and all good art. To what school do I now belong? None. What do I think of writings upon art and art criticism? Mistakes." With one wild leap he was free from the constraints of theory. He let slip backward glances, when, for instance, he noted that if there were no scientific basis for art then Meissonier, the Rococo designer, might be judged to be the equal to Monet, but that was a risk which had to be run.[1] It wasn't judgement which he feared so much as the articulation of that judgement to a point where art might become "canon hampered" and enslaved to tradition and priestcraft.[2] He was, after the renunciation of 1890, in the clear, unhindered and at large.

At some point, perhaps just before the writing of *The Death . . .* in 1890, the scales had fallen from his eyes. He wrote, in the 1880's, as an Olympian or at least as a mandarin from a ministry, capable of this sort of judgement: "It is true the Suffolk peasantry is inferior to the Norfolk peasant, both in intelligence and in fine feeling".[3] In addition his early reports on nature came fragrant with romance and learning; in 1886 a pike "like a bold Viking essays the unknown regions of deep water in search of prey",[4] and he can imagine a silver-bellied roach swimming in a "peacefulness, sacred to Zoroaster".[5] By 1888, however, he admitted to less than omnipotence, and in *Pictures of East Anglian Life* the sight of a bank of furze shining in the sun brings him up against the inadequacies of language and art; their gamut was limited, and they were but sorry tools and hindrances to anyone attempting "to get nearer to the great mysteries of life and beauty – to Nature".[6] After the years of omnicompetence he became fixated on inadequacy, inability, falling short, cliché and mere

[1] With reference to P. H. Emerson, *The Death of Naturalistic Photography*, London 1890.

[2] The phrase "canon hampered" appears in 1886, in *Life and Landscape on the Norfolk Broads*, by Emerson and T. F. Goodall. It is used with respect to the superiority of the art of the early period in Ancient Egypt.

[3] P. H. Emerson, *Pictures of East Anglian Life*, London 1888, 3.

[4] *Life and Landscape on the Norfolk Broads*, 41.

[5] Ibid., 34

[6] *Pictures of East Anglian Life*, 92.

approximation. The great mystery was all that mattered, but it
was ineffable, beyond reach and certainly beyond the power of
art to capture. Emerson murmurs about it again and again in
the diary of 1890–91: "Our world is exquisitely beautiful, and
life joyous to the brave and the true-hearted. It is useless sighing
for the knowledge that is witheld. Verily, as Heine has said, a
fool is waiting the answer of the great mystery that the Lords
of life and death have hidden from us. A slamming of doors
and the sounds of gruff voices broke the spell." This was on
September 22, at the outset of the journey. Emerson, despite
his disclaimers, was that fool waiting for the answer.

Despite all his talk of "useless sighing", Emerson knew
well enough how to put his finger on "the great mystery". He
was often in contact, as here in "On the Sandhills" from *Marsh
Leaves*. He is on the shore, listening to the waters "and the
distant, deep-toned, regular hum of the working sea-bottom, a
music steady and sure, sounding as if the pivot upon which the
world spun round was grinding in its bearings out there beneath
those green and pearly fields." Eventually he sleeps and dreams,
and feels that "the sea and the dunes were one indissolubly,
eternally united, until the mighty roar of the spinning world
shall cease for ever and ever." Emerson in touch with "the great
mystery" was, verily, Emerson in touch with the sublime English
of the Old Testament and the Book of Common Prayer, and that
of Gray, Milton and Wordsworth. Like others, he had trouble
with strong(er) precursors who had been there before him. He
acquiesced, even thrilled, to that power in inherited language,
and seems to have been without shame, even anxious to declare
his indebtedness, as in this pre-recorded vision from "The First
Voice of Spring" in *Marsh Leaves*:

> As the spring sun settled red behind the reed-tossed fretted
> sky, and left the marshland to darkness and to me, there
> flashed before my mind the delicate glowing landscape of am-
> ber and silver-grey, through which the soft croaking voice of
> spring resounded, filling the senses with a lasting music, as the
> music of the sea lurks ever in the beautiful spotted shells gath-
> ered from dead coral beaches.

The croaking voice of spring might have been his own, but all
the rest is Gray's *Elegy* and Wordsworth on daffodils, with a
culminating piece of folk mystique. Emerson in ecstasy was half-
way towards fraudulence, splendid in borrowed prose, and not
apparently minding much if he declared the extravagance of that
sort of orotund vision.

His later work looks and reads like a rebuttal and under-
mining of most of his assumptions of the 1880's. It is as if his
renunciation of 1890 allowed him to see what had gone before
both as radically flawed and as a necessary starting point. Until

1888, at least he had written with detachment, an onlooker for whom the East Anglians were specimens, and backward specimens at that, with their quaint beliefs in, for instance, the need to keep quiet about pigs if any fish were to be caught.[7] Emerson knew more than his subjects, and could be counted on to frame their language and their beliefs by reference to remote history and mythology. He spoke less with any voice of his own than in the cultured language of institutions promising permanence. The Emerson of the 1880's was a learned society. But that intuition of "the great mystery" made detachment a condition forever of the past, and introduced Emerson to a new experience of time.[8]

If whatever it was that lay out there was to be apprehended, no matter how inadequately, it would be in a time not necessarily of Emerson's choosing. Henceforward all time was sanctified; there were to be no more privileged moments calculable in advance and, by extension, no more hierarchies. He might be addressed at any time, which entailed constant alertness and a kind of fine tuning which is hardly even hinted at in the anthropological surveys of the 1880's. Revelations, when they came, might be nothing more than murmurs, or they might be spoken by simpletons and other passing traffic. Nothing could, with confidence, be overlooked, and *On English Lagoons* has the author paying attention, even ostentatiously, to the briefest of inconsequential encounters. On 14 February 1891, they met an old man with a boyish face under a wide-awake hat, in a loose overcoat, corduroys and old patent leather shoes. Hardly an heroic peasant, he pointed to the smoke from their funnel:

> " 'You're blowing off steam, then'.
> 'Yes', replied Jim solemnly.
> 'You've got a nice little ship here, then'.
> 'Yes', repeated Jim.
> 'She ain't a big 'un'.
> 'No'. He drew off. . . . ''

Moments came and went, significant or not. By contrast, the time of the early books was all-time, no-time, a composite of memories and learning, which Emerson acknowledged with irritation in *On English Lagoons*. The boat in which the journey was accomplished, *The Maid of the Mist*, was a converted cargo

[7] Ibid., 35.

[8] The "great mysteries" are introduced in *Pictures of East Anglian Life*, 92, with respect to furze in the sun: "The gamut of human language is pitched within too limited a compass. Man cannot speak. Then he tries to express them by colour, but, here, too, the gamut is limited, and the poor hand is but a sorry tool and hinders him as he tries harder and harder to get nearer to the great mysteries of life and beauty – to Nature". For "the great mystery" itself, see P. H. Emerson, *On English Lagoons*, London 1893, 20.

barge and had once been *The Spark* and, as The Harnsee (a
knowing fenman) remarked on 21 September 1890, "used ter
belong ter Gaby Thomas, then she used ter ferry ice for the
Columbia fleet out of the old ship that they kept in Breydon in
them days". She had been *The Great Eastern* too, and had carried
meal;[9] and others knew of different histories, to a degree which
eventually exasperated the crew, who felt, in the end, that they
were transparent or scarcely existent inhabitants of a ghost ship.
The Harnsee and his compatriots looked through them into an
insistent legendary past, much as Emerson himself had looked
through his specimen fenmen of the survey books. The journey
is interesting in another respect, for it seems, in the absence of
a map, to go nowhere; the *Maid* drifts through names (Rockland
Broad, Buckenham Ferry) and seasons, and seems merely to
endure, to undergo. Then an appendix lists precise details of
weather and temperature. *On English Lagoons* is, among other
things, a reflection on duration with reference to time. There is
on the one hand the turning of the tides and seasons, and on
the other Emerson's fitful experience of that process.

Time is an even more central preoccupation in *Marsh Leaves*
which can read, at first glance, like nothing more than sporadic
nature notes, punctuated by bird-song. To be more precise,
snipe drone, ring-doves croon, red-legs whistle "a-love, a-love",
and chaffinches call "spink-spink". Some bird-calls registered a
spirit or mood in the landscape, and might have special affinities
with a season or configuration, but more importantly they elic-
ited alertness on his part and stood as prefigurations of the voice
which would speak "the great mystery". In one section, "A night
Walk in Early Spring", he recalls himself walking by the water
and listening for stirrings in the dark woods; he is intent, like
a primeval man watching for danger as if his life depended on
it. The woods sleep, banks of mist drift and a boat glides noise-
lessly on the river, and then the spell is broken by the cry of a
night-bird. In addition he presented himself watching constantly
for elusive moments around dusk when the day might be said
to have turned to night, and for the coming of spring and au-
tumn. He watched, that is, for moments which could never be
established with any exactitude, which meant that he was con-
demned to failure. In nature, that is to say, he rehearsed his
impossible relationship with "the great mystery". Lest there be
any mistake, he included two emphatic cameos in *Marsh Leaves*,
both of which bear on his disdain for social, regulated time, the
time of mere duration rather than of experience. In the second
fragment in the set, "The Fenman's Clock", a timepiece is suc-
cessively dismantled, improvised, patched and finally boiled;
and then in the fortieth fragment, "A Wherryman – his Watch",

[9]*On English Lagoons*, 164–5.

something similar befalls a pocket-watch: "she want frying. She'd no face on her, and her inside was out of order; she want to have a box o' liver pills." Both pieces establish a strong enough image of digital, accounted time to emphasize, by virtue of difference, something of the nature and meaning of his constant walking and listening.

How do the photographs supplement these fragmentary, devious texts? They are as difficult to make out, often quite literally so, and many of them, at around 16 cm × 8 cm, might be miniatures. In addition they regularly feature remote subjects in half-light. They might just be read as judicious abstract arrangements bearing on a spirit in the place, for sets of dark posts, reeds and weeds make regular intervals in the mist and snow, but that reading answers only in the short term. *Marsh Weeds*, for instance, is a refined arrangement of stems on a white ground, but at the same time precisely differentiated in that the stems stand in three groups fading towards the left. It elicits close attention. Others are more documentary than abstract, and in *A Winter Pastoral*, which is a picture never likely to make the anthologies, a line of sheep in the distance eat scattered turnips before a stripped wood; a hut stands small in the trees, and might indicate lambing-time in early spring. Sheep eating in a field: he took the subject several times, and not merely because there are sheep in Norfolk, but because sheep grazing or eating at their leisure establish interval and a pattern of sorts, and they might scatter beyond the point where they can be described as a flock. For Emerson, student of silences, dawn, dusk and seasonal transitions, a flock of sheep might constitute another challenging problem of definition. Additionally, a flock feeding represents a certain quality of attention, and Emerson was often at pains to establish an idea of mere animality, of existence solely in order to survive; animals come close, in several of his fragments, to death and maiming, but come through "unconsarned as passengers".[10]

His photography in both *On English Lagoons* and in *Marsh Leaves* remains naturalistic, despite the renunciation. It continues to evoke moments and the physical feel of places. Sheep eat, a horse grazes, a steamer nears ice in *The Fetters of Winter*, and ripples spread on water. In the earlier book more moments are registered more intensely, in the ripples stirred by a rowing boat on still water, for example, and in the shape of a ferry bell twice outlined against the mist at Buckenham Ferry. They might be compared to the art of Thomas Eakins, a forerunner and contemporary, for Eakins was also a connoisseur of moments and attention, as involved in the movements of a surgeon's knife (twice – and famously), the dipping of oars and the mending of nets. The difference is that Emerson's naturalism is residual, a

[10]The phrase occurs, for instance, in ibid., 156.

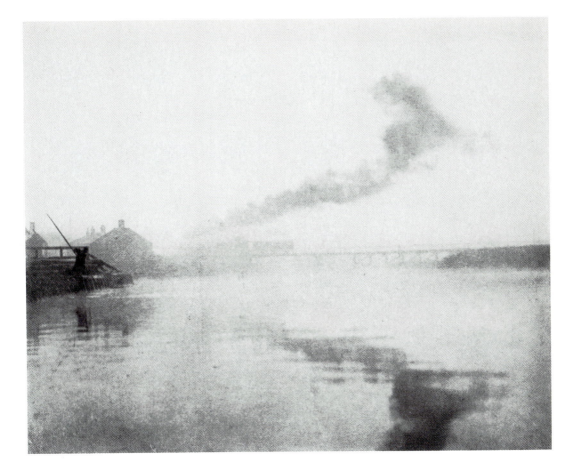

1. P.H. Emerson, *The Bridge*, photo-etching, 1895, from *Marsh Leaves*. Royal Photographic Society.

stage on the way, and a memory of a condition both necessary and necessarily transcended. Steamboats and railway-engines also move in the distances of some of these late pictures; they move on the margins of visibility, and might be overlooked but for spreading plumes of smoke. They might indicate noise in silence, and, because of their remoteness, emphasize the act of attention which he so valued; but, at the same time, they inscribe figures in the landscape, and it is this incipient figuration which finally distinguishes these images.

Smoke issues from a point, and then drifts and dissipates in light air. It does so doubly in these late pictures with their reflective rivers and lagoons. Through the prevalence of mist, snow and fog Emerson gives ample evidence of undifferentiation; he could, in some cases, have been working in the Sahara or on the surface of the moon so limitless does the scene appear. And then the smoke reflected makes the sort of figure which might announce the discovery of an alphabet. In *The Bridge* (Fig. 1), the vastness is disturbed by a mark which might be a tilted *A* or *V*. Failing smoke he might register an inn sign reflected by

2. P.H. Emerson, *At the Ferry – A Misty Morning*, copper-plate engraving, 1893, from *On English Lagoons*. Royal Photographic Society.

the water's edge, or trees either reflected to make a symmetrical figure or re-charted in terms of cast shadows. What do they mean, these signs? A framed bell at Buckenham Ferry silhouetted against a ground of mist (Fig. 2) invokes memories of sound in stillness, but in the main Emerson's late signs signify little more than their being signs, fugitive, fragile marks in the face of mist, winter, darkness and the void. Some of the earlier photographs were, by contrast, much more obviously metaphoric – unmistakably so. In the well-known *Gathering Water-Lilies* of 1886 (*Life and Landscape . . .*) the flower grasped signifies light taken, somewhat as it might be by an emphatic botanist; and the early poachers in *Pictures from Life in Field and Fen* and *Pictures of East Anglian Life*, who stand for attentiveness as well as for freedom, stare transfixedly into the undergrowth lest there be any mistaking their meaning.

The tilted posts, broken weeds, inn signs and far spinneys no more than hint at the possibility of meaning, of any meaning in the face of that huge yonder. In the texts, too, something similar happens in Emerson's use of dialect. In his specimen

days, and for the sake of completing the picture, he quoted at
length in local dialect, often stopping to explain derivations.
Dialect survived, to teach him a thing or two, and eventually
he came to realize that the common speech, even in the mouths
of The Harnsee, Darkel, Jim and the other fenfolk, also spoke
his own predicament into being. He developed an interest in
clichés, adages, throw-away phrases, mere utterances. He at-
tended to naming, and on 14 October 1890, found perfection in
the shape of a gunner who had just shot two rare ospreys on
Rockland Broad:

> " 'What's your name? ' I asked.
> 'Thientific, that's my name, sir, though some of 'em call
> me 'Chizzles', 'cause I was prenticed to a carpenter'.
> 'Who gave you the name, "Thientific" ? '
> 'Well, sir, I was crowding of coal. I was doing the job, and
> I crowded out about forty seven ton of coal unloading
> a wherry, when a man whistles to me *wheit*. I went and
> shot eleven mallard out of twelve with one shot, and
> Mr. Jay see the shot and he say, 'That's thientific', and
> that name hev stuck to me' ".

Mr. Jay was on the spot with his lisp, and so Thientific was
named more or less by accident, and the story remembered
through oddly weighted circumstantial details. Intricate narra-
tions, told by other fenmen with powerful if erratic memories,
culminate in triumphant mottoes: "That's all right, the sparks
hev all gone upwards" (with some reference to a hazy story of
shooting accidents and lungs on the rushes);[11] "He died wicious,
but he ate werry nice" (Josh's last words on a monster eel which
took a long time dying).[12] Such phrases, like those marks set
against the voids in the photographs, stand out from the wil-
derness and uncertainty of memory, and satisfy the need for an
end and for a definition, even if it is no more than a whistling
in the dark: "I'm Joe Jonas. Nobody care for me, and I don't
care for nobody. Ha! ha! ha! "[13]

His greatest invention, photographer or not, was Old
Wrote, who opens and dominates *Marsh Leaves*. Old Wrote,
drawn from the life, took his name from an old English root
which gives wrought (as in wrought-iron), and he had wrought
hard all his long life. His capacity for work had given rise to the
name. Aided by a giant son, he wroted as a reed-cutter, after
decades of survival on a small farm; and he was in his eighties,
and a giant, and deaf. Emerson's feeling for the old man shines
through, and he gestures towards his being a hero through some
references to earlier prowess as a wrestler. A genuine hero might

[11]Ibid., 51–3.
[12]Ibid., 5–8.
[13]Ibid., 69.

have heroic memories, but Old Wrote can remember little more than the price of flour forty years ago, "4 shillun a stone", when a man could earn 1/9d. for mowing an acre of grain – the price stood at 3/– in 1890. But Old Wrote is enhanced rather than diminished by his prosaic memories, constant snuffle and primeval greeting, "Dar bor . . ." – from the root which gives "boer" and "neighbour". His deafness matters, too, for it meant that this colossal figure, who might have been intended as Emerson himself, lived at a radical remove from an environment in which "the great mystery" would, as *Marsh Leaves* was about to show over and over again, promise to declare itself. He is the most moving of all Emerson's disclaimers, an example of greatness completed and sealed by such banalities as come to mind in the absence of what might be adequate.

Emerson ended, like Joe Jonas, shouting in the dark and waiting for the call. All the rest – his erstwhile colleagues – were tradesmen, and could go to hell. History amounted to nothing. Time unfolded, but inscrutably, in the fog and among accidents. Sometimes infinity sang its songs to him, although often to words taken from the great singers. Better to make the best of a bad job and end with a curse or a catch-phrase. At the same time he had heard of "the great mystery", and its being, whatever it was, shaped and gave point to his work. Emerson belongs, that is to say, less to the history of photography than with Henri Bergson, for example, in a large history of Time – the real subject of Emerson's anguish and anger.

18. GEORGE DAVISON:
Impressionist and Anarchist

Brian Coe

George Davison (Fig. 1) was born in September 1854 in Lowestoft, England, where his parents, Elizabeth and William Davison, had moved from Sunderland. His father, a shipyard carpenter who worked for a firm of Lowestoft shipbuilders, retired around 1890 and died soon after. George had an elder brother, William, and two sisters, Annie and Elizabeth, all of whom worked from an early age to help support the family. George, looked on as the bright hope of the family, was maintained at elementary school, at some sacrifice, until he was fourteen. He had several years of secondary education at St. John's Church School, and kept on with continuation classes. In his late teens he passed the "Boy Clerk" or Second Division Civil Service Examination and in 1874 was offered a post in London in the Exchequer and Audit Office at Somerset House. In 1882 he married Susanna Louisa Potter, whom he had met through church activities, and they moved into 10 Battersea Rise, sharing the house with brother Will and sister Annie. Their first son, Ronald, was born in 1884; two more sons died in infancy and in 1888 their last child, Ruby, was born.[1]

Davison seems to have taken up photography around 1885, and joined the Camera Club when it opened on 14 November 1885. He was an active member and was appointed assistant honorary secretary on 16 February 1886. He was an immediate success; indeed, his performance was so impressive that on 7 November 1887 the club members presented him with a testimonial, a clock and sixty guineas. Davison had begun to exhibit his photographs in 1886; his first reviews were for entries in the Amateur Photographic Exhibition of that year. They were mostly of scenes around Lowestoft – "vigorous pictures, well selected", said one reviewer (*Amateur Photographer*, 21 May 1886) (Fig. 2). In the Photographic Society of Great Britain Exhibition of the same year he showed six pictures; his *Entrance to Lowestoft Harbour* was well received. He applied for membership of the society and was accepted on 9 November 1886, giving his address as

[1] The author's grateful thanks are due to members of the Davison family, notably his grandson Mr. David Davison, and to his god-daughter, Mrs. Enid Citovitch, for providing personal details of Davison's life, and many photographs. Mr. Ieuan Hughes, one-time Warden of Coleg Harlech, provided valuable help in tracing details of Davison's later life.

1. Frederick Hollyer, *George Davison*, platinum, c. 1895. Private collection.

the Camera Club. He may have discovered already the disadvantages of a home address in a poorer area of London. By 1888 he had become sufficiently influential to be elected a member of the council of the society.

At this early stage in his career indications of some of his other interests had appeared. His first published letter, to *The Amateur Photographer*, April 1886, concerned the educational and philanthropic uses of photography, urging the presentation of

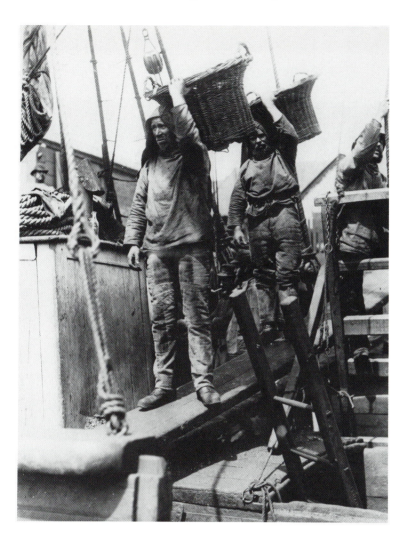

2. George Davison, *Coal Heavers*, silver gelatine, exhibited 1887. National Museum of Photography, Film and Television.

magic-lantern shows in the poorer districts of London. His concern for the education of working people, born of his own experience, was in later life to become an overriding passion, as we shall see. He was an enthusiastic user of Alpha paper, a printing-out paper with a matt surface, very like salted paper. In a discussion at the Camera Club in January 1887 he said that such papers "rendered the feeling of a subject much more effectively than the ordinary albumenised paper" (*AP*, 28 January 1887). At the next Camera Club meeting he attacked the idea of rigidly applying formal rules of composition:

> Mr Davidson [*sic*] thought that nothing was gained by finding pyramids or pyramidal lines in the composition of pictures, and that nothing good would ever be done by building up a picture on such a system of rules He would prefer to

consult the feeling or impressions at the time of selecting and studying a subject. (*AP*, 11 February 1887)

In these views we see the beginnings of Davison's espousal of the principles of impressionism – the movement which had taken root in the art world some ten years before. Impressionists neglected form for the visual impression – an impressionist painter was one "who aims at representing objects according to his personal impressions, without any concern for generally accepted rules" (Buffon). The favoured themes of the impressionists were landscapes, seascapes and skies – natural subjects for the photographer. Davison was critical of the practice of awarding medals at photographic exhibitions; ironically, he was a major recipient of such prizes. "He has carried off more prizes this year than any competitor, professional or amateur" (*AP*, 6 January 1888). He was concerned that photographic exhibitions should be judged by artists:

> If awards are to be given, then surely the judges for the art section should be recognised artists only . . . there were not half-a-dozen well-known photographers who were actually competent to act in the capacity. The knowledge required to act with certainty could only be attained by long study and high culture, such as could only at present be secured by selecting well-known artists with trained minds. (*Journal of the Camera Club*, June 1888).

This view was also expressed by Dr. P. H. Emerson in *Naturalistic Photography*, published in 1889. Of exhibition judges he said, with his customary tact, "in nearly all cases they are utterly incompetent. No one can judge a work of art unless he is an artist".

Emerson's theories on naturalism in photography had at their heart the concept that since the eye at any moment can be focused on only one plane of the subject, the photographer's task was to use the lens so as to select the key plane and to subdue the rest by softer definition (Fig. 3). This ran counter to the approach of the traditional photographer – the "f/64 man" who stopped down his lens to achieve critical sharpness throughout the entire picture. The concept of selective focusing is today so conventional and commonplace that it is difficult to appreciate the passions aroused by this suggestion in the 1880's.

Davison espoused the cause of naturalism in photography, and almost from the beginning his photographs show the use of selective focus to detach the subject from its surroundings. A review of his series *Winter in the Marsh, Meadow and Mudflat* (Fig. 4), exhibited at the Liverpool Amateur Photographic Association exhibition in 1888, said that "unlike some workers, this gentleman can give the idea of distance, without that disagreeable and impossible fuzziness which appears to be their sole idea of distance" (*AP*, 16 March 1888). At this time he became

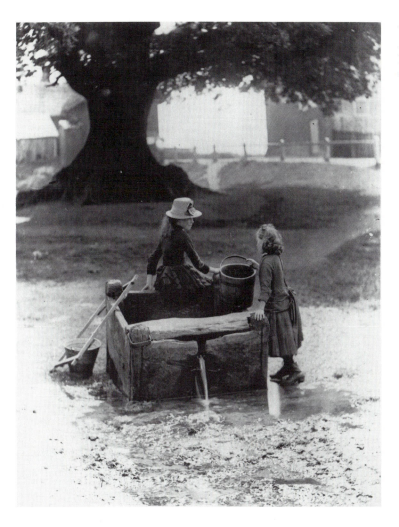

3. George Davison, *Girls at a Well*, silver gelatine, c. 1888. National Museum of Photography, Film and Television.

an ardent supporter of Emerson, defending naturalism against its detractors, notably H. P. Robinson, who had engaged with Emerson in a long and, at least from Emerson's side, vitriolic correspondence in the photographic press. Davison said:

> It is not in man, even in f–64 man, to overlook the unnaturalness of joinings in photographic pictures, and the too visible drawing-room drapery air about attractive ladies playing at haymakers and fishwives. Naturalism does not stand or fall upon a question of how much or how little softness of focus is admissable, but it certainly is diametrically opposed in its view to the much worship of register marks, and to all *un*naturalism in figures and their attire. Its creed is, *Truth, and the best of everything.* (*The British Journal of Photography*, 13 September 1889)

In a later letter responding to Robinson, Davison said:

4. George Davison, *Winter in the Marsh, Meadow and Mudflat*, silver gelatine, exhibited 1888. Private collection.

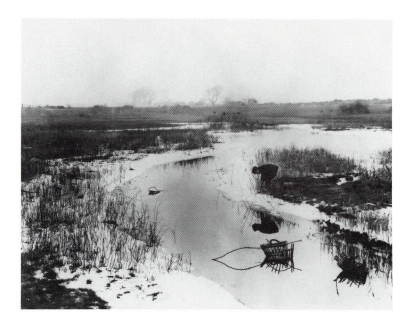

Naturalism is a revolt from the domination of conventionalism in composition and in colour, and has resulted in a school of thinkers and workers who gain their inspiration from nature, and charm us by giving us truth, beauty, and poetry expressed in the translations of their impressions. Of course there are degrees of naturalism, and, in such a revolt, some excesses would be expected. But these are not to be feared in photography. Photography, indeed, has had much to do with the growth and development of naturalism itself, and it is harder for the photographer to offend against naturalism than for other artists. (*BJP*, 4 October 1889)

In an October 1889 letter responding to an article by the Rev. T. Perkins, "Limitations in Art Photography", in which Perkins argued that the impression of Nature gained through the eye is the sum of a number of instantaneous impressions, all sharp, Davison wrote in the *Journal of the Camera Club*,

. . . on this theory he will have to move his eye not less than eight times over a moderate-angled picture of 40 degrees. He will know better than I do how long this will take. This will be the time he must wait before he gets his sum of sharp impressions, and it is a very appreciable period. . . . If the eye range more quickly over the scene than gives time for focussing each section, then, the sum of the impressions, we might claim to be *diffusion*. . . . Mr. Perkins assumes that those he criticises claim for the principal object in a picture that it should be sharp and the rest out of focus, but as a matter of accuracy, the feeling is that even the chief incident should be taken without its distracting detail, and putting out of focus is our chief means of doing this.

Replying to his old friend, and archetypal "f/64 man", Colonel Joseph Gale, Davison wrote:

> Mr. Gale admits the necessity of subordinating detail, but he does not go to the point of seeing that sharpness throughout in every plane must give false value where those various planes have to be represented on one surface. Take it another way. Because the eye can in a certain time work its way over the whole of a scene and secure the whole in sharp focus bit by bit, it does not follow that it *does* so, or is required to do so, by the artist. *His* interest may be in depicting the beauty and pathos that he sees and feels in the life and labour of one figure or group, and this is where the sympathies are to be drawn and rivetted. The rest may be enough as mere suggestion. (*AP*, 8 November 1889)

The prolonged correspondence over naturalism which had been triggered by a critical review of Emerson's book, which he presumed had been written by H. P. Robinson,[2] had turned increasingly to arguments between Davison and the traditionalists. Davison was seen as the "faithful henchman" of Emerson, but when Graham Balfour wrote that although Emerson was head of the naturalistic school, "Mr. Davison might run the self-elected champion of the old school hard" (*BJP*, 6 September 1889), this was all too much for the unstable Emerson. In an "English Letter" to the *American Amateur Photographer* in which he reviewed the current Photographic Society of Great Britain exhibition Emerson wrote:

> The first exhibit that calls for mention is Mr. George Davison's. . . . We regret that Mr. Davison should have exhibited this series, and after the "Part o' Day" [Fig. 5], which I was glad to call your attention to in my last letter, these are bathotic indeed. Technically, they are of the ordinary photographic type, and artistically they won't hold at all. In the majority, too much landscape is included, and in all the figures look posed and artificial, and the tone is false. The picture is what the French call moue, and won't hold at all. This gentleman's work is very uneven. . . . We hope sincerely that such a promising worker as Mr. Davison will not think that he "has arrived", and be spoiled by the ignorant and vapid praise of interested and designing persons. (*AP*, 29 November 1889)

This patronizing criticism provoked another round of correspondence in which most correspondents defended Davison, but despite Emerson's attack, we find him defending the doctor against criticism.

> [He has] the credit of being the first to present some of the aspects of artistic focus to the photographic world. . . . A

[2]Emerson attacked Robinson in a letter to *Photographic News* (abbreviated as *PN*), 7 June 1889, accusing him of reviewing anonymously his book in the *Amateur Photographer* (abbreviated as *AP*). Robinson replied (*PN*, 14 June 1889) refusing to confirm or deny authorship.

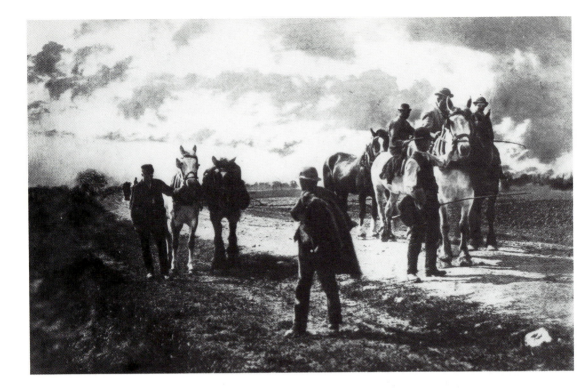

5. George Davison, *The Part o' Day*, platinum, exhibited 1889. Private collection.

good deal of prejudice against what some deprecate as "these extreme views" (because they are simply new to them) has been caused by unfortunate personal animosity to the expounder, and to jealousies on the part of those who previously held the field upon finding their ground cut away by a new teacher of deeper insight and higher purpose. The times required an uncompromising reformer. We have scarcely seen the beginning of this splendid stimulus. (*JCC*, March 1890)

This valiant defence of his mentor did Davison no good at all, especially when he was supported by Emerson's old adversary, H. P. Robinson:

I have of late been frequently asked why I have expressed my admiration of certain out-of-focus pictures by Mr. George Davison and others, seeing that I have been a constant opponent of the Naturalistic School. My reply is, that the present practice of these clever photographers is diametrically opposed to the mistaken doctrines of this so-called school as so dogmatically put forth by Dr. Emerson. (*AP*, 10 October 1890)

Of course, Emerson had to reply to this:

If Mr. Davison does in certain cases advocate pinholes, that is no proof that he has given up Naturalistic tenets, and if he were to give them up that would in no way affect them – they had already won the sanction of the best of many of our young *painters* before Mr. Davison took them up, to discard them for a time, and then resume them. . . . But I am sure that

Mr. Robinson's intention to play off Mr. Davison against me will fail – he tried it last year. Mr. Davison is more modest, and knows to whom credit is due more than Mr. Robinson thinks. (*AP*, 24 October 1890)

However, for Emerson the last straw came when Davison read a paper on "Impressionism in Photography" at the Society of Arts in December 1890,[3] in which he discussed naturalism in art. Emerson was incensed that his "disciple", whom he had hitherto regarded with a patronizing eye, had now, it seemed, become the "master". He published a black-bordered pamphlet, *The Death of Naturalistic Photography* (1890), copies of which he sent to the photographic journals, with permission to publish. In it he renounced all the naturalistic theories he had so vigourously promoted. After denying that he now had any theories on art and explaining that he now believed that photography was the lowest of the graphic arts, he went on:

> A final word. . . . At the Society of Arts the other day, a paper was read by Mr. Davison – *an amateur without training, and with* superficial knowledge – in which my *old* ideas were freely and impudently handed about, and no credit given me. It was whispered about by some of my enemies that this person had originated some of the ideas of Naturalistic Photography. To enlighten the public, I append a quotation from his letter to me on this point. *There are plenty more confessions of "his lack of knowledge"; that his articles were "drivel" – it is his own word – and other confessions of incompetence and proofs of plagiarism, if necessary.* He is now welcome to my cast-off clothes if he likes – he or anybody else. It is with deep regret I do this thing, and it is only as a duty to myself. I justify myself by stating that I wrote privately to Mr. Davison, expostulating with him for freely appropriating my ideas, and telling him if he did not give me full credit at the Society of Arts, I should publish a history of the matter. He never replied. He can publish my letter in full if he likes. This was Mr. Davison's reply to a letter I wrote to him and others asking if they minded me thanking them in public for their support. His reply is dated from the Camera Club, Dec. 16th, 1889, ONLY A YEAR AGO. It is, "I AM GLAD AND PROUD TO BE IDENTIFIED IN ANY WAY WITH NATURALISTIC PHOTOGRAPHY, BECAUSE I BELIEVE IN WHAT I UNDERSTAND IT MORE AND MORE CLEARLY TO BE, BUT I DOUBT VERY MUCH WHETHER ANYTHING I HAVE DONE DESERVES RECOGNITION."
>
> I sent a copy of "Naturalistic Photography" some time ago for review to the editor of the *Journal of the Society of Arts*, and it got a bad notice. All the ideas offered the other night were thus offered to the Society *previously*. . . . This sort of treatment, which is nothing new to me, may excuse some of my bitterly written invectives. (*Photographic News*, 23 January 1891; *BJP*, 23 January

[3]Davison's paper to the Society of Arts was published in full in *The British Journal of Photography* (abbreviated as *BJP*), 19 December 1890, and in *PN*, 19 and 26 December 1890, and 2 January 1891.

1891) (The sections in italics were removed from the *BJP* report
by the editor "for obvious reasons".)

Davison was quick to respond with a robust and outspoken
letter to the photographic press (this time it was the *Photographic
News* editor who had qualms, not printing the sections in italics):

> First, do not let photographers suppose that Dr. Emerson
> has the right to claim any originality in regard to naturalistic
> arts. He has merely adapted to photographic methods ideas
> current amongst certain artists. He is, therefore, neither enti-
> tled to claim further recognition than this, nor has he the
> slightest right or power to order the funeral of naturalism in
> photography. Secondly, the limitations of photography are not
> so great as he now, *for vindictive purposes*, wishes to make out,
> for the individuality of the worker is freer than he asserts. . . .
> Thirdly, if "all writings and opinions upon art are as the crack-
> ling of thorns", why does Dr. Emerson return to his vomit in
> this pamphlet and re-discuss certain art matters, and why, in
> the name of all that is consistent, does he threaten photogra-
> phers with another book on art later on? . . . *the fact that Dr.
> Emerson should have left the Camera Club cannot fail to make that
> Institution more attractive and comfortable to all reasonable and social
> people.* Eighthly, Dr. Emerson's repudiation of the claims of
> photography as a means of artistic expression is perhaps only
> natural. In my opinion there is something sadly wanting in
> most of his photographs, and he himself is probably now find-
> ing this out. I trust he is devoting himself to some other pur-
> suit more suited to his abilities – a humorous friend of mine
> suggests fretwork.
>
> In regard to the personal matter, and what Dr. Emerson
> calls my "superficial knowledge", I shall be well pleased to let
> my photographic pictures speak for themselves, and stand side
> by side with his, before any competent and unbiased judge.
> The quotation used from my private letter seems to me to read
> in refreshing contrast to the rest of the pamphlet. Dr. Emerson
> was anxious *at that time* to recognise what I had done for natur-
> alistic photography. I was not, however, particularly anxious to
> be very closely identified with Dr. Emerson and his violent ag-
> gressiveness. A little of the same appearance of modesty would
> not injure him. The whole of this business appears to have aris-
> en, first, in that I dared in a very appreciative criticism to point
> out Dr. Emerson's weakness in treating figures in photographic
> pictures. In reply to that he wrote: "You are wrong about my
> figures; they are yet alone" – a sweet bit of Emersonian mod-
> esty. From that time . . . he seems to have begun to say hard
> things about me to others. That I should have ventured to dif-
> fer from him in respect of the qualities of diffractive photo-
> graphs caused him further attacks of spleen, and, finally, the
> fact of my being invited to read a paper at the Society of Arts
> appears to have upset the whole of his years of study on na-
> turalistic photography, and wrought him up to the pitch of ful-
> minating this *mad* pamphlet. The letter which he calls an
> "expostulation", and to which I sent no reply, was one long

violent insult, alternating between threats and wheedling. *I simply allowed Dr. Emerson to stew in his own bile. I was too busy to disturb myself with bandying insults.* . . . Finally, I do not wish it to be supposed that I do not sympathise with Dr. Emerson in his affliction. There are some grains of sense in the pamphlet. . . . But every reader ought to be cautioned against paying too much heed to the outbursts of one who is blown about by every wind of doctrine – now a well-expressed word of a "great painter", now the influence of a common every-day artist, and now a misunderstanding of a scientific experiment. (*BJP*, 30 January 1891; *PN*, 30 January 1891)

The photographic world looked on with glee. Henry E. Davis wrote:

Can it be true, or is Dr. Emerson playing off a joke on us? It seems too good news for actuality that the prime instigator of the naturalistic racket has at last felt the error of his ways, and returned to artistic sanity. . . . All lovers of art photography must be delighted to find how Dr. Emerson throws off the tag-rag and bob-tail who have striven to render themselves illustrious by clinging to his coat-tails. It really seems as though he has been for some years piling up a big joke on them previous to depositing them very carefully in the mire. (*BJP*, 30 January 1891)

All this cannot have improved Emerson's temper, and he fired off another long letter to the journals, whose editors felt obliged once again to censor the text. The letter was a direct personal attack on Davison, "an 'audit clerk' [who] has found time after or between office hours to perform good secretarial work for an amateur photographic club". Emerson made much play of Davison's humble calling (although by this time he was in a senior position), with references to "clerkly personages" who could "only dabble in art after office hours". He ended by saying that *gentlemen* would "cut" him (*BJP*, 20 February 1891; *AP*, 20 February 1891).

Living in a highly class-conscious society, Davison must have been hurt by these references, and they no doubt contributed to the development of his political beliefs, which were to become his major preoccupation in later life. Davison issued a short letter in reply, declining to argue on any subject except photography.[4]

By the time of this controversy Davison had reached a position of prominence in the photographic world. Probably because of the high regard in which he was held as honorary secretary of the Camera Club, George Eastman had asked him to become a director of the Eastman Photographic Materials Company when it was established in England in November 1889. He joined Henry Strong (Eastman's partner), W. H. Walker (the

[4]*BJP*, 27 February 1891.

American manager of the new company), fellow photographer Andrew Pringle, Colonel J. T. Griffin and Colonel Allix on the board, acquiring twenty-five preference shares at ten pounds each, using money loaned by his friend W. F. Baldry.

He had been constantly experimenting with chemical and optical methods to produce the softening of detail in the photograph, which he saw as the means of creating the desired impressionistic effect. In the Photographic Society of Great Britain's 1888 exhibition he exhibited a picture taken with a pin-hole instead of a lens:

> From time to time such pictures have been produced as curiosities, but it is only of late that the suggestion has been made that such a method is practically available. The picture in question was taken on a fairly bright day with an exposure of a quarter of an hour, the size of the hole being a fiftieth of an inch. It is about ten inches by eight in size, and the plate was placed at about twelve inches distance from the hole. An ordinary exposure with a lens might have been about two seconds, so that with the small amount of light admitted through a pinhole between 400 and 500 times the amount of exposure is required. (*BJP*, 5 October 1888)

The principle of forming an image with a pin-hole was an ancient one but, contrary to popular belief, had not been applied in photography until the general adoption of the much faster dry plate process around 1880 made manageable exposure times possible. Davison was one of the first to exploit the technique for pictorial photography; for the next few years his exhibition entries generally included pin-hole pictures. The photographic press remarked on his activities; a report of a Camera Club outing to Gomshall in Surrey in May 1889 said: "Here Mr. H. P. Robinson, who had come to spend a quiet country day socially with the party, enjoyed the morning in charge of part of the apparatus of the Honorary Secretary, who was pinholing about in the most devoted manner" (*JCC*, June 1889). On a later excursion to Heathfield in Sussex in August 1889: "Both the plate-makers and the hop-pickers did well. The festive pin-hole, too, was well to the fore, and diffused focus and merriment around" (*JCC*, October 1889).

Davison's growing reputation as a photographer, and the emerging leader of the new impressionistic school, was reinforced when one of his pinhole photographs, *An Old Farmstead* (Fig. 6), taken on the outing to Gomshall, won a medal at the Photographic Society of Great Britain's exhibition in 1890 (another prick of the goad for Emerson). The picture created something of a sensation, not only in itself but also because of its presentation:

> This has no mount at all in the ordinary acceptance of the word but has, instead, a broad receding flat under the glass, so

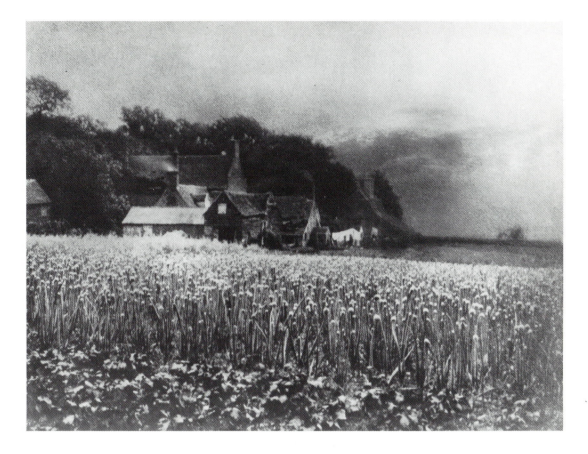

6. George Davison, *An Old Farmstead*, photogravure, exhibited 1890. Royal Photographic Society.

that the picture is perhaps half an inch behind the latter. The flat and glass are enclosed in a plain but bold gilt moulding of considerable width; the tone of the print is warm, its light and shade subdued and massive, and details merely suggested. (*AP*, 3 October 1890)

Even H. P. Robinson, that staunch defender of the old ways, was quite impressed:

> This, I presume, is the picture which gives the most offence to your correspondents, as well as to others, and in some degree I am glad to see it, for nobody can be more opposed to the "fuzzy" school than I am, but I hope I am able to see artistic merit, *when it exists*, in methods to which I may be most opposed. I cannot admire the egotism of any man who says "my way is the only way". I see many excellent, and some rare, artistic qualities in Mr. Davison's picture. . . . His scheme did not seem to contemplate more than the production of a pleasing impression of nature embodied in a picturesque subject. Now nothing can be more difficult than this, if we may judge from the lamentable attempts that have been so prominently forced on our attention during the last two or three years. Here Mr. Davison has succeeded where all others have failed. . . . The light and shade is most satisfactory, and the picture has "feel-

ing", a quality rarely present in a photograph. (*BJP*, 10 October 1890)

No sooner had the controversy with Emerson died down than another row boiled up. This time it concerned the preparations for the Photographic Society of Great Britain's 1891 exhibition. Davison had entered pictures at the invitation of members of the Exhibition Committee, and although delivered thirty-six hours after the deadline for acceptance, they *were* accepted by a member of the committee, with the understanding that they were to be hung as eligible for competition, or not at all. They were hung, and listed in the catalogue, but after six days, on the day of the final judging, they were removed by the secretary, Captain Mantell. On the same day, H. P. Robinson, a vice-president of the society, visited the judging with a visitor, and was asked to leave by Assistant Secretary H. A. Lawrence, although as a council member he was entitled to be present, and, indeed, had been asked to join the Hanging Committee. Although he had not been able to do this, he had agreed to lend a hand. This mixture of confusion, petty officiousness and inflexibility in applying the regulations had dramatic consequences, furthered by the refusal of the council of the society to express regret to H. P. Robinson over the affair, despite the fact that for very many years he had been the most active and prominent supporter of the society and its exhibitions. Robinson, Davison and ten other members resigned from the society. In a letter replying to criticism of his and Davison's actions, Robinson wrote:

> It is the sign of a weak cause to revive the old slander that Mr. Davison and I desired special privileges in connection with the last exhibition. Mr. Davison certainly required no special privileges. In my opinion, and in that of others, the obligation was all the other way, and it was a privilege for the Society to get such a splendid collection of pictures as he sent in. The only favour he required was one that had been only too gladly granted for years when good exhibits were to be secured by it, and it could have been no desire for the good of the Exhibition which prompted a new member of the committee, and the new secretary, to find these pictures were not acceptable after they had been accepted and hung for days. It was only when it was thought probable they would get a medal that it was found that they ought not to have been accepted, for the very insufficient reason that they were sent in a few hours late. (*PN*, 9 September 1892)

Robinson, among others, voiced the opinion that the society had become preoccupied with technical matters – "scientific pedantry rampant" – while "art has for many years been scarcely mentioned". A small group of the dissidents formed an association in May 1892 to present a special Invitation Exhibition at the Camera Club in October, timed to coincide with the Pho-

tographic Society's show. The exhibition of sixty-eight photographs selected for their artistic qualities was largely organized by Davison. This exhibition had followed the lead set in May 1891 by the Vienna International Exhibition of art photographs, to which Davison had sent entries: "Foremost among the impressionists is George Davison, and it must be confessed that both his landscapes and figure pictures make a truly artistic impression" (*PN*, 15 May 1891). The initial informal group had developed following a circular letter to like minds from Alfred Maskell, mentioning a talk with Davison about forming "a kind of little Bohemian Club."[5] A group met at the Restaurant d'Italie in Soho on 9 May 1892. H. P. Robinson, Lyonel Clark, George Davison, Henry Hay Cameron (Mrs. Cameron's son) and Alfred Maskell were present; A. Horsley Hinton was asked, but was absent. They discussed the formation of an association with "mysticism and symbolism implied". After proposing various names – The Gimmal Ring, The Parabola – at another meeting on 27 May they decided on "The Linked Ring". Each member was to be called a Link, and each was to take a quaint name. H. P. Robinson was "The High Executioner", with responsibility for "hanging" exhibitions. Davison was "Deputy High Executioner". By June 1892 twenty-eight Links were on the roll. Meetings were called "Unions", with food, drink and smoking; each meeting was presided over by a Centre Link, who acted for one month only. Each new entry had to be proposed from within the Ring and voted in unanimously. The highly democratic structure of the Ring was undoubtedly due to Davison's influence, and a reaction against the autocratic officialdom of the Photographic Society. After the initial success of the Invitation Exhibition at the Camera Club, the Ring instituted an annual Salon, the first of which was held in October 1893. The Salon reflected Davison's philosophy of exhibitions, that they "are not instituted as a means of scattering just so many distinctions, but as popularisers of photography, and as incentives to the highest class of artistic work." (*AP*, 20 January 1893). He was the chairman and principal organiser of the Salon, which included fourteen pictures by Davison, including a number printed on fabric. The annual Salon was held at the Dudley Gallery at first; from 1905 to 1909 it moved to the Galleries of the Royal Society of Painters in Water Colours. By 1896 the Salon had established itself as an important event, but the rivalry with the now *Royal* Photographic Society show at Pall Mall grew stronger. Davison defended the Salon against the charge that it was less representative.

> The Pall Mall Exhibition deals with pictures, science, apparatus, and records. Industrial, scientific, and pictorial divisions

[5] A copy of Maskell's letter is inserted in *The Book of the Linked Ring*, a largely manuscript record of its proceedings, now held in the Royal Photographic Society's Collection.

are mixed confusedly. Not one of the divisions has so far been properly looked after, but exhibits have been taken just as chance happened to bring them. ... Now in the sense that the Salon does not touch any of these special applications of photography outside artistic work, it is undoubtedly more narrowly representative of photographic work than the Pall Mall show. ... The Salon is all the more representative of its one purpose by its concentration. It is managed by a body composed of all exhibitors who have distinguished themselves in prominent exhibitions by originality and artistic knowledge in their work.

He defended the practice of pricing for sale prints exhibited at the Salon:

> In painting galleries those who paint in their leisure time and those who rely upon their painting as a livelihood are on the same footing, and both alike put a price on their productions. There is no opening in art for the malpractices of the running path, nor any ground for difference of treatment or separation from motives of snobbishness or "class" as in clubs. (*AP*, 18 September 1896)

This was another sign of his sensitivity on this subject. On the question of sale of photographic prints, Davison had earlier written:

> Editors and critics do not understand that the production of a good photographic print may involve very considerable expenditure, both in time and money. My estimate of the actual cost of materials used to produce a large photograph, 20 inches by 16 inches, suitable for exhibition, mounted but not framed, is nearer thirty shillings than a pound, and I do not know that I am more than ordinarily clumsy or difficult to please. (*JCC*, May 1894)

Although Davison still took an active part in the affairs of the Camera Club, he had resigned as honorary secretary in February 1894. He explained: "My regular business requires more of my energies, and my future official prospects and responsibilities compel me to take this step. I am sorry to break away from the old duties on behalf of the Club, but the considerations I have referred to are of an urgent kind, and must, of course, have precedence" (*JCC*, March 1894). His resignation was widely regretted, and at the Annual Dinner of the Camera Club on 25 April 1894, attended by over a hundred members and guests, Davison was presented with a testimonial on behalf of more than two hundred and fifty members. He received a Tantalus case and a purse of one hundred guineas, and he was toasted "with enthusiastic acclamation, and with musical honours".

He continued to promote impressionism in photography through his writings and exhibition prints. His picture of Charing Cross footbridge, *Rain, Steam and Iron*, in the 1896 Salon attracted much attention:

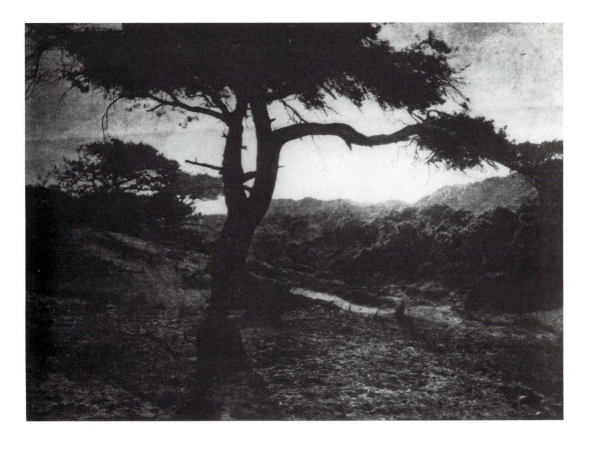

This picture impresses one, first as evidence that it was seen as a picture in the mind before it was recorded so admirably, and next by its strong literary quality. That is to say, although the subject is exactly as it appears to a chance wayfarer, the atmospheric effect is caught at a moment when the prose of its daily aspect has taken a certain poetry which would sound mere penny-a-line gush if we tried to explain it in words, and is yet very real, and a sentiment which the scene itself has often impressed on you. (*Photograms of the Year*, 1896)

7. George Davison, *The Long Arm*, photogravure, exhibited 1900. Royal Photographic Society.

He remained the leading exponent of diffusion (Fig. 7), but emphasized the need to subordinate technique – particularly focusing – to intention:

... a technically good photograph in respect of focus is one in which the definition is well suited to the purpose, no matter whether it be sharp, differentiated, or diffused. ... Now I am anxious not to appear desirous of appeasing certain sections of sharpists. There are sharpists and sharpists. There are those who really understand why they want some sharpness all over, and who go for what they want and get it effectively. These do not fail to see the good qualities of general diffusion.

But there are others who seem very deficient in understanding and knowledge of artistic effect and practice, who remain bound to some journalistic policy or tradition of an ignorant past, and who have their sense of beauty cramped by the most unemotional experience and unimaginative influences. (*AP*, 2 April 1897)

Now at the peak of his achievement as a pictorial photographer, Davison made a very significant move. He had continued to be a director of the Eastman Photographic Materials Company; in May 1897 he left the audit office to become assistant manager of the company. One of his last acts before joining the company was, with F. Seyton Scott, to assemble a major collection of pictorial photographs for the People's Palace Art Exhibition, opened on 24 May 1897 by the Duchess of Portland. The show was a great success with the working-class East-Enders, and provided further evidence of Davison's continuing social commitment. His first act after joining the company was to put together a major Amateur Photographic Competition. H. P. Robinson, one of the judges, explained how it was organized:

> In the beginning a circular was sent to the amateurs of the world as far as they could be reached, and the Eastman Company is far-reaching, offering prizes to the amount of 600£. for photographs, the chief condition governing the competition being that the negatives must be made with a Kodak on Eastman's transparent film. The method of printing, enlarging, &c., was left open to the choice of the photographer. The framing was done by the promoters. The ruling spirit, or the wizard who worked the magic, was Mr. George Davison, whom we all know. . . . I am not sure that such a boom as happened was expected, but I do know that, when I heard that "over 25,000" had been sent in, I wondered why I had been such an idiot as to promise to be one of the jury, for here appeared to be work for the rest of the natural lives of all available Judges. (*BJP*, 3 December 1897)

The exhibition was presented at the New Gallery, Regent Street, and the whole show was designed by the Glaswegian designer George Walton, who "achieved a masterpiece", according to Robinson. In addition to the selected entries from the amateur competition, there was an invitation exhibit of work by leading photographers, including Davison himself, an important section of photographs by European royalty – quite a coup for Davison – and a trade and technical section. Davison had the company's Harrow factory create a special bromide enlarging paper – Royal – for the many, often big, enlargements. The show was a tremendous success, being visited by more than 25,000 people during its three-week run. It subsequently moved to the National Academy of Design in New York, where almost 26,000 people saw it.

To promote the virtues of the company's rollfilm cameras

Davison persuaded several of his photographic friends to try out the new models so that their results could be used for advertising or promotion. Among those taking part in this scheme, started in 1898, were Paul Martin, Eustace Calland, J. Craig Annan and, notably, Frank M. Sutcliffe, whose great enthusiasm led him to try out virtually every new Kodak camera until 1906.

At the end of 1898, Kodak Limited was formed in England to take over the businesses of both the Eastman Kodak Company in America and the Eastman Photographic Materials Company in England, together with the many small subsidiaries throughout the world. This arrangement lasted only a short time, until the income tax commissioners attempted to tax the company on the world-wide, rather than local, earnings, when George Eastman promptly returned financial control to the United States. Davison was offered the post of deputy managing director, at a salary of £900 per annum until June 1899, and thereafter £1,000 per annum for the term of the five-year contract. He was enabled to purchase 18,775 ordinary shares in the company, with an option of a further 3,750. Davison naturally accepted. The sudden death within a short time of the managing director, George Dickman, caused Davison to take over his duties, and he was confirmed as managing director in March 1900.

Despite his important new responsibilities, Davison still found time to exhibit. The Salon, of course, had its usual quota of prints; the major photographic exhibition at the Crystal Palace in April 1898 included twenty-eight prints of his, among them *An Old Farmstead* (see Fig. 6), now renamed *The Onion Field*. In the same year his entries for the Paris Salon were approvingly reviewed by Robert Demachy: "The excellence of his four other exhibits suffices to place Mr. Davison in the first rank" (*AP*, 12 August 1898). At the London Salon in 1898 he showed for the first time gum-bichromate prints. The softening of fine detail and broadening effect of this process, together with the almost complete control it gave the photographer during printing attracted Davison, who employed it for many of his exhibition prints for the next few years. In 1899 he began what was to become an annual custom of sending to friends and acquaintances photogravure reproductions of his photographs as New Year's gifts. He kept up this practice almost until his death; most of the surviving Davison photographs are from this series of reproductions (Figs. 8 and 9).

Inevitably, Davison's corporate responsibilities began to affect his own output. His entries for the 1901 Salon were thought not to be up to his usual standard. Things were not going well in business, either. As competition from other manufacturers increased, Davison pursued what was to be a nearly disastrous policy of price-cutting, and the company entered into litigation with other suppliers, notably George Houghton and Sons, over their infringement of Kodak trademarks. The com-

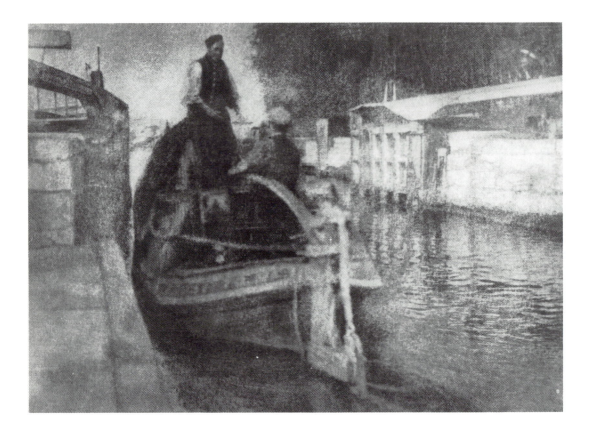

8. George Davison, *Molesey Lock*, photogravure, exhibited 1905. Royal Photographic Society.

pany won the case, but it was not popular, and this, coupled with an attempt to restrict trade by binding agreements with dealers, left ill-feeling among amateur and professional customers for many years. These troubles, and the falling profits from the European market for which Davison had responsibility, worried George Eastman, and his confidence in Davison weakened. In November 1903, after Davison had asked for a new long-term contract and a salary increase to £2,000, Eastman replied:

> It does not seem to me advisable or necessary for the company to make another long contract with you for services. . . . I wrote you that I thought the post of manager in Europe was worth $10,000 but I do not think your services are worth that amount. You are more of an inside office man than you are an outside up to date manager and until the business is got well into hand I think you ought to bear this in mind and content yourself with a reasonable salary.

In December 1903 he wrote again to Davison:

> I do not want you to think that I have not confidence in you, that is perfect confidence that you are doing the best you

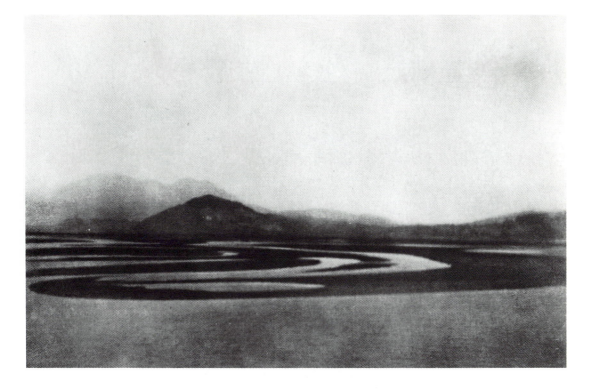

know how for the company, but I do know that the business there will have to be run so as to get into closer touch with the trade. . . . Heretofore the business has been run too much like a Government office. . . . Almost every time that we have gone out for trade over there we have tried to do it by cutting prices. The result is that it will finally leave us with nothing to work with. . . . The thing to do is to keep prices to the highest notch and get out and hustle for the trade.

9. George Davison, *Landscape*, photogravure, n.d. National Museum of Photography, Film and Television.

Although things improved slightly for a year or two, Davison was not able to pull things round as Eastman desired, and on 5 December 1907 he wrote to Davison:

> I believe it will be necessary to change the management and I write this to ask you if you will give notice of your resignation, to take effect say April 1st? In asking you to do this I am not unappreciative of the fact that you have always done your level best for the interest of the concern. I only think that you have not the faculty for selecting and managing men that is required to make the most out of the organisation. Personally I much regret to propose the severance of our relations after so many years working together.

But in a further letter in December 1907 he asked Davison to join the board of the Eastman Kodak Company, following the death of Lord Kelvin.

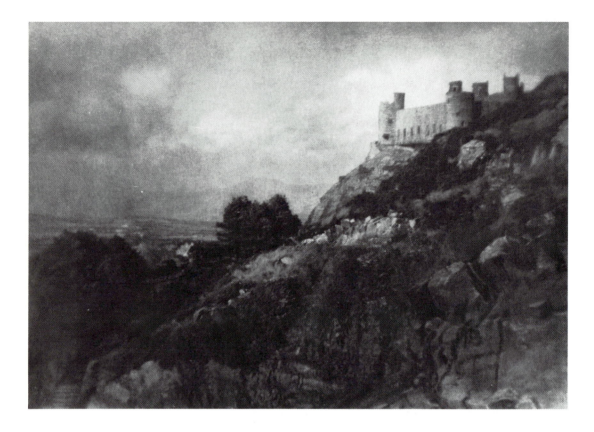

10. George Davison, *Harlech Castle*, photogravure, 1903. Private collection.

Although Davison had continued until now to exhibit at the Salon, he was much less in evidence than before, and in 1908, for the first time, he entered no pictures, although he was on the selection committee. By 1910 internal dissentions within the Linked Ring were coming to a head:

> After last year's Salon, the Perfectionists, led by George Davidson [*sic*], contended that the work of the Salon was completed, that the useful exhibitions for the immediate future would be those arranged by a few men, by mutual agreement, without any general invitation to outsiders, and showing only the most advanced work. (*Photograms of the Year*, 1910)

By one vote, it was resolved that the Linked Ring should not hold an exhibition in 1910. Already, Davison had proposed unsuccessfully in November 1909 that the Linked Ring should be wound up; the new resolution was the effective end of the organization, although a group led by F. J. Mortimer tried to continue with a "London Salon" exhibition in the autumn of 1910; almost every leading worker was absent from that show. The group led by Davison formed the London Secession, which held a single exhibition in May 1911, at the Newman Gallery. Davison exhibited a single print, of Harlech Castle (Fig. 10). It was his

last contribution to a photographic exhibition. He had now become involved in other matters.

After his retirement from Kodak Limited his strong social conscience developed into a passionate enthusiasm for the anarchist movement. He was now a very rich man; his early investments in Kodak shares were now paying handsomely. The family had moved a number of times since the Battersea days, and were living at Shiplake in the White House, designed by George Walton. Davison now had all the time in the world on his hands. His political activities came to the attention of his former employers in 1912. The American managing director of Kodak Limited, W. S. Gifford, wrote on 9 May 1912 to Eastman:[6]

> I am sending you herewith copy of the "Anarchist" . . . the Managing Editor and Proprietor of this sheet is George Davison, who arranged for rooms for the printing office directly over our premises in Buchanan Street, Glasgow. . . . Davison is putting up money for the erection of a building in Glasgow, to be devoted to Anarchist doctrines.
>
> A few days ago there was a Socialist procession which went along Kingsway, and in the ranks walked Davison, particularly conspicuous by being hatless. It seems to me that this is going pretty far for one who is a director of a Company to whose prosperity he owes everything he has. The only charitable construction that can be placed upon it is that he is crazy.

Eastman's initial response to Gifford was: "Since writing to you about the "Anarchist" I have read the sheet and am not surprised to find it rather wishy-washy. If I was going to be the editor of an anarchist paper I think I should get some ginger into it." Davison then replied to a letter from Gifford asking if he was indeed connected with the "Anarchist":

> *Of course* I am "interested" in "The Anarchist", as in everything which is concerned with the philosophy of "anarchism", or, rather, "anarchistic Communism". Every man of ordinary intelligence who closely studies the conditions of society & the various social theories . . . *must* be "interested" in it. You yourself would be. . . . I am "interested" similarly in the genuine original Christian philosophy which is three parts anarchistic communism & and in your own Ralph Waldo Emerson's work . . . it is only the general stupid confusion & ignorance that makes it necessary for me to add that I would object to acts of personal violence to secure any end. That is no *essential* part of *any* anarchism. . . . *Intellectual* bombs are good enough for any movement.

He went on to deny any direct control of *The Anarchist*, but said that he had "a considerable admiration for the young man who

[6]Permission to quote from records and correspondence in the archives of Kodak Limited and the Eastman Kodak Company is gratefully acknowledged.

at present is editor – one of the finest young fellows I have ever met."

On 25 June 1912, Eastman wrote again to Davison:

> While I should not feel at liberty to volunteer any criticism of your attitude on any social question, I do feel that if you are lending aid to an advocate of anarchy you are not a useful or suitable member of our board of directors and think you ought to resign. . . . In saying this, of course you will understand that there is no personal feeling involved in this matter. If I had other than a friendly feeling it would have been apparent heretofore. I am not too intolerant to view with great interest the tendency of a man of your stamp toward anarchy and would not have a word to say against it if I did not think it was inconsistent with your holding the position of director in our companies.

Eastman wrote again on 4 January 1913:

> In conformity with the bye-laws you are one of the American directors retiring at the next general meeting. Of course you will understand . . . that there is no intention of re-electing you. I am merely writing this to let you know so you can resign if you prefer to. . . . I take this opportunity to acknowledge with thanks your Christmas picture, which is fully up to your high standard.

Davison replied, protesting that his views were not a practical disability:

> I should have thought that George Eastman would have wished the biggest shareholder on this side to be there. And I should have thought that, as long as I hold the shares and draw the dividends, he would have considered me as safe as the other directors! . . . I am led to the conclusion that Anarchistic Communism is the most rational and beautiful philosophy of social order that has been evolved up to now. And I think the "anarchistic tendency" would be good for all the Directors and Executive as teaching genuine "scientific management".

He was, of course, not re-elected to the Eastman Kodak board, ending twenty-four years of direct connection with the company.

By now Davison was dissatisfied with his former way of life. He spent more and more time in Harlech, North Wales, where Walton had built him a splendid house, Wern Fawr. This became the centre of his political activities, which he extended to embrace art. In a letter in March 1913 to his friend the Welsh politician Thomas Jones he wrote:

> You must go on and achieve a post-Impressionist exhibition. That cannot fail to prove stimulating & interesting. It is an expression of that natural evolutionary & revolutionary spirit

which is moving and working everywhere these days, a revolt against the authoritarian mandate (academic or whatnot) *from above* & a reliance on the expression *from within*. There are some mere party men amongst them, & some too recondite (like Picasso & his group) for the general, but for the most part the pictures are full of interest, decorative, distinctive, deadly destructive to any, even the finest, of the photographic type of painting, and just self-expression (the only line of progress & education). Right out of their own experience is being evolved the worker's distrust of leadership and officialdom of every type – the authoritarian domination *from above* (Gods, priests, academics, states, Labour Leaders, Trades Union Conferences – Parliaments – &c &c &c) so they must come to *think* and *speak* and *act* for themselves.

In a letter to Jones in June 1913, after talking about his visits to the industrial areas around Manchester, he wrote, "it makes it harder & harder to go back to White Houses & Wern Fawr & luxuriate there even tho' the family entreat and protest."

The break came on August Bank Holiday 1913 at the family home at Shiplake. Davison called his family together and said he wanted his freedom – he would set about divorce proceedings later, but had to be free at once. He promised to provide financially for the family, and left for Liverpool to stay with the photographer Malcolm Arbuthnot. While shocked and bewildered, the family was not entirely displeased, for his new free-thinking ways were not theirs. He took over Wern Fawr, leaving the White House to the family. He wrote to Jones in March 1914: "Wern Fawr will *probably* be undergoing some transmogrification shortly – a long standing intention – no resident domestic service – no kitchen versus parlour – and perhaps a modern children's (say 6) training home."

He "adopted" a number of slum children for his "school" and persuaded Miss Joan Jones, who had been living with Arbuthnot, to come and teach the "family". He had adopted a diet of fruits and nuts, and the family reported seeing him in London in 1915 in "strange white or wooly clothing". His sisters Annie and Lizzie had gone to Wern Fawr to live, but in 1916 someone told them of the relationship that had developed beween Miss Jones and Davison, and they packed up and left in horror. His son Ronald reported, "G.D. *'The Rich Relation'* seems very happy with his 'friend' ". Miss Jones, the daughter of a sea-captain, was lame, and small – the family unkindly referred to her as "the dwarf". They had a daughter, Doreen, in 1921.

During the First World War, Davison came into the limelight again. On 11 December 1917, Mr. Clement Edwards, Liberal M.P. for Glamorgan East, during question time in the House of Commons asked the Prime Minister

whether he is aware that a person named George Davison has for some time been lavishly spending money on the South

Wales coalfield for the purpose of propagating syndicalist and pacifist doctrine; that, without any business, industrial, or social association with the coalfield, he some time ago purchased for £1,500 a derelict mansion in one of the mining districts, and spent some thousands of pounds in renovating and altering it ... that he has used the mansion for entertaining pacifists and syndicalists from all parts of the coalfield, and that the premises have been used for carrying on secret conclaves of pacifists and syndicalists for the purpose of instructing conscientious objectors as to the attitude they should assume before the tribunals ... that he has contributed largely to the funds of the Central Labour College, London ... whether he is aware that Mr. Davison is connected with Kodak, Limited ... and that Kodak, Limited is formally associated with a German company. (*Hansard*, 11 December 1917)[7]

The authorities found no action necessary and the matter was dropped. The mansion referred to was the White House at Ammanford, which was to provide political and other education for a generation of Welsh socialists.

Wern Fawr in the later 1910's and early 1920's became a centre for artistic and political gatherings. The Fabian summer schools were held there; Welsh miners camped in the grounds and attended political sessions in the house. Harriet Cohen, Eugene and Leon Goossens and Astra Desmond, among others, were regular weekend visitors. Wern Fawr had both a player piano and player organ, and Davison and Alvin Langdon Coburn, who lived nearby, used to give Sunday recitals for local people. At Christmastime, Davison would give five shillings' worth of groceries for thirteen weeks to all the widows and old people of Harlech. Although he was not popular with the "chapel people" for his Sunday goings-on, he was loved by most of the local people, especially the children, for whom the Christmas parties at Wern Fawr were a highlight of the year.

Davison's health deteriorated and from the early 1920's he spent much of the year in his holiday home, the Château des Enfants, near Antibes, in the south of France. He had bought the large villa from the king of the Belgians. He used to charter a whole train from London, filled with children, teachers (and Miss Jones's relations), for summer holiday trips. His old friend Tom Jones persuaded him to sell Wern Fawr for conversion to an adult education college; Davison sold it for £7,000, less than a third of its market value, and it opened in 1927 as Coleg Harlech. It is still operating, and the building shows the connection with Davison in Walton's use of *GD* initials as decorative motifs.

George Davison died at the age of seventy-five on 26 December 1930 at the Château des Enfants. As at Harlech, he had been a benefactor to the local people, and large numbers of the

[7]*Hansard* is the official record, published daily, of the proceedings in the English Parliament.

local population turned out for the funeral. He was cremated at Marseilles, and his ashes were returned to the villa, where George Walton designed a memorial chapel, paid for by his family.

George Davison was probably the most influential figure in the development of the Pictorialist movement at the end of the last century. He expounded his philosophy of art in photography through extensive writings – he was a regular editorial contributor to *Photography*, which claimed the largest circulation of any photographic magazine in the world, from 1889 to 1897. He wrote from time to time for other journals, both English and foreign, notably American.[8] His pictures were regularly entered in international exhibitions, and widely reviewed. Through his regular correspondence with Alfred Stieglitz[9] he encouraged the Secessionist movement in the United States. Urbane, charming and generally well-liked by his contemporaries, he had all the more influence on them. He was the very antithesis of Emerson, whose violent outbursts antagonized many who might otherwise have been sympathetic to his theories. Today, Emerson is well remembered and credited for his promotion of naturalistic photography, yet Davison, who did at least as much to develop the cause of art in photography, is comparatively little known.

[8] A notable series of illustrated articles on ''Composition'' by Davison was published in the American journal *Photographic Times* in July, August and September 1897 and January 1898.
[9] A large number of letters from Davison to Stieglitz are now held in the Beinecke Rare Book and Manuscript Library, Yale University.

19. FREDERICK EVANS:
The Spiritual Harmonies of Architecture

Anne Kelsey Hammond

A philosophical turn of mind moved Frederick Evans to choose cathedral architecture, a most difficult pictorial subject, as his vehicle for expression. Even in his youth, Evans had an unquenchable hunger for the arts and read the best of English literature and philosophy he could find. He also studied the theosophical treatises of Jacob Boehme and Emanuel Swedenborg, and a contemporary writer on Swedenborg's teachings, James John Garth Wilkinson. In 1886, he wrote to Wilkinson, praising his book *Human Science and Divine Revelation*:

> I get greater satisfaction from this book than from Swedenborg, perhaps because of its greater condensation and the abiding charm perfect English has for me. Swedenborg's style is quaint and delightful . . . but he lacks the concentration, illuminating revealing power, and perfect handling of a perfect instrument, that I find so fascinating in your great book.[1]

Writing an introduction to Wilkinson's memoir,[2] Evans recommended to his readers a work by Henry James, Senior (father of the novelist), called *Christianity, the Logic of Creation*. James's devout humanism paralleled the teachings of Swedenborg, in whose "correspondences" man was a microcosm of the universe, and every object in nature a reflection of a spiritual quality.

Reflets dans l'eau[3] gives an emblematic interpretation of reflections in the water in terms of such Swedenborgian correspondences. In it, the young trees are linked to their perfect reflections in the stream by a low river-bank. A different negative of the same subject by Evans, titled *French River of Populars* (private collection), shows that a single tree which does not appear in the river reflection has actually been covered with opaque watercolour, blocked out so that it would not appear in the print, preserving perfect correspondence between the elements above and those below.

[1]F. H. Evans, in a letter to Wilkinson, 3 February 1886, collection of The Swedenborg Society, London.

[2]F. H. Evans, *James John Garth Wilkinson; A Memoir*, London 1936 (reprint of 1912 edition), 46.

[3]A. Hammond, "Frederick H. Evans: The Interior Vision", *Creative Camera* 243 (March 1985), 18. (Hereafter, references appear in the text as, for example, CC18 = *Creative Camera*, p. 18.)

The concept of God in Nature (God's presence immanent in the natural world) developed in the nineteenth century out of a concept of God as Nature. In 1835, one of the foremost compilations on the natural sciences was commissioned by the Earl of Bridgewater to demonstrate "the Power, Wisdom and Goodness of God as Manifested in the Creation". In one of the eight treatises, the author's note explains:

> In order to avoid the too frequent, and consequently irreverent, introduction of the Great Name of the SUPREME BEING into familiar discourse on the operations of his power, I have, throughout this Treatise, followed the common usage of employing the term *Nature* as a synonym, expressive of the same power, but veiling from our feeble sight the too dazzling splendour of its glory.[4]

So pervasive was this natural theology, that the nature poetry of writers much later in the century continued to be underscored with divine inference.

At the age of thirty, Evans began writing to the poet George Meredith, quoting from his poems and novels, and expressing concern that Meredith's public was neglecting him. When his request for a photograph of the poet drew no response, he sent Meredith a portrait of the painter Burne-Jones by the photographer Frederick Hollyer, hoping he might consent to have his photographic portrait made.

The value Frederick Evans placed on the works of George Meredith is attested to in his photograph *Deerleap Woods: Surrey, "Woods of Westermain"* (CC19). It pays homage to Meredith's composition from his "Poems and Lyrics of the Joy of Earth",[5] and was made in 1908 or 1909 as one of Evans's many illustrations for a memorial edition of Meredith's collected works. "You must love the light so well / That no darkness will seem fell", writes Meredith in his poem "The Woods of Westermain". In the world of the woods, the traveller is advised to ally himself with spiritual energies against subversion by base instincts of fear and egoism. In Meredith, the "spirit" of man is not his otherworldly aspect, but his essence, the evolutionary product of mind and body which gives him imagination, the power to transform the real into the ideal. In Evans's photograph, the central tree trunk which commands our attention is bent and weathered but illuminated brightly at its heart. The patch of light imprinted with the shadow of the trunk seems to be cast by the tree itself – spirit and body at one with Nature:

> Light to light sees little strange,
> Only features heavenly new;

[4]Peter Mark Roget, *Animal and Vegetable Physiology Considered with Reference to Natural Theology* (Bridgewater Treatises, 5), London 1835, 13.
[5]George Meredith, *Poems*, 3 vols., Memorial Edition, London 1910, 2:33–47.

Then you touch the nerve of Change,
Then of Earth you have the clue . . .

In 1911, Evans contributed four landscape photographs as illustrations to an article about Wordsworth in *Country Life*.[6] The first three are set in "Wordsworth Country", but the last is titled *The Woods of Westermain*. In the second half of the nineteenth century when philosophic and scientific discoveries were de-sanctifying the poetic landscape, Meredith was still committed to meaning in Nature. Meredith as much as Wordsworth gave "every natural form, rock, fruit, or flower . . . a moral life",[7] and saw the infinite process of change in Nature as the key to life and growth.

Among the printmakers of his own day whose work Evans enjoyed and collected was the French lithographer Odilon Redon. Although they were both stimulated early in their artistic careers by experiments with the microscope, it sent them in very different directions. To Redon, it suggested the elimination of perspectival space altogether, while for Evans the microscopic world reflected the macrocosm. Evans' eye responded to the elegant organic forms he found under the microscopic lens, but the value of his photomicrographs[8] to his later work was in the process itself. Because of the microscope's extremely shallow depth of field, he had to move zoom-lens–like through successive planes in the subject in order to focus. This focal control was a kind of preview to his experience in architectural photography of the "aerial image", a term used in normal-scale camera work for the perception of the subject on the ground glass which consisted of innumerable planes of focus parallel to the lens, from which the photographer could select. Thus, Evans saw the sections of minute sea creatures as having an organic relation to space similar to that of the vaulted aisle of a cathedral.

In 1903, Sir Theodore Andrea Cook, in his book *The Spiral in Art and Nature*, presented the spiral as a formula for natural growth and artistic proportion. Cook investigated the form and effect of the spiral, based on the logarithmic progression in pure mathematics, everywhere in life and art; from microscopic bacilli, the shapes of sea-shells, and the Golden Section in art, to distant spiral nebulae. In a later edition, in 1914, titled *The Curves of Life*, his chapter on the mediaeval spiral staircase was illustrated with Evans' photograph *Lincoln, Stairs in S.W. Turret* (CC20). This image shows the vital nucleus of the cathedral framed as a work of art in stone. All compositional devices – line, contrast, the effect of recession in space given by overlap-

[6]"The Making of Wordsworth", *Country Life* 29, 752 (3 June 1911), 796.
[7]William Wordsworth, "The Prelude", *The Poetical Works of William Wordsworth* Book Third, London 1869, 457.
[8]See Beaumont Newhall, *Frederick H. Evans*, Millerton, N.Y. 1973, 10.

ping planes – lead in to the one complete shape of the Gothic arch formed by a single vault rib of the turret. This is a typically Gothic form of construction, with the newel or central keystone supporting a spiral or stairs and a corresponding series of arched ribs which form the turret ceiling. Evans shows the form of the arch literally in the key of the stone, and figuratively at the heart of the Gothic style, which was, as the branching vault and turn of the steps suggest, generative as well as aspiring.

Cook approached the problem of the spiral with the energy of the true amateur, and a Ruskinian devotion to the observation of nature, even though Cook's vitalist view differed from Ruskin's moralistic naturalism. Ruskin took religion as the authority for moral excellence in natural forms, whereas Cook was reviving the secular, classical concept of the tendencies in nature to ideal shapes such as the spiral. Cook's ideas were rooted in the findings of writers in the 1840's and 1850's: Joseph Jopling, who studied ancient Greek architecture in the light of Hogarth's "line of beauty" (the curve); Francis Cranmer Penrose, who measured the slight asymmetry in the shape of the columns of the Parthenon; and D. R. Hay, who wrote that "Aesthetic science . . . is based upon that great harmonic law of nature which pervades and governs the universe".[9]

Although the appendices of *The Curves of Life* offer supportive mathematical formulae, Cook's main concern was "not mathematics, but the growth of natural objects and the beauty (either in Nature or in art) which is inherent in vitality".[10] Cook also found this sense of elemental energy in Leonardo da Vinci's art and architecture, and in the botanical writings of Goethe, the first "morphologist", on the spiral growth of plants. They impressed Cook equally with their ability to project their artistic minds onto the problems of science, but it was Leonardo's study of sea-shells in particular that fired Cook's enthusiasm for the principle of growth inherent in the spiral shape. The *Nautilus pompilius* represented for Cook the most perfect example in nature of the logarithmic spiral; the Nautilus organism built consecutive valved chambers of increased size without altering the perfect shape of the ever-widening spiral. Writers like Charles Napier in 1870 saw the nautilus as analogous to "man, who like the nautilus lives in his last chamber – where the last events of his life occur. He cannot go back into the past; he must go onward. In proportion to the length of his life; it may be in great events or it may be in years, so is his attainment".[11] "Chambered Nautilus," a poem by Oliver Wendell Holmes (1858), expresses

[9] D. R. Hay, *The Science of Beauty*, Edinburgh and London 1856, 15.
[10] Theodore Andrea Cook, *The Curves of Life*, New York 1979, 32.
[11] Charles O. G. Napier, *The Book of Nature and the Book of Man*, London 1870, 136.

a sense of the individual's enslavement to the inexorable advance of time, with images of growth and transition:

> Year after year held the silent toil
> That spread his lustrous coil;
> Still, as the spiral grew,
> He left the past year's dwelling for the new,
> Stole with soft step its shining archway through,
> Built up its idle door,
> Stretched in his last-found home, and knew the old no more.

The nautilus shell, in the nineteenth century, had become in many ways a symbol of evolution. In the twentieth century, the spiral shell served as a photographic subject for both Edward Steichen and Edward Weston.[12]

In *The Crypt, South Ambulatory, Gloucester* (CC21), Evans places the Norman arches which form the passageway, tangent semicircular shapes, in visual relation to the design of a coil or spiral. More than a device for directing the eye of the viewer through the space in the photograph, this groined vaulting (a shape of the greatest geometrical strength) is the very heart of the cathedral. It is from this crypt, with exterior walls dating back to the eleventh century, that the cathedral really grew. Originally, it served as a shrine for the bodies of saints, becoming the object of centuries of pilgrimage. The church as an institution having outgrown its shell, Evans presents it as still holding fossil-like within it the secret of growth. Holmes's poem on the nautilus ends:

> Build thee more stately mansions, O my soul,
> As the swift seasons roll!
> Leave thy low-vaulted past!
> Let each new temple, nobler than the last,
> Shut thee from heaven with a dome more vast,
> Till thou at length art free,
> Leaving thine outgrown shell by life's unresting sea!

Evans photographed other organic forms in architecture, such as the spiral staircase at Blois, and the cloisters of Mont St. Michel (Fig. 1). His studies of the French châteaux commissioned by *Country Life* resulted in the publication of *Twenty-five Great Houses of France* (1916), with a text by Cook. His interest in the formal properties of these subjects was fed not only by photomicrography, but by a series of geometrical line drawings he produced with pendulums.

In 1827, Sir David Brewster, inventor of the stereoscope, devised an instrument which could visually demonstrate elliptical patterns produced by sound vibrations. In his *Scientific Pa-*

[12]See Mike Weaver, "Curves of Art", *EW100: Centennial Essays in Honor of Edward Weston, Untitled* 41 (1986), 80–91.

1. Frederick H. Evans, *Mont St. Michel, Cloisters*, negative 1906, halftone from *Twenty-five Great Houses of France*, 1916.

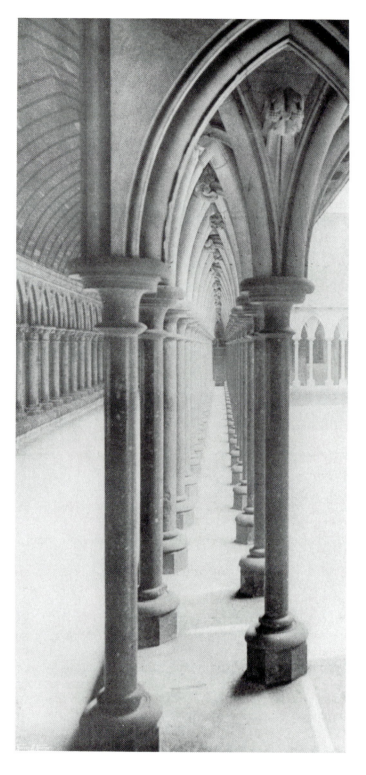

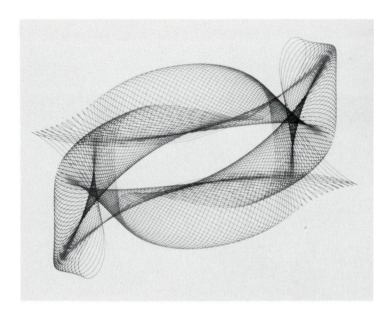

2. Frederick H. Evans, *Harmonograph*, c. 1911. Private collection.

pers, published in 1879, Sir Charles Wheatstone called it a "Phonic Kaleidoscope", a mechanical tracing of the curves created by pendulums combining two simple harmonic motions. The device Frederick Evans used for his own experiments, called the "harmonograph", used glass pens with coloured inks to draw the delicate gradations of decreasing curvature described by the pendulums. The resulting figure (Fig. 2) showed an apparently infinite number of curved lines, each one travelling at a minutely reduced degree of ellipse until the pendulums were at rest. The designs often resembled collapsed and twisted spirals.

The geometrician Henry Perigal (1801–98), an acquaintance and portrait-subject of Evans,[13] invested a lifetime of study in the laws of compound circular motion. Although not a photographer himself, his deep interest in photography was apparent by his membership in both the Royal Photographic Society and the Camera Club. Perigal's adaptation of the Geometric Chuck (invented by J. H. Ibbotson in the early nineteenth century for ornamental wood-turning) enabled him to produce complex figures by combination of two harmonic motions of various periods and relative phases. "Period" and "phase" were terms used in the analysis of vibrations and sound waves, for which the harmonograph was first devised. In its earliest form, Blackburn's pendulum (1844) traced the orbit of its curvature in sand or lampblack. Lissajous's figures (1857) were created by the vibrations

[13]*British Journal of Photography* 38, 1641 (1 October 1891), 663.

3. Goold's "twin-elliptic pendulum", from J. Goold, *Harmonic Vibrations and Vibration Figures*, London 1909. Science Museum.

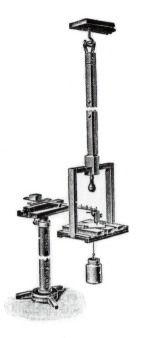

of two tuning forks placed at right angles. In 1894, Perigal exhibited curve-drawings done with a bow compass at a *conversazione* of the Royal Society along with Joseph Goold, who presented his "twin-elliptic pendulum" (Fig. 3), "which delineated an endless variety of beautifully curved figures, the result of a certain law inseparably connected with music".[14] It was reported that Perigal's handiwork so closely resembled the tracings of Goold's "harmonic pendulum" that one could be easily mistaken for the other.

In 1909, Goold published the theory and practice of his invention in a book called *Harmonic Vibrations and Vibration Figures*. Often called "music made visible", harmonograph figures were ordinarily produced by the motions of two separate pendulums; Goold's device coupled them vertically by placing the main weight above the drawing surface, and suspending a second deflecting pendulum weight beneath it. Using Goold's instrument, Frederick Evans produced a number of albums of his own "twin-elliptic pendulum curves". Just as a musical chord resulted from two sound vibrations in harmonious relation, so the figures produced by the harmonograph were pleasing to the eye in their coherent symmetry only when the twin pendulum actions were set in harmonious ratios. For example, a "period" ratio (the relative distances from the drawing surface of the two

[14]Richard Kerr, "Hidden Beauties of Nature", *Mothers and Daughters* 3, 7 (July 1894), 139.

pendulums) of 5:6 would give in music a minor third; 2:3 a major fifth; and 1:2 an octave. A drawing performed by pendulums swung at random would appear tangled and confused, whereas concordant vibrational proportions produced coherent lines of classical but organic design. Goold's approach to the essential formula of life was based on the mathematical proportions of harmony, and related to the patterns of planetary orbits – the "music of the spheres".

Frederick Evans was a lover of music as well as other forms of art, and during the years of his greatest photographic productivity, he was simultaneously building his reputation with the player-piano. The "pianola" (originally a trade name for a player-piano built by the Aeolian Company) became extremely popular at the turn of century for its entertainment value. Commercial piano rolls were made available for all musical tastes, from popular tunes to Gershwin, Strauss and Debussy.

In 1904, Evans gave a musical demonstration on his pianola at the time of his one-man show of architectural photographs at the Camera Club. He pointed out surprising parallels between the two media in another concert in 1911, and he admitted that in unskilled hands the weaknesses of both pianola and camera were "its lack of gradation, its monotony of tone, the absence of real delicacy . . . or any sense of interpretation".[15] Interpretation was the way by which the individual's response to a work of art might add something to the original. It was, in its perfection, an artistic act which, in the words of pianola enthusiast George Bernard Shaw, "becomes such an act of re-creation as Wagner found in Liszt's playing of Beethoven Sonatas".[16] It was this "re-presentation" of the works of great musical artists that Evans aimed to achieve through the pianola.[17] The limitation of the early pianolas (which caused the air forced from the bellows to be applied equally to all notes) Evans overcame by his mechanical modification of the instrument to one-fifth its normal setting. Releasing the pedalling tension, Evans allowed himself a greater range of dynamic expression – or a longer tonal range – without sacrificing definition. In a sense, Evans expanded the expressive potential from piano-forte to pianissimo-fortissimo. He also owned a perforating device with which to cut and alter his own rolls for the player-piano. "Phrasing in music", wrote Evans "is akin to elocution in speech, the perfect realisation of the spiritual, the innermost, meaning of a passage".[18] The poetry

[15]"Shaw–Evans", *The Amateur Photographer* 53, 1379 (6 March 1911), 220.

[16]George Bernard Shaw, "The Religion of the Pianoforte", *Fortnightly Review* 326, n.s. (February 1894), 264.

[17]Evans also "re-presented" in platinotype the wood engravings of Blake, Holbein and Edward Calvert.

[18]F. H. Evans, "Correspondence", *The Musical Standard* 35, 902 (15 April 1911), 231. Another photographer-pianist, Ansel Adams, pointed out in his *Autobiography* (London & New York 1985, 24) the similarity between tonal "phrasing" in music and photography.

of the spoken word, the musical composition, or the photograph could only be meaningfully expressed through interpretive phrasing, and tonal control.

During the years in which the controversy over the "mechanicalness" of photography was argued most fiercely, two of the loudest voices were those of the etchers Joseph Pennell and H. H. von Herkomer, who protested that no man who could not draw could be considered an artist. But Henry James, Senior, had written that it was not the method that determined the work of art, but the spirit. Works of art did not arise from natural productivity (providing life's needs) or moral productivity (duty to other men), but from pure "spontaneous" invention. This inventive spirit might find its realization in any medium, and was not lessened by achieving its form through the tools of advancing technology, as long as the chosen form served the idea. "[The artist] beholds in nature more than nature herself holds or is conscious of," wrote James. "His informing eye it is which gives her that soul of beauty".[19] Frederick Evans brought to the microscope and the harmonograph an immanent awareness of visual cross-references in nature, which his eye gave shape to in his photographs. As Evans's eye "informed" his subjects, their significance was built out of his intellectual energy and reconstructed from his aesthetic experience.

Until the late nineteenth century, the use of wide-angle lenses in architectural photography often demanded an elevated camera position in order to reduce the effect of lens aberrations, and to give a faithful appearance of distance and space. Frederick Evans lowered his point of vision to eye level, or the height at which the draughtsman would have worked, giving a sense of perspective "in the eye's habit of seeing". Evans's concept of "good drawing" began with the human point of view but required a careful choice of lens, from the many focal lengths available, in order to present correct proportions as well as a "special sense of beauty of line".[20]

In his earliest architectural photographs, made in 1890–91, Evans followed the parallel roads of topographical accuracy and sketching society composition. These very early interiors, with their wealth of detail and correct linear perspective, have value in retrospect only as preliminary exercises. The photographic world had become flooded with "views", carried home by thousands as souvenirs of the picturesque experience. The revival of the stereograph about this time afforded the viewer a new kind of spectacle, the sensation of super-depth, which Frederick Evans dismissed as abnormal. To him, the human point of view

[19]Henry James, Sr., "The Principle of Universality in Art", *Lectures and Miscellanies*, New York 1852, 114.
[20]F. H. Evans, "Good Drawing in Photography", *Photography* 13 (10 May 1900), 318.

and the unity of the interior space were essential to the viewer's understanding.

Evans sought not to duplicate the experience of the cathedral interior but to present an image abstracted from the immediate physical sensation, layered with meaning. *Ely Cathedral: Southwest Transept to Nave* (also titled "A Memory of the Normans") (CC25) shows both "good drawing" and great imagination. The Norman Romanesque pillars overlap visually to make up a series of exact half-arches. If each half-arch were doubled, together they would appear as a Gothic pointed arch. The shape of the Norman arch is implicit in pointed Gothic, but this picture celebrates the later Gothic lightness of spirit over the solidity of Norman foundations – English growth and development founded on a Norman memory.

Halation, or light fog, was generally an effect which photographers sought to eliminate, but to Evans's way of thinking there were two varieties: one was the technically unacceptable reflection of bright points of light off the back of the glass plate and onto the emulsion (giving additional unwanted exposure, or fog), and the other was "true halation", the atmospheric effect which softened hard edges without causing any distortion in the image – a quality prized by serious photographers throughout the history of the medium. The gentle refraction of light through vapour was skilfully transformed by Evans into the dramatic lighting of *Westminster Abbey: The Apse* (CC13). Our attention is drawn to three areas: the choir (foreground), the windows of the apse, and the lighted choir aisle (far right). The outline of an archway above the aisle encloses in it the shape of a window containing two sepulchral figures. Facing away from the light source (and away from each other) they are nevertheless illuminated by the true halation of a cloud of light.

The relationship between human figures and windows is a recurrent theme in the work of Evans. Another is the pair of doorways, one lighted from beyond and the other dark. In *The Apse*, Evans shows two sets of "doors"; the pair on the smaller, human scale appears in the altar-screen (which is separated from us by a number of steps) and the other pair is larger than life, one archway leading out of the apse into the light. The moisture in the air was a twofold blessing for Evans, serving both the effects of illumination and diffusion, and providing pure highlights while at the same time lowering contrast so that detail could give substance to shadow.

Westminster Abbey was also a favourite subject of Axel Haig, draughtsman for the architect William Burges and etcher of Gothic interiors. In 1885, Haig published a set of seven etchings in his book *Impressions of Westminster Abbey*, in which his own descriptive text was set within a red border of ornament in the style of mediaeval manuscripts. By the 1880's, Haig's fine architectural etchings of Chartres, Canterbury and Durham ca-

thedrals were being applauded for their dark, mysterious beauty in *The Art Journal* and *The Athenaeum*. As a bookseller and book collector during those years, Frederick Evans had developed a deep appreciation for the black-and-white print, and as a lover of art he read these journals from cover to cover. Rich, detailed rendering of shadow was a quality peculiar to the etching and the mezzotint, and one which Evans emulated in his own photographs. Where Haig's etchings differ in style from Evans's platinotypes is in their degree of decoration. Axel Haig placed greater emphasis on ornamental detail in his interiors, whereas Evans saw the greatest pictorial potential in the cathedral stripped of its modern fixtures. He often persuaded the dean of the cathedral to remove such things as pews and gas fittings for the making of the photograph so that the cathedral would appear in all the glory of its ancient stonework. Both artists, however, cherished the Gothic spirit of the Middle Ages, its romance and mystery.

In a series of prints of the Abbey, Evans made what appeared to be a straightforward photographic survey of the interior. Simple descriptive titles, conservative grey mounts and ink-lined borders suggest at first glance that they are presented as documents of Westminster. In fact, these images were made on commission to *Country Life* magazine (in which they were reproduced, in the summer of 1911), and although the colourful insignia of the artist-photographer are stripped away (monogram, multiple-mounting, evocative title) the poetry remains.

Henry VII Chapel, Font Cover (CC16) combines three of Evans's most significant themes: the door, the font and the stairway. The door stands open, implying not an invitation but a passage. The baptismal font is covered but betrays its centuries of use by discoloration of the floor tiles next to it – a darkened space almost the shadow of a figure which, once purified, may ascend the well-worn set of steps to the place above, flooded with light. Although named for the monarch entombed within, the spiritual resonances of passage and deliverance are heightened with the knowledge that the chapel was dedicated to the Blessed Virgin.

Evans worked on the premise that art reveals to us not just our individual tastes but a spirit of cultural reverence. Although the cathedrals were erected in the Middle Ages to the glory of God, they were designed and built by men as full of power and knowledge as those who created our greatest works of art and literature. Westminster Abbey, for instance, was especially rich in cultural associations: Chaucer occupied a dwelling in an adjoining garden, some of Shakespeare's finest scenes take place there, and "the first book printed in England was printed within its precincts".[21] Charles William Stubbs, who was Dean of Ely

[21]Peter Cunningham, *Westminster Abbey; Its Art, Architecture and Associations*, London 1842, xxiii.

4. Frederick H. Evans, *The Bishop's Throne, Durham Cathedral*, platinum, 1912. 68-220-46. Philadelphia Museum of Art. Purchased, funds given by Dorothy Norman.

when Evans went there with his camera in 1897, believed that the English poets, from the Anglo-Saxon Cynewulf and mediaeval Langland, to Shakespeare and Browning, were the true prophets of their age, and that their inspired teachings worked to humanize, and therefore Christianize, the world.

"In sure and certain hope of the resurrection to eternal life" is a phrase from the burial service of the Book of Common Prayer. Evans abbreviates it in his print entitled *"In Sure and Certain Hope", Entrance to Chapter House, York Minster* (1902) (CC17). The slant of light in this image creates a relationship between the tomb effigy and the stained-glass window, mediated by the enormous façade of the Chapter House door. This dark archway might represent, in its awful physiognomy, the constant choice between hope and despair in every moment from birth to death – the twin doors are our entry and our exit. The only hope which places us beyond its terrors is that niche of human proportion illuminated by the window above – the embodiment of belief by which fear of death is overcome. The narrow strip of window is not just the revealed radiance of Divine Grace but a glimpse of eternal life.

The Bishop's Throne, Durham Cathedral (Fig. 4) uses a familiar combination of interior motifs through which the viewer is imaginatively led. The dark empty space in the foreground must be crossed in order to reach a flight of stairs, contiguous with a vast spiralled pillar. The ascent leads to the throne (and its architectural crown) in a balcony above the arch of the bishop's tomb. The niche of *In Sure and Certain Hope* is here replaced by

the throne and the coronation yet to come. The relationship between the tomb and the ecclesiastical throne above implies direct spiritual transmigration from the earthly state to the position of the elect. The motif of the arch, seen on the left as a type of illumination (the windowed screen next to the stairway), and on the right as a dark place of death (the crypt), conveys positive and negative shades of meaning. Evans photographed windows, arches, pillars and stairways in endless combinations, which, he wrote, "make up a whole I never tire of".[22]

In the genre of architectural photography, the interior of Wells Cathedral was a popular subject among antiquarians and pictorialists alike. In Ward and Lock's *Guide to Wells Cathedral* of 1889, special note is made of one architectural element in particular, the "noble flight of stairs" at the approach to the Chapter House. Henry W. Bennett, who wrote articles for the London journals on architectural photography as well as on techniques of development and carbon printing, contributed his own version of it to the exhibition of the Royal Photographic Society in 1899, and referred to it as "the Beautiful Decorated Stairway". Bennett recommended the inclusion of all structural elements of an interior in the picture.[23] If there were stairs in a particular view, it was advisable to include the railing, not only for overall realism but because diagonal lines running into the composition would increase the sense of distance. He did not approve of lenses of long focal length, as they resisted any suggestion of advancing or receding surfaces and denied the illusion of deep space, which, to the topographical photographer, was one of the camera's most convincing effects.

In "*A Sea of Steps*", *Wells Cathedral: Stairs to the Chapter House and Bridge to Vicar's Close* (Fig. 5), Frederick Evans used a 19-inch Zeiss anastigmat lens, more than half again as long as Bennett's recommendation. Evans always worked with lenses with as great an assortment of focal lengths as were available, selecting the magnification which just filled the ground glass with the desired portion of the view. He framed his image of the stairs to exclude the stonework over the arched doorway and the hand-rail along the wall, making the ascent appear even more precarious. The flattening effect of the lens, however, contributed to an even linear definition through the picture. By printing in platinum, as opposed to Bennett's carbon process, Evans brought reduced contrast to the print so that each shadowed step with its delicate highlight would receive clear but soft articulation.

In another view (CC26) Evans turned his whole attention

[22]F. H. Evans, "My Best Picture and Why I Think So", *The Photographic News* 51, 588 (5 April 1907), 276.

[23]Henry W. Bennett, "Architectural Photography", *The Photographic Journal* 24, 4 (23 December 1899), 85–91.

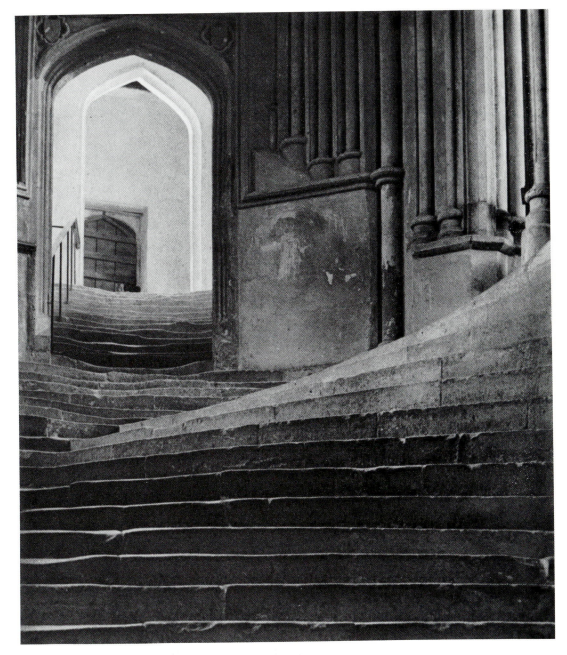

to the measured elegance of the flight of steps. Fanning out with mathematical precision from the newel stone, right, it leads to the entrance of the Chapter House. But, in his *Sea of Steps*, Evans shows the stairs to the Chapter House as "steep, and apparently untreadable".[24] His intended effect is more than a topographical

5. Frederick H. Evans, "*A Sea of Steps*", *Wells Cathedral: Stairs to the Chapter House and Bridge to Vicar's Close*, platinum, 1903. Royal Photographic Society.

[24]F. H. Evans, "Wells Cathedral", *Photography* 16 (18 July 1903), 65.

description. "The beautiful curve of the steps on the right as they rise to the height of the Chapter House floor, is for all the world like the surge of a great wave that will presently break and subside into smaller ones like those at the top of the picture".[25] The visual tension achieved by the pull of the stairs curving toward the Chapter House is also an ideological one: while the door at the head of the stairs leads to the Vicar's Close from which, in a sense, comes the affirmation of belief, the Chapter House, poised at the crest of the wave, represents the secular interest of the cathedral. It is here that the Chapter of Deans conducts church business. Of the series of three images Evans made of this famous stairway, the one which was published first, in 1900 (CC26), shows this dramatic divergence – an actual separation of the stairs where they take different paths.

In his *Sea of Steps*, Evans excluded the main hand-rail on the left. Using his telephoto lens, he visually flattened the steps, accentuating their sheer insurmountable slope. Adrift in a tide of disorientation, the viewer takes hold of a visual life-line: the near-square wall of stone centered in the composition. The square, as the symbol of the earth, formed a meaningful basis for the geometry and construction of the cathedral. For the Greeks, the "tetragonon" (rectangle or square) was a symbol of perfection which signified the human life and the human soul. The poet Simonides of Ceos, as early as 500 B.C., recognized the square as "a symbol of the ethical and intellectual perfection of man".[26]

We are confronted with the challenge of an ascent which leads toward three goals: the radiant arch, the square of perfection, and the temple of the world. This *sancta scala* presents, at different levels, the "harmonic correspondence" of Swedenborg, "exemplified by the relation between light, intelligence, and wisdom".[27] Yet the discolorations on this square render intelligence humble in its imperfections. The seventeenth-century poet George Herbert, in *The Temple* (1633), saw a spiritual analogy in such stains in "The Church-Floore":

> The gentle rising, which on either hand
> Leads to the Quire above,
> Is *Confidence*:
> But the sweet cement, which in one sure band
> Ties the whole frame, is *Love*
> And *Charitie*.
>
> Hither sometimes Sinne steals, and stains . . .

[25]Ibid.

[26]Gerhard B. Ladner, *Images and Ideas in the Middle Ages*, Rome 1983, 2 vols., 1:141–2.

[27]Emanuel Swedenborg, *A Hieroglyphic Key to Natural and Spiritual Mysteries*, trans. J. J. Garth Wilkinson, London 1847, 33.

Evans's conviction in a spiritual progression from this world to the next is expressed in his memoir of Wilkinson: "When one thinks of the poetry, the romance, the love hidden in us, . . . is it any wonder that one turns with dismay from the man who talks of no immortality?"[28]

[28]Evans, *James John Garth Wilkinson,* 87.

20. J. CRAIG ANNAN AND D. Y. CAMERON IN NORTH HOLLAND

William Buchanan

On a Dutch Shore and *The Beach at Zandvoort* by James Craig Annan (1846–1946) were internationally important photographs at the turn of the century. *The Beach at Zandvoort* (Fig. 1), a tiny print sometimes measuring a mere 3 cm × 15 cm, was exhibited in London in 1893. It was published in *The Studio*, in London, in 1894. It appeared in 1895 in both *The Photographic Times* of New York and the *Photographische Blätter* from Vienna. It was exhibited in Brussels in 1897, in Hamburg in 1899 and was reproduced that same year in *Das Photographische Centralblatt* of Munich. *On a Dutch Shore* (Fig. 2) was exhibited in Berlin in 1899. It was beautifully reproduced in the Art Folios of *Die Kunst in der Photographie* (Berlin) in 1900, and in *Camera Work* (New York) in 1904. In 1906 it was hung in Annan's show at the 291 Gallery in New York, and it was also seen in Philadelphia.

These two photographs, taken on a beach in Holland in 1892, must have reached almost anyone interested in photography at the turn of the century. This is even more remarkable when one considers that they were taken at the very beginning of James Craig Annan's career. Yet it is less remarkable when one considers his advantages. He was a son of Thomas Annan (1829–87), a fine portrait-photographer who also produced *Old Closes and Streets of Glasgow*, a moving account of the city's horrifying slums. He was born in a home called Talbot Cottage. He could remember meeting, as a child, D. O. Hill and he had lived for six months in Rock House in Edinburgh where Hill and Adamson produced their superb calotypes. In addition to all that, Annan had become a consummate technician in photogravure, going with his father in 1883 from Glasgow to Vienna to learn this new process from the inventor himself, Karl Klíč.

About 1890 Annan began to make prints in photogravure from the original paper negatives of Hill and Adamson. Perhaps it was this, with his experience of reproducing works of art for the family firm, which awakened and then sharpened his aesthetic sensibilities. He had no formal art training, but he studied masterpieces. In 1891 he shared his interest in Hill and Adamson with D. Y. Cameron (1865–1945). Cameron re-worked their *Mrs. Rigby* then, calling his etching *Old Age*.[1] Cameron was to become

[1] *Mrs. Rigby* is reproduced in S. Stevenson, *David Octavius Hill and Robert Adamson*,

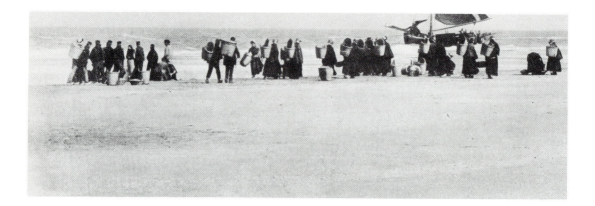

1. J. Craig Annan, *The Beach at Zandvoort*, photogravure, 1892. Metropolitan Museum of Art, New York.

one of the brilliant etchers of his generation, a member of both the Royal Academy and Royal Scottish Academy, eventually receiving a knighthood. Annan was a friend of other eminent Scottish printmakers: William Strang (1859–1921), of whom he made a superb portrait; Muirhead Bone (1876–1953), who, like Cameron, was later knighted; and Cameron's sister Katherine (1874–1963). At this time there was an intense interest in printmaking and collecting.

Annan and Cameron's trip to the north of Holland did not break any new ground (that was left to two of the Glasgow boys, George Henry and E. A. Hornel who, next year, went on a painting trip to Japan). Holland was a well-beaten track for tourists and artists alike. They may have made their choice because they knew the paintings of the Hague school. Two local art dealers supplied their work to several local private collections, which has also resulted in the strong representation of the Hague school in Glasgow's collection today. It is impossible to think that Annan and Cameron did not see the examples of their work at the International Exhibition held in the city in 1888. In it were at least six paintings each by Bosboom, Mauve, the Maris brothers and Israëls. These, with Mesdag and Weissenbruch, were the principal members of the group which painted, in a Realist manner, landscapes, canals, beaches, dunes and the lives of fisher folk and peasants. One characteristic of the Hague school was its grey tonal palette. While it is true that the landscape was predominately grey, and that greyness was also noted by Annan, another reason for a grey palette was, surely, the influence of photography now being felt by painters every-

Edinburgh 1981, 143, version h. Aberdeen Art Gallery has a print of *Old Age*. It and all the other prints by Cameron mentioned are reproduced in photogravure by J. Craig Annan in F. Rinder, *D. Y. Cameron, An Illustrated Catalogue*, Maclehose 1912.

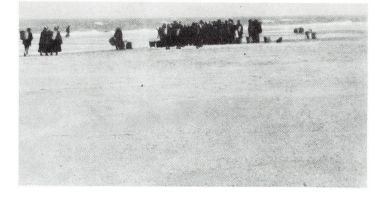

where. Also in the 1888 exhibition were two works by the French artist, Isabey, attracted, like so many others, to Holland.

There was one work in that exhibition which may have firmly lodged itself in Annan's mind, especially the way in which the shapes of the figures were arranged against a backdrop of shore, sea and sky. It was Josef Israëls' *Shipwrecked Mariner* (now *Fishermen Carrying a Drowned Man*, National Gallery, London). This painting was reproduced as an etching by William Strang

2. J. Craig Annan, *On a Dutch Shore*, photogravure, 1892. From *Camera Work*.

in the commemorative book of the exhibition, *A Century of Artists*, edited by W. E. Henley. Reproductions of works in heliogravure (i.e., photogravure) of *Wood Nymph* by Burne-Jones and *Girl Sketching* by Raeburn are credited to Annan.

Annan was not to break any new ground on this trip as far as subject-matter was concerned. With one important exception, it had all been used before. The beached fishing boat had been painted by Gudin, *On the Scheveningen Coast* (present location unknown), as early as 1844; by Jongkind in 1861, *Fishing Boat on the Beach* (Kröller-Müller Museum, Otterloo); and then by the Hague school, which flourished from the 1870's, with the subject being taken up by Jacob Maris, Mauve, Mesdag and Weissenbruch. Fish auctions on the beach, women arranging fish on the sand, were painted by Mauve, Blommers and Sadée. In 1882 Van Gogh, another admirer of the Hague School, produced an early oil *The Beach at Scheveningen in Stormy Weather* (Stedelijk Museum, Amsterdam) in which, with the added difficulty of blown sand sticking to his wet canvas, he tackled the problem of making a picture from the dunes, the sea, the sky, a boat at anchor, a cart and horse, and some figures, just as Annan was to do ten years later. About the time of Annan's visit Jan Toorop painted men struggling to move a fishing boat on the beach at Katwijk (Stedelijk Museum, Amsterdam). One day, some scholar may survey these many pictures to determine which fishing boats appear how many times in which pictures.

Annan created, with his camera, fresh and vital images from what by then must have been hackneyed subjects. *The Beach at Zandvoort* has a delightfully asymmetrical composition. The figures are reduced, at first glance, to what looks almost like a line of musical notes, though on close inspection every activity of these tiny figures is clear. A reproduction of *The Beach at Zandvoort* loses a great deal of its quality, as do all works in photogravure. It also loses its scale. It is a powerful work packed into a tiny space. Sometimes, as reproduced in volume two of *The Studio* in 1894, the print is cropped near the top of the boat's mast, and sometimes it is cropped lower, just above the boom. The latter seems the more successful for it emphasizes the print's long, narrow shape, which may have been dictated by the long line of sky meeting sea. It has been suggested that a panoramic camera was used to take it, or that it was made from a number of prints skilfully pieced together and then re-photographed. Is it not one print, from a standard camera, of a motif taken from a distance? Perhaps only part of the negative was printed, or a print was trimmed to a small strip. On this trip Annan used, mainly, a hand camera which produced quarter-size plates.

Annan's *Beach at Zandvoort* makes the compositions of the exceedingly popular painter Bernard Blommers (1845–1914) seem highly conventional. Annan might have seen his *Fishwives by the Sea* (Fig. 3) when it was shown in the 1888 exhibition.

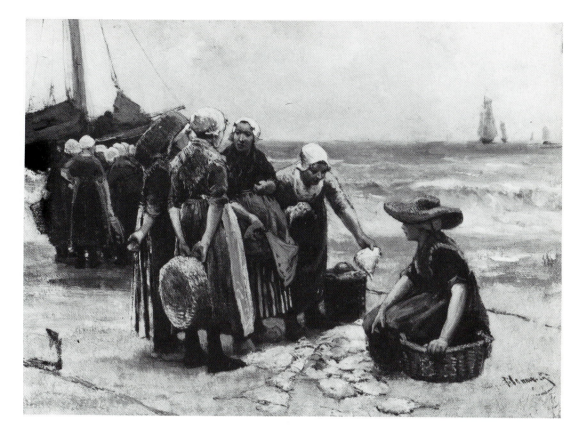

Blommers drew his subjects from Zandvoort, Katwijk and Scheveningen. The fisher people of Scheveningen are described in one guide-book as being like a foreign tribe. Though they lived only two miles from The Hague, they spoke their own dialect, wore their own costume and intermarried. This would seem to be exactly similar to the fishing community at Newhaven, then just outside Edinburgh, which Hill and Adamson have immortalized. Of Zandvoort nothing original remains for it was razed during the Second World War. Zandvoort has been rebuilt, and is now a cosmopolitan resort with a motor-racing circuit. Annan described it as it was in 1892:

3. B.J. Blommers, *Fishwives by the Sea*, oil on wood, n.d. Glasgow Art Gallery and Museum.

> Then suddenly we came upon the village nestling peacefully in a hollow among the sand dunes, a mass of dark red tiles and cold grey gables clustered like the eggs of some great seabird in the nest it deserted centuries ago. All is cold and grey for it is early Spring and last year's grass is only a shade deeper than the sand, which stretches hillock beyond hillock until they meet the greyer sky . . . and there is no sound but the muffled roar of the never ending swell upon the broad beach.
>
> There are no streets in the village, and the houses are

4. Alfred Stiegltz, *Landing of the Boats*, half-tone from a carbon print, 1894. Metropolitan Museum of Art, New York.

thrown together . . . the winding paths between and around the houses and goatsheds present a sad contrast to the general order and tidiness of the Netherlands.

In the morning we are awakened by a busy clatter of wooden shoes, the sun is shining brightly, and the air seems rippling with activity.[2]

The boats were returning. They hunted for herring, sometimes sailing as far as the North coast of Scotland. Annan was ready with his camera.

Alfred Stieglitz, that key figure in American photography, was also ready with his camera to photograph returning fishing boats, but on another beach and two years later. He was at Katwijk about twelve miles down the coast. His photograph *Landing of the Boats* (Fig. 4) is an almost exact illustration of Annan's description of the boats landing at Zandvoort:

On come the *pinkens*, as the fishing boats are called, bounding over the blue waves; with their brown sails fully set, come splashing into shallow water, until their progress is stopped by grounding on the sand. Instantly a man is overboard, the water is up to his neck, but on he comes struggling, with an anchor on his shoulder. Then another and then a third make for the shore, bending beneath similar burdens. Energy and anchors, windlass and wave combine to bring the massive

[2]"Zandvoort," in L. Raeburn, ed., *The Magazine*, November 1894, 31–40. This handwritten publication by students of the Glasgow School of Art and their friends, now in the school library, also includes contributions from the architect Charles Rennie Mackintosh.

pinken thumping and scraping, into water sufficiently shallow to permit the discharge of the cargo.

The excitement is now at its height and welcomes must be of the shortest, for the auctioneer is waiting to dispose of the cargo as each boat arrives.

Annan's *On a Dutch Shore* is of an auction, though this is not apparent from the evidence in the print. As a composition the crowd forms a dark shape balanced against the shape of the two boats which are now turned seawards, into the wind. The group at the auction is engaged in an urgent and intense activity on which their livelihood depends. It is an eloquent photograph about a tiny group of people fighting to survive in a vast world of sea and sand and wind. Such a highly charged atmosphere, always quietly stated, pervades the very best of Annan's work.

In contrast, Stieglitz chose an exciting moment for his *Landing of the Boats*, for the men who have gone overboard with the anchors could yet, even in sight of home and loved ones, perish. Stieglitz and Annan made photographs which are potent, accurate accounts of the life of these fishing communities. In another context, are they not also fine examples of documentary photography? Stieglitz admired the work of Annan. Such works as Annan's *Sand Dunes* were influential on Stieglitz's style at this period; Annan had caught the men and the horse in mid-step. Stieglitz owned many photographs by Annan, including this one, and he and Annan were to become friends through a long correspondence.

Travail du Soir was the name of the print of a Dutch work-

man which Annan showed at the Paris Salon in 1894. It became first *Toil*, and then was corrected to *Labour–Evening* when that same year it was shown in New York at the Joint Exhibition of The Photographic Society of Philadelphia, the Society of Amateur Photographers of New York, and the Boston Camera Club. Also in this exhibition was a photograph called *Beach at Zandvoort*, though it is almost certain to have been *Fisher Wives*. Annan sold two works and it may have been this print which was bought by the Syracuse businessman George Timmins, one of the earliest collectors of photography in America.[3] When *Fisher Wives* was later exhibited in his collection it was described in *The American Amateur Photographer* of July 1896 as "one of the modern eccentricities: a little sky, a narrow strip of sea with a row of fisher women on the margin, and a vessel on its bosom, and all the rest bare sand. It takes a bold man to try to make a picture with such an arrangement but Craig Annan both tried and succeeded."

There is one photograph, *Reflections – Amsterdam* in which Annan does deal with new subject-matter. The print is composed of the end of a barge, a horse-drawn tram, an advertisement for cocoa, a row of houses and the reflection of all these in a canal. Catching moving reflections in water is a subject particularly suited to photography. It was a subject in which the Hague school had no interest whatsoever. Annan brings us back to mundane town-life in contrast to the elemental forces of wind and sea on the beach. *Reflections – Amsterdam* was seen in both Europe and America. No original print of it has yet been found, so it is reproduced here (Fig. 5) from page 103 of volume two of *The Studio* magazine in 1894.

Cameron was interested in involved and detailed subjects to challenge the fine draughtsmanship of his etching needle. He etched tall, narrow houses in Amsterdam, windmills at Zaandam (Fig. 6), the clutter outside a shop selling "Tabak en Sigaren", and a courtyard in Alkmaar, where they were in April. Cameron's *A Canal, Amsterdam* concentrates on the straggle of buildings along each bank, whereas Annan looked into the canal to find his subject for *Reflections – Amsterdam*. However, Annan may have prompted Cameron's tiny etching *Waves*: it measures roughly 4 cm × 13 cm, which suggests not only in size, but also in subject, a relationship to Annan's *Beach at Zandvoort*. There is also *Fisher Folk*, another Zandvoort subject, in which Cameron tackles a crowd on the beach. In both these works Cameron seems less sure of himself.

Annan made work as a direct response to the technique of etching. One of these, *A Photograph from Life*, appeared as an

[3]Reproduced in *The American Amateur Photographer*, April 1894, 152; *The Photographic Times*, January 1896, 4; *The Practical Photographer*, October 1904, opposite 8. The Museum of Photography, Antwerp, has a print.

5. J. Craig Annan, *Reflections – Amsterdam*, 1894, half-tone from *The Studio*, 15 December 1894.

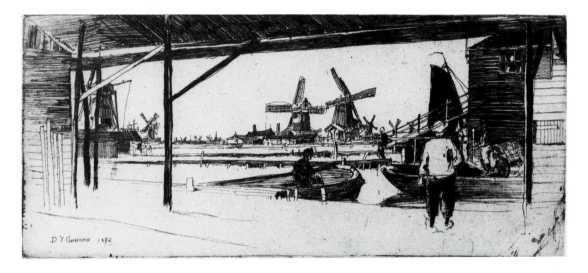

illustration to an article in *The Studio* in April 1894. It shows a man straining to move a boat by its bow. The man and part of the boat are shown against a completely plain background. In *Camera Notes* (New York) in January 1901 this image was reproduced with the addition of a head (only) of a second man watching. "A. M." (probably Alfred Maskell), the author of the article in *The Studio*, entitled "Suppression and Modification in Photography", wrote that Annan

6. D.Y. Cameron, *Zaandam Windmills*, etching, 1892. Hunterian Art Gallery, University of Glasgow.

> simply carries to greater lengths than is usually practised a process of stopping out on the back of the negative the details which he wishes to modify or to suppress. Here, again, the artist hand is of first importance. . . . An objection which may be anticipated is that the action of light in photography does

not draw in lines but paints, rather, in broad oppositions of light and shade, and that therefore we have no right to use methods which appear to be contrary to the spirit of the art.

A review of the London Salon of 1893 in *The Studio* had ended "and while critics are discussing if there be Art in Photography, photographers are settling the question by themselves." Annan was one such photographer.

When they returned from Holland, Cameron made an etching of Annan's mother wearing a Dutch head-dress. He called it, untruthfully, *A Lady of Holland*. Later, Cameron painted her portrait (Glasgow Art Gallery and Museum) wearing another Dutch head-dress. Annan was to go, again with Cameron, this time on a trip to the north of Italy in 1894. It was important for him to be with another artist, he explained, because when he worked with those who "had little intimate knowledge of art, I have found the contents of my camera to be sadly lacking in that subtle something which makes one photograph so very much more interesting than another".[4]

A list of about twenty-five Dutch titles by Annan has been compiled, but only about fourteen existing prints have been found. Cameron published a set of twenty-two north Holland etchings and there are ten others. An exhibition of their work opened on 10 October 1892 to handsel[5] the gallery of Annan and Sons at 230 Sauchiehall Street, Glasgow. Annan made prints in red, green and brown, which must have contrasted sharply with the black-and-white etchings, especially as etchings and photographs were hung alongside each other. This bold move paid off, for *The British Journal of Photography* reviewing the show on 28 October commented, "It may be safely said that this is the first occasion in which photographs and etchings have been brought together into such close relationship . . . the conclusion is forced upon one that photography, at all events, can hold its own." The exhibition's invitation card listed the places Annan and Cameron had visited, Amsterdam, Haarlem, Alkmaar, Zaandam, Zandvoort and Utrecht, where Cameron drew a timber merchant's, while Annan found a double row of trees to pay a homage to Hobbema.[6] It also announced that the exhibition was of etchings and monotones. How strange that Annan chose to use the word "monotone" instead of "photograph". Perhaps he thought that no one would be interested in photographs. He could not have been more wrong. When, next year, he sent work, including *The Beach at Zandvoort*, *Utrecht Pastoral*, *Reflections – Amsterdam*, and *Fisher Wives*, to the London Salon, they

[4]From a report of Annan's address at the opening of his one-man show at the Royal Photographic Society in *The Amateur Photographer*, 2 February 1900, 83–4.

[5]"To celebrate the first use of" (*The Concise Scots Dictionary*, Aberdeen 1985).

[6]*Utrecht Pastoral* is reproduced in S. Stevenson and J. Lawson, *Masterpieces of Photography from the Riddell Collection*, Edinburgh 1986, 39.

were not only hung but *Fisher Wives* was sold (for three guineas). On 6 February 1894 he found himself elected a member of the Linked Ring. He was at the beginning of what was to be an international career.

21. ADOLF DE MEYER:
L'Après-midi d'un Faune

Michele Penhall

On 29 May 1912 Vaslav Nijinsky's ballet *L'Après-midi d'un Faune*, premiered at Le Théâtre du Châtelet. Two years later, on 15 August 1914, a suite of thirty photographs taken by Adolf de Meyer of Nijinsky and his seven co-stars in their roles from that dance production was published in Paris as *Sur le Prélude à l'Après-midi d'un Faune*.[1]

Baron Adolf de Meyer's personal association with Nijinsky is obscure. The literature describes nothing of the relationship between the two men. De Meyer's life and career before settling in the United States was active and mobile. Together with his wife, Olga, he occupied residences in London, Paris and Italy. The couple followed all cultural activities wherever they resided, especially the ballet. Thus it is not surprising that when Diaghilev's Ballets Russes came to London in 1911, Olga de Meyer was responsible for the troupe's accommodation.[2]

Bronislava Nijinska recalls overhearing her brother's arrangment with someone for the publication of de Meyer's photographs taken of *L'Après-midi d'un Faune* and the subsequent cheque he issued for one thousand pounds to be used for the cost of the publication.[3] Nijinsky's intervention is proof of a vested interest in the project, the arrangements for which are likely to have been with de Meyer himself. The published album left the printer's hands in the summer of 1914, destined for the United States. Owing to the outbreak of the First World War, the cargo ship which carried the edition is said to have been sunk by the Germans. Therefore only a few copies remain today.

Despite de Meyer's Edwardian-dandy life-style, he was an ardent photographer in the Linked Ring from 1898 until his resignation in 1908. Along with Alvin Langdon Coburn, he organized a photography exhibition in London showing the work of American pictorialist photographers like Clarence White,

[1]The reproductions for this chapter are taken from a facsimile edition *L'Après-midi d'un Faune: Thirty-three Photographs by Baron Adolf de Meyer*, Eakins Press Foundation, New York 1978, by kind permission of Leslie Katz. In 1983 Dance Horizons co-published with Eakins Press an edition with half-tone reproductions, *L'Après-midi d'un Faune: Vaslav Nijinsky 1912*.

[2]See Philippe Jullian's essay in *de Meyer*, ed. R. Brandau, London and New York 1976.

[3]*Bronislava Nijinska: Early memoirs*, ed. I. Nijinska and J. Rawlinson, New York 1981, 508.

Alfred Stieglitz, Edward Steichen and Gertrude Käsebier. De Meyer consistently exhibited his own work, and Alfred Stieglitz published seven images by him in *Camera Work* 24 (1908), later dedicating an entire issue (40:1911–12) to his photography. The photographers' mutual admiration is apparent in their correspondence.[4] De Meyer constantly questioned his own artistic aims. It seems fair to assert that although his later fashion work was primarily of a commercial nature, his early goals, regarding the work he produced before 1916, were mainly aesthetic. This early work was very much a part of pictorial traditions prevalent at the turn of the century. It was at the end of that first decade of the new century that de Meyer made the photographs of Nijinsky and his seven female partners.

These photographs are said to have been made in one afternoon, and appear to have been the result of a collaboration between Nijinsky and de Meyer. Although he photographed the dancer in many of his other roles,[5] it is not clear why de Meyer did such extensive work on this particular ballet. Also, judging from the literature concerning Nijinsky's ballet, it seems unlikely that he would have given de Meyer complete artistic licence to compose and construct the images. The major writings on Nijinsky which deal with his first choreographic effort all stress his obsession with this ballet. De Meyer's is the only complete documentation of this remarkable performance, for there are no records of the staging as it was performed. In the early years of the twentieth century it was rare for dance performances to be preserved through the cinema. The ballet performances of Vaslav Nijinsky were thus never recorded by the motion picture industry.

The revolutionary impact of *L'Après-midi d'un Faune* on the Parisian audience during the 1912 season is better grasped when seen in the context of the company's planned repertoire. The two ballets which preceded the debut of *L'Après-midi d'un Faune* were choreographed by Michel Fokine, resident choreographer of Diaghilev's Ballets Russes. One, *Le Dieu Bleu*, premiered 13 May 1912, and was a lavish production with Orientalized features, including Indian and Siamese elements incorporated in the set decorations and costuming. A week later, on 20 May, *Thamar* opened. This second production was another one-act ballet based on the legend of Thamar, queen of Georgia, in Russia, who threw her lovers from the turret of her residence after having stabbed them. Although both performances were new to the audience, they were still in keeping with the theatrical conventions that one expected from an evening at the ballet. They were comfortable entertainment. Exotic costuming, elab-

[4]Stieglitz Archive, Beinecke Rare Book and Manuscript Library, Yale University.
[5]See L. Kirstein, *Nijinsky Dancing*, London 1975, for more dance photographs by de Meyer.

orate set designs and a coherent plot combined with a conventional series of graceful movements were the expected components. The audience could not have been prepared for the revolutionary performance of 29 May 1912.

L'Après-midi d'un Faune was Nijinsky's first attempt at choreography. He initially worked out the dance with his sister, Bronislava Nijinska, during many sessions in their living room. Rehearsals for the actual performance numbered at least ninety. This may not seem like unusual preparation for a ballet, but Nijinsky's *L'Après-midi d'un Faune* lasted only twelve minutes. The seven female dancers, all rigorously trained in the Russian tradition, had virtually to retrain their entire bodies to conform to Nijinsky's progressive dance notation. This was not a ballet of *grands jetés, pirouettes* or romantic *pas de deux.* The movements of his choreography were stiff, angular and minimal. This was an idea conceived by Nijinsky as a revolutionary kind of ballet, completely foreign to his contemporaries, and not without influence.

Nijinsky's artistic ideas for his ballet are ultimately linked to ancient Greek mythology and to Egyptian wall-painting. His concepts recall Isadora Duncan's progressive dance theories, which also cast aside existing techniques and began to construct movement from a totally new direction. Nijinsky wanted a definite departure from convention: "I want to use the archaic Greece that is less known and, so far, little used in the theatre. However, this is only to be the source of my inspiration. I want to render it my own way. Any sweetly sentimental line in the form or in the movement will be excluded".[6] Nijinsky's exposure to the art of Egypt and ancient Greece is relayed in a story about his trip to the Louvre with costume designer Leon Bakst.[7] If Nijinsky was inspired by the frieze-like configuration of Egyptian wall painting and especially the figures on Greek vases, this inspiration also derives from the original myth.

One possible source for Nijinsky's ballet could be Stéphane Mallarmé's poem *L'Après-midi d'un Faune* (1876). Parallelling the Greek myth, the theme of Nijinsky's ballet and Mallarmé's eclogue is the lustful nature of Pan.

The faun Pan resides in Arcadia tending flocks, herds and beehives. When not asleep (a favourite pastime), he can usually be found pursuing nymphs – notably, the nymph Syrinx. When this chaste creature reaches the shores of the river Lado, in order to escape the lustful clutches of the persistent satyr, she is transformed into a reed. Pan cuts this rush down and fashions it into a pipe. This simple reed pipe is all he has left of his vanished love.

Nijinsky's choreographic interpretation of the legend,

[6]*Bronislava Nijinska,* 315.
[7]R. Buckle, *Nijinsky,* New York 1971, 163.

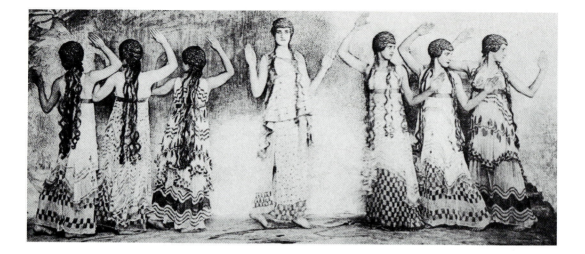

1. Adolf de Meyer, *L'Après-midi d'un Faune*, collotype, 1914. Courtesy of the Eakins Press Foundation. Photograph by Richard Benson.

whatever the pictorial sources, remains unique. Debussy's Prelude served more as background to the work than as an integral part of the ballet. The musical score was not followed in a note-by-note fashion. Nijinsky's notation had the dancers, himself included, execute their steps in strict profile. All limbs, heads as well, were also held as a frieze. Hands were flat, showing either palm or back. Torsos faced front or back. Feet were mostly bare – Nijinsky and the main nymph wore sandals – and the dancers walked in profile, on their heels with knees slightly bent (Fig. 1). The movements were carried out in a continuous stream of angular motion, not stopping till the end of the sequence.[8]

While the apparel of the nymphs was of a diaphanous nature covering most of their bodies and supposedly inspired by the designer Bakst's trip to Crete, Nijinsky's attire in portraying the satyr was minimal and close-fitting, and suggested the body. His horns were short, his ears pointed. The spotted character of his costume made it difficult to differentiate between leotard and flesh. This and the fig leaf were all that he wore. The setting was also stark and merely indicated the idea of a mottled landscape, with only a portion of the stage fashioned to simulate Pan's den.

De Meyer's sequences of images begins with Pan lounging in his den, playing a pipe, followed by two extreme close-up photographs of Nijinsky displaying a bacchic cluster of grapes. Enter next, one of seven nymphs, and then a photograph of all seven in strict angular form. Twelve images follow of the nymphs in various groupings, or of a solitary figure in detail, always with an emphasis on overall choreographic structure as opposed to individual character. When Pan emerges again, ten-

[8]Ibid., 164–5.

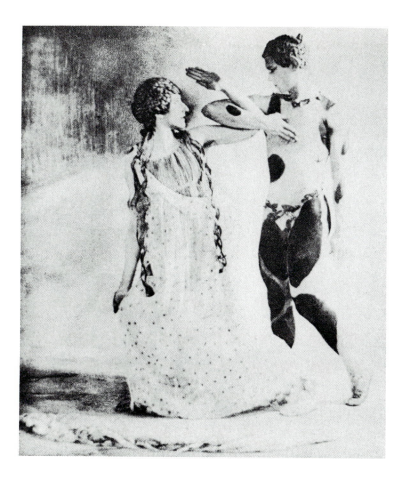

2. Adolf de Meyer, *L'Après-midi d'un Faune*, collotype, 1914. Courtesy of the Eakins Press Foundation. Photograph by Richard Benson.

sion increases: Nijinsky's portrayal of this goatish being is strongly assertive. His glance pierces the eyes of the intended nymph and her posture weakens with the tension. They embrace and separate, and the nymph Syrinx is led away by a companion nymph. Pan then recovers his nymph's lost scarf and revels in his find while he withdraws to his den to complete his fantasy. Such is the general order of the album.

The album of photographs is now more easily understood as a collaborative effort. It is inconceivable to think that after all of Nijinsky's efforts on this production, he would succumb to being a mere participant in the project. Nijinsky brought de Meyer's skill and photographic sensibility together with his own choreographic genius to produce an almost cinematic trailer of the ballet. The images move across each page not gracefully but emphatically. De Meyer mostly keeps his camera at an average distance from the dancers but zooms in for numerous effects, especially to emphasize the extreme Egyptian flatness which Nijinsky worked so hard to convey. These photographs in no way resemble the starched quality of routine dance stills, yet

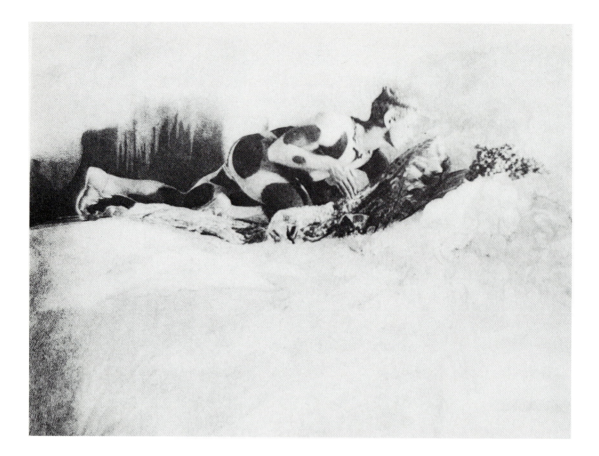

they hold no glamour either. They do show, even if obliquely, an intense intimacy between Pan and Syrinx (Fig. 2). There is a kind of cold romanticism and stilled sadness in the expressions of the pair and their precise gestures. Pan's final retreat and almost orgasmic rapture is elegantly revealed by de Meyer when Nijinsky caresses the scarf as though it were the nymph herself (Fig. 3). Many images seem odd when looked at individually. The impact lies in the ensemble which functions best viewed in the intended album.

Inexplicably, the publication of these photographs did not immediately take place. Acquiring funds may have been a problem. The illustrations were collotypes, which have some of the tonal characteristics of aquatint. This beautiful reproductive process helped to translate the overall style of the original photographs which had a strong painterly effect. This kind of reproduction of the *L'Après-midi d'un Faune* images reflected contemporary taste and was directed towards the kind of audience able to afford an expensive album, the estimated retail price of which was two hundred and fifty French francs, although there

was another edition on different paper which sold at one hundred and fifty francs.

The photographs constituting *L'Après-midi d'un Faune* are a synthesis of the work of two individual artists working in two different media. The ability of de Meyer to interpret Nijinsky's choreography through photography is very impressive. This collaboration illustrates why such images known to twentieth-century viewers as part of de Meyer's oeuvre exist in a somewhat different category from the rest of his pictures. While nothing can bring back the particular staging of the performance of 29 May 1912, Adolf de Meyer has reconstructed the essence of this revolutionary moment through his personal photographic style. It is this interpretive reconstruction that makes these photographs important beyond their documentary function.

22. MALCOLM ARBUTHNOT:
Modernism and the End of Pictorialism

Melinda Boyd Parsons

In 1908 and 1909, the British artist Malcolm Arbuthnot mounted what seemed to be a concerted attack on the sensibilities of the photographic community. His "ammunition" was a series of abstract photographs which were apparently almost totally at odds with the prevailing British Pictorialist aesthetic. Most critics and photographers were aghast at the images and could not imagine what had inspired Arbuthnot to produce them. To these people, Arbuthnot and his abstractions were an isolated phenomenon not grounded in any tradition. Actually, though, in retrospect, he can be seen in several contexts. First, his photographs were an extreme extension of certain basic Pictorialist principles, especially its formalist bias. Second, Arbuthnot was part of a small group of self-consciously avant-garde photographers who had developed within the Pictorialist movement but by 1908 were railing against what they saw as its unwillingness to keep up with the modernity of the new century. Arbuthnot's 1908 abstractions were the most radical visual expression of this group's attempts to "update" the Pictorialist aesthetic.

Pictorialism itself, as an international style in photography, had taken shape around 1890 in western Europe and America, embodying a belief that photography could move beyond a transcriptive recording of the physical world to enter the more transformative realm of fine art.[1] As such, Pictorialism was influenced by the concurrent fine-art movements, Symbolism and Art Nouveau, with their emphases on transcendent but elusive meaning and sinuous, decorative formalism. When applied to photography, the idealization that was the end goal of this aesthetic was realized through the selection of appropriately Symbolist subjects and an individualistic interpretation of those subjects through compositional or technical means. Typical subjects might include idealized landscapes, allegorical figure studies, moody portraits or nostalgic views of rural life. Generally, the beauty and spirit of the subject were considered of prime importance and were enhanced through the arrangement of elements in the original scene and the decorative, expressive

[1]See John Taylor, *Pictorial Photography in Britain, 1900–1920*, London 1978; and Margaret Harker, *The Linked Ring; the Secession Movement in Photography in Britain, 1892–1910*, London 1979.

disposition of those elements across the picture surface. Most
Pictorialists subscribed to these ideals, though they differed in
the means they felt were proper in crafting an image. Some
leaned towards an approach in which the appearance of the
scene was altered so as to bring it in line with the way the artist
saw it in his "mind's eye". Such changes were accomplished
through hand-manipulation of the negative, the print, or
both, the most favoured techniques being the gum-bichromate
and the bromoil processes. Other workers preferred the rigours
of the so-called straight method, with its unmanipulated nega-
tives and prints, a purism which encouraged more sensitive
seeing and greater care in the initial selection and arrangement
of the subject. The major difference between the "gummists"
and the "purists" lay in whether beauty was felt to reside in
unaltered nature itself or whether it could only be found in a
nature edited and reshaped by the hand and eye of the artist.
Whatever their differences, however, all the Pictorialists were
united in their belief that photography could approach the con-
dition of the fine arts, both in terms of a selective idealization
of nature according to the artist's personal vision, and in terms
of photography's ability to convey emotional and intellectual
content. It was this latter belief in photography's potential to
mean something beyond what it actually portrayed – to embody
transcendent "Truth" and "Beauty" – which allied the Pictori-
alists with the Symbolist artists.

 In England, the group which promoted the ideals of Pic-
torialism most consistently was the Linked Ring Brotherhood.
It had been founded in 1892 as a secession from the larger Pho-
tographic Society, a group whose "Philistinism" (or so it was
felt) made it incapable of sufficiently distinguishing art photog-
raphy from documentary or scientific photography. The Linked
Ring's membership was international, though the British pre-
dominated, and it eventually embraced most of the well-known
artist-photographers in the world at the time including James
Craig Annan, George Davison, F. Holland Day, Robert Dema-
chy, Frank Eugene, Frederick Evans, A. Horsley Hinton, J. Dud-
ley Johnston, Gertrude Käsebier, Baron Adolf de Meyer, Henry
Peach Robinson, Edward Steichen, Alfred Stieglitz, Frank Sut-
cliffe and the Viennese Trifolium. The group also fostered the
development of several important younger photographers in-
cluding Malcolm Arbuthnot, Alvin Langdon Coburn, F. J. Mor-
timer and Clarence White.

 Through the 1890's and the opening years of the twentieth
century, the Linked Ring had promoted a moderate version of
Pictorialism, involving a careful balance between "significant"
subject-matter (defined as that which manifested degrees of
"beauty" and "truth"), sentiment (the emotional response to
that beauty and truth) and decorative composition. For the most
part, British members of the Linked Ring eschewed extremes of

chiaroscuro or focus and avoided overly obvious allegorical sub-
jects, preferring the landscapes, seascapes, genre scenes and
portraits favoured by most British painters. Because of their con-
cern with the transcendent meaning of such subjects, they also
tended to avoid the kind of formalism which drew attention to
itself as formalism, distracting the viewer from the significance
of the subject.

Such was not the case, however, with the small, avant-
garde group mentioned above, who were all members of the
Linked Ring but who, by 1907–8, saw its moderate version of
Pictorialism as outmoded. This group, effectively forming a
secession-within-a-secession in the Ring, complained that the
Ring had lost the reformatory zeal which had occasioned its 1892
formation and was now unwilling to evolve stylistically. These
self-consciously "advanced"agitators included Annan, Arbuth-
not, Walter Benington, Coburn, Davison, Demachy, Johnston,
Steichen, Stieglitz, White and a few others. The photographic
style they promoted involved many of the excesses avoided by
the more traditional British Pictorialists, including exaggerated
tonalities and focus (e.g., Coburn's *Bridge, Ipswich* or Benington's
Church of England),[2] overtly allegorical subjects (e.g., White's
Symbolism of Light or Steichen's *In Memoriam*),[3] and an overem-
phasis on formalist patterning (e.g., Benington's *After the
Storm*).[4] Sometimes these artists also depicted what traditional
Links considered commonplace, insignficant subjects – mere
glimpses of the passing scene with no higher meaning. Coburn's
1908 *Flip-Flap* exemplified this tendency, as did Steichen's 1905
"snapshots" of Steeplechase Day.[5] In spite of the obvious vari-
ability of the style championed by the "progressives" within the
Ring, however, it was usually identified by the generic term,
"American-style." Not all those who practised it were American,
nor did each of them emphasize all its characteristics in every
work. Nevertheless, to British critics, "American-style" implied
the tendency towards extremes of aesthetic effect found most
often in American photography. They disliked this (in many
cases) because it diminished the naturalism of photography,
calling attention to the formalist structure of the picture and the
purported cleverness of the maker more than it did to the in-
trinsic beauty or worth of the subject.

Such differences in style implied a profound variance in
their practitioners' attitudes towards subject-matter. While this

[2]*The Bridge, Ipswich* is reproduced in W. Naef, *The Collection of Alfred Stieglitz;
Fifty Pioneers of Modern Photography*, New York 1978, 302; *The Church of
England* in Harker, *The Linked Ring*, pl. 1.4.
[3]*Symbolism of Light* is reproduced in *Clarence H. White*, ed. W. I. Homer, Wil-
mington, Delaware 1977, pl. 83; *In Memoriam* in E. Steichen, *A Life in
Photography*, New York 1963, pl. 28.
[4]*After the Storm* is reproduced in Taylor, *Pictorial Photography in Britain*, pl. 25.
[5]*Flip-Flap* is reproduced in Taylor, ibid., fig. 10; *Steeplechase Day* in Steichen, *A
Life in Photography*, pl. 45, 46.

was important in itself, the lack of sympathy and understanding it fostered between the more conservative and the more progressive members of the Linked Ring was soon to produce unfortunate consequences in the larger photographic community. At the Linked Ring Salon of 1908, it was the more avant-garde members of the Ring who dominated the Selection Committee, leading to a predominance of American-style photography and the rejection of many relatively conservative British Links who usually exhibited at the Salon. The ensuing bitter controversy concerned both differences in aesthetic principles and the related question of political control within the Ring itself. Sadly, the dispute was so heart-felt that within two years it had destroyed the Ring as an organization, and it never re-formed. Even worse, this sense of disaffection was not limited only to England. Pictorialism had been an international style, and after 1910, the whole movement began to break up, largely due to perceived differences between the traditional Pictorialist aesthetic, with its roots in the nineteenth century, and the newer style, which seemed to presage the formalism of modern art. Although Pictorialism continued to be practised among certain groups in Europe and America well into the 1920's, those photographers whom Modernist historians classify as "advanced" moved on to other styles, thus effectively ending Pictorialism's twenty-year ascendency as the first really successful international style in photography.

Many years later, Dudley Johnston undertook to write a history of the Pictorialist movement, and in a lecture he presented on the subject, he noted the influence of the Post-Impressionist style in painting on the small group of progressive Links who fostered the demise of the Ring.[6] Post-Impressionism had taken shape as a movement in the 1880's and 1890's in France, along with Symbolism, though both became international in scope. The two styles shared many characteristics, the most important being their mutual concern with a deeper reality believed to exist beyond the veil of material appearances. The main difference between them was one of degree, rather than essence: the Post-Impressionists placed more emphasis on formalist abstraction as a vehicle for meaning and mood, while many (though not all) Symbolists relied more heavily on subject-matter and iconography to convey meaning.[7] However, by the early twentieth century, the formalist bias in Post-Impressionism had led to its being perceived, at least by some, as a possible basis for the development of a new style that would reflect the

[6]J. D. Johnston, "The Development of Pictorial Photography in Britain and America, 1843–1910", circulated as a lecture script with slides, 1941. Cited in Harker, *The Linked Ring*, 146, 174.

[7]For recent expanded definitions of each movement, see Robert Goldwater, *Symbolism*, New York 1979; and *Post-Impressionism; Cross-Currents in European and American Painting*, London and New York 1980.

modernity of the new century – a flattened, formalized, reductive style that would leave behind what was seen as the unnecessary "significance" and "sentiment" of nineteenth-century subject-matter. Among the photographers who subscribed to this view (and there were very few), none managed to create a more radical visual expression of it than did Malcolm Arbuthnot in his abstractions of 1908.

What was most surprising about this was the fact that Arbuthnot was essentially an unknown, at least until 1907.[8] In that year, he had sprung, apparently full-blown, into the photographic arena with an unprecedented seventeen prints accepted for exhibition at the Linked Ring Salon. He had exhibited occasionally before 1907, in a murky, American-style landscape mode the critics had dubbed his "dark, solemn, and vague style"[9] – though it must be said that these early works were generally well received. Nevertheless, this earlier, limited acceptance did not explain the sudden, overwhelming appreciation of his photography in 1907. Many years later, in his memoirs, Arbuthnot himself said only that he had suddenly realized in 1907 that he was no longer living in the age of the conventional picture, so he set about creating a series of images with stronger formalist compositions.[10] He did not say what had triggered his realization. In retrospect, however, it has become apparent that his 1908 abstractions were inspired by his new awareness, around 1907–8, of the formalist theories of Post-Impressionism, of which he had learned from several sources.

The earliest example of such Post-Impressionist–inspired work by Arbuthnot was *To Larboard* (Fig. 1), shown at the Salon in 1907. This dynamic image, depicting the slanting deck of a yacht under full sail, was created in the oil pigment process, which allowed Arbuthnot to make subtle tonal and compositional adjustments. His manipulations increased the formal unity of the picture, which in turn enhanced the expressive energy of the subject itself. Thus, while the subject was in no way the sort usually favoured by the Post-Impressionists, the image can nevertheless be seen in a general way as "Post-Impressionist", for it possessed that complete unity of formalism and expression that was the essence of Post-Impressionism. Arbuthnot himself was pleased with it because it captured "that indescribable feeling of delight which one experiences on board a vessel, when, with a fine whole-sail breeze, she forges her way through the

[8]For a biography of Arbuthnot and a more detailed discussion of his photography, painting and sculpture, see Melinda Parsons, *Malcolm Arbuthnot (1877–1967): British Post-Impressionist*, Ph. D. dissertation, University of Delaware, 1984.

[9]Anonymous clipping from *Morning Post*, c. September 1905. Arbuthnot scrapbook, collection of Robert Tilling, Jersey, C.I.

[10]Malcolm Arbuthnot, "Random Recollections", 76–77. Unpublished typescript, collection of Robert Tilling, Jersey, C.I.

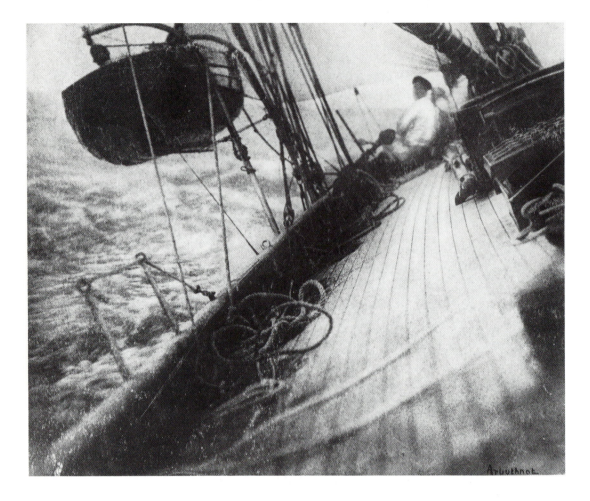

1. Malcolm Arbuthnot, *To Larboard*, oil pigment, c. 1907. Royal Photographic Society.

green seas, casting a cloud of spray from her bow, [racing] away as though possessed with the very elixir of life".[11] While the making of the picture had, of necessity, been somewhat precarious, the end result was a masterpiece of calculation. The diagonal of the deck, carefully placed so as to bisect the image, was offset by opposing angles in the mast and spar, as well as by the more delicate tracery of rigging. The details of the figure in the bow were softened with hand-work, and the lower edge of the sail was altered slightly in direction, both so as not to compete visually with the grid of diagonal lines which dominated the image. Finally, the implied violent forward thrust of the vessel through the rough sea was moderated by an essentially "closed" composition within the framing edges of the image.

[11]Malcolm Arbuthnot, "My Best Picture and Why I Think So", *The Photographic News*, 4 October 1907, 320.

For Arbuthnot, *To Larboard* functioned as an emblem of the modernity of the new century, both in its suggestions of movement and speed, and in its rakish formalism. His new awareness of the expressive possibilities of such formalism had probably resulted from a constellation of interrelated influences, which, though Arbuthnot applied them to the development of a proto-modernist, twentieth-century aesthetic, were derived from nineteenth-century Post-Impressionist theory. The most general and pervasive influence was that of Whistler, whose formalist and evocative "art for art's sake" came to the attention of British photographers in the large 1905 Whistler retrospective exhibition. Arbuthnot's response to Whistlerian tonalism had been rather clumsily manifested in his earlier "dark, solemn, and vague" landscapes, but by 1907 his handling of Whistlerian forms was confident enough that he felt able to "play variations" on them. Indeed, what lent *To Larboard* its energetic modernity was Arbuthnot's modification of Whistler's aesthetic. Most of Whistler's paintings were static – hushed, contemplative moments anchored to the surface of his pictures by web-like grids of horizontal and vertical elements. While Arbuthnot retained Whistler's surface orientation in *To Larboard*, he tilted the grid on a forty-five-degree angle that seemed to liberate the image from Whistlerian stasis, freeing its nautical subject to skim joyously over the sea.

The strong diagonal composition in *To Larboard* also suggested the influence of Japanese art. While *Japonisme* had been implicit in Whistler's program, there were several more direct sources Arbuthnot encountered in 1907 which could explain the *Japoniste* flattening and asymmetry in *To Larboard*. One was the well-known English photographer Frederick Evans, whom Arbuthnot met in 1907.[12] Evans, who collected Japanese art and artifacts, instructed Arbuthnot in the connoisseurship of Japanese ink painting, particularly the work of Sesshū and Sesson. Later, Arbuthnot acknowledged that it "was a wonderful lesson for a young man, as I was then".[13] It was also in 1907 that Arbuthnot struck up a friendship with the American photographer Alvin Langdon Coburn, who reinforced Arbuthnot's appreciation of Japanese art, as well as his awareness of the importance of formalist structure. Coburn had absorbed these interests from his own teacher, the American artist Arthur Wesley Dow, with whom he studied in 1903.[14] But the lineage of the ideas can be traced back further through Dow to Dow's mentor Ernest Fenollosa, an American art theorist and scholar of Japanese art. Fenollosa believed that the basis of art was pure

[12]Malcolm Arbuthnot, "The Linked Ring Days", *The Photographic Journal – Section A* 60 (February 1945), 34.

[13]Ibid.

[14]A. L. Coburn, *Alvin Langdon Coburn, Photographer: An Autobiography*, New York 1966, 22.

form, what he described as the "throwing together of spots of color according to harmonic relations of *notan*, hue, size, and shape".[15] *Notan* was a Japanese term for the patterns formed by dark and light shapes arranged across the surface of a picture; the formal value of *notan* existed independently of any representational aspect of the picture. In fact, mimetic representation occupied a very low position in Fenollosa's hierarchy of artistic value, for, as he had noted, "the Japanese . . . would just as lief at first see a picture upside down; that is, they admire beauty of line and color in art, rather than . . . merely depicting nature".[16] Fenollosa believed that such principles could become the basis of a new art whose meaning and emotional effect derived from the refined manipulation of formal elements.

Fenollosa had the chance to make his ideas on the reform of art practicable when, around 1890, he met Dow, who was just back from Paris. In France, Dow had travelled periodically to Pont-Aven, where he is said to have met Gauguin at the Pension Gloanec.[17] Having thus been exposed to the theories of Post-Impressionism, Dow had returned to the United States in 1889, where he had prepared to set up a teaching practice in Boston. During the 1890's, he and Fenollosa together developed the Fenollosa–Dow system of art education, codified in 1899 in Dow's textbook, *Composition*. Within this system, the primary formal elements were line, *notan*, and colour. As Dow taught it, the student was to approach his study in a gradual manner, beginning with the simplest arrangements of one or two basic forms. Only after mastering design on this level was the student allowed to move on to more complex, representational compositions. According to Dow and Fenollosa, visual composition was essentially as abstract as musical composition, and in both media artists had to learn to manipulate the basic formal elements first. In his text, Dow said that great art consisted of "delicately harmonized proportions [and was] a music of lines and spaces",[18] ideas he had derived from the Post-Impressionist theories of Gauguin and Whistler. Music had been perceived as abstract because, through its arrangement of tones and intervals, it could evoke an emotional response in the listener without actually telling a "story" in words. This had led to the idea that the visual arts could beneficially imitate such abstraction, moving away from the earlier nineteenth-century interest in "significant" narrative subjects to a new, more modern emphasis on the significance of form itself.

Such were the ideas Coburn learned from Dow. In the

[15]Cited in Marianne Martin, "Some American Contributions to Early Twentieth-Century Abstraction", *Arts Magazine* 54 (June 1980), 158.

[16]E. Fenollosa, *Catalogue of the Exhibition of Ukiyo-e Paintings and Prints Held at Ikao Onsen, Oyeno Shinzaka, from April 15 to May 15, 1898*, Tokyo 1898, 5.

[17]See Frederick Moffatt, *Arthur Wesley Dow*, Washington, D.C. 1977.

[18]A. W. Dow, *Composition*, New York 1899, 21.

summer of 1907, he shared them with Arbuthnot, who used them as the basis of his foray into abstraction in 1908. The two men holidayed together in 1907, and in August, Coburn wrote to Stieglitz that he and Arbuthnot were "on the jump!" "Arbuthnot is here," he wrote from Ramsgate,"[and] he's very much alive – when he is elected to the Ring, he will do something to help reform it". A few weeks later, after the Salon had opened with Arbuthnot's seventeen prints, Coburn crowed to Stieglitz that "Arbuthnot saved the day at the Salon! . . . Worthwhile your meeting him if possible". The tenor of Coburn's letters makes it obvious that even in 1907, he saw the Linked Ring situation as one of "progressives" versus "traditionalists". Further, he seems to have viewed Arbuthnot's work as a crucial factor in their program to push or drag the Ring into an "American-style", twentieth-century aesthetic. By December, Coburn told Stieglitz that Arbuthnot was working on "some splendid new stuff".[19] This was probably the more abstract imagery Arbuthnot was preparing for the 1908 Salon, based on the Post-Impressionist teachings of Dow that he and Coburn had so recently discussed.

Of Arbuthnot's entries in the 1908 Salon, several were by far the most extreme photographs there in their abandonment of "significant" subjects or meaning in favour of form for its own sake. In this respect, he actually exceeded Post-Impressionist formalism, which had always been used to enhance the meaning of the subject. Here, Arbuthnot used his subjects only as an excuse for pure formalist play, as, for example, in *The Bathers* (Fig. 2), depicting the flat black silhouette of a bathing-machine wheel with the heads of two children just visible through the spokes. Following Dow's musical lead, Arbuthnot concentrated here on the artful arrangement of a few simple "notes" of tone and the intervals of space between them. In a sense, the heads of the children poised on the surface of the picture between two spokes can even be seen as a visual analogy for musical notation, in which notes are positioned along the lines and spaces of a staff. The subject, then, is not the ostensible one – children at the seaside – but, rather, pictorial form itself. In its essence, *The Bathers* referred not to the real world but to the world of art theory, especially theories suggesting the relationship between aural and visual art and their shared potential for abstraction.

Several other artists probably also influenced the style of Arbuthnot's 1908 abstractions. One was the English painter and poster artist William Nicholson, who had studied briefly in Paris where he encountered that unflagging proselytizer of Post-Impressionist theory, Paul Sérusier. Back in England in the

[19]Coburn to Stieglitz: 27 August, 16 August, 6 September, 12 December 1907. Alfred Stieglitz Archive, Beinecke Rare Book and Manuscript Library, Yale University.

2. Malcolm Arbuthnot, *The Bathers*, half-tone from *Amateur Photographer*, 29 September 1908.

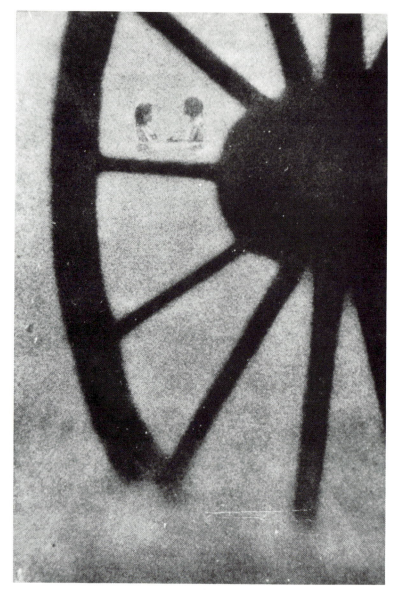

1890's, Nicholson had teamed up with the painter James Pryde to produce a series of poster designs in a new style – a reductive, visually simplified mode based on the use of cut-paper silhouettes.[20] These posters bore a strong resemblance to Arbuthnot's later silhouette-reliant photographs like *The Bathers* and almost certainly influenced him. While Arbuthnot did not meet Nicholson

[20]Duncan Robinson, *William Nicholson: Paintings, Drawings, Prints*, London 1980, 5.

3. Malcolm Arbuthnot, *A Study in Curves and Angles*, half-tone from *Amateur Photographer*, 2 January 1909.

until 1910, he later said he had admired Nicholson's work for quite a while previously. In addition, the theatrical subject-matter of many of the posters would have ensured Arbuthnot's familiarity with them, since he had long been an avid theatre-goer.

This interest in the theatre probably also led Arbuthnot to a final source of inspiration, the abstract stage-set designs of the English actor and director Edward Gordon Craig. Like the Post-Impressionists, Craig was interested in the expressive emotional potential of abstract form and had thus rebelled against the illustrational realism of traditional stagecraft. Between about 1900 and 1907, he developed a style which replaced such sham realism with large, blocky architectonic forms intended to rise and fall from the stage floor in conjunction with the movements of the actors, the rhythms of the musical accompaniment, the changing colours of the lighting, and the overall mood of the play. His intention was to produce an emotional response in the viewer based on the manipulation of these formal elements rather than narrative content. He mounted several such "abstract" productions in London in the opening years of the twentieth century which Arbuthnot could have seen, and in 1908 he published the first issue of his "little magazine" *The Mask*, which included some illustrations of his abstract stage designs.

Craig's attempted synthesis of musical and visual expression would not have been lost on Arbuthnot, who was already interested in the parallels between music and the other arts. In fact, the completely abstract yet expressive nature of Craig's designs was probably the catalyst for Arbuthnot's two most radical abstract photographs, which were not produced until late in 1908. He published these images, *A Study in Curves and Angles* (Fig. 3) and *The Doorstep: A Study in Lines and Masses* (Fig. 4), in a January 1909 article, "A Plea for Simplification and Study in Pictorial

4. Malcolm Arbuthnot, *The Doorstep: A Study in Lines and Masses*, half-tone from *Amateur Photographer*, 12 January 1909.

Work".[21] The article tackled what Arbuthnot and his progressive group saw as the major problem with traditional Pictorialism: an over-reliance on the details of subject-matter in photography at the expense of any sense of underlying formal structure. This, he felt, was attributable to the fact that so few photographers had any background in art; consequently they had little awareness of the ways the formal elements of art – line, tone, shape – could be manipulated to enhance the expressive impact of their photographs. But to Arbuthnot and his friends, such manipulation was more than mere enhancement: it was now seen as the "modernization" of photography, because the most advanced artists they were aware of – the Post-Impressionists – also used formalism this way. In order to "catch up", Arbuthnot suggested that photographers undertake a self-imposed course of study in design, practising first with a few simple, essentially abstract visual elements. Having mastered that, they could then move on to more complex, representational imagery. The echoes of the Fenollosa–Dow system were unmistakable:

[21]M. Arbuthnot, "A Plea for Simplification and Study in Pictorial Work", *Amateur Photographer and Photographic News*, 12 January 1909, 34–5.

Assuming that the photographer's choice be landscape, there is no necessity for what is called a "view"; better, far better, take a portion of it . . . and strive to make an effective study of it. Note how the light falls upon it, determining the tone values . . . ; scheme how to place it on the plate that the most is made of the object in conjunction with its decorative value, and, in short, get at the very soul of the little bit of nature upon which you are concentrating.[22]

To illustrate his points, Arbuthnot included *A Study in Curves and Angles*, which was a fragmented vision of the spokes and shadows of a cartwheel, and *The Doorstep: A Study in Lines and Masses*, depicting the softer tonal shadows of a set of steps. Both "subjects" – a wheel and a doorstep – implied human activity and movement, a concern Arbuthnot might have absorbed from Gordon Craig, who felt that movement was the essence of abstraction. Certainly the formal strength of *To Larboard* the year before had been based on a sense of movement. Possibly, too, Arbuthnot's selection of a doorstep as a subject was a response to a 1905 series of soft, tonal drawings by Craig, titled *The Steps*.[23] These depicted a large, stage-like set of steps which, under varying conditions of light and shadow, were intended to evoke different moods in the viewer. Arbuthnot's interest in "getting at the very soul" of his own set of steps was similar, though his image was more clearly removed from any real-world context or obvious expressive content by his emphasis on formalist structure. This purely geometric formalism may have had its source, then, not just in Craig's work, but in Fenollosa's belief that the absence of "human incident" was the "keynote of absolute decoration" and thus the basis for a purer kind of art.[24]

Arbuthnot concluded his article with the confident statement that if photographers could absorb the principles of these abstract "studies in simplicity", they could be assured that their later, more complex images would possess "a character and individuality which many years of slipshod working would fail to achieve".[25] That he was able to follow his own strictures was amply indicated by his own more complex photographs from 1909, of which *Lulworth Cove* was one of the best (Fig. 5). Here the studies in simplicity of 1908 bore fruit in a unified, lyrical but representational vision of great expressive power. By contrast, his abstractions of 1908 seemed like individual notes of music, selected arbitrarily and played in isolation. *Lulworth Cove*, on the other hand, possessed the unity of a completed musical piece – perhaps a prelude – with a leitmotif of triangular forms to further its counterpointed melodies of spatial depth and pictorial flatness. The theme was the fascinating, lyrical web of

[22]Ibid., 35.
[23]Reproduced in B. Arnott, *Edward Gordon Craig and Hamlet*, Ottawa 1975, 19.
[24]E. Fenollosa, *Mural Painting in the Boston Public Library*, Boston 1896, 13, 16.
[25]Arbuthnot, "A Plea . . .", 35.

5. Malcolm Arbuthnot, *Lulworth Cove*, gum platinum, 1909. Alfred Stieglitz Collection, Metropolitan Museum of Art, New York.

lines formed by the chalk cliffs at Lulworth Cove, whose scale was determined by the small, dark note of a figure in the foreground. Formally, this figure was the base point of a triangle whose other points were the semaphore station and the boat. Conceptually speaking, each of these objects resided in a different spatial plane: the station, with its signalling function, implied a symbolic connection with the far distance; the boat was (apparently) safely enclosed in a harbour in the middle-ground; while the figure was in the foreground. Formally, though, the boat was *not* in the harbour but perched precariously on the upper edge of the cliff. By thus placing the boat, the station and the figure on the same visual plane, Arbuthnot not only compressed the pictorial space but set up a tension between apparent meaning and pictorial reality which ultimately reinforced the validity and mutual interdependence of both. Such rigorous spatial organization was not easy to achieve, a fact

recognized by at least one critic, who said, "Such an essay is
the high-water mark of ambition. . . . Eminently worth doing by
one who could handle it so masterly as Arbuthnot, . . . it is not
a class of thing to be multiplied indefinitely, or imitated by ear-
nest disciples".[26]

Just so. In another time or place, this image might have
been what Arbuthnot hoped it would be – a prelude to usher
in the larger work of a chorus of voices, all singing variations
on a Modernist theme. But instead, it functioned as a swan-
song, both for traditional Pictorialism and for its Modernist ex-
tension in work like Arbuthnot's. Not that Arbuthnot had en-
visioned summoning this chorus single-handedly. He saw
himself, and rightly so, as just one figure within a larger group
of artists and theorists, all interested in exploring the expressive
potentialities of formalism in a modern age. In the end, it was
the increasing ubiquity of this equation between formalism and
modernity that displaced traditional Pictorialism, making it seem
outmoded. Arbuthnot's work was just symptomatic of this larger
shift. What these proto-Modernists did not realize at the time,
however, was that their own Modernist world was also about
to be dismantled, at least temporarily, by the horrors of political
reality, which cast a killing shadow over the premature bloom
of Modernism. The First World War absorbed both artists and
their art, quenching much of the combativeness that had in-
formed prewar aesthetic wrangling – the kind of contentiousness
that had destroyed the Linked Ring, for example, or the aesthetic
in-fighting in the Stieglitz circle. After the war, there was a
general move in Western culture to a more conservative range
of styles, and in photography it was not until the mid-1920's
that another concerted trend was detectable. Called the "New
Photography", it comprised two tendencies – a focus on the
theme of man in society and, in many cases, a fragmented, semi-
abstract style. It seemed the antithesis of Pictorialism's romantic,
unitary, idealized vision, and yet its roots stretched back to the
Pictorialist era. As Dudley Johnston had noted in his lecture on
the history of Pictorialism, there was a similarity between the
abstract tendencies in the New Photography and the earlier ab-
stractions of artists like Arbuthnot in England or Paul Strand in
America. Not that these early abstractions necessarily had either
a direct influence on the New Photography or a directly causal
role in the downfall of Pictorialism. Rather, they were only early
warnings of aesthetic and social changes that became stronger
after the First War, leading to a pervasive sense of fragmentation
and disunity. Ultimately, it was these larger changes that de-
stroyed Pictorialism. For its values were rooted in the nineteenth
century, and even though it extended chronologically into the

[26]H. Snowden Ward, "The Work of the Year", *Photograms of the Year 1911*, London
 1911, 26–7, 67–71.

twentieth, it was the last possible moment in the twentieth century in which the romance of "Truth" and "Beauty" could be maintained with utter conviction. Perhaps the Pictorialists should be envied their moment.

SELECT BIBLIOGRAPHY

Anne Kelsey Hammond

Hubertus von Amelunxen, *Time Reprieved, Time Retrieved: The Invention of Photography by Willam Henry Fox Talbot*, London 1989.

A. J. Anderson, *The Artistic Side of Photography*, London 1910.

H. J. P. Arnold, *William Henry Fox Talbot, Pioneer of Photography and Man of Science*, London 1977.

M. Susan Barger, comp., *Bibliography of Photographic Processes in Use Before 1880*, Graphic Arts Research Center, Rochester Institute of Technology, Rochester 1980.

Michael Bartram, *The Pre-Raphaelite Camera; Aspects of Victorian Photography*, Boston 1985.

Keith Bell, David Harris and Grant Arnold, *The Photographs of David Octavius Hill and Robert Adamson*, Saskatoon 1987.

Bruce Bernard, *Photodiscovery: Masterworks of Photography 1840–1940*, London and New York 1980.

Albert Boni, ed., *Photographic Literature: An International Bibliographic Guide*, New York 1962.

Albert Boni, ed., *Photographic Literature 1960–1970*, New York 1972.

W. Arthur Boord, *Sun Artists*, London 1891.

Robert Brandau, ed., *de Meyer*, London and New York 1976.

Richard R. Bretell, et al., *Paper and Light: The Calotype in France and Great Britain, 1839–1870*, Boston 1984.

A. Brothers, *Photography: Its History, Processes, Apparatus, and Materials*, London 1892.

David Bruce, ed., *Sun Pictures, the Hill-Adamson Calotypes*, London 1973.

Gail Buckland, *Fox Talbot and the Invention of Photography*, London 1980.

Peter C. Bunnell, ed., *A Photographic Vision: Pictorial Photography, 1889–1923*, Salt Lake City 1980.

Camera Work, A Photographic Quarterly, ed. and pub. Alfred Stieglitz, 1903–17, rept. New York 1969.

Brian Coe, *Colour Photography: The First Hundred Years, 1840–1940*, London 1978.

Van Deren Coke, *The Painter and The Photographer: From Delacroix to Warhol*, Albuquerque 1964, 1972.

Janet Dewan and Maia-Mari Sutnik, eds., *Linnaeus Tripe: Photographer of British India 1854–1870*, Toronto 1986.

Frances Dimond and Roger Taylor, *Crown and Camera: The Royal Family and Photography 1842–1910*, London 1987.

R. O. Dougan, *The Scottish Tradition in Photography*, Edinburgh 1949.

Josef Maria Eder, *History of Photography* trans. E. Epstean, New York 1945, rept. 1972, 1978.

Roy Flukinger et al., *Paul Martin Victorian Photographer*, Austin 1977.

Colin Ford, *The Cameron Collection: An Album of Photographs by Julia Margaret Cameron*, Wokingham 1975.

Colin Ford, ed., *An Early Victorian Album: The Photographic Masterpieces (1843–1847) of David Octavius Hill and Robert Adamson*, London 1974, New York 1976.

"From Today Painting Is Dead": The Beginnings of Photography, London 1972.

Helmut Gernsheim, *The History of Photography*, London 1969.

Helmut Gernsheim, *Incunabula of British Photographic Literature 1839–1875*, London and Berkeley 1984.

Helmut Gernsheim, *Julia Margaret Cameron: Her Life and Photographic Work*, rev. ed. Millerton, N.Y. 1975.

Helmut Gernsheim, *Lewis Carroll: Victorian Photographer*, London 1980.

Helmut Gernsheim, *The Origins of Photography*, London 1982.

Helmut and Alison Gernsheim, *Alvin Langdon Coburn: Photographer*, London 1966, rept. New York 1978.

Helmut and Alison Gernsheim, *Roger Fenton: Photographer of the Crimean War*, London 1954.

Lucien Goldschmidt and W. Naef, *The Truthful Lens*, New York 1980.

John Gray, *Calotypes by D. O. Hill and Robert Adamson Selected from His Collection by Andrew Elliot* (1885), pub. privately 1928.

John H. Hammond, *The Camera Obscura: A Chronicle*, Bristol 1981.

John Hannavy, *A Moment in Time: Scottish Contributions to Photography 1840–1920*, Glasgow 1983.

John Hannavy, *Roger Fenton, of Crimble Hall*, London and Bedford, 1975.

John Hannavy, *Thomas Keith's Scotland*, Edinburgh 1981.

Margaret F. Harker, *Henry Peach Robinson: Master of Photographic Art*, Oxford 1988.

Margaret Harker, *The Linked Ring: The Secession Movement in Photography in Britain, 1892–1910*, London 1979.

Mark Haworth-Booth, ed., *The Golden Age of British Photography: 1839–1900*, Millerton, N.Y. 1984.

Robert Hershkowitz, *The British Photographer Abroad: The First Thirty Years*, London 1980.

Elizabeth Heyert, *The Glass-House Years: Victorian Portrait Photography 1839–1870*, Montclair and London 1979.

Michael Hiley, *Frank Sutcliffe: Photographer of Whitby*, London and Boston 1974.

Tom Hopkinson, *Treasures of the Royal Photographic Society 1839–1919*, London 1980.

André Jammes, *William H. Fox Talbot: Inventor of the Negative–Positive Process*, Frankfurt 1972, New York 1973.

Bill Jay, "Francis Bedford 1816–1894", *Bulletin of the University of New Mexico*, no. 7 (1973).

Bill Jay, *Victorian Cameraman: Francis Frith's Views of Rural England 1850–98*, Newton Abbot 1973.

Bill Jay and Dana Allen, eds., *Critics: 1840–1880* (History of Photography Monograph Series Special Edition No. 1), Arizona State University, Tempe 1985.

Ian Jeffrey, *Landscape*, London 1984.

Ian Jeffrey, *Photography: A Concise History*, New York and Toronto 1981.

Ian Jeffrey and David Mellor, *The Real Thing. An Anthology of British Photographs 1840–1950*, London 1975.

J. Dudley Johnston, *The Story of the R.P.S.*, London 1946.

Bernard E. Jones, ed., *Encyclopedia of Photography*, London 1911, rept. New York 1974.

Edgar Yoxall Jones, *Father of Art Photography: O. G. Rejlander 1813–1875*, Newton Abbot 1973.

Robert Lassam, *Fox Talbot: Photographer*, Tisbury 1979.

Raymond Lécuyer, *Histoire de la Photographie*, Paris 1945.

Joanne Lukitsh, *Cameron: Her Work and Career*, Rochester 1986 (exhibition catalogue, International Museum of Photography at George Eastman House).

Valerie Lloyd, *Photography: The First 80 Years*, London 1976.

Valerie Lloyd, *Roger Fenton: Photographer of the 1850's*, London 1988.

Neil McWilliam and Veronica Sekules, eds., *Life and Landscape: P. H. Emerson: Art and Photography in East Anglia 1885–1900*, Sainsbury Centre for Visual Arts, University of East Anglia, Norwich 1986.

Oliver Matthews, *Early Photographs and Early Photographers*, London 1973.

Katherine Michaelson, *A Centenary Exhibition of the Work of David Octavius Hill 1802–1870 and Robert Adamson 1821–1848*, Edinburgh 1970.

C. S. Minto, *Thomas Keith: Photographer*, Edinburgh 1966.

Richard Morris, *John Dillwyn Llewelyn, 1810–1882: The First Photographer in Wales*, Cardiff 1980.

Alison Morrison-Low and J. R. R. Christie, eds., *"Martyr of Science": Sir David Brewster 1781–1868*, Edinburgh 1981.

Vanda Morton and Robert Lassam, *Nevil Story Maskelyne*, Corsham n.d.

Hugh Murray, *Photographs and Photographers of York: The Early Years 1844–1879*, York 1986.

Weston Naef, ed., *The Collection of Alfred Stieglitz*, New York 1978.

Beaumont Newhall, *Frederick H. Evans*, Millerton, N.Y. 1973.

Beaumont Newhall, *The Latent Image: The Discovery of Photography*, Garden City, N.Y. 1967.

Beaumont Newhall, *The History of Photography: From 1839 to the Present*, New York 1964, London 1972, New York 1982.

Beaumont Newhall, ed., *Photography: Essays and Images*, London 1981.

Nancy Newhall, *P. H. Emerson: The Fight for Photography as a Fine Art*, New York 1975.

Y. Nir, *The Bible and the Image: Photography in the Holy Land*, Philadelphia 1985.

Arthur Ollman, *Samuel Bourne: Images of India*, Carmel, Calif. 1983.

Eyal Onne, *Photographic Heritage of the Holy Land 1839–1914*, Manchester 1980.

Graham Ovenden, *Clementina Lady Hawarden*, London and New York 1974.

Graham Ovenden, *Hill and Adamson Photographs*, London and New York 1973.

Graham Ovenden, ed., *A Victorian Album: Julia Margaret Cameron and Her Circle*, New York 1975.

Richard Pare, *Photography and Architecture*, New York 1982.

A. Pearson, *Robert Hunt F. R. S. 1807–1887*, Penzance 1976.

Larry Schaaf and Hans P. Kraus, Jr., *The Pencil of Nature* (limited facsimile edition of Talbot's work), New York 1989.

Aaron Scharf, *Art and Photography*, Harmondsworth 1968, rev. 1974.

Aaron Scharf, *Pioneers of Photography*, New York 1976.

Heinrich Schwarz, *David Octavius Hill: Master of Photography*, London 1932.

Grace Seiberling and Carolyn Bloore, *Amateurs, Photography and the Mid-Victorian Imagination*, Chicago and London 1986.

Robert S. Sennett, *Photography and Photographers to 1900: An Annotated Bibliography*, New York and London 1985.

Robert A. Sobieszek, *British Masters of the Albumen Print*, Chicago and London 1976.

Stephanie Spencer, *O. G. Rejlander: Photography as Art*, Ann Arbor 1985.

Sara Stevenson, *David Octavius Hill and Robert Adamson*, Edinburgh 1981.

John Taylor, *Pictorial Photography in Britain 1900–1920*, London 1978.

Roger Taylor, *George Washington Wilson*, Aberdeen 1982.

A. Thomas, *The Expanding Eye: Photography and the Nineteenth-Century Mind*, London 1977 (pub. as *Time in a Frame*, New York 1977).

D. B. Thomas, *The First Negatives: An Account of the Discovery and Early Use of the Negative–Positive Photographic Process*, London 1964.

D. B. Thomas, *The Science Museum Photography Collection*, London 1969.

Peter Turner and Richard Wood, *P. H. Emerson: Photographer of Norfolk*, London 1974.

Two Victorian Photographers: Francis Frith, Francis Bedford, from the Collection of Dan Berley, Brockport, N.Y. 1976.

Louis Vaczek and Gail Buckland, *Travelers in Ancient Lands: A Portrait of the Middle East 1839–1919*, Boston 1981.

Julia Van Haaften, *Egypt and the Holy Land in Historic Photographs: 77 Views by Francis Frith*, selection and commentary by J. E. M. White, New York 1980.

Julia Van Haaften, *From Talbot to Stieglitz: Masterpieces of Early Photography from the New York Public Library*, New York and London 1982.

E. J. Wall, *The Dictionary of Photography*, 14th ed., Boston 1937.

John Wall, comp., *Directory of British Photographic Collections*, London 1977.

John Ward and Sara Stevenson, *Printed Light: The Scientific Art of William Henry Fox Talbot and David Octavius Hill with Robert Adamson*, Edinburgh 1986.

Mike Weaver, *Alvin Langdon Coburn: Symbolist Photographer*, New York 1986.

Mike Weaver, *Julia Margaret Cameron: 1815–1879*, New York and London 1984.

Mike Weaver, *The Photographic Art: Pictorial Traditions in Britain and America*, London and New York 1985.

Mike Weaver, *Whisper of the Muse: The Overstone Album and Other Photographs by Julia Margaret Cameron*, Malibu 1986.

John Werge, *The Evolution of Photography*, London 1890.

Stephen White, *John Thomson: A Window to the Orient*, London 1986.

Walter E. Woodbury, *The Encyclopaedic Dictionary of Photography*, New York 1896.

Linda Goforth Zillman, *Sir William Newton: Miniature Painter and Photographer 1785–1869* (History of Photography Monograph Series), Arizona State University, Tempe 1986.

INDEX